Library Media Programs and the Special Learner

D. Philip Baker

and

David R. Bender

1981
Library Professional Publications

©D. Philip Baker and David R. Bender 1981

First published 1981 as a
Library Professional Publication (LPP)
an imprint of The Shoe String Press, Inc.
Hamden, Connecticut 06514

Library of Congress Cataloging in Publication Data

Baker, D Philip, 1937-
 Library media program and the special learner.

 Includes index.
 1. Exceptional children—Education—Audio-visual
aids. 2. Instructional materials centers.
3. Resource programs (Education) I. Bender, David R.,
joint author. II. Title.
LC3969.B34 371.9 80-24806
ISBN 0-208-01852-2
ISBN 0-208-01846-8 (pbk.)

Printed in the United States of America

If you seek them, They are not asleep

Richard de Bury

This book is for Alice FitzGerald, a tireless and imaginative leader in work with handicapped children, as Executive Director of the Association for the Aid of Crippled Children in New York City, and later as the Associate Director for the Foundation Program which supported pioneering research into the prevention of many handicapping conditions afflicting children. Her guidance, unfailingly kind and modest, is always sincere and honest. She remains a commanding influence upon the lives and work of many, of whom we are but two.

Contents

Foreword

Johann Wolfgang von Goethe once wrote that, "He who serves the public is a poor animal; he worries himself to death and no one thanks him for it." But Goethe was dead wrong. There are great satisfactions in public service and the greatest of them is making our political system work as it was intended, by extending the civil rights which are at the heart of our democratic system to citizens who have not received their full protection.

In this book, *Library Media Programs and the Special Learner,* the authors understand why the Education for All Handicapped Children Act (PL 94-142) and other important legislative, judicial, and administrative acts which guarantee handicapped learners the *right* to an appropriate education are a reality today. This is precisely because our political system responded, as it is designed to respond, to pressures from these citizens and their advocates. The Constitution of the United States guarantees all citizens the right to petition the government for redress of grievance. That is where our concept of citizen advocacy was born. The Constitution is the beacon that lights the path to equal rights. It has lighted the way to legislation to secure the right to an appropriate education for millions of physically and mentally handicapped learners.

But the passage of laws, rulings by the judiciary, and administrative regulations regarding the civil rights of the handicapped take us only part of the way along the road of an immense journey. The government's power to order the lives of its citizens and redress their grievances is finite. Other barriers—some psychological, some economic, some social and some political—impede our progress. To successfully complete this journey to extend the full measure of the abundant riches of the finest public and private school system in the world to the exceptional learner will require perseverance, an abundant faith in ourselves, and a commitment by teachers, library media specialists, parents, students, and many others that we can accept the challenge and do the job.

For years I have been a strong supporter of school library media programs. Unlike other instructional programs, this program cuts across a broad range of knowledge and skills to provide service and leadership within the school. It seems to me these are the very attributes we will need most if we are to meet successfully the educational needs of special learners, ranging from the handicapped to the gifted or talented. The array of services, programs, and activities which will be necessary to educate these disparate groups with credibility and, we hope, excellence, will doubtless severely tax the resources of our schools. They already have.

But the library media program, with its rich tradition of teaching a great variety of learners with many different learning styles and needs, has long been in the forefront of educational programs which advocate individualized instruction, matching the appropriate material to the needs of the learner, the importance of providing more than one kind of learning environment, stimulating learners to learn to the fullest extent of their capacity, and helping other professionals to achieve the competence and confidence to do their jobs well.

The library media program is a bridge which makes possible interchange and interaction among teachers, students, administrators, parents, the community, and other library or information programs. The pivot of this informational program, composed of people and materials, should be the school library media program.

Philip Baker and David Bender have judged correctly, I feel, that special education programs will greatly stimulate school library media program development. I do not believe that it will be possible to realize the bold promises of government to special education without excellent library media programs, staffed by professionals and support personnel and volunteers who understand what they are doing, and who know that their work does make a difference. This book provides many examples of some extraordinary successes with all kinds of special learners, ranging from the most severely mentally or physically limited to the most gifted or talented. If we do indeed learn by example, then this book is a valuable addition to the profession's literature.

Finally, this book's advocacy of the need for the library media specialist to be an excellent teacher, of both young learners and teachers, provides an emphasis badly needed in many school library media programs. The library media program and the library media specialist are critically important if our schools are to provide quality educational programs. From the cat-bird seat at the very heart of the school's instructional program, the library media specialist can exert an enormous influence for good throughout the school. This book, *Library Media Programs and the Special Learner*, challenges us to work as hard as humanly possible to see that library media programs and special learner programs contribute with exuberant excellence to the school and the community. I believe it is an appropriate challenge and that we are up to it.

Charles McC. Mathias, Jr.,
United States Senator, Maryland

Preface

The programs reported in this book were observed and reported to us in 1979-80, and descriptions are based on the programs as they were operating at that time. Although changes inevitably take place in both program and staff, these library media programs geared to special learners in various kinds of settings were, when observed, and probably remain, exemplary. As such, they are worthy of note, not only by school library media specialists and planners, but by special education teachers and other personnel, administrators, teacher educators and others concerned, as professionals or as parents and other laymen, with special education.

We greatly appreciate the help of the many professional colleagues who answered questionnaires about their programs, arranged and prepared for site visits, and facilitated our work in many other ways. We are especially grateful to the site observers, listed in Appendix IV, who made the visits and reported to us what they had seen, heard and experienced.

A word of explanation is in order about the letters IEP, and the words they stand for, both used frequently throughout this book. Officially they mean Individualized Education Program, the words used in the Act, PL 94-142, to mandate tailored learning prescriptions for each child. Many places

and publications have used variations: "individual" "educational" and often, "plan" instead of "program." We have tried hard to be correct and consistent, but if some variations have crept into this book, we ask your indulgence.

One further note: be assured of our commitment to the elimination of stereotypes and "isms" and understand that it is in order to avoid the awkwardness of "his/her", "he/she" that we have in most cases used the generic masculine pronoun to mean both male and female persons in all of the various professional categories mentioned in this book.

<div align="right">

D. Philip Baker
David R. Bender

</div>

Introduction

In a world in which cynics abound and find fertile soil in which to sow their seed of disbelief, a book which holds the optimist's view seems, perhaps, strangely out of step. Nonetheless, we endorse the view that if we set goals and work tirelessly to achieve them, with persistence, infinite patience, and a vision to sustain our belief, then the human condition *can* be made better. We believe that visions of what *can* be inspire more faith than fears of what is, or might be. We believe that if our wills are strong, and our imaginations directed and disciplined, then dreams can become reality, and little is impossible.

Others—the great philosophers whose thoughts were deeper and wider than ours, and the great creative writers, more articulate and compelling—have expressed their boundless confidence in the power of faith. They have told us that faith, fortified by reason, and manifest in the inquiring mind, can find solutions, even define the meaning of existence. It was Oscar Wilde who told us that, "A map of the world that does not include Utopia is not worth glancing at, for it leaves out the one country in which humanity is always landing."

As we are all keenly aware, this period in history is not likely to be remembered as one of the great ages of faith, nor is

reason its goddess. The institutionalized madness that surrounds us forces millions to live Thoreau's bleakly described, "lives of quiet desperation." To Hume, "the truths of reason are true by definition, like mathematical axioms," and while we may not be able to trust that this is so, we can perhaps accept his corollary that, "the truths of the world we live in are based on experience." It seems to us that reason must be based upon knowledge of, care for, and concern about the human experience.

We are jolted by each day's dreadful news into a sense of living in a world beyond reason, a world that has lost its reason. Most of the time we just "hang on" to try to protect whatever we may have from all comers or takers. We accept brainwashing by television, movies, radio, newspapers, and yet reject its use in war and politics. Our seemingly limitless ability to intimidate ourselves is matched by an equally unlimited capacity to stretch the boundaries of irrationality to the last frontier. We live in an age of boredom, alienation, and meaninglessness. It is an era of many seekers and few finders, characterized less by a search for truth than by a passion for finding meaning. Failing that quest as well, most settle for a numbed state of coexistence with a world in which there are no absolutes, few expectations of good, and no rules for intact survival. The glib cliche, "new ways for new days," is the watchword for what might better be called whistling by the cemetery. Ours is a culture which expresses its values in plastic see-through jeans and the newest disco sound, and which displays its truest beliefs on a T-shirt. Philosophy, whether it is of the situational and with-it variety of an Andy Wharhol, or the arcane notions of a Spinoza, cannot and never has substituted for human experience when it comes to applications to real life.

Our purpose in thus evaluating our present circumstance is neither to depress unduly nor to sell our particular view about the present human condition. It is, rather, to provide a framework for the subject of this book: library media programs and how they may serve the needs of the special learner. To do this, we feel, requires a context and a sense of history. We want our book to reflect the realities of the task. We think it is

not possible to write a book about, become involved with, teach, or in any way to impact the world of the special learner, without some serious thought about why we do what we do.

Special learners *are* special, and their specialness should provoke those who work with them to search for some deeper meanings to shape their conviction about what they are doing and why. But of course anyone who works with *any* learner should be taking time to give thought to what he is doing and why. This should go without saying, but recently expectations about what we want to accomplish with those we teach have become ensnarled in a behavioralist net which seeks to measure, quantify, tabulate, and classify every human learning experience into a taxonomy of reinforced behavior and outcomes. Learning goals have become hostages to merciless measurement and ceaseless validation, and we think it makes teaching and learning a very dull exercise instead of the joyous discovery it should be. Teaching the special learner, and indeed all teaching, should be a thoughtful, compositional, creative act. It requires a great deal of thought to plan for outcomes which the teacher can affect, rather than expecting that learning can be reduced to a stimulus response pattern.

The principles we identify for planning, guiding, and producing through library media programs for special learners are intended to encourage readers to try them out in their own situations. *There is no one right way.* Logic has its own power to persuade, and logic dictates that there are several routes one may choose in order to achieve successful media programs with special learners. We aim to expand the dimensions of the feasible for library media programs and the special learner, and even perhaps move beyond these limits to suggest new and exciting ways for library media programs to serve the wide range of children considered under this term.

If we are deeply sensitive to the traumas of the times, so too are the special learners, and so too are the excellent teachers and library media specialists who will teach and influence them. We hold that personality and conviction, as well as imagination, instinct, and intuition, are as much tools of the trade for anyone who would work effectively with the special

learner as are the media, the tests, and other instruments. It is for this reason that we have lingered over the times and related them to our beliefs. No one, least of all a teacher of the special learner (and teacher includes all library media specialists, as well) can ignore the philosophy which undergirds what one does. In examining a range of library media programs that work well with special learners, we hope to evolve a philosophy for their conduct and activities. The spontaneity of fine teaching is made possible only when the practitioner has the security of understanding what he is doing, and of holding convictions which provide a springboard for innovation, improvisation, and extrapolation.

James Gould Cozzens, whose novels reflect an extraordinary perception of the human condition and a dedication to probing it for realities, speaks many a universal truth in *Guard of Honor*. Among other things he says: "In any human situation, there are more variables than any human mind can properly take account of . . . most people, confronted by a difficult situation, one in which they don't know what to do, get nowhere because they are so busy pointing out that the situation should be remade so they will know what to do. . . . There are reasons for everything that is. . . . Figuring them out increases our understanding, may arouse our indignation or our compassion. They add up to say that if things had been different, things might be different. That seems quite likely, but things aren't different, they are as they are. That's where we have to go on from."

And so it is. Accepting this view is not defeatist, but it does force us to surrender some attempts to control what we cannot control, to face into what *is,* and to develop what we are. Acceptance allows us rationally to assume an obligation, even a burden, and makes it our responsibility to go on from there. So it is with teaching or being a library media specialist. If we cannot believe that our work has value, why do it? Believing means knowing that everything any learner ever does or experiences is learned forever, and that both the good and the negative experiences are retained. Believing means that to give a learner a positive experience is to have a positive impact on that individual forever. This is teaching, raised to its highest power.

This book is above all a book about teaching. True, it contains descriptions of exemplary programs; details of how gifted and talented learners can find motivation, direction, and discovery with the help of the library media program; ideas about how an emotionally disturbed or a hearing impaired learner may find satisfaction and intellectual growth through the use of the library media program; and some indications of how teachers and parents of special learners may achieve greater success in their roles through the aid of the library media center. It is a book of some history, too, with perspectives on the present, and some conjectures about the future. It is a book which seeks some answers, raises many questions and offers, we hope, some solutions or at least possibilities of solutions. It is a book which seeks to provoke the reader to become a more serious searcher and a keener observer, while at the same time inspiring the desire to try out some of the ideas and innovations which shape the activities described.

We do not bring about growth, renewal, and change just by gazing into a mirror with self-satisfaction. Analysis and adaptation are required for healthy growth and desirable change, and they come about through observing what others do that is outstanding, and adapting it to our needs. Success in fostering change and in solving tough and intractable problems never happens, never has happened, when ideas are repressed. The success of any change rests ultimately with the ability of those who want to make changes to convince those whom they wish to change that for one thing, change is desirable, and that, for another, those most closely involved should take an active role in shaping it.

Attitudes toward change and the steps toward acceptance of new ways are as predictable as humanity itself. Dramatic change takes place for the most part in a setting of benign indifference. Usually, not many will resist, but equally few will be anxious to join in the long uncomfortable processes of adjustment. Abrupt, mass-pressured change is not the best road to change because it scares people off rather than attracting them. The paths of human history are littered too with the bones of those who, driven by the warmth of their own

convictions, got too far ahead of possible followers and failed to convince others concerning changes they knew were required. While bringing about change does not demand the unquestioning approbation of every follower, it cannot be successfully installed in the face of widespread, angry opposition.

American educational reformers have too often neglected these facts, leaving a lasting and negative legacy of botched innovations and improvements to be dealt with on a day to day basis by such frontline troops as library media specialists, who see the smooth transition to positive change as a prime responsibility. Schools seem to resist change, but in fact it is not the institution that resists but those who run and operate it. Resistance comes from the principal, the parents, the teachers, the boards of education, the community. Even students can be the focus of resistance. Any attempt to foster change must take into account the contradictory strains that may inhabit a single individual temperament. One strain may be imaginative, romantic and creative, and the other, docile, orderly and obedient. These can become forces for and against change, pulling against each other, and must be kept in some sort of balance and harmony. It takes leadership of an uncommon order to create compatability where there is none. The word which describes this process best is one many people do not like the sound of, but which makes life possible: *compromise*. This art of settling for a little less than the ideal of either opposing side may indeed be a form of erosion, but the Indian poet Tagore (who was apparently against it) exalting, "I will go on with no other follower than one!" had never spent much time in a school setting. Idealism must be tempered with pragmatism, and some "give" to our personalities, if our most cherished ideas are to be synthesized with the beliefs and expectations of others. No final results will ever be quite what we would have wished or intended, but accepting this may result in our being able to foster more desirable change than we might have dreamed possible.

We hope that this digression to talk about change has not seemed a digression. This book, as we have told you, is about library media programs and special learners; it is also by

definition a book about managing change, because the focus on teaching and learning provisions for special learners may result in some of the most fundamental changes American education has yet seen. We propose to help these changes along by projecting and promoting library media teaching programs which include and express humanistic values. Arthur Combs, an articulate and caring critic of education in this country has said, "I am a humanist because *I know* that humanistic factors will determine the effectiveness of any learning." If learning does not involve the learner in discovering the meaning of what is presented, there probably is no learning. It will take some widespread changes within the schools to make this possible, and this will in turn require an improved dialogue with parents, with other citizens, with students, and among members of our own profession.

We hope that in some degree expectations can be raised and change promoted by presenting these descriptions of library media programs which exemplify good teaching methods, project an outstanding ability to involve learners, parents, teachers, and others in their activities, and show library media programs as being in the forefront of leadership in special education. Special education provides a new dimension of service and an opportunity to present in a new context two basic contributions of quality school library media programs: (1) that they are there to help learners to choose and use the best and most important information available for their purposes; and (2) that they personally involve the user/learner in doing something useful with the information he obtains.

For most of the twenty years just passed, library media programs have asserted that their true reason for being was to provide an element of leadership in the instructional program. The 1969 *Standards* and the 1975 *Guidelines* focused on this commitment with relentless emphasis, almost as if by saying it, it would become so. We do not ignore the message; quite the contrary, we see the building of quality services to special learners as a magnificent and significant *growth opportunity* for library media programs, an opportunity to place themselves ever more directly in the educational mainstream. We

see the focus on the needs of the special learner as a prime target of opportunity for the library media program to show some ways in which it may play a more vigorous role in instructional leadership in the school, district and region it serves.

Our primary focus may indeed be upon meeting the needs of the special learner through the library media program, but we are well aware of other major concerns, including:

(1) Emphasizing the instructional role of every media program, and the need for library media specialists to be skilled teachers both of student and teacher learners;

(2) the need to define, maintain, and modify, when appropriate, the philosophy and purpose by which the library media program provides instructional support and leadership;

(3) the purpose of education today and the role that the teacher (and again, we count the library media specialist as a teacher) plays in it;

(4) the importance of maintaining standards of excellence in teaching and learning;

(5) the strength that comes from understanding the purposes of what we do and a belief in its importance, and of doing it with intensity tempered with humanity and sensitivity;

(6) the need to interpret the purposes and goals of the library media program not just to principals, teachers, and students but to an even wider community of parents and citizens; and

(7) the need to comprehend far better than we have previously, the importance of the theoretical base of understanding about how humans learn.

Jean Piaget, Jerome Bruner, and Bruno Bettelheim are seminal influences upon our work, and to the degree that the library media specialists understand what they and others like them say about how we learn, their teaching effectiveness will be greatly enhanced. *Understanding* is the cornerstone upon which fine teaching is built—understanding of what

teaching is, of how to do it, and above all of what the learner is feeling and learning. This is basic and hardly original, but how often it is ignored, or worse, not even considered at all, by many who teach.

Other themes inform this book as well: for instance, the quality of the attention given to the selection of the instructional materials used in many library media programs—often not as good as the task demands. It is essential that library media specialists realize that no teacher, however gifted with intellect, imagination, energy, or personality can contain all of the resources necessary if learning is to occur for the range of students found in most classrooms. Meeting the needs of the special learner strongly underscores this particular reality. Every teacher needs help whether he or she knows it or not—and most of the best ones know it. Often this help will manifest itself in the form of an audiovisual device, an artificial resource outside of the teacher's ability to provide. The proper selection and correct use of any and all resources should occupy a high priority in the planning for excellent teaching. We would like to believe that it does, but from what we know at first hand and have observed in a variety of schools, we know that this is not so. The same kind of skill that leads one to choose red-coated bubble gum over blue-coated bubble gum prevails in much of the selection, especially of audiovisual materials used in instruction. The relationship of good media use to teaching the special learner, every learner, must be established. The audiovisual materials—the filmstrips, the audio and video cassettes, video programs and films, recordings—all have a legitimate place among the core components of instruction. But in asserting this, we accept, too, that the issue of evaluation, selection, and use of these materials must receive far higher priority than we now give it. Using audiovisual materials demands cohesion, sequentiality, and goals, just as good teaching itself does.

Then too, we are concerned about design, and how design relates to use in the library media center. Something more than Oz-like fantasy should power our architectural creations. We have seen wretched excess result from the perversion of the cliche that the library media center must be at the

Heart of the school. Of course it should, but not necessarily in a physiological sense! The heart must always be in the upper chest of a body for things to work, but the "heart of the school" should be less a definition of location than a statement of belief about the library media center's role in the instructional program! The fixation with location has led to some cathedral-like centerpieces as library media centers which may do more to distract the attention of young learners than to enthrall it.

But obviously the antidote to the overbuilt library media center is not to do away with it. Environment is important to learning, and for special learners the relationship between facility and program is especially important, for the physically limited learner, unavoidable. We do, however, admit a bias in presenting here those programs which delivered outstanding and innovative instructional services without becoming hostages to their facilities. Such programs have never existed because they had elegant, splendid, or even adequate quarters. We looked for, and found, many that went far afield—frequently away from a building—in their search for the right combination of resources and environment to deliver an effective library media program for special learners.

The library media program that would provide excellent services to the special student must learn to take a broader view of opportunities and possibilities. The needs and expectations of special learners, who range across a spectrum from emotionally scarred to physically or mentally limited to gifted and talented, are much too diverse to be served at just one location. So an important theme of this book is that in planning library media services for these children there need not be an excessive preoccupation with facility.

The threads of these concerns will run throughout this book, to surface again and again in the chapters that follow and in reports of specific programs. There is still another thought to be kept in mind, too: the challenge of serving the special learner in all of his variety and diversity will become increasingly not only a matter of better quality service to an existing population, but to an expanding population of special learners as well, as our expertise in identifying those with

learning problems increases, and as early identification of latent defects or talents becomes the norm.

Just now, due largely to the emphasis on application of the mandates of Education for All Handicapped Children Act, PL 94-142, the enforcement of appropriate parts of the Rehabilitation Act of 1975 and other federal-state legislation, the greatest share of attention is on programs to meet the needs of limited learners. Not to be overlooked, however, as they often have been, are the special programs required by the talented and gifted. We assigned a high priority to seeking and reporting some outstanding programs in this area of special learning.

The development of special education programs to meet the needs of children who had heretofore been both segregated and shortchanged educationally can be seen as the unfolding of one of the great civil rights acts of our history. There are in this nation today between eight and ten million mentally and/or physically handicapped children. Theirs is a tragic history, one of thwarted dreams and abandonment, of being hidden away unable to develop the abilities to match their disabilities. But it would be a mistake to become so emotionally involved with this ignoble history that we fail to require that the limited learner and the program that is planned to develop his abilities must be held to reasonable and suitable performance standards. To do otherwise would be a further disservice. There must be expectations, goals to be met, obligations to be assumed by both program and learner. Success or failure measured in terms of one's capability is part of any good teaching program. For, while the less able, because they are less able, must receive very special care and teaching, they must not be allowed just to "get by" but must be encouraged to do the best of which they are capable. Also, it is well to bear in mind that the first piece of advice which most doctors give to the family of a child who is newly diagnosed as mentally or physically limited, is that they must not let this child dominate the life of the family to the detriment of its other members. And so the special learners, whether limited or super talented, must not be allowed to dominate the life of the school nor an undue proportion of the services of the library media

program. Perspective and balance between meeting the needs of the special and the needs of the other learners in a "regular" school must prevail or much of the point of mainstreaming is lost.

The successful library media program for the limited child will develop qualities of instructional and personal programming that are an enriching complement to an already good program, not just add-ons. Educating the limited or gifted learner should improve the quality of education for *all* the children within the school. To the extent that special learner programs force us educators to look closely at the total learning process for each individual child and sharpen our ability and determination to teach each child in the way most appropriate to his abilities and disabilities, the education of the special learner will have a salubrious effect upon all teaching and learning. There is a certain irony here, for much of what will be required to develop appropriate programs for special learners is what we have claimed to be doing for all children right along! The requirement is, quite simply, that each child proceeds at his own pace, that the teacher recognizes early on what this pace is, and then applies a carefully chosen combination of methods, techniques, and motivational stimuli to help the learner along the way to his *own* level of success. The proper, the best, instructional materials, combined in a good learning environment with teacher strategies, are of course an integral part of this complex and subtle process in which we too often fail even with non-problem learners. We sometimes fail to account for the subjective factors present as we move from one learning expectation to another. Too often we make the assumption that external change produces internal transition in a stimulus/response style. This may explain why so much teaching and so much media use is directed toward changing behavior as opposed to changing attitudes. If refining our strategies for education of the special learner forces some accommodations with the reality of how and why people learn, then all teaching and learning should improve.

Because of the legal and social expectation about the education of the special learner, change may be accounted as certain, particularly for those who fall within the mandates of

PL 94-142. It is possible to drift into change without recognizing its imperatives until they create a crisis. This is not a good idea, because though crises do force change, they do not always force progress. Too often, change in education has either been for the sake of change or provoked by pendulum swings in public sentiment. We believe that library media program leaders have a special responsibility to both promote change and manage it effectively. They must be doubly aware, then, that future—and present—changes will have an impact on every school and upon every one of them. Effects, yet to be measured, range from the inconvenience of increased bureaucratic controls—both state and federal—concerning the education of the special learner, to the challenges of new teaching methods, materials and teaching programs. Already evident is the fact that large numbers of specially trained or retrained teachers, administrators, and support personnel will be needed. The millions of Individualized Education Programs (IEP's) which will result from the process of planning and carrying out education for special learners must involve the active participation of the library media program and so the preparation and continuing education of school library media specialists must be considered.

Thus, the mandates of PL 94-142 become one of the greatest opportunities ever presented to extend and enrich the instructional purpose of the school library media program. Providing a "free and appropriate education for limited learners in the least restrictive environment" should have a marked impact for good upon the development of library media programs and the work of media professionals. Unfortunately, there are some negative possibilities as well, having to do with costs. Economically speaking, special education has become a growth sector in American education, but the high cost per pupil of services may tempt local districts to make up the difference between costs and federal-state special education grants by taking away funds from other programs, *including the library media instructional program*. The essential relationship of the library media program to the special learning programs *must* be made abundantly clear, and soon!

There are also other factors, many of which will affect the

library media program. For example, instructional materials will have to be developed in a wider range of media formats. Captioned filmstrips, which fell into disfavor more than a decade ago (with the advent of audio cassettes), have reappeared as an important learning resource for the hearing-impaired. On the other hand, we must take care not to embrace the audiovisual format as the sole instrument for special education. The costly errors of the sixties, still cluttering the closets and storage cabinets of many a library media center (remember language labs and programmed learning hardware?) need to be remembered, and the misjudgments in selection and of instructional usefulness that brought them there can serve as a warning against any medium that promises to have all the answers—or worse still, be "teacher proof."

Looking at new uses for traditional audiovisual materials will be an important element in planning program for the special learner, but of course there must be some new ones created and evaluated with a new, higher level of professional competence. Unfortunately, new product development by manufacturers depends upon the availability of research and development money, and inflation has shrunk both company profits and venture capital. This, combined with sharply reduced financing for local education systems means that the availability of new products needed in special education has been severely reduced. Grants, demonstration projects, and other government-funded projects can no longer be counted on in a period of massive economic troubles. Less money, and more to do with it may be the watchword of the times.

All of this will place greater emphasis upon the production of locally developed materials. As never before, teachers and library media specialists must rely upon their own experience and work together to provide suitable materials for special learners. The library media specialist who could help teachers and students to produce their own instructional media has always been more highly regarded by colleagues and students for this skill than for almost any other. While will power, intellect, and perseverance cannot overcome every obstacle, we found them to be important elements in many of the

successful programs we visited. The outstanding profession-
al media specialist will enjoy refining the knack for creating
new things out of old, finding new uses for picture books, new
combinations of audio and video materials to fit the needs of
the special learner. It may be economic necessity that presses
us into it, but this is an enormously satisfying way to teach,
all the same. The qualities of imagination, curiosity, and
willingness to experiment will go a long way toward making
the library media specialist a skilled special educator.

It is reasonable to expect that the challenge of providing
new materials for special learners and finding new uses for
traditional materials will stimulate the growth of networks
and resource sharing, and we looked for, and found, examples
of such networks that have exerted a very positive influence
on special education programs. High costs of materials,
equipment, personnel and space—to name but a few—must
result in stepped-up cooperative efforts to operate programs
and services on a district, statewide, or regional basis. The
tradition of local control of education is deeply ingrained in
the American political tradition, but networks are already
playing an important role in providing educational services
for special learners. They are valuable not just because they
may reduce—or at least spread more equitably—the costs of
such programs, but because of their potential for affecting
attitudes, sparking and creating more imaginative programs,
and opening access to many more resources for each school,
each classroom, and each child. No network can substitute for
a strong building library media program, but networks not
only enrich and supplement each program but provide what
no one building could do as well by itself: staff development,
program evaluation, review and examination opportunities,
and equipment servicing. We have found, and reported in this
book, that networking at several different levels brings a
better, more diversified and effective program to special
learners and to all learners.

Pioneering programs for the gifted and talented especially
have demonstrated that learning hardware can have real
validity. The need to learn how to use the appropriate mate-
rials with the correct equipment in a manner that provokes

inquiry and learning is a prime concern. In many schools, computer-assisted instruction (CAI) has become an enrichment program. The computer terminal, often used for technical services processes such as ordering, film booking, and inventory, has direct instructional uses when approached with ingenuity. While programs for the gifted have been tied to remote centers for scientific and technical research through the computer terminal,they have great potential for limited learners as well. The availability of books on computer language make it possible for the learner to pace himself and proceed. Other programs, in addition to those for the gifted, have already begun using the computer in most innovative ways. It is not unusual, for example, to find the Guidance Information System in many high school library media centers, where terminals can access data bases which provide career, vocational, and college information to students. Indeed, computer-assisted instruction is so widely available now in elementary and middle schools as well as high schools, that it can no long be considered trendy. A carefully considered and planned application of technology to improve instruction becomes increasingly a central responsibility of the library media program in relation to all teaching, but especially in connection with special education programs.

Teaching the learning-impaired, the sight-damaged, and others with severe physical limitations requires special equipment, and some of these programs are reported here. We did not include, however, programs which seemed to us to depend almost entirely on machine wizardry for their personality and impact. We looked for equipment use that kept feeding back into excellent teaching by a human being. We library media specialists have asserted for at least two decades that we have special skills in *applying* technology to the teaching-learning process and *its* improvement; we have never, most of us, made the mistake of thinking that technology could take over the whole job. We have an excellent chance, which we had better take, to make good our claim.

Despite earlier statements that fine facilities don't necessarily make fine library media programs for special learners or any other learners, we *do* have an interest in the kind of

facility that houses the library media program. Morale and the impetus to deliver a top notch program *can* be increased significantly by the right environment. The cathedrals of our era may well be our school buildings, inspired by a desire remarkably similar to that which sparked the cathedral building of the middle ages: a desire to make a statement about what we value most—in our case, education. Monuments to local pride do not always follow function, and we admit to prejudice against overdone facilities, but in a book which deals at least in part with physically handicapped learners, facilities are a vital, functional part of learning. We do examine, therefore, renovation and construction to meet these special needs.

Through the years, a source of great strength and richness for many school library media programs has been contributions by volunteers, many of them parents. These contributions are so well known that, like many good things, we often take them for granted. Changed economic conditions, role changes, and more women working for pay, and competition from other agencies have combined to reduce significantly the number of volunteers working in school library media programs. Still, the volunteer remains a sustaining factor for many thousands of programs. We anticipate that the library media programs that will be developed to serve special learners will stimulate a resurgence of volunteer interest and participation. The special learning program carries a rich lode of the one element that most attracts, and holds, the volunteer: the opportunity to make a difference, to make a sustained contribution to a young person's learning. The work of the volunteer with the special learner is quite a different matter from shelving books, pasting pockets, or pursuing overdue books. Most special learning programs, either in the classroom or in the library media center, demand constant and intensive personal contact and individual reinforcement between teacher and student. It is a one-on-one opportunity, and an unparalleled chance to see the results of one's caring, sharing and effort. This should attract volunteers back into the school library media center, and selling this opportunity should not be overlooked. Older citizens have much to give

here; their years of living and working represent extraordi-
nary wealth, as does their inclination toward calm accep-
tance, and every effort should be made to recruit them to this
purpose. Special education programs are people-intensive
programs, and those involved don't all have to be profession-
als. Quite the contrary; a mix is very desirable, and we have
reported some volunteer involvement programs in this book.

PL 94-142 legally guarantees the parent an influential voice
in the kind of education a child will receive. Parent involve-
ment, especially in elementary schools, has traditionally been
extensive and intense. During the past decade this involve-
ment has often been of an adversary nature, with confronta-
tion rather than cooperation the energizer. In fact, the early
stages of development of most special education programs
were the results of parent-instituted court action, the ultimate
in confrontation. The greatest stimuli to the special learning
programs were, in addition to the court actions, the legislative
actions induced by pressure groups. The use of the class
action suit and the due process and equal protection clauses of
the Constitution eventually brought the special learning pro-
grams into being through the legislative route. Like the *Brown
v. Board of Education* decision outlawing discrimination on
racial grounds, later reinforced positively by the civil rights
legislation, PL 94-142 demonstrates the power and respon-
sibility of Constitutional government to protect the rights of
minorities. Majorities, after all, take care of themselves by
securing power through the democratic process. It is impor-
tant for educators to fully understand that we have special
education programs in the schools because they secure the
civil rights of a large minority group. They were hard won,
and they are, and will remain, a highly political matter.

In effect special education mandates open all public educa-
tion programs to the intense scrutiny of the judicial systems
which may be called upon by parents to protect their rights or
the rights of their child. Doubtless, special education pro-
grams will continue to incite confrontations between parents
and guardians of special learners and the schools which are
required to provide a "free and appropriate education to
anyone between the ages of three and twenty-one." Deciding

what is appropriate and what is truly free is a matter that transcends mere educational policy. In many school systems, in fact, the lawyer has become the most important member of the Board of Education. The effects of all this on educational administrative decision-making are not a particular concern of this book, but they affect all special learner programs, including most definitely, the library media component of them.

We believe, though, that when the era of showdown and show me have run their course, as they surely will, a new spirit of parent and family concern for constructive involvement will manifest itself within communities and their schools. And we expect that this will lead to greater appreciation and concern for the school library media program, especially for those which have proved themselves adept at developing excellent services for special learners, programs that help the community and the schools to fulfill their legal obligations.

Social engineering within the schools and other institutions has not proved to be the unalloyed virtue it was believed to be twenty years ago. Faith in the absolute value of science and technology in reordering our lives has vanished, for along with the computers, the transistors, and the satellites have come the carcinogens and the breakdown of a well-established order, not yet replaced by the kinds of values most of us want to live with. "Civilization," said Ghandi, "is not the infinite multiplication of human events, but their limitation to essentials to be shared by all." Establishing as a priority the education of special learners was long overdue, and it may be the last and most significant attempt at social/civil engineering we are likely to see in the schools for the remainder of this century. Special education "demands" raised against the ebbing tide of reform programs may be somewhat out of step in times like these, and it may not be possible to meet all of the most strident ones. The public, occupied in this decade with saving itself and its job and its home, may not be as tolerant as it might once have been of even the most just demands. President Gerald Ford, when he signed PL 94-142 into law observed that "it promises more than the federal government

can deliver and its good intentions could be thwarted by the
many unwise provisions it contains."

The danger of a strongly adverse public and taxpayer
reaction against the costs and demands of special education is
real and present, but the best way, we believe, to deal with
this is to face up to the fact that a certain amount of backlash
exists. It is well to remember that a number of library media
programs, too, have been pulled under by the weight of their
unfulfilled promises and visions too vague or abstract to gain
public support. We need every ability we have to plan realis-
tic programs, to deliver them as effectively and as econom-
ically as possible, and to evaluate them and revise them when
necessary. This calls for flexibility and a sense of accom-
modation. It calls too for political acumen and good human
relations. Nothing less will do, because nothing less will let
special education programs work and succeed as we know
they should—not because of demands, not because they are
"hot"—but because they are right, and because nothing could
more forcefully demonstrate the value of library media pro-
grams for all children.

Chapter I
Legal and Historical Bases for Today's Special Education

There are many books in which to read the tragic story of how the Western world has dealt historically with physically or mentally limited persons. More terrifying and more shameful, even, are the films and reports that come to us from time to time, spilling out of institutions in which abuses are still practiced upon those immured in them. At best, even with humane treatment, there are still human castaways of whom the view has been the traditional one, that their conditions are fixed for life, with no hope of change or improvement. There is, even yet, a hangover of fear and superstition where the disabled or mentally deficient are concerned.

Our attitudes are the result of centuries of conditioning, of the heritage of many diverse cultures all of whom regarded the different and disabled as objects of loathing to be destroyed at birth, hidden away or mocked and tormented. The law of the survival of the fittest governed not only primitive tribes, but the civilized cultures of the ancient world. In Sparta, the law of Lycurgus demanded that afflicted new borns be simply left out in the elements to die or be devoured. Infanticide was widespread and condoned in the Greco-Roman world, and upper-class Romans initiated the practice of keeping "fools," a practice developed and maintained

throughout the medieval world. The supposed relationship of
deformity to mayhem and murder was underlined in story
and song: Rigoletto, the hunchback in Verdi's glorious opera
sang like a dream, but he killed and bagged his daughter in a
rage; Richard II, cruelly deformed in back and legs, was said
to have murdered the little princes in the Tower, and Shake-
speare carefully associated for us Richard's physically dis-
abled body with a twisted mind. Even the ameliorating
influence of the Christian tradition of caring for those who
were different and loving our neighbor whatever his condi-
tion of mind or body fixed firmly in our minds that miracles
were required to heal the halt, the blind, or the insane.

Such cultural conditioning in regard to our view of the
limited or deficient people in our world is hard to overcome,
but we believe that medical science and legal measures have
between them turned over a new leaf where hope awaits them,
and new insight and vision informs the rest of us. Some
selected milestones along the road to understanding and posi-
tive treatment of limited persons may be in order.

Most people who have examined the history and develop-
ment of special education ascribe to a French doctor of the
eighteenth century, Jean-Marc Gaspard Itard, a monumental
contribution to all the work with mental retardation that
would follow. Itard established clearly and for the first time
that whether or not an individual is retarded depends to a
great degree of what is demanded of him. A careful researcher
and observer, Dr. Itard worked for some years with a so-
called "wolf-boy", found wandering, completely wild and in a
state of nature, in the Auvergne, in France. He recorded all of
the events, his methods and the results, in a book, *The Wild
Boy of Auvergne.* The "boy" lived between the years of 1774
and 1838, and as a consequence of his training, the expecta-
tions about what could be accomplished with the mentally
retarded were altered forever. Itard showed that the values
and the expectations that the teacher brings to his work with
the learner make a tremendous difference. He proved indis-
putably that the most essential thing that the teacher of the
mentally retarded can do is to *adapt* teaching techniques and
materials so that they stimulate the learner's latent potential

for learning. We have taken the liberty of transposing Itard's observations about his teaching techniques and methodologies into twentieth-century idiom, but the analysis and the reporting are there, a breakthrough, an illumination of a subject until then unexplored.

As any good teacher does, Itard established clear learning goals for his young human who could make no human sounds, and knew no human behaviors. In doing this, he made the assumption that as a teacher he could make a direct and beneficial impact upon the boy's learning. He took pains to express his interest in the boy as a person in the belief that pleasant social experiences would reinforce good conduct. He sought intellectual and social growth by introducing new needs and expectations that would extend the boy's range of ideas and ability to think. He developed the boy's use of speech by requiring him to imitate, and by forcing him to talk in order to get what he wanted: imitation reinforced by reward. He induced the boy to focus simple mental operations upon objects of physical need over a period of time, and then apply these learned mental processes to achievement of other objects desired. Finally, he sought to improve the boy's social relationships by systematically presenting relationships with other persons.

Itard was among the first to demonstrate that the teacher of the retarded must help the learner to take an interest in the socialization process, by involving him in an environment beyond that of his own need; to help the learner practice applying the process of reasoning to complex matters; to take an active interest in where the learner is going, plot the course to be followed, reinforcing what has already been learned by practice, while transferring what has been learned to new learning challenges. All of this remains, to this day, at the core of what good teaching is for anyone working with retarded learners.

Edward Seguin, who carried on Itard's work after his death, documented further that every retarded child could benefit from what Seguin defined as a three-pronged treatment program: medical, psychological, and educational. Slowly, there began to flow from his work and that of his predecessor

acceptance of the fact that the retarded learner may be different from the normal learner, but he is a learner all the same, and as such can be reached and taught through the use of adapted materials, techniques, and methods. This was an enormously significant legacy for all educators that followed.

The nineteenth and early twentieth centuries saw a dramatic change in the attitudes and practices concerning the needs of the retarded learner. Historically, this was the era of the institution where help for the special learner was provided discreetly and out of sight, out of mind, of the rest of the world. However, in these settings, at their best, great strides were made in medical and teaching techniques. In 1817, the Connecticut State Legislature appropriated $25,000 for the founding of an asylum for the deaf under the direction of the Reverend Thomas Gallaudet, in Hartford. The famous college for the deaf in Washington, D.C., was later named in his honor. Public Law 186, passed in 1879, provided $10,000 for the American Printing House for the Blind to produce brailled materials and signalled early federal recognition of this handicap—as did also establishment of the Library for the Blind in the Library of Congress.

In 1905, Binet and Simon devised their intelligence quotient (IQ) test to measure the mental age of a child in relation to his actual or chronological age. Their work increased understanding that mental retardation, while it represents less than normal intelligence and a reduced capacity for learning, does not necessarily prevent any learning at all, and that given the right expectations and methods a great deal of learning is possible. However, the dominant view of the era was that this learning (or training as it was called then) was best accomplished in an institutional setting, under the careful control of a proper medical staff, and as far removed from the public eye as possible.

When, in an address before the National Education Association (NEA) in 1898, Alexander Graham Bell suggested that annexes be built adjacent to public schools for the purpose of educating the deaf, blind, and the mentally deficient, a new era began. Bell had a more than casual interest in this, for he himself was hearing impaired. Through his example as an

inventor in making a highly valued contribution to a society already worshipful of technology, Bell did much to destroy the misconception that physical disability limits its bearer to an unproductive life. Four years later, still pressing his views with messianic fervor, Alexander Graham Bell urged that "special education" (he was one of the first to use the term) be provided within the schools so that the mentally and physically limited might benefit from the important socializing affects of placing the special learner in close proximity to the "normal" learner. NEA's response this time was the formation of a Department of Special Education.

Once launched, Bell's ideas about special education gained rapid acceptance. There was, during the first seventy years of this century, an early attempt at what would later be called "mainstreaming," programs which anticipated that the special learner, despite his limitations, could in most cases be returned to a nearly normal environment. These first efforts, however, generally ended in failure, and as failures often do, they left a legacy difficult to overcome when the time to redeem promises once and for all finally came due.

Theories about educating the special learner focused ever more intently, in the early years of this century, upon such concerns as: utilizing the "natural" activity of the child, the use of social activities to improve and enrich language ability, an attempt to correlate different kinds of learning activities as a means of reinforcing learning, individualizing instruction by adapting it to individual needs and capabilities, attempting to make learning lead to utilization so that it affects real life, trying to relate experiences preceding instruction to formal learning, and training the attention span and thinking capacity of the special learner. Classroom practice, however, tended to reflect instead a belief that what most special learners needed was learning presented in smaller and easier doses, to be repeated endlessly until the learning "took." The idea of "holding back" children until they did "the appropriate work" found its roots in this practice.

In 1954, extensive government support for research into the causes and treatment of mental retardation was the result of the passage of PL 83-538. The Handicapped Children's Early

Assistance Act of 1968 funded model centers so that excellent practices in the education of handicapped learners could be observed and emulated. These selected examples illustrate the court decisions and legislative actions which came to a head in the activist atmosphere of the sixties and seventies. Built upon earlier laws, these were the culmination also of long decades of effort by millions of families who live daily with the needs of the handicapped, and the coordinated lobbying of private foundations and agencies.

Paul Mort, one of the more provocative conceptualizers about education observes that, "It takes 15 years for three percent of the schools to absorb a new idea." This is hardly encouraging news when one considers the many new ideas and innovative methods that must be rapidly adopted if special education is to play the major role now assigned to it. But we have hopes that the process—at least for conceiving and transmitting, if not totally absorbing, new methods for teaching the special learner—may be somewhat accelerated. Several unique, yet mutually reinforcing, factors have been at work to stimulate the pace of the process.

By the 1960s, we had discovered a great deal more about the medical causes of retardation and physical deformity than we had ever known previously. By this time, too, there began to be a much wider acceptance of the theory that even for the educable mentally retarded learner there was far greater ability to learn than had been thought possible. Better diagnosis and early intervention with treatment became increasingly important, and there was growing belief that if diagnosed early enough and treated properly many deficiencies could be prevented, or at least minimized. Particularly with an understanding that *learning disabilities* were indeed different from mental retardation came important changes in attitudes and practices about teaching special learners. We are now increasingly aware that aside from the obvious handicaps caused by physical or mental deficiences or limitations, the instances of emotional disturbances have burgeoned rapidly. Each year more children in the seven- to eleven-age range seek psychiatric or psychological help. The Foundation for Child Development in a 1977 publication en-

titled, *A National Survey of Children,* noted that from 1970-1976 there was a 60 percent increase in such referrals. The statement was made in this publication that in 1976, 1.2 million children had experienced an emotional, behavioral, mental, or learning problem serious enough that a parent felt, or was told, that a child needed help. Every statistic available substantiates that this figure has accelerated precipitously during the years since that time.

Such statistics can serve merely to overwhelm one with a sense of futility. With that much wrong with that many, where do you start? One must recall that the condition of children is reflected in their attitudes, their behaviors, and their accomplishments, and that these are the result of complex combinations of inheritance and environment. Our concern for identifying the special learner must include a close look at the society in all its aspects if the dimensions of the special learner population are to be identified, and steps eventually taken to prevent those disabilities that could be prevented.

There has been a growing realization that many factors, hitherto unrecognized as such, could increase the chance of the birth of a brain-damaged child—factors such as poor nutrition, smoking, and drug taking by the mother during pregnancy, even environmental pollution. Among emotional disturbance factors, the single-parent home, a growing phenomenon, is seen to have a bearing upon learning disabilities and associated behavior problems. Anorexia (prolonged loss of appetite), dyslexia (a reading disability), and hyperkinesis (an uninhibited behavior pattern) have been observed and recognized as causing learning problems either as the result of brain damage, or the result of psychological problems.

By the 1960s there was a general consensus as to the way in which our society should shoulder its responsibility for educating special learners. Agreement developed that diagnosis should not result in mere labeling but should be used to prescribe appropriate treatment. Also recognized by this time, was the fact that some disorders should be more properly considered symptoms, which vary as to time and intensity, and indicate other problems. Such specific and

previously thought-to-be-irreversible variants of retardation as mongoloidism, formerly thought to prevent learning, could now be treated with an extraordinary degree of success. The social convulsions of the 1960s forced recognition that minority racial groups and members of lower socioeconomic cultural groups presented some medical and educational problems related to cultural bias and stress, in addition to physical disadvantagements of various kinds. In any event, by the end of the decade the view had emerged that something, either medical, nutritional, or educational could and should be done for every mentally or physically limited child. This hop, skip, and jump through the medical, social, and educational forces that converged by the early seventies has certainly missed some of the important events and persons in the process, but it does provide some perspective. It also accounts for, perhaps, the state of readiness of the richest country in the world to face up to the enormous task of providing properly for the increasingly well identified members of a very special minority, ready to claim the right to join society and make the best contribution of which they are capable.

And that brings us now to the legal base for today's special education programs and some background on how they developed.

No less a founding father than Jefferson expressed the belief that, "It is the noblest purpose of democratic government to secure and protect the rights of its *minority* members." Indeed massive intervention on the side of minorities to help them to secure their Constitutional rights is an expression of faith in the democratic process, based on the belief that majorities take perfectly good care of themselves because they control the political institutions which secure their right to "life, liberty, and the pursuit of happiness." It is important to us as educators to understand the convergence of political forces which shaped the revolutionary changes in our provisions for the physically and mentally handicapped.

By the 1960s government intervention to secure minority rights was almost always done in terms of two sections of the Constitution of the United States. The first is that portion of the Fifth Amendment which reads that, "No person shall ... be

deprived of life, liberty or property without due process of law." The second provision is found in the Fourteenth Amendment which says, "Nor shall any state deprive any person of life, liberty or property without due process of law." Important too, is the well-established Constitutional doctrine that all citizens do have the right of its equal protection. It is not possible to extract from the vast array or events and decisions more than an overview of how these two Constitutional principles were used to gain the right of appropriate education for special learners.

Controversy was guaranteed from the start, for decisions about what constitutes due process rests finally upon a definition of "reasonableness"—something being fair and appropriate. But, as the Concise Dictionary of American History points out, reasonableness, like due process itself, has no legal definition save in precedent. The practice of a judge or judges applying the term specifically rests upon a conception of what "ought to be"—more often than not, a subjective matter.

The result of such imprecision is a great multitude of possible interpretations, and inevitably in a system based upon law, masses of litigation and appeals. That due process interpretation is subject to changing economic, political, or social conditions is well understood; court rulings concerning the legality of racial segregation provide a good example of this fact. What was Constitutional under an earlier due process ruling is liable for review and a reverse decision in other times when different values mandate new Constitutional interpretations.

Such were the matters manifested in the struggle to gain rights for the mentally or physically limited citizen. Action and decisions in interpreting due process and equal protection were going on at the national and the state level at the same time. As early as 1874 the California State Supreme Court ruled that, "Education is a right, a legal right as distinct as the vested right of property." It would take a hundred years and a forceful combination of state and national judicial, legislative, and executive actions to make it stick, but the California ruling was an exact foretelling of what was to be.

Three court cases are perhaps the most representative examples of how the court system provided new judicial interpretations to obtain the rights of the handicapped. That handicapped children, like all other children, had an *absolute* right to be educated was specified in the ruling in 1971, in the case of the *Pennsylvania Association for Retarded Children* v. *The Commonwealth of Pennsylvania.* The Federal District Court ruled that Pennsylvania statutes which promised that the individual had a right to a public education, but with exceptions to be decided by the local school district, were unconstitutional. The handicapped individual's right to an education had been pretty much determined by the ability to persuade a local school district to take responsibility for it. This was perfectly acceptable to the Commonwealth of Pennsylvania; it was not at all acceptable to the court. Supplication, ruled the court, "is not only demeaning but unconstitutional." For under the due process clause, the individual's *right* to an education, "cannot be abridged by the intervention of public school administrators who assume the right to provide or withhold their services."

This court, in the Pennsylvania case, extended its comments further by ruling that, "everyone is entitled to an education; there is no such thing as ineducability." Of course, such sweeping rulings which clearly espouse a particular educational philosophy often have the effect of infuriating whose against whom the decision has gone. The legal history is full of such controversial decisions which do not, as the legislative process does, seek solutions in compromise or accommodation. As a flash of summer lightning sharpens our vision to what we can see in contrast to its brilliant light, so does the boldly assertive ruling taken in *PARC* v. *Commonwealth of Pennsylvania* make startling clear a newly expressed conviction that ineducability, if it occurs, is the fault of the system which fails in its responsibility to educate, rather than lack of ability of the individual to benefit from appropriate education.

In Washington, D. C., shortly thereafter, the case of *Mills* v. *The District of Columbia* was brought. This class action suit was brought by children with a variety of handicaps, includ-

ing mental retardation, hearing and sight loss, and other multiple handicaps, to have their education provided in a public school setting and at public expense. It is worth quoting some of the judge's ruling.

No child eligible for publicly supported education in the District of Columbia shall be excluded from a regular public school assignment by a rule, policy or practice of the Board of Education of the District of Columbia or its agents unless such a child is provided:
(a) adequate alternative educational services suitable to the child's needs, which may include special education or tuition grants; and,
(b) a constitutionally adequate prior hearing and periodic review of the child's status, progress, and the adequacy of any educational alternative.

Again, a court ruling foreshadowed what a Federal law would eventually require. Such court actions greatly influenced the thinking of those who would write PL 94-142.

Most school districts responded at first to such judicial fiats by simply ignoring them.

A California case, *Diana* v. *The State Board of Education*, foreclosed on the practice, common in most districts, of using norm based tests of achievement or ability, to label and place students in classes. The case concerned the rights of a non-English speaking student, and the court's decision was a complete disavowal of this practice. The case was settled under the "influence" of the court, so no final ruling exists, but the agreements reached in the settlement clearly had the court's blessing. Among these agreements were:

(1) that a child whose primary language is not English must be tested in his primary language as well as in English;

(2) that questions which rely entirely on a verbal fluency in an unfamiliar language are unfair and cannot be asked;

(3) that children enrolled in the public schools who had been tested only in English had to be retested.

School districts were required to submit their retesting plans to the state for its approval, and school psychologists

had to develop more applicable testing and measuring devices.

At the heart of the plaintiff's case was a deep concern about the large number of minority group students enrolled in special education classes in contrast to the proportion of those enrolled in regular classes. Were special education classes being used as a dumping ground for unwanted and troublesome minority group students? The court never ruled on this question, but its view of the case seems clear in light of the agreements sponsored between plaintiff and defendant. This same question, however, remains vexatious today for the many school districts with large minority populations.

Anger there has been, and outrage, at the decisions to insure the appropriate education of handicapped learners at public expense as a right. Acceptance has been far from universal, but the outright viciousness and deadliness that accompanied the white/black civil rights decisions has never surfaced. After all, the needs of the handicapped are a powerfully heartstring-oriented issue, but beneath their assurances of caring for the handicapped many have masked cold-heartedness, prejudice, and hatred.

There are plentiful excuses: "I'm all for it, but we just can't afford to do it," or, "I support it, but our first responsibility has got to be to our normal learners." *Mills* v. *The District of Columbia* threw out these hiding places for the unwilling in a brisk sentence: "Defendents shall not exclude any child resident in the District of Columbia from such publicly supported education on the basis of a *claim of insufficient resources.*" Not enough money to share among the special learners who have an equal right to education with every other child? Case dismissed.

It is not expected and it never was that everyone will accept these decisions 100 percent down the line. In fact, it is perfectly appropriate and hardly bigoted to have some misgivings and reservations about the consequences of such sweeping intervention into education by the courts. It seems likely that the judges that handed down these rulings had never actually taught a handicapped (or any other for that matter) learner; had never grappled with the problems faced

by every board of education about where to get the money to finance a costly undertaking of which the ultimate cost shows no outer bounds; had never tried to measure the progress of a severely mentally retarded learner toward an expected but unmet goal; and had never tried to read a story in a library media center to six emotionally disturbed children. No matter. We can maintain a healthy skepticism about the long range merits of such intervention, but decisions have been made and it is our job to uphold them. And of course we do accept the intent and respect the right that is thus upheld.

There is no question but that the annoyance or anger of many is based in the recognition that the Special Education Movement is moved by a political lobby whose timing was brilliant and who capitalized on every factor they could command to press for their single issue. Because it is a reform movement in an area which badly needed reform, the lobby could cloak itself in righteousness while employing tactics no different from those of any other lobby to gain its ends. This lobby has been prone to all the weaknesses of most single issue coalitions: narrow mindedness; reluctance to compromise; a sometimes vindictive hostility to those who will not go along with it all the way; and an aggressive confrontation stance, among other common and unattractive elements of all such movements.

We are certainly not propogandists for the lobby, nonetheless, we recognize that the judicial intervention was probably made inevitable by the fact that state and national legislative and executive branches, which have the prime responsibility to regulate and balance the social system, showed themselves unequal to the task. Had they exerted effective leadership of the kind which offers accommodation, consensus and planned change, then the vacuum created by their inaction would not have been waiting to be filled by judicial fiat.

Our brief analysis of judicial actions which have in such large part brought us face to face with the challenge of today's special education program has, then, resulted in the following:

(1) There is a Constitutionally guaranteed right to an edu-

cation for all children, and this right cannot be abridged by reason of any mental or physical handicap;

(2) the education guaranteed by this right must be appropriate to the learner's individual needs, and must be provided at the public's expense;

(3) the right to an education at the public's expense cannot be abridged due to a lack of funds;

(4) the contention that certain handicapped children are ineducable is not permissable;

(5) the least restrictive or most normal atmosphere is to be preferred in providing an education for the handicapped child;

(6) the overriding consideration in every decision about what is an appropriate education for a handicapped learner is the absolute Constitutional requirement that its due process clause be followed so that equal protection under the law is guaranteed.

It is important to remember that however much the courts and other agencies may have been involved in mandating special education programs, the primary responsibility for implementation remains with the local school district and its schools. The content and substance of the learning that is to be provided, the competence of the teaching, and quality of the materials used, is up to them. The extraordinary thing is that thousands of diverse local communities, using different approaches, come up with remarkably similar programs and results.

It is still the local school district which must deal at first hand with the facts of life that go with compliance, chief among them the dissatisfactions of parents who see programs they want their children to have go down the drain in the scramble for funds, and short fall funding itself. Belief in the Constitution's due process clause is sorely tried in the effort to save an educational program (as often as not the library media program) that is being damaged and deprived to make money available for special education.

At the district level the issue reduces itself quickly to what is possible within the educational budget. Is it possible to

maintain the art program, the music program, even the library
media program or the general learning program intact in light
of the escalating costs that special education programs inev-
itably carry with them? Speaking to this point in terms of the
library media program—something we as supervisors have
had to do often recently—if library media programs are to be
able to play a vital and effective role in educating the special
learner, it makes no sense to cut the very funds with which
they are expected to do this. We shall have to be articulate,
concrete, even aggressive in putting this idea across so that
funds are maintained for what we are already doing for the
general instructional program. Funds will probably need to be
either redirected or added to the budget from some other
source to take care of a big new special education respon-
sibility. As always, it is important to have all of the correct
facts at hand, and to be sure to negotiate with the right person.
We must expect, too, that no matter how well we argue the
worth of our programs or how well we demonstrate their
value, we shall have to compromise with our expectation of
providing the best possible library media program and be
content with "as good as possible" with fewer resources than
we need. Even when money has been fairly abundant, the
harsh fact is that in all but the most excellent and enlightened
school districts, school library media programs have often
been found on the administrator's list of second level pri-
orities. The more aware and astute the individual library
media specialist is about matters of budget, mandated pro-
grams, local politics, sources of funding, and innovative pro-
grams, the better things will turn out for the program.

It might be well for us to realize that special education's
advent presages an era of much more limited and restrained
and much less unilateral and authoritarian decision-making
by school administrators. The mandates which espouse the
special learner's right to a free and appropriate education
carry strongly the implication that we are to be wary of the
"expert" whose know-it-all expertise can decide the only
"right" course of action. What the court rulings and the legis-
lative and administrative regulations all uphold as proper is
the school administration which says to parents and children:

"Let me help you to determine what is best, but the final decision is yours." Gone, banished, is "I know what is best for you and you will do it!" The kind of participatory decision making and shared authority, even with professional staff, that is called for is an unsettling notion to many administrators, but to be asked to involve parents and children in such activities adds a dimension of threat and stress that is almost unbearable.

What we are saying, is that not only will school administrators need all the help they can get in learning to play their new roles under the new rules, and that library media specialists, by reason of the way they already operate can be of great help to them in doing this, but something else: decisions regarding any attempt to dismantle the library media program by too sharply, and unfairly, reducing its funds, can be greatly modified or reversed by parent and community concern. Such attempts, arbitrary decisions which would indeed harm the entire instructional program as well as the special learner program, should be brought to public attention properly, with due regard for the amenities, tact, not getting the boss caught in the middle, and providing escape hatches for backing down gracefully. Library media specialists are going to have to learn these political/bureaucratic ploys if they truly care about the welfare of their programs and as an end result, the good of their learners. In the present and forthcoming climate, it will pay the school library media program manager increasingly to be certain that parents, and the community at large, know what the instructional responsibilities of the library media program are, and what order of support it requires to enable it to do its job with special learners and with other students as well.

As to the attributes of the school library media specialist which can be of such value under the present circumstances: most good library media programs are based upon a form of consensus-based decision-making which comes into play in finding out what is best for the learner and how to go about achieving it. Consequently, arbitrariness is one of the least of the components of the library media program atmosphere. The library media specialist is accustomed to a process of

instruction by probing, searching, motivating, defining, explaining, finding, and discussion; as a consequence, the library media specialist in many buildings has become the best qualified person in the building to understand why working with special learners, teams of teachers, special teachers and parents, requires a tailored process and methodology for each learner. Creative leadership, positive action with the special learner program, is a ready made role.

And so we turn now to the legislative aspect of the impetus for today's and tomorrow's special education programs.

We have implied, and it is appropriate to state directly that Public Law 94-142 (the Education for All Handicapped Children Act) is indeed a civil rights act. Its roots as we have seen lie in direct political action, citizen advocacy and court ruling, and controversy, and this has already affected the course of its development and application.

It is almost impossible to arrive at the exact number of persons who are to be included under the mandates of PL 94-142 as it takes full effect in 1980. Some maintain that as many as 12 percent of the population, or 10 million people between the ages of three and twenty-one could be affected by the law. Others place the figure at 8 million. While a range of one or two millions may be read casually, it provides an unacceptable margin of error in establishing just what programs will be needed for which learners. What this means is that we don't know the numbers we are talking about, and so make guesses based on sample groups. We need better statistical information.

One of the reasons for this lack of information is that identification of specific learning disabilities and of many of the mental and physical disabilities people have is very shaky. There is new knowledge developed daily, and diseases not even known ten years ago are now recognized and diagnosed as having some effect or another upon ability to learn. Doubtless, this instability will continue as more sophisticated techniques of diagnosis come into use by the medical profession. One can assume that the numbers described as learning disabled will continue to expand as more persons, other than doctors—family members, teachers, for example—

become familiar with symptoms of disability. But, as in any single issue reform movement, the special education movement has its zealots, its groupies who are ready to overplay the cause and see in almost any child a special learner. Over-enthusiastic followers have been known to backfire on valid and well intentioned initiatives in education. This has happened before as with the "Back to Basics" movement. "Tricky" becomes dangerous when leaders are overwhelmed by their disciples.

So, although predicting is risky, it seems likely that the special learner population will expand and pressures thereby will accelerate. Government and education are both intensely susceptible to single-issue pressure groups, and so their pressure—with more parents and more children involved—will doubtless be maintained and probably increased.

The intent of the framers of PL 94-142 is made very clear in its statement of purpose, "to assure that all handicapped children have available to them a free and appropriate education which emphasizes special education and related services designed to meet their unique needs." Every element of the act: the mainstreaming, the Individualized Education Program (IEP), the planning and placement teams, the counseling and support services—all these and more—are designed to put this sentence into effect. While one may wonder whether the law's proponents considered every alternative strategy for its implementation (doubtful), the law states its purpose unequivocally.

The effect of PL 94-142 has been to bring handicapped persons out into the open, encouraged by the law's stated belief that nearly every child can become productive and self-sufficient. The law's components almost guarantee challenge and upset to the fixed order. They include:

(1) The strong due process clause, which protects the rights of both the child and the parent, spells out parent rights carefully. Such matters are specified in detail as identification of a learning disability; the evaluation of the child by professionals; the placement of the child in a program appropriate for him. An appeals process is established which al-

lows the parent to pursue these things at higher levels if they feel wrong or inappropriate decisions have been made by local school officials. Legal redress is assured at every step of the way.

(2) The requirement that school systems provide for the education of special learners in the least restricted and most normal environment means that segregated special education classes are to be used only as a last resort. It is expected that most special learners will be placed into the mainstream educational program, integrated as fully as possible into all aspects of its life in regular classrooms.

(3) An insurance plan which protects the mainstreaming requirement by stipulating that an Individualized Education Program (IEP) must be prepared for each learner who is diagnosed as needing one. This IEP must have in it a written statement of goals, short term and long term objectives, and specific educational services to be provided for each individual learner. With parents participating in the team which prepares this for each child, there will be also an expert in the particular problems at hand, an administrator, an appropriate psychological or sociological services representative, and anyone else who has a relationship to the situations being evaluated and prescribed for. It is possible even to include the special learner for whom the IEP is being prepared, if this seems desirable. The IEP has been described as part prescription, part blueprint, part teaching plan, but it combines these elements to become a full-time commitment to providing whatever educational services are necessary to achieve its goals for the special learner. The formality of the procedures and the fact that a written document results give the IEP the air, if not really the authority, of a contract. The IEP outlines the extent to which the special learner will be able to participate in regular education programs, and the starting date of the program. It must be reviewed at least annually, or periodically as necessary, and revised according to the progress of the learner or in terms of any other altered circumstances. Objective criteria for the evaluation of each learner must be established and adhered to.

PL 94-142 requires that all testing and evaluating of stu-

dents must be both racially and culturally nondiscriminatory. Evaluative testing is to be done in the dominant language of the learner as well as English, and no one test can serve as the single determinant of placement. Again, equal protection and due process concerns are evident.

The fact that the Local Education Agency (LEA) is responsible for providing a free and appropriate education for any child residing in its jurisdiction means that in the case of severe mental retardation, physical disorder, or profound emotional problem, if the LEA decides that it cannot provide the proper education in a public school, it must pay the bill for the child placed in an out-of-district school or program. Tuition in these custodial schools is astronomical, sums of $20,000 a year being not unusual. This financial Sword of Damocles provides a strong impetus for local districts to furnish as many special learner programs and services as they can at home. It will probably, however, never be possible to do it all locally, and this very open-ended and potentially costly section of the act places heavy financial pressures on the school system. But, recalling the decision in *Mills* v. *The District of Columbia,* lack of money is no excuse, and if a child in need of special facilities is there, the money must be found.

The law specifies that over the three-year period 1977-1980, first priority was to go toward providing an education for those handicapped children not already receiving an education. A second level of priority was assigned to provisions for those severely handicapped children whose educations were judged to be inadequate. By 1980, when the law became fully in force, all children between the ages of three and twenty-one had to be encompassed. The encouragement here of the development of programs for preschool learners is a priority which dovetails nicely with the growing sense of need to establish these programs for all children, and it will affect the early identification of special learning problems significantly.

It is significant that the states are given a rather larger voice than they are accustomed to in controlling the operation of PL 94-142 within their jurisdictions. This factor has given a good deal of uneasiness to many about how far the state will go in

interposing itself into the affairs of the local school district. As far as necessary to insure compliance, is the likely answer to this one. For example, the law requires that each state have an advisory board for the special education program which includes handicapped persons, teachers, and parents. These boards are to "advise the state" about unmet needs; overlooked thus far is the fact that they have the power to comment publicly on proposed new rules and regulations, or changes in them, and that they are empowered also to *assist* in evaluation of local programs. Certainly this forecasts a far more active role for the states, and more authority in oversight of the special learner's education. To a degree, PL 94-142 merely accelerates an already significant shift of power over education decision-making from the local to the state and federal levels. It is still too soon to know exactly how the fifty state councils will perceive their advisory duties, or how actively they will pursue them, but the potential for activist intervention is there, and we can assume, given the times and its tempers, will be used in some cases.

Beginning in 1978 when the Law began to be phased in, the federal government paid 5 percent of the average cost of educating the handicapped child under the authority of PL 94-142. By 1980, when the law took full effect, this share had increased to 40 percent. A formula allows each state to retain 25 percent of this money to pay for the cost of state services related to administration of the act, and the remaining 75 percent is simply passed on to the local education agency. The funds may be withheld by either the state or federal government for noncompliance with the law.

These then are the key features of PL 94-142. When its provisions were placed in tandem with those of Section 504 of the Rehabilitation Act of 1973, a structure of protection of the educational rights of a significant minority was firmly in place.

The Rehabilitation Act of 1973 is a civil rights act which requires compliance with or conformance to federal law. A one-sentence quotation from this law makes its intent clear; it "prohibits discrimination against handicapped persons by any agencies assisted by federal funds." It states also that

everyone should be allowed "to work and to learn and com-
pete on a fair and equal basis." Its mandates foreshadowed
those of PL 94-142, and called for a "free and appropriate
education for all children regardless of the nature or severity
of their handicap." The Rehabilitation Act encouraged posi-
tive efforts to create job opportunities so that a disability
would be "no longer a barrier to employment." Under this act
college and post-secondary education were to be adapted to
the needs of handicapped persons, and equal treatment was to
be accorded to them by all social service agencies.

Undoubtedly, the act's best known section is its most visi-
bly apparent requirement that barrier-free access be provided
to the physically handicapped through alterations such as
ramps for wheelchairs, handrails and wide entry doors in
public toilets, and lowered curbs. These alterations caused an
initial flurry of anxiety but most of it has faded away as the
bills were paid and the changes became part of the normal
landscape.

Altogether, the two bills provide not only a mandate, but a
mutually reinforcing and complementary vision of life and
improved opportunity for the handicapped.

For the parents of a handicapped child, PL 94-142 is indeed a
very special Bill of Rights. Through it the way is made clear to
an education for their child, and with it more hope of security
and happiness for the child's future. Their responsibility is to
know what the law says, and to work tirelessly with other
parents, professionals, and advocacy groups to see to it that
the law is applied fairly and properly to their situation.
Education for the handicapped is no longer a privilege to be
pleaded or bargained for: it is a right guaranteed by law. But
since, as we have said, the roots of these laws lie within the
civil rights movement, their provisions will be extended to
their fullest only through active advocacy-oriented citizen
effort. This means parents must make views and expectations
known, assert rights, and sometimes push against a passively
resistant bureaucracy or a hostile public mood. One may hope
that this forceful advocacy can remain in most instances
persuasive and considered rather than strident. Advocates
can afford to be firm but gentle in applying pressure since the

force of law is on their side, but persistence will be necessary and redress is available if it is not initially successful.

And so we arrive at the front lines—the local education agency and the school buildings where the special learner programs are to be delivered. Getting the mandates of PL 94-142 translated into classroom strategies and activities must mean effective breaching of the same barriers as those to any of the previous educational reforms. The educational establishment is deeply conservative and prone to the conviction that many intrusions, if ignored with sufficient tenacity, will go away. Stonewalling is a well-practiced bureaucratic exercise. Being facile at moving things about to provide the appearance of progress, even when nothing at all is happening, is another.

In line with the "shunt-aside syndrome" one might predict that in many schools, professionals will quickly learn the approved way in which to fill out the special learner's IEP with little relevance to his unique needs; also how to reassign special learners to different and "appropriate" instructional environments so that their own tranquility is restored and order maintained. The "shunt-aside" syndrome will encourage many of us to sit through endless planning and placement meetings, to dialogue for an eternity with parents, psychologists, and sociologists about what is to be done, or even finally, doing it, with poor results. Little or no apparent change will be wrought in the lives of the handicapped children as a product of this prodigious amount of busy work. This sort of thing can happen in a school district where the habit of manipulating children is strong, and the real issue is not the welfare of the children, but who exercises what power over whom.

Most professionals hope, above all else, that the learners they teach will be successful in learning. They want to help them to find the right path, to each his own. Most teachers are neither gifted nor are they failures. As with the children as a whole, the teachers at each end of the spectrum are in the minority. Most of them fall within the broad "average/normal" range of talent and accomplishment. This means that on a day-to-day basis most teachers are reasonably conscien-

tious about doing their jobs well; can be motivated by example and with interest stimulated, to exchange less satisfying or satisfactory teaching methods for better ones; can gain the proper self-confidence to accept change and try new ways.

History records nothing to our knowledge that shows that passing a law makes something right if it is wrong—especially in the classroom. To be sure, PL 94-142 in its inclusiveness and the totality of that which it requires from the American educational system, is unique. And the fact that it sets up a system of permanent government funding to finance its mandates and requires a universal and uniform application across the fifty states gives it a better chance to alter education drastically than most laws have had in the past. Still, it is up to the classroom teacher, the library media specialist, the other school professionals, either to do it or not to do it—correctly, constructively, successfully. These are the real instigators of changes that must take place, and they must be convinced that they are involved, listened to, respected in regard to the program, before they will make a commitment both to its creation and the consequences. Otherwise the law, for all the advocates and the organizations, the lobbies and the judges, could turn out to be as unworkable as its bitterest critics hold it to be.

As we have said earlier, change cannot be forced at the level where it counts. Desirable changes can be subverted and the theories supporting them destroyed unless those who must do the plain hard work are willing to do it. They become willing only when convinced that the task is "right" and they feel a common identity with those with whom they will work. Encouragement and anticipation of a reward—usually in teaching a psychic one—are necessary too.

Professionals need assurances too about PL 94-142. They need to understand that the law does *not* mean that:

there is to be a wholesale "dumping" of handicapped or limited children into the school;

that when the special learner is assigned to a classroom, the teacher will be left alone to make all the decisions, prescribe, etc;

that the needs and expectations of the special learner must prevail at all times, even to the detriment of the other children in the room;

that the teacher of the special child must kow-tow to him, ignoring inappropriate behavior or not requiring the rudiments of learning and socialization;

that every professional is going to have to return to school for more education or training in how to deal with the special learner;

that the classroom teacher must become a master diagnoser, prescriber and evaluator for all special learners, and be held entirely accountable for what they learn or do not learn.

There must be other assurances, too, for the teacher, the administrator, and the library media specialist who must now try to deal with the mainstreamed special learner in a regular school setting. It is reasonable to believe that, to a great extent, the methods legally imposed relating to the individual prescription represent mainly a refocusing of educational practices already in use in most schools of adequate quality. If this is so, then PL 94-142 should prove to be of great help to teachers by reinforcing the use of techniques they already know to be correct and useful. The able teacher knows that to teach any child effectively it is necessary to compensate for and teach to individual learning style, aptitude, need, and expectation. Excellent teaching requires, as it always has, harmonious interaction between teacher and student, the stimulation which provokes the learner's desire to learn, and the teacher's commitment to spark that motivation. It is essentially a two-person drama. Many of the activities mandated by PL 94-142 may be used as a structure to help the teacher to improve planning to achieve greater teaching success with all children, not just the special learners. It is apparent already that PL 94-142 can have an enormous spin-off value to educators if they will carry over the experience gained from special learner programs to the teaching of others as well. There is nothing we can see in the details of the PL

94-142 structure that is not applicable to excellent teaching of every child in the regular classroom:

(1) the need for a detailed plan for teaching each child
(2) identification of special learning problems
(3) establishment of learning goals and objectives
(4) a timetable for introducing appropriate learning strategies
(5) parental involvement in both planning and learning
(6) a normal, open, conducive learning environment

It is all too true that the law carries with it the potential for burying good intentions under a paper pyramid of administrative regulations. Even worse, perhaps, it may be subjected to the strong urge of educational bureaucrats to separate themselves into their areas of expertise and try to carry out the program within a closed circle of special educators. In some special education programs this tendency is already apparent with special education teachers, psychologists, sociologists, and others claiming that they alone can attend to the needs of the special learner. This kind of performance contravenes directly the intent of the law, which is, of course, to release the special learners from the narrower world of these folk and let them benefit from exposure to teachers who are not specialists in limitation and abnormality, and therefore out of the slots and away from some of the labels previously assigned to them.

How to put the tenets of PL 94-142 into actual teaching practice is a matter of the highest concern to the school library media specialist. Unquestionably, as PL 94-142 is perceived as an irreversible fact of life in our schools, the influence of the special education consultants and teachers, the sociologists, psychologists, and other specialists will grow, but its innovations and changes are too far-reaching for them to try to handle by themselves. We have said earlier that reform and innovation in education comes about only if the classroom teacher is convinced, committed, and involved, and this is certainly true in special education. For innovation of this magnitude, however, it will be necessary to gain the support

and assistance of the entire staff. There is no room here for any sense of "that's their thing, let them do it," nor the resentments and hostilities that can be avoided.

We firmly believe that above all, the special learner mandates and the special education advocates must have the strong support and active and positive assistance of the library media specialist if they want to be successful. The opportunity for the library media specialist to work with other professionals, to help them accept that PL 94-142 is educationally sound and that it can be successfully and even happily implemented, may be the most significant one to come along for long years to come. The library media specialist's contribution of persuasion, experience with this kind of teaching, and example, may be the key to success for the program in many buildings.

The process of persuasion really comes under the heading of staff development, a natural activity for the special kind of teacher the library media specialist is, and one whose programs have put into practice the kind of teaching upon which PL 94-142's mandates are based. The library media program has *always* fostered individual learning over mass inculcation; attention to the process of discovering, assimilating, and using information at a pace determined by the learner and guided by the professional; evaluation of the individual in terms of his own expectations and motivations, not by test results based on "norms." The fact that the library media specialist has been doing these things will be reassuring to classroom teachers, who respond well to the positive influence of peers about what can or cannot be done. This is a psychological fact of life to be utilized with the utmost care by the library media specialist, for it can provide an entré to a closer professional *teaching* relationship with the classroom teacher which could not be more desirable if it had been made to order.

The excellent library media program has always based its modus operandi upon the importance of transforming by example, of influencing events by changing minds, of adding a sense of purpose where one was lacking, by a contagious willingness to try new ways. Mainstreaming, perhaps the

most crucial component of PL 94-142, is a comfortable concept
for library media specialists to work with. They may well
become the mainstream connection, the essential go-between
and transfer link for new ideas and practices among special
education teachers, classroom teachers, administrators, cit-
izen groups, and others connected with the program.

It is now well established that the very best library media
program is the one which has been mainstreamed into the
entire school's instructional environment. Just so, with PL
94-142, not only is the special learner mainstreamed into the
regular classroom, but the special learner program, its pro-
cedures and methods, must be eventually mainstreamed into
the overall instructional program. To the extent that this
happens, and that the principles and techniques become fully
incorporated, the special education mandates will have an
enormously beneficial effect on all learning for all students.
Library media specialists with their hard-earned understand-
ing of how to be a special teacher, and with a two-decade start
on how to revolutionize instruction without infringing on
classroom teacher turf, and how to lead without usurping the
prerogatives of others, or raising hostilities—have a unique
bridging role to play.

The alert library media specialist will have recognized at
once that mainstreaming is, after all, a kind of integration.
Labeling, classifying, predetermining potential accomplish-
ment on the basis of a child's belonging to a particular group is
unknown in any excellent library media program. It is now in
effect explicitly forbidden to do this in any aspect of the
instructional program.

Understanding *how* to teach the mainstreamed special
learner is of paramount concern to the teacher who must do it.
Only after this is understood does *what* to teach become
important. The library media specialist who holds fast to
identification as a teacher, and a teaching peer, can share the
realities of learning required for the special learner program
and so well known to the library media specialist as teacher:
the importance of learner engagement with learning; the im-
portance of a correct level of difficulty of the materials; the
importance of learning time being adequate to accomplish the

job and enjoy a feeling of success and creative assimilation; the stimulating affects of open inquiry and choice of ways to learn and materials to learn from; the importance of self-direction. Teaching the special learner means, as library media specialists understand it, not just providing information but suggestions and guidance to the learner and help in evaluating what he has accomplished and what more he wants to accomplish. Library media specialists can share their understanding that mainstreaming presents no pressure to learn what others are learning in the same classroom at the same pace, if everyone is learning according to his own prescription and at his own pace.

Traditionally, the library media program has looked beyond its own location for its resources, both human and material. Utilizing community resources in the special learner program, helping to educate nonspecial children to be mainstreamed happily with the special learners, welcoming aides and volunteers into the effort and helping other teachers to do the same—these aspects will be looked upon by excellent library media specialists as only small extensions of what they have been doing right along.

As with any new effort that calls for flexibility, new relationships, accommodation, the course of the acceptance of PL 94-142 into the educational mainstream will doubtless be fitful, erratic, and troublesome. Mainstreaming will not solve the problems of American education; it will not even solve all of the problems of special education. But it is important to remember that the concept of mainstreaming and some evidence of its usefulness existed before it was ever given its current name. Because PL 94-142 does carry with it, however, the potential for bringing great change for the better to classroom instruction, and improved library media program opportunity for instructional leadership and visibility, it deserves the utmost in support and cooperation from school library media specialists.

Chapter II
Teaching the Special Learner

This is a book about library media programs which are effective instructional programs for special learners, and so it is also a book about teaching. We are as much concerned here with the art and craft of teaching as we are with the materials of the library media professional's job. The instructional focus and function of the library media program as they have developed over the past two decades have put the school library media specialist indisputably into the teaching mainstream. Not as evident, perhaps, but of great consequence, has been an additional dimension to this teaching role: that of being a teacher of teachers as well. No other professional in the school, save the principal, is given such a sweeping mandate to carry out.

The search for the hows, the whys, and the ought-to-be's of better teaching intensified during the seventies, and the concern with improved teaching methodologies became institutionalized in a variety of staff development programs, teacher centers, and other training efforts. These programs differ from those that went before them in that they are largely located at the school district or regional level. Belief that there are "correct" teaching methodologies, and use of technological know-how to produce "good" teachers, unfortunately domi-

nates our planning for most of these programs. The effort often seems to be to find the "right" methods for teaching this or that subject and then to homogenize these methods so that they may be dispensed for everyone to use. This seems to us to entail largely misspent energy. If good teaching were just a matter of finding the right method and applying it universally, we could stop looking right now, for most of us already know more about good teaching than we have ever put into practice.

The trouble seems to be that unlike Pavlovian theory, the proper stimulus does not always deliver the expected behavior or result. Each teacher brings to the business of teaching qualities of mind, humor, patience, perseverance, sensitivity, and motivation in greatly varying proportions. Above all, each teacher—and of course this goes for each school library media specialist, too—brings to each learner a different level of belief that the learner is a thinking being and has the capacity to become. In library media programs, application of the stimulus-response-behavior approach to teaching has led to the general acceptance of the idea that with enough repetition (i.e., stimulus) young learners will *learn* the card catalog, or how to use the almanac, or dictionary guide words, or whatever has been predetermined as important for the learner to learn at a particular grade. Each subject has its own painful application of this misdirected axiom.

One need not cite further examples to make the point that good teaching is more than finding the right teaching method or applying the correct stimulus in the proper quantity to get the desired result. Common sense, sound instincts, and sensitivity about what you are doing to those you teach transcends any method or technique. Learners, whether they be mentally or physically handicapped, gifted and talented, or run-of-the-mill variety, are *persons,* not dogs kept in boxes so that they may be programmed by a bell or an electric shock. All learners bring with them a unique and marvelous capacity to learn, a capacity that is renewed and expanded almost endlessly when a fine teacher makes a lasting impact. When we give a learner a good experience, that experience counts and even multiplies itself throughout the life of the learner.

Unfortunately, the scars of bad experiences remain too. Excellent teachers accept implicitly the fact that their actions and decisions matter, and that they can do more to teach all learners than many of us have ever believed possible.

Nurturing the uniqueness of each learner, and achieving with him an understanding that both the learner and the teacher are richer for having touched each other's lives is a very real force in good teaching and always present; but the ability, the talent for doing it, is well-nigh impossible to encapsulate in a staff development unit. All it or we can offer are some suggestions, several alternatives, and a parade of possibilities in the hope that every library media specialist who teaches the exceptional or special learner will take on some of the magic of the inspired teacher. Without the special quality which engenders belief in the learner that he can learn, there will be no creditable library media program for the special learner.

Most children are more similar than they are different, and the "hows" of teaching the diverse range of special learners are remarkably similar to those for other learners. As for all teachers, the major concern for the library media specialist is to help the special learner to transfer insights and understanding from what is already known to new learning. The library media specialist must understand that the surest way to effect this transfer is to ensure that what is to be learned has personal meaning, something to tie it to the existing knowledge of the learner. We learn best and remember longest those things in which we have some personal involvement, and which have the greatest importance to us. The learner's motivation to learn something new depends to a large extent upon success and satisfaction in using what has been learned previously. The attention span of the learner depends largely upon the degree of comprehension stimulated in the first place by interest in what is happening.

The environment which sustains and motivates the will to learn must be systematic, orderly, and purposeful rather than regimented, repressively rigid, and haphazard. The recent past has shown a tendency by educators to mistake the unplanned and the overpermissive with the creative. Order

and discipline are good things, not bad, and when enforced by compassionate, concerned teacher or a caring library media specialist, entirely consonant with a humane learning environment. Except by chance, learning cannot occur amid chaos. Most library media programs have developed instructional components which feature openness as a spur to inquiry and involvement with learning, but never, it is to be hoped, at the cost of an orderly environment in which everyone's right to learn in his own way is maintained. Keeping this in mind will serve the library media specialist well when it comes to teaching the special learner.

Not long ago *Education Weekly* restated for its readers the "Seven Cardinal Principles of Education." Oddly enough, the seven principles, formulated in 1918, were found to be perfectly valid by the educators who reviewed them sixty years later. Indeed, a review of these principles evokes a response of "why not?," for they conclude that it is education's responsibility to concern itself with: (1) the development of health, (2) the command of fundamentals (basics), (3) worthy home membership, (4) vocational competencies, (5) effective citizenship, (6) worthy use of leisure, and (7) ethical character. Note the emphasis on education's role in building character, and note, too, that there is nothing specific in the list about the use of education to sharpen intellect and to help us make rational decisions. The point is that every teacher who cares about being a fine teacher has an identification with these principles. Teaching does make a difference in character; if it doesn't, why do it? These principles, with their slightly old-fashioned ring, are not really dated when one examines them closely, and they can give us a strong sense of continuity between past and present. Specifically, they seem to mean seeing teaching as an opportunity to enlighten rather than just inform. The library media specialist who seeks to become a more effective teacher should cherish such reminders from the past to help to explain why we do what we do.

While the special learners' needs are unique, the fact is that with careful and sensitive adjustments, their needs and expectations are not so far removed from the regular student's needs as one might expect. All teachers have the respon-

sibility—forsaking our preoccupation with subject special-
ization or grade level, which are really not as important as
they often seem—to help develop powers of critical thinking,
the ability to use skills in solving problems, and an under-
standing of sound human relationships. It is a valid general-
ization to say that the more competent the learner becomes in
these matters, the more likely it is that an appreciation for all
learning will follow, together with the skills to pursue it. If
our efforts to teach flow from a belief that all learners can
develop interests and aptitudes and synthesize affective ex-
perience so that it becomes personalized and real, then what
we want to have happen in the classroom or library media
center will follow as a natural consequence.

All learners, but particularly special learners, need an at-
mosphere that affords them a sense of acceptance and respect,
one that reinforces each individual's feeling of self-worth and
self-esteem. Providing this atmosphere gives the learner the
motivation to go ahead and to try to achieve still more. This is
the cornerstone of the best methodology any teacher can
possibly use.

Every school library media specialist or teacher should
wonder whether these considerations motivate the media
center or classroom. Does the library media program present
every learner with programs relevant to the real world? Do
these programs reinforce in that they build upon previous
learning successes? Are they reflective of individual learner
needs and individual levels of mental and physical develop-
ment? Are they planned in terms of transforming abstract
ideas or theories into useful learning experiences? Are they
helpful in learning and retaining factual data, while at the
same time promoting interest and imagination? Are they
capable of motivating abstract reasoning that results in
sound conclusions? Are they able to hold the learner's atten-
tion and keep him personally involved and interacting with
learning? Are these programs mindful of eliciting respect for
the rights of others? Are they worthy of the respect and
collaboration of other teachers because they are all of these
things?

The above list which defines excellent teaching and in-

struction leans heavily upon the writing and thinking of Arthur Combs, a wise and humanistic thinker and writer about education. Perhaps it will not sound overly physiological to say that we must get "inside the learner" to exert a lasting and positive influence. It is the world of internal motivation and self-direction into which we must tap, rather than trying to impose external persuasion to enforce learning as behavior modification.

How to use the media well to reinforce the affect of these face-to-face encounters that are teaching and learning must of course occupy a good deal of our attention. Here again, as with methods in general, the assumption that once the right materials are found they can be applied pretty universally can lead us astray. Part of the problem lies in our concept of "satisfactory results." To many teachers, "satisfactory" translates into getting the learner to do what they want him to do, and confusing learning with a student's ability to "parrot back" what they want to hear from him. As Combs points out, the information we want the student to learn will be assimilated—really learned—only in the degree that the learner discovers personal meaning in that information. Facts as they seem to the learner are learned, not necessarily facts as they are. Accepting the learner's perceptions and incorporating them into what is being taught can mean much greater involvement for the student in seeing relationships, thinking critically, and expressing convictions. Such teaching helps the learner to sort out the facts and to make some judgments and decisions about them. Even with the best of motives, a teacher's insistence that the learner "get it right" (which invariably means getting it the teacher's way) can trap us into the assertion that what we teach is always right, and that the way things seem to us is the way they *really* are. In this same corner into which we paint ourselves, whether in the classroom or the library media center, the learner who does not agree with us is stupid or trying to provoke us, and needs remediation. "Innovative" methods or materials are of little real value if we want them only to assist in manipulating learners more efficiently, instead of teaching them how to think.

What then makes a good library media specialist into an excellent teacher as well? Sensitivity as to how things appear to others; and awareness that learners will react to and learn as a consequence of how things seem to *them*. The outstanding teacher/library media specialist discovers quickly what is important to the learner, and follows up swiftly and certainly. "Discovering what is important" is a vague kind of phrase at best, but when you think about the reverse of it, the point is clear. You have only to think about all of the experiences which you, as a student, tried to share with the teacher who concentrated with relentless single-mindedness on your mastering what, at that point, seemed unimportant to you. The library media specialist who thinks of himself or herself with pride as a teacher will be proudest of all of the learner's own belief in the learner's capacity to learn, rather than the teacher's ability to teach.

Much of what we do in teaching is based upon faith in the power of external motivation. We think of the desire to compete with others as a virtue. The thing to remember about competition, though, is that you only compete well if you think you can win. When people are forced to compete on unequal terms, not believing that they can win, they are not motivated to try very hard. It matters little that the teacher exhorts; the unmotivated students become discouraged quickly, they quit, and become our failures. When competition becomes the *only* spur to learning, then sound values—in education or for life—are in danger. Obviously this is not to deny that competition for win, place, or show is part of our cultural heritage, the instinct for it a survival instinct.

If teaching the garden-variety learner—the so-called normal learner who is presumably motivated by some desire to succeed and who is armed with some confidence that he can learn—is complex and getting the teacher and learner together is difficult, what then of the special learner, disabled in one of many ways or more than one way, or emotionally disturbed? How does the teacher, or the library media specialist, learn to cope sensitively and with just the right mix of acceptance and redirection, with behavior that may be overtly hostile, aggressive, regressive, depressive, and fantasy-

laden? How does one teach to, or around, or through, such variants as perfectionism, fears and phobias, anger, dependence, and a further list of other neurotic or even psychotic conditions? On the other hand, how do we motivate and guide the gifted and talented special learners, with the longer attention spans, the bottomless need to know, who revel in the nuances of abstraction and extrapolation, often with a drive for perfection that puts them just around the corner from some of the special learners we characterize as mentally disturbed?

It is all very well—and we have done it often in this book— to state that the learning needs of the special learner, from the most profoundly emotionally or physically limited to the most intellectually gifted and creatively talented, are not so different from the needs of other children. Well and good, but the special learner will be different, often very different, in the way the expectations for learning will be met. Certainly, all children must develop coping and survival skills. Developing the communication skills—listening, speaking, reading and writing—is important. Health and safety habits must be learned as well as recreational pastimes, social skills, and establishment of interpersonal relations. Finally, intellectual development is a key expectation. It is easy to say to the teacher or the library media specialist about to face a class of emotionally disturbed students for the first time: "Be natural and relaxed; remember the rules for good behavior control— sound and fair discipline, be consistent, provide rewards where indicated, and make the students grow in responsibility and independence; view each child as an individual who wants to learn and can learn; set and maintain sound learning expectations and guide the learner toward meeting them, helping, all along the way to explore, and find out for themselves." This is all fine advice, and it is the way teaching all children is supposed to go. But, as in teaching other, nonspecial children, and perhaps a little more so, it doesn't all go quite always as its supposed to go.

First off, there are our own prejudices, part folklore, part superstitious fear. Such prejudice shows up our ignorance when we assume that the severely handicapped child, for

example, could not possibly be gifted, talented, or highly motivated. After all, if a sound mind is supposed to go with a sound body, then the reverse must be true—that a fragile or distorted body plays host to a like mind.

It is not pleasant to confront our own ignorance, or to admit that our attitudes about the mentally or physically limited are so rooted in the pervasive American tradition that honors winning above all else. Somehow we cannot be satisfied with ourselves or with anyone else unless we or they excel—not only run the race, but finish it in triumph. It is even possible that full success in teaching the physically or mentally limited learner will itself remain limited until there is a widespread change away from a value system dominated by competition.

We ought to take, at this point, a closer look at exactly who the limited or special learner is. The United States Office of Education, now transmuted into the U. S. Department of Education, has classified the children with special needs into specific categories:

the mentally retarded
the hard of hearing
the deaf
the visually handicapped
the deaf and blind
the specific learning disabled
(perceptual or brain injury)

the health impaired (chronic or acute limiting problems)
the orthopedically impaired
the multiple handicapped
the seriously emotionally disturbed
the talented and gifted

These are words with which we have some associations, but what do they mean, really?

Read these wise and compassionate words of Dr. Richard A. Gardner from his extraordinarily perceptive book, *MBD: The Family Book About Minimal Brain Dysfunction:* "The special child usually knows that he is different. . . . Other children read better, catch a ball more easily, or laugh at jokes he cannot understand. . . . Often he is in a special class; he may be going to a doctor, and others may make comments to him confirming their awareness of his difficulties." Gardner points out that children are much more capable of accepting

painful realities than is generally appreciated, indeed are far less fragile in this area than most adults would believe. What is difficult for the special learner to handle are the anxieties caused by prejudice, ignorance, and furtive whispers behind the back. When fantasies are given full reign, the child's worst anxieties about self-worth are confirmed: "I am different!"—devastating knowledge. A sense of helplessness, fear, and frustration can burst to the surface as anger; believing that failure is a "given" is a heavy burden and often contains a self-fulfilling prophecy.

Perhaps the most important attitude that the library media specialist teaching the special learner can bring to the task is a calm certainty that though failures will abound, there is hope for a measure of success. Success may be limited to a narrow range—a sentence spoken in response to a picture, some words expressed in reaction to a story, a picture taken to show the family—these are minor miracles for many a special learner and represent triumphs of the will, bolstered by courage and determination. They are the fruits of the enabling teacher, too. The library media specialist teaching the special learner, working alone or with another teacher, must above all else establish a relationship with the child based on trust and honesty. True for all teaching, this is especially important for the special learner. Establishing this trust requires that every activity sustain and reinforce the learner's self-concept and self-confidence. For most special learners, the reservoir of self respect is not deep, and is easily churned up into disarray. Whether in the library media center or the classroom, every teaching activity must be shaped to the needs of the particular special learner. This means finding alternative routes to success, and it means measuring and treasuring success in small amounts.

But there is a great deal more to teaching the special learner successfully than just having faith, hope, and courage. The library media specialist who intends to deliver a creditable special learner teaching program must, for example, keep excellent records about what is attempted, what succeeded and what did not. Often these records are anecdotal, and require a skill seldom associated with the usual administra-

tive pattern. The professional also learns quickly not to rely
solely upon personal qualities and a limited collection of
instructional materials. For two decades the profession's
Standards and *Guidelines* have adjured us to get into the
mainstream of educational activity, and to make the library
media center an influential part of it. It is satisfying to note
that the mainstreaming of special learners into regular in-
structional situations may at last get us there. In order to
teach special learners successfully, we must now cooperate
and collaborate with a variety of people including other
teachers, students, parents, administrators, community re-
source personnel, public librarians, and regional resource
center people.

Seen in this light, the library media program demands of PL
94-142 with its mandates about mainstreaming, indi-
vidualized educational programs and "least restrictive en-
vironments" is not such a terrible burden; it is also a sponsor
of the fullest involvement possible by library media programs
in the teaching and learning of the direct instructional pro-
gram.

But the idea of library media specialists teaching and
providing library media services to special learners is scary
all the same. It is not what most library media specialists
prepared themselves to do. Their preparation probably in-
cluded learning about selection of materials; acquiring and
organizing materials; and quite recently some instructional
design, educational technology, developing learning strat-
egies, and related instructional concerns. For at least a gener-
ation, most professionals have agreed that the school library
media program must be something more than a repository for
materials, a booklined study hall, remote and instructionally
unrelated to the school which houses it. The roads travelled to
make it so have been many and varied, but the dynamic,
innovative, and instructionally oriented library media pro-
gram which takes as its goal nothing less than influencing and
infecting the entire school environment has been called for by
every leading conceptualizer of the recent past. Suggestions
about how to do it range from adopting the "come hither" of
the Arabian houri to a doctrine of hot pursuit and "bring 'em

back alive." But however effected, the mission has been to seek out, to influence, to change.

Most library media specialists now accept the role for themselves that goes with this mission. And most library media specialists who follow the activist instructional role within the school building know that their success depends not just upon technical skills and organization, but upon such things as personality, energy, and circumstances. Nevertheless, exploring and coming to grips with the needs of special students puts most library media specialists into a world where they never expected to find themselves. Asked to deal with the unexpected, usually without much advance notice, people often react with apprehension or hostility. A deftly managed technical services operation, even a finely honed instructional development program, counts for little when an excellent library media specialist is confronted by five emotionally disturbed learners who have come for a book talk. This book talk bears little resemblance to those carefully rehearsed library school scenes in which a peer jury sits in bemused judgment on each others' efforts. No one ever told the library media specialist how to deal physically with getting five emotionally disturbed learners through a ten-minute book talk or story hour.

In order to cope, one must understand something about a proper use of physical restraint. We all act out of feelings of anger, anxiety and frustration, but some of us have learned how to divert these primal emotions into socially acceptable actions; emotionally disturbed children have not. Understanding how to restrain the emotionally disturbed child with a bonding hold of affection that acts as physical restraint, without its being sensed as punishment for acts that cannot be controlled, is something few of us know anything about. But it is a skill to be learned and practiced by the teacher/library media specialist of the emotionally disturbed.

And just how does the library media specialist with no special preparation, and little equipment but good intentions, develop a decent program for a brain damaged child? What do you offer that transcends being just fifteen minutes in the dark with a fairy tale film strip? How do you present a

program which is not just another magic show to sedate further still personalities and responses already deeply locked away?

Consider too, the dizzying extremes: the child who exhibits withdrawn, passive behaviors, or in startling contrast, an almost hyperkinetic frenzy. Such behavior may not be the consequence of brain damage or emotional disturbance, but of a teacher's effort to mold and control the fiercely resisting mind of a gifted learner. Channeling huge outpourings of creativity, intellect, and ego into accomplishment and institutionalized achievement is another kind of challenge the library media specialist probably did not face in library school education. Not much, in fact, is being taught there about how to teacher special learners, and it is unlikely that library schools will be able to do very much to prepare or upgrade the school library media specialist to be an effective teacher of the special learner. This is said, not by way of condemnation, but in simple recognition that most institutions cannot react very quickly when asked to meet a variety of demands brought upon them by rapid changes in the professional role in all directions.

Some schools of education, on the other hand, are offering some outstanding courses to help both the new and the veteran teacher to meet this challenge. Several programs described later give examples of in-service staff development efforts that have been undertaken to assist teachers and library media specialists to learn on the job how better to teach the special learner effectively. We believe that much of the best direction and assistance for both library media specialists and teachers will come from colleagues and resource people through state departments of education, district or regional staff development programs, and programs offered by professional associations, and above all through the one-to-one and small groups meetings through which we have always managed to trade and share professional abilities, good ideas, and original thinking.

Before the library media specialist embarks on a new career/mission as instructional resource person and teacher of the special learner, an assessment of personal attitudes and

expectations, as well as professional capabilities, is in order. This personal/professional inventory regarding self-identity and beliefs and abilities is important because it helps to "set the house in order" and set the stage for confident concentration on the learner. It requires us to look, really closely at the outset, at what we are equipped to do and what we are not equipped to do.

Initially this is a discouraging process, for we may perhaps expose ourselves as woefully deficient in just about every skill we will need to relate the library media program to the complex needs of the special learner. Examine carefully what portion of this discouragement may be self-pity or resentment to the tune that since "they" are making us do it and not giving us much extra help to do the job well "they" expect us to fail anyway, and we promise not to disappoint them. None of that, now! Remember that the basic strengths evident in any decent library media program provide a perfectly good base for the addition of special learners. It is important to continue the assessment process by affirming that you do have reasonable faith in yourself, and that the kind of negative self-intimidation that begins by saying that something cannot be done will never, never get it done—it is a self-fulfilling prophecy. Remember, professionally speaking, there is here the exciting potential for greatly strengthening the teaching aspect of the library media program.

Speaking in terms of personal characteristics, for a moment, there must be certainly resources of the spirit and the will. It might be well, perhaps, to begin with a sense of gratitude that we are being called upon to put our personalities and professional skills both to use in the service of children who need them so badly and will be so enriched by having our effort and attention. Our role in encouraging and motivating—and a high degree of motivation *must* be engendered in the special learner—requires sensitivity and awareness, understanding of how the learner feels about himself or perceives himself. Alertness is essential, for the library media specialist must be able to diagnose in the learning domain with as much accuracy as possible. This is often difficult, since many disabilities are not readily apparent or hard to

define, and symptoms may be misleading. *Patience* is a paramount characteristic: you must learn to be patient with the learner, but even harder and more important, perhaps, with yourself, for you must learn to accept being wrong frequently.

The library media specialist in this association with the special learner is not unlike the doctor, who, given some visible symptoms, draws upon a range of medical knowledge to decide what is the matter, but admits freely that there is no absolute certainty about the problem or the cure. We are inclined to glory in our ability to solve problems, but many of the "problems" associated with the special learner are often *not soluble* in the sense that they can be cured or healed. Accepting this ought not to depress us, but be seen as giving balance to our work, and also giving some of the excitement that belongs to the inventor and experimenter. We know that much can be done to educate special learners, but they may not all learn just as we program them to, nor to the ends, or with the results we choose for them. How glorious, how satisfying for us and for them if they discover some ends or results of their own.

The library media specialist who wants to learn to be an effective teacher of special learners, to make a difference to them, must be aware that teaching time spent with special learners must be clear in its focus and specific in its purpose, but mindful that much of the time may be filled with distractions and peripheral matters. Knowing what you want to do and how you want to get there, and the effort to try to keep the special learner on track is important, but you are not a failure if things don't go as planned. Good teaching is something more than the sum of its parts; it has intellectual underpinnings that do not come from instinct alone, but spring from understanding some of the theoretical foundations and utilizing them. Thinking through what has to be done and how to do it, and doing it, is a process during which many things may go wrong; evaluation and ability to respond and remedy the process are an essential part of it. If when things go wrong our only recourse is exasperation and retaliation against the learner, then we are as bad as our worst critics say we are. This is why we must have, to fall back on, an understanding of

theory, the security of careful planning, good record keeping, and thoughtful evaluation which helps us to adjust strategies and even change some expectations about outcomes.

We must be concerned about a room's environment, for it is well established that environment has a significant effect upon learning. This is as true of the library media center quarters as it is of the classroom. For special learners this means a therapeutic environment, one that provides a safe atmosphere in which to learn and one that is structured and orderly. A library media program that is already thoroughly mainstreamed into the school's entire instructional program will have little difficulty in being of tremendous help in mainstreaming special learners into that same instructional program, tailored to fit them. A library media specialist who is already part of the teaching team in diagnosis, prescription, and evaluation will fall into the rhythms of the special learner from selection of materials to outcome evaluation, for the special learner as for any other.

As we have said before and will say many more times in this book, attitudes shape good teaching at least as much as techniques do. Basic to our attitudes must be the understanding that special learners, like other children, are guaranteed the right to an appropriate education. No one, no individual teacher or media specialist, can guarantee that this right will be fulfilled for *any* child, and for the special learner it takes effort and cooperation from many people, and to a greater than ordinary degree, to come even close to its fulfillment. To provide in the best possible way for the special learner, the competencies and strengths of classroom teachers and library media specialists must be joined by those of administrators, special education teachers, support staff, volunteer and aide, and parents and other community members. The success of this particular learner, in all his varieties and diversities, will rest ultimately upon the openness to planning, sharing, and collaborative working of all of those categories of people. In addition, psychologists, social workers, and even the children themselves will determine just what is appropriate for them in a radical break with the past—but the past as it really *has been*, not as it was *supposed* to have been. The individualized

learning plan mandated for special learners greatly resembles individualized and individually prescribed instruction and the child-centered teaching we are *supposed* to have been doing for all children for some years now. Parent and community involvement and the fostering of social and personal development may actually become the norm, too, thanks to the special learner's mainstreaming in our schools.

Another not-so-incidental benefit of the special learner focus on education as a whole plays right into the hands of the library media specialist, for it may call a halt to the kind of poor teaching and learning of which they can see the consequences on any school day: the "stop and shop" conquest of unconnected, unused, and therefore largely meaningless facts. What are the chief agricultural products of Russia? How many countries are in the United Nations? Such questions turn many children into adept copiers and parroters of whatever encyclopedia has the most to say about the topic. The consequence for most special learners would most likely be total confusion and failure to put the pieces together into anything of meaning to them.

If teaching the special learner doesn't have an enormously positive affect on all teaching by classroom teachers and library media specialists, we shall be very surprised. It will do this by making them:

more aware of the importance of deliberately designing programs that require appropriate pacing, and reinforcement and use of what is learned;

more convinced, once and for all, that environment does affect learning positively or negatively;

more sure that careful assessment of individual learner needs is essential before teaching can proceed;

more determined that methods and strategies must be forged out of belief that *every* child can learn and that the teacher can and will make a positive contribution to that learning;

more energetic in initiating planning and carrying out teamwork with other professionals and lay persons;

more imaginative in using human and materials re-
sources in new and innovative ways;

more willing to try, and better able to accept failure or
only partial success.

While we may seem to have downplayed the importance of
methods in teaching the special learner, we are not rejecting
them out of hand. Perhaps what we want to convey is rather
that method must be so internalized as to be almost invisible
or at least unobtrusive. Just as the flow of music from the
hands of a great musician makes the playing look easy and
hides technique and hours of practice, so the ease with which
the excellent teacher uses methods belies the years of study,
experience, and thought which are hidden from view. The use
of sound methodology does not nullify creativity. It is, after
all a *sense of proportion* that enables us to maintain the
balance among methodology, theory, experience, improvisa-
tion, and intuition that defines the excellence we need from
library media specialist and library media program. It re-
mains the rarest of personal or professional qualities, but
fortunately one that almost anyone can cultivate.

Within this framework about the role of methodology the
spelling out that follows may be helpful to the library media
specialist in trying to become a more effective teacher of the
special learner. Some steps include:

(1) specifying results to be obtained;

(2) setting minimum standards to which the learner must
be committed;

(3) providing means of measurement to see whether goals
are being met;

(4) identifying alternative methods of achieving goals if
initial activities fail to do this;

(5) keeping careful records or anecdotal information which
will aid in the process of achievement and evaluation;

(6) planning for assessment of the whole process and what
happened, or did not happen, while the teaching was going on.

Each of these steps can be used either as a straitjacket or as

a vehicle to help learners get where they want to go. It all depends on the teacher whether the method is used to facilitate or strangle. It should aid, not block, good teaching, but method can be very useful in sticking to it—often the hardest job with the special learner. Mental and physical fatigue can set in when things don't seem to move ahead, and breed a sense of "wasted" time on children who can't or won't learn "no matter what I do." Self-confidence on the part of the teacher is a delicate plant to root, but once securely in place it sustains accomplishment greater than was believed possible. Ability to trust oneself is a critical ingredient in success with the special learner.

Staying the course in teaching the special learner is demanding; its ways will be blocked at one time or another by failures, by wrong judgments and decisions. Perserverance and resourcefulness will be required to outflank the roadblocks and get on with the commitment. This calls for good spirits and good morale and also a certain amount of what was once called dogged determination. This attitude is hard, because culturally we have not been conditioned to believe that sustained and steady progress toward a goal is often the best guarantee of success. Instant result and quick success is our media-hyped expectation about almost every hurdle we face. Intolerance of failure and our inability to accept it is reflected in much of our educational planning, in the search for new methods that make success in learning certain, and in our haste to discard them when, having tried to apply them universally, we have seen them fail. We cannot risk, with the special learner programs, the fits and starts that have characterized so many of our endeavors. What is needed is plain old-fashioned staying power, buttressed by self-confident ability that allows us to stay with something until it is made to work, or at least until we have made the necessary adjustments so that it will, without jettisoning the entire program. It is essential to remember that the ability to deal with failure is an important measure of a program's worth, and always a precursor of growth. Good common sense, a willingness to face difficulties head-on, and to persevere despite set-backs are characteristics of great value.

Overall learning objectives occur in clusters, most of them related to changes on the learner's part. These changes are much the same whether they take place in a physically or mentally limited learner, a gifted and talented student, or a garden variety "regular" learner within the normal range. They are apt to include:

(1) improving the skills of communication including writing, reading, listening, and viewing;

(2) developing the basic skills associated with coping, and sustaining more advanced learning;

(3) developing skills of socialization, the "get along skills";

(4) developing attitudes and activities that promote mental and physical fitness;

(5) developing awareness of career possibilities and the vocational competencies to pursue realistic career choices;

(6) developing an appreciation for good use of leisure time through appropriate recreational activities.

Each of these clusters of objectives—communication, intellectual development, socialization, physical and mental fitness, vocational competencies, and enjoyment of leisure—is relevant to the adjusted individual needs and expectations of special learners, whether they are limited in any way or gifted; only the techniques and strategies to achieve them vary.

Good program management has always been a key element in a successful library media program, but it is especially important for the library media specialist who is operating as a member of a special learner teaching team. If management methods are not refined and improved, the professional will simply be overwhelmed by the impact of work with special learners while carrying on the regular program for the other children. Among the management improvements, planning and preparation would specially focus attention to: goals, and the specific objectives—with time lines—which will lead to the achievement of the goals; strategies and learning activities, with planning in advance of use the combination of human and materials resources required for them; innovation

and experimentation, as a part, within reason, of as many activities as possible; *evaluation,* of all types, by users, teacher colleagues, staff; *records and reporting.* These aspects are central to all program management, whether for special learners or not.

We have referred to Piaget to make or reinforce a point about teaching. His ideas about how children develop into thinking, feeling, and discovering persons are important to everyone who teaches children, and especially useful to school library media specialists who are working, or planning to work with special learners. We cannot hope and would not presume to summarize his theory, but point out a few elements here as an introduction or reminder to dig deeper into it.

Piaget tells us that as children move from one stage of intellectual development to another, the passage depends upon an amalgam of physiological growth, social interaction, and previously developed mental abilities. The three types of growth should move together, and in order to learn, children must be actively involved in the process. The learning we associate with an excellent library media program includes foundational physiological learning such as physical control and discrimination as to auditory and visual reception and perception. Memory, too, is sharpened by looking and listening, and upon these foundation skills develop the ability to express ideas and to reason. While this mixture of physiological and mental skills is developing, they are matched by a similar growth in the social skills. While Piaget's work deals with the nonexceptional child and his learning, there are more similarities than differences between the learning styles of special learners and that of other children. If all goes well, the skills develop interactively as they are supposed to, do complement and reinforce each other. The sequential maturation of the intellectual and social aspects fosters a sense of assurance in the child and acceptance by others. Thus encouraged, the learner experiments, manipulating facts and ideas, making guesses, daring to discuss, argue, explain, and even change his mind about what he believed earlier. As one interpreter of Piaget has said, "In healthy development, learners produce their own creations." This seems to us the very essence of learning.

With special learners not everything develops as it should, so what does the above mean, albeit oversimplified, to the media specialist who is trying to develop a useful teaching program for special learners? We believe there are important implications for the development of sound programs. Piaget assures us that the best instructional media programs for special learners are those that help them to develop the skills of locating, organizing, and using information, as opposed to the mere recitation of where's and what's. It means that library media programs must offer special learners opportunities to *do* things on their own, mastering basic skills, and applying them to progressively more complex and challenging learning experiences. Information, that elusive mass about which all library media programs revolve, is valued not in the form of nuggets to be mined and hoarded, but as a protean resource to be used by the learner to practice, apply, and extend acquired skills to new situations. Purveying information so that what is known can be used to unlock the unknown is the highest purpose to which the library media program can aspire. Success breeds success as new experiences extend knowledge, which in turn expands social and intellectual competence. It is excellent teaching, harnessing excellent materials to learning objectives, that makes this happen. This kind of teaching on the part of the library media specialist requires flexibility in applying information to learning tasks, flexibility about time periods in which things are to be learned, and flexibility in allowing the learner the freedom he needs to choose what to do and when to do it. This freedom is based upon trust: the trust by the teacher in what the learner is capable of, the trust of the learner that the teacher will be there to guide him when needed. Tact, perception, and sensitivity are the prime requisites in the teacher-library media specialist while guiding, suggesting, critiquing, encouraging, and otherwise sustaining the process and the progress. This extraordinarily difficult kind of teaching relies not upon the approving nod or the word "right" to reward success, but in being able to tolerate failure and partly reached objectives. It is hard work for the teacher and hard work for the learner. It makes of the library media specialist-

teacher a learning guide, a facilitator and supporter amidst the pain and effort of self-disciplined growth, rather than a manipulator—too often seen as a distorter—of facts. This is true "open learning," not to be confused with some of the frivolous innovations of recent years that gave the term a bad name, and a legacy that was hard to overcome. The kind of open learning we describe demands *real work* to master *real subjects* by means of a structure, and attention to the basic skills set forth earlier. The learner accepts its disciplines because the rigors produce learning which is useful, and therefore important, to the learner.

We have certainly implied that attitude—on the part of the library media specialist and others involved in the effort—is of paramount importance in reaching and teaching the special learner. We cannot ignore, however, the reality that much of the program for the special learner was *imposed* through laws and regulations upon the school and the persons—classroom teachers, administrators, aides, as well as library media specialists—who are charged with carrying it out. Just as it is the nature of institutions to resist change, so it is all too human to resist what is imposed from "on high," especially when it is imposed upon people who may already feel driven and overworked. This can cause problems, and with the problem special learner or the severely limited child there is every reason to believe that teacher resistance will be high. Many of the proposed educational reforms of the 1960s and 1970s failed to achieve their intended goals because they were rejected or perverted by teachers who resented being left to carry them out with little understanding of what was involved, how it was to be done, and why. Few teachers were prepared to really put into practice the individually guided learning program or to deal with children, parents or colleagues in an ungraded school. Understanding, techniques, resources, and help were often all lacking. Most of us though, would support the intent and the assumptions behind these reforms and those behind the mandates of PL 94-142 and other special learner education mandates. Library media specialists can in fact do a great deal to help most teachers see the new responsibilities in a more positive light by giving them some achievability.

The more teachers are involved, together with library media specialists and other appropriate personnel, in planning and putting changes into practice, the less onerous the changes and the onset of the new programs will seem. The library media specialist, we believe, has a very special and important role to play, second only to that of the principal, in helping to plan and gain teacher support of new or altered programs of instruction for special learners. Over the past two decades, most school library media specialists have come to realize that a certain amount of their talent and energy must be devoted to helping teachers to adopt innovative practices that will improve their teaching, or help them to be more effective teachers. This in-service educational role not only helps teachers to strengthen their use of the library media program but strengthens the library media program as an instructional resource as well.

Managing change well spells the difference between riding in triumph on its waves or being drowned in it. The power to inspire a positive attitude in others is a priceless professional asset. The library media specialist is in a very visible position. Working daily with teachers, the media specialist can introduce, persuade and convince that the job can be done. The library media specialist who accepts this administrative role of change activist and agent will be viewed as a priceless asset to any school, and will gain power accordingly. The force of persuasion, and a positive outlook on the part of the library media specialist is basic, but it is not enough; the kind of self-concept must be fostered in the teachers themselves that makes them willing to work at creative problem solving, to take initiative and be responsible for the decisions they will help to make, and to see themselves as professionals whose involvement will mean success for the entire enterprise. The teacher in a staff development situation is no different from any other learner; remembering it will not guarantee success, but forgetting it will almost surely guarantee failure.

In thinking on the "what do I do, where do I start?" level, the first step must be understanding the valuable contribution and the rewards to be reaped in helping others to accept change constructively. The role of teacher motivator has

always been a major one of the exemplary library media specialist; laced with management expertise, it can be a prime factor in the success of the special learner program. The library media specialist presents no threat to any other professional and is in a good position to lead the special learner initiative in the spirit of camaraderie and good morale which is part and parcel of a well-run effective school. Bring along a few leaders to a sense that accomplishment of the objectives is possible, and that the library media program's resources can do much to make it possible, and the less motivated teachers will begin to follow their example, listen to some new ideas, and try some new instructional techniques and materials.

Thus far, we have alluded to "mainstreaming" only in passing, putting it aside until we had talked about teaching and learning styles, motivation, staff development, and other elements. Now it is time, it seems, to bring mainstreaming onto center stage, and talk about what it is, what it proposes to do, and above all how it relates to the library media program. After some of the fears, uncertainties, and hyperbole that often surround any discussion of mainstreaming are stripped away, it seems safe to say that mainstreaming may rightfully be considered one of the greatest teaching innovations in a very long time. It carries with it some staggering numbers: the potential to affect millions of learners (perhaps as many as ten million) and millions of teachers (perhaps as many as three million). This fact alone would force many changes in our schools. As with many revolutionary developments, and this movement must be regarded as one, the words of PL 94-142, which represent both the summation and the future of special education, are deceptively simple.

The law states, among several major conditions, that the special or handicapped learner must be educated within the least restricted environment. This means that to the extent possible, the learner must be placed in the most normal environment obtainable, that in which nonspecial children operate on a daily basis. This environment is considered the "mainstream" in that the handicapped learner must be educated with those who are not handicapped unless the Indi-

vidualized Education Program (IEP) governing his education specifies some more suitable arrangement. The intent is that the special learner be educated side by side with other children to the extent that this is possible. As one observer put it, "the average child is being asked to share some educational benefits with the handicapped learner." The corollary is that the special learner should receive as little special attention, attention that sets him apart from the other children, as possible, at least within the regular classroom.

The achievement of skills we expect of the physically or mentally limited learner will vary with the severity of the limitation. Millions of young learners with less severe disabilities have a good intellectual potential that can be stimulated and sustained by proper attitudes and abilities on the part of teachers, library media specialists, parents, and other children in the classroom. Whether the specific teaching is based upon psychoanalytic, humanistic, behavior modification or environmental patterning is less important than the fact that there are learning patterns to be responded to, and that there is belief on the part of teachers, learners, and everyone else concerned that learning is possible. Even before the passage of PL 94-142, of course, many severely handicapped children, especially those with physical handicaps, demonstrated that they could function well in a heterogeneous school environment with little or no dislocation in the operation of the school.

There is no question but that mainstreaming carries with it additional burdens. It will not be successful without commitment and labor, and indisputably much of the labor must come from the front lines—the classroom teachers and the school library media specialist. This front line personnel must be given time to grow into the task, to talk with each other, to plan with each other, and not expected to embrace some difficult new work as martyrs. Keeping constantly in mind that mainstreaming involves giving some special attention to special needs of certain learners, just another form of individualized instruction, should reduce anxiety and hositility somewhat. If we agree that a prime function of *all* teaching is to provide the structure and sequence that help the

learner along the path to more learning, while using what has already been learned, then mainstreaming begins to appear not so very different from other teaching situations. Teachers in any classroom have always had to deal with a broad range of abilities and disabilities.

Doing what is right is often far harder than knowing what is right. Ensuring minority rights by law when it would be easier, perhaps, for us to ignore them is bound to provoke disruptions and hostility. *But we believe with all our minds and hearts that library media specialists can cope with it, and help others to cope with it.* The sociologist Daniel Bell has said that, "the hallmark of librarianship has long been its pragmatic view of the world," and "practical," "reasonable," and "sensible" are words we can be proud to associate with the library media program. Common sense enables us to look at a situation and begin to do something about it; it is worth weeks and months of agonizing and conjecturing about how on earth we are ever going to do what we must do. Steady pace toward reasonable goals and practicing the art of the possible are the sensible ways to manage change and lower anxiety levels— one's own and those of others. In mainstreaming the special learner, we would do well to remember the words of Betty Fast, the late and important innovator in the field of school library media programs, who pointed out that "special education children have the same needs as others for love and affection, for positive experiences, for self-development and for people to accept them." It helps a great deal to look at special learners first as children, and then as people needing special help. This helps the teacher and the library media specialist to share the legal imperative that the special learner and the nonspecial learner are to learn side by side in the same educational environment, even though with different paces, different styles, different goals, and different expectations.

It is historically accurate to say that library media programs have always shown a special flair and competence in helping the special learner. Our belief is that mainstreaming of special learners will not work well unless there is an effective library media program to strengthen and support it. This belief is born of knowledge of what library media spe-

cialists have already done with thousands of special learners over the years. The library media program does not judge or value learners in terms of grades; its being removed from the grade sweepstakes has always reinforced its relationship to all sorts of special children, one-on-one. The library media center is in affect an hospitable "half-way house" to all children who seek unique and personalized assistance. Library media specialists know that needs for materials or services are not always self-evident or well articulated, and that some gentle probing, thoughtful listening, and caring guidance may turn up the hidden needs behind the stated one. Library media specialists know that no group of learners ever learns at the same pace even while using precisely the same materials. They believe learner motivation and involvement are paramount, and no single teaching method or strategy will ever serve to involve an entire group of children in learning. They are sure one professional alone cannot meet the individual needs of a wide variety of learners found in most classrooms, and that learning must involve team effort by parents, community agencies, and other kinds of professionals in appropriate combinations with educators. They know that risk-taking is inherent in trying new ways and new ideas, but that this is what makes progress possible. They are convinced that the attitude that admits of no *final* failure must be present in every teacher so that trying another way, and yet another, will free the learning ability that exists in every learner. These are some of the essentials shaping and directing all exemplary library media programs, and because these attitudes and motivations are so truly and intimately a part of library media program planning, we feel an enormous optimism and anticipation about the role of the library media program in creating a rich and satisfactory mainstream program for special learners in our schools.

Stemming from these articles of faith are the strategies and techniques that will help the library media specialist in teaching the special learner. One thing to remember is that many handicapped children have the important characteristic of being able to compensate for a loss of a sense or skill with the sharpening of another. For example, the blind child often

displays a heightened sense of hearing, and the deaf child more acute vision. Professionals need to be aware of such things and use them to good advantage.

With all learners, but with the special learner especially, it is important to start with a reasonably accurate assessment of what the learner may be expected to learn. This does not mean that all learning will be effortless or fun, for as with nonspecial learners the intellectual capacity should be stretched, but not all at once. Inevitably, the special learner will have experienced more than the usual measure of frustration and failure in trying to learn. There is need for much more than even the usual awareness of how big a piece should be be bitten off at one time. Outcomes must be anticipated with great care and the realization that the learner's expectation may not always match ours.

The effective library media teaching program for the special learner does better to stress the elements and services of the library media program that transfer or process information through human contact rather than by technological means. It is also helpful to recognize that the learner's problems may have multiple causes and that there will be multiple ways to meet them. Special care in selecting materials for the teaching team that works with the special learner can help insure that needs and abilities are matched with the proper learning opportunities. Many materials already within the library media center can be adapted quite readily, and experimenting with how what materials are best used by special learners is an important step before purchasing new and special materials. Much material will need to be prepared locally in response to unique local needs. The resulting increase in production should sharpen the instructional focus of the materials. Because they are being created to fill an exact need, often those of one particular child, producing and using these materials will require more intensive attention to alternative learning styles. User need prevails when such produced materials reduce abstractions to a level of reality and personal meaning to the individual.

Most teachers have a tendency to let subject matter mastery predominate over the importance of helping learners to see

relationships for themselves as learning proceeds. To many, the distinction between rote memorization and understanding is unclear and leads to confused teaching and learning. Poor use of media does not help, either. Reliance on one instructional medium with which they feel at home, a single machine or method, will not pull teachers or library media specialists through when teaching the special learner. Flexibility and a solid knowledge of how learning occurs are essential.

Timetables, goals and objectives, performance indicators, and a host of other things associated with teaching activities have important limitations when applied to the physically or mentally limited learner. It is as important, for example, to anticipate lack of progress at times as it is to expect it. Refining, narrowing, focusing, and applying are all words that are key to teaching the limited special learner. A slower and sometimes a more sporadic pace does not mean no progress at all, and it is important to just keep things moving. In motivating the special learner it is necessary to deal with and resolve moments of conflict, disappointment, and failure and remain alert to alternative routes for getting to the same point if they are needed. It is important to keep your cool, allow frustration to be vented without confrontation, learn to spot trouble ahead, and not to overreact if trouble comes. The feeling to be fostered within the special child is one of partnership in which good times and bad can be accepted as the inevitable consequence of trying to learn and do for oneself with the help of someone who cares. Successful partnerships must be based upon a sense of security and mutual trust. Establishing this trust is the first thing a good teacher does with any learner. Patience with oneself and with the learner, a sense of humor, and abundant optimism are vital ingredients. Other ingredients are the ability to develop agreements about "where we are going" and how to proceed to go there; the ability to spark ideas without making them "mine" or "yours"; and the ability to loosen constraints or to provide restraints when called for. One must have the instinct for knowing when to reward or when to say, "Try, try just once more, you can do it." All of this is what teaching the special learner means as it involves attitudes and conduct and instincts.

We would like to hope that the legally imposed obligation to provide for the rights of the special learner to an appropriate education will before too long be matched and balanced by the motivation that will come from the satisfaction that springs from success and the reward that comes of knowing that what we are doing is just and right. We must keep before us the undeniable fact that our obligation to help special learners become all that they are capable of becoming is remarkably consonant with our obligation to all learners. This assumes of course that we believe that our obligation extends to doing everything in our power to help them develop to the greatest extent possible their physical, social, intellectual, and moral selves. It is a large and serious obligation, but one we are able to discharge superbly if we can summon the will to do so.

Order and quiet are important contributors to a good learning environment. If activities affect learners so that they ricochet about like a busted bag of marbles, that's not teaching. Learners can become excited about learning without expending nervous energy bordering on hysteria; they can be involved while understanding that creative expression must be disciplined and channeled. Requiring an appropriate end product to learning, a solution to a problem or a suitable action, is not a contradiction to creative teaching. Successful seekers should find something concrete.

Karen Harvey and Lowell Horton provide some illuminating insights about this matter in an article, "Bloom's Human Characteristics and School Learning," which appeared in the November 1977 issue of *Phi Delta Kappan*. They, and Bloom, underscore for us that, "most students are similar with regard to learning and motivation for further learning when provided with favorable learning conditions." They point out that only 1 to 3 percent of the most severely limited learners are not included under this rubric. It is with the special learners—the vast numbers of them—included in the 97 percent, those who can be influenced by events and atmospheres, stirred by ideas, and moved by a sense of purpose to transfer abstract concepts into activities that this book is chiefly concerned, and that teachers and library media specialists are being asked to incorporate into the mainstream. It is important to be

fully aware of the direct and powerfully negative relationship
between unfavorable learning conditions and the learner's
ability and motivation to learn. Although in this case it is
Bloom's theories which spark the observation that too many
schools provide unfavorable learning conditions, this criti-
cism has been leveled by education's critics from Plato to Ivan
Illych: educators plan education for their own convenience,
not that of the learners. The compulsion to classify students
as "good," "average," or "poor," is a good example that comes
to mind.

Let's admit it once and for all! The combined influence of the
atmosphere, the environment, and the *teacher* does make a
difference in what's happening. It doesn't have to be a world
of extremes—either you get it or you don't—in which so many
students fall between the two stools with no one to rescue
them. The effective teacher can provide inspiration *and* disci-
pline, challenge *and* security in the proper proportions and
combinations to help the learner build upon previous learning
and move ahead.

The *quality* of a library media program has often been
equated with the *quantity* of materials, space, and personnel
it can command. To be sure, quality programs cannot be
delivered without adequate resources to call upon, but the
quality, scope and impact of a program does not depend as
totally upon them as we have been led to believe. The quality
of a library media program and the worth of its linkage to the
school's instructional programs relies to a much more limited
degree than we might wish to the quantity of resources and to
a much larger degree than we would like to admit upon
harder-to-measure assets such as morale, leadership, deter-
mination, pride, and expectation of success. Too many of us
find excuses in quantitative failings—not enough teachers,
not enough aides, not enough books, not enough time, or this
or that. These excuses often sound plausible—we *do* lack a
great deal that we should have to do the job right—but these
lacks are not often the causes of failure.

The teacher's proper role is not sifting through and sorting
out the achievers from the stumblers, the also-rans from the
winners; it is to provoke inquiry and stir motivation as

stimulants to learning. If the teacher does not personally judge, label, reject, or pass upon individuals, then mainstreaming can work.

Our hope is that mainstreaming will be able to transcend the negative aspects imposed upon it by technical/legal emphasis on the things that must be provided or accomplished to teach the special child to be more like the normal child, or at least to find the means for him to function more adequately in the world. If not, our finest hours will be those spent in installing hand rails in wider toilet stalls and putting in wheelchair ramps. This is not to say that such renovations to provide barrier free access to the schools are not a part of mainstreaming the physically handicapped, but they are only a relatively minor part (albeit expensive) of the job.

If mainstreaming mentally or physically handicapped children into the regular classroom becomes a matter of just finding "the right way" to do a job for an integrated group of special and regular learners at the same time, the mandate will not be realized. Those children who cannot make a stab at being "regular" will fall by the wayside, worse off than they were before in their isolation. Or if, as President Ford warned, mainstreaming becomes merely another administrative process which seeks the right test, or the right referral to the right teacher, or preparing an IEP which prescribes an arid and unimaginative program of treatment, we in the library media program will have allowed it to fall far short of its promise.

We must bear constantly in mind that the heaviest burden in the entire mainstreaming process is that borne by the special learner who enters with the expectation that he will become more like his nonspecial learner classmates. The learner's physical or mental limitation is played down; mainstreaming tends to reinforce behavior changes that make the special learner more like the normal learner. The expectation is that special learners will adapt to overcome their limitations to the extent possible.

Some iffy assumptions color this approach to the goals of mainstreaming. One relates to a predominant cultural value: that the more alike we are the better off we are; being the same as others is good, and being different is bad or at least suspect.

Another assumption has it that there is a learning continuum along which all learners fit, within either a positive (normal to gifted) or negative range (subnormal to severely limited). If we allow mainstreaming to become a process whereby the special learner will be changed to fit into the regular classroom and the narrow range of learning expectations which control it, then mainstreaming is just another method to be used to ensure that learning is nothing more than acquiring new behavior patterns. This kind of learning translates into a stimulus/response pattern, controlled by a teacher whose dominant concern is to provide a method which predicts with assurance how learning may be reduced to a recipe to be used and reused to get the "right" results from every learner. It will not work with special learners, who do not conform well to mass-produced expectations nor respond well to artificially established levels of achievement or behavior.

The library media specialist is, in the midst of these dilemmas, in a unique and fortunate position. The excellent library media program has never been organized around the expertise or knowledge of just the library media specialist. It has had a long and productive history of accomplishment with its own brand of mainstreaming, combining people and materials with support, inspiration and personalization of instructional programs, and services to a vast range of learners. Special learners entering this kind of environment need only adapt to that which is appropriate to their own needs, just as everyone else does. They will receive motivation, help with goals that are relevant to them, confidence that they can accomplish, opportunity to practice and apply what they learn, encouragement to keep trying, and reward of several kinds.

Library media specialists long ago abandoned the search for a single method, kind or piece of material, that makes all learners want to learn. They know that it is a mix, prepared a little differently for each learner, that makes him want to learn. They will do well—many have already started and gotten well underway, as this book describes—and more than most teachers, to ensure the success of mainstreaming in thousands of schools. But it is perhaps in the potential for developing the professional skills of other professionals, for

working closely with them to help them work securely with the special learner, that the greatest future for library media specialists lies in connection with special education. We describe herein a number of programs which demonstrate how the library media program may be directed toward the process of helping teachers to improve their abilities to work with special learners. This reinforces, albeit in a special direction, the commitment we have made long since to the position that a major preoccupation of the school library media specialist must be with helping teachers to use instructional technology effectively in teaching. It follows that teachers who have developed the attitudes and expertise that encourage them to incorporate these elements into their teaching will generally support continued development of the library media program. There is no reason not to be candid about getting this message across: what's good for the school, the teachers, and the students and their learning is also good for the library media program and its development.

It is probable that mainstreaming will force many teachers and library media specialists, too, to honor some lip service commitments to good teaching. Anyone engaged in teaching special learners of all varieties will range far afield and be mighty happy to find resources, and ideas. An obvious first stop should be at the door of the library media center, and the alert library media specialist should anticipate this and be ready to exploit it. That is a major purpose of this book: to help you, the library media specialist, to anticipate and meet the opportunity at hand. You will see, as we have, that programs for the special learner have vastly increased the importance to the school library media center of shared resources and networking arrangements of many different kinds.

We are not being condescending or smart-alecky when we suggest that the teacher's learning needs and those of the special learner be considered in tandem when planning is going on concerning how the library media program can best support either or both groups. It is important to remember that the teacher's learning is stimulated or stunted by the same conditions influencing student learners. How often have

we all experienced resentment at the faculty meeting or staff development session when every professional is treated the same, with the assumption that everyone present has exactly the same learning needs, and learns exactly like everyone else. It is bad teaching, but it remains a dominant mode of many professional presentations. We treasure, accordingly, those who take the time and make the effort to find out about our capacities and needs, and help us apply what we have learned.

We will close this chapter on teaching and the instructional responsibilities of the library media program by offering a few summary guidelines for the library media specialists who want to work successfully with the mainstreamed learner or the teacher of that learner:

(1) Get to know the individual as well as possible. Self-identity and good self-concept engendered by the interest and acceptance of others are especially important to those who know themselves to be limited physically or mentally.

(2) Listen well to what others have to say, but wait to act until there is time to make your own judgments about the best way to proceed.

(3) Range as far as possible in the search for information. Find out if there is a specific learning disability in the learner, what his strengths and weaknesses are, what his attitudes toward himself are, his disability, his needs.

(4) Introduce the learner into the mainstream gradually and be prepared for actions and attitudes that reflect anxiety, fear or hostility, for they are there and will appear.

(5) Be prepared to change course and alter goals in collaboration with the learner, but always keep moving and know that those blessed plateaus where achievement is savored, lie ahead, too.

(6) Know your own irritability quotient and frustration level, and don't be afraid to discover that you can become frustrated and irritated when things don't go as you wish. Knowing when your gasket may burst can keep you out of the overreaction pit most of the time.

(7) Do not believe that you can establish a "normal" range

for every mainstreamed learner. Look instead for a range of behavior and activity which fits, most of the time, into a pattern which you and the learner have agreed is appropriate. And don't be alarmed when from time to time progress is sacrificed to a rash of bad conduct; expect to experience the result of frustration and failure, for you will.

(8) Always capitalize on the learner's strong points, and help him to develop them.

There are emotional highs and lows insistently present when teaching special learners, but all the same, prosaic concerns like selection of materials, organization, management, ease of retrieval, and use and the constant surveillance of the physical set up will be the central focus of the library media program for special learners.

Exemplary Programs

The following fourteen programs represent regional educational support systems of various sorts that focus on improvement of teaching and learning for the special learner. Some of them we would characterize as networks, others as staff support/staff development cooperatives. A few are statewide in scope, others concerned with only one school district, and still others with multiple school districts or even several states. We present them below in alphabetical order by state.

Southeast Arkansas Learning Center, Pine Bluffs, Arkansas

Delaware Learning Resource System, Dover, Delaware

Metro East Center, Georgia Learning Resources System, Scottsdale, Georgia

Chicago Regional Program, Title I, Chicago, Illinois

South Metropolitan Association/Regional Inservice, Media and Information Service, Harvey, Illinois

Lawrence Learning Resource Center, Lawrence, Kansas

Missouri Special Education Instructional Materials Center, Columbia, Missouri

The Media Development Project for the Hearing Impaired, University of Nebraska, Lincoln, Nebraska

Roswell Independent School District, Roswell, New Mexico

Learning Resource Library, Washington County Educational Service District, Portland, Oregon

School of Education, Portland State University, Portland, Oregon

South Dakota Department of Education and Cultural Affairs, Division of Elementary Education, Library and Media Services, Pierre, South Dakota

Department of Special Education, Greenville Independent School District, Greenville, Texas

Utah Learning Resources Center, Murray, Utah

SOUTHEAST ARKANSAS LEARNING CENTER
Pine Bluffs, Arkansas

A visit to this program inspired one visitor to make some telling observations about the gap between the world of the "haves" and the world of the "have nots," and about what was once referred to as "the revolution of rising expectations."

The Southeast Arkansas Learning Center is typical, in more ways than most of us would like to believe, of programs that have been developed throughout the country to serve the special learner. It is underfunded and understaffed like most of the others, with too few facilities and materials for the job it is expected to do. But this program, with its well-planned determination to do a lot with a little underscores the widespread reality that planning to meet the needs of the special learner within the classroom or the library media center has been largely of the casual or piecemeal variety—a sort of "what do we do now and how do we do it" approach.

Library media programs are carried out by persons to whom authority has been delegated, but that authority must be accepted if the responsibilities that go with it are to be undertaken. This program is marked by joyous acceptance of the challenge of the authority delegated, and one of its strengths is that it demonstrates the value of enthusiasm and the worth of experience and how the two relate to and reinforce each other, whatever else may be lacking in the way of advanced degrees or training.

There is a sense of rightness and confidence that motivates this program. It is a modest program accomplishing some matters of importance, and proves daily that it is what you do with what you have that counts. What is not at all typical about it is the enormous value it delivers with limited resources. Also untypical is that the results it produces in terms of what it set out to do have been carefully substantiated and evaluated by an independent consulting service. All in all, it cannot but make one wonder about the dicta of quantitative guidelines and standards and those who use them to aver that

it is not possible to have an effective program of quality and merit unless it meets or exceeds certain standards for collections, facilities, budget, and staffing.

This center began four years ago, one of four established as support for Arkansas school systems which were then beginning to face a swelling tide of special learners for whom special education programs must be provided. Funded initially for two years with federal funds, it was hoped and anticipated that local support would take over responsibility for all four programs, but the Southeast Arkansas Learning Center is the only one of them still serving both a district and a region.

Located in the former auditorium of an old school building, the center was originally housed at the end of a long flight of stairs, making it inaccessible to the physically handicapped. This situation was remedied in 1980 when the center was relocated in first floor quarters with access for those in wheel chairs.

In the school year 1975-76, in preparation for a pending evaluation, the staff of the center made a comprehensive assessment of needs and as a result committed itself to a series of service goals with accompanying objectives as steps to achievement of the goals. Among the goals were the following:

(1) Special Education and regular classroom teachers in the district will demonstrate increased skills in analyzing and using special education materials with handicapped children in their classrooms.

(2) The center will continue the distribution of materials and the dissemination of information, as well as consultation on request by the special education and classroom teachers.

(3) The center will provide staff development and consultative services to participating teachers and administrators.

(4) The center will provide consultative assistance to the participating school districts in planning and accomplishing improvements and expansions in present programs as needs and resources are identified.

(5) The center staff will develop a program component to provide assistance to teachers in creating and coding teacher-

made instructional materials, designed to be used in individual education plans (IEP) based upon specific skill deficiencies of identified handicapped children.

As a planning model for any educational support program, and for the clarity of their expression and their specificity these statements are worthy of emulation in any school building or school district in the country. But the saying and the doing are different matters and are often worlds apart. Did the program meet these goals? How did it do so? Where did it fall short and where did it succeed? And, ultimately, was the impact of its services beneficial to teachers of the handicapped learner or to the special learners themselves?

A rating scale to evaluate the thirteen services of the SALC was devised by the staff. Its value scale was from one to five, with the number five representing the highest level of satisfaction. The services rated included preview of materials, loan of materials, review of professional materials, consultation workshops, newsletter, individual prescriptive plans, assistance with materials selection appropriate to learner needs, delivery service, and, finally, appropriateness of available materials. We list these, by the way, not just to enumerate the services, but because they are an excellent index as to what services and programs the regional support center should provide. The service rated highest by teacher users, (67 percent of the respondents were special education teachers) was the loan of instructional materials for teacher use, followed closely (within a percentage point of value) by the loan of professional materials. A statement found in the final evaluative report says that, "all respondents were very positive in wanting the service continued, with the most positive average rating going to the loan of instructional materials."

Distribution of materials, the dissemination of information, and consultation services were requested by way of special forms which were distributed widely within the district. Completed forms requesting materials or consultative assistance were mailed to the center or taken there by others using materials or going to programs there. A list of all materials available for preview and loan to teachers was provided to each school in the district, and revised periodically to keep it

useful and current. Delivery among the schools was done by
the consultant going out for program work. Every special
education teacher is worked with at least once a month, and
other teachers are seen at their request.

Now, right here is the point at which many similar pro-
grams disintegrate, and for want of a nail, a kingdom can be
lost. Professionals just don't drive vans, distribute materials,
or tote things about; that's an aide's job! But not so here, and
any imagined loss of professional dignity or status was more
than balanced out by the opportunity created by the consul-
tant not just dropping things off (as an aide or delivery person
would have done) but taking time to work with the requesting
teacher to make sure that use of the materials was understood
or even to suggest alternative uses for them. Called by a
fancier name, this is staff development, and in this district the
low-key, low-intensity approach pays off richly in terms of
improved use of materials and equipment with handicapped
learners. Teachers borrowed materials for two week periods
with extensions possible. Use records were kept on all mate-
rials as well.

District staff development structured for groups was not
ignored in favor of only the personalized one-on-one encoun-
ter, however. Typical workshop sessions conducted by the
center included (1) an introduction to the center's services; (2)
awareness of learning problems; (3) multimedia reading ma-
terials; (4) making materials; and (5) math materials making.
The workshops, usually of one or two days duration brought
teachers and administrators together to work and plan for
improved programs for handicapped special learners and
received uniformly high ratings. The reason for this is not
hard to find, for the programs filled a specific need felt by
teachers and administrators to improve their abilities in this
area. Sometimes outside consultants were used in the work-
shops, a refreshing blend of local and imported talents and
experiences.

Direct participation of the center in individual teaching
programs was extended through its assistance in evaluating
services available to handicapped learners as well as through
the field testing of various screening instruments and pro-

cedures to identify youngsters with potential handicaps and through assistance in helping to design special "child-find" programs (programs aimed at locating learners with limiting handicaps which had heretofore been undiagnosed or unidentified). The center also helped school personnel to cope with state and federal mandates relative to identifying and teaching the special learner. The program's ability to deliver such well-targeted and practical consultative programs to professionals (who are often just overwhelmed by the tasks, real or imagined, of coping with the special learner) clearly has much to do with the high regard in which the center is held. It helps professionals do their jobs better by providing reassurance and guidance and direction and focus. This assistance, above all, is what most professionals want and expect from such support programs. What a difference it makes to ask for help and actually get it.

Finally, the center assumed the responsibility for a modest technological support component. Again, modest is the appropriate word for the equipment used consisted of a Thermofax copier, a dry mount press, a roll laminator, and a visual maker. It was a minimal investment in equipment, but it was an investment in items most likely to be used by teachers, for they have an immediate instructional need for the products created by using this equipment. Three production workshops were held, and a consultant was available to go to schools on an appointment basis, to help teachers produce materials there as well. Such simple and widely available machines, and an assortment of small items such as magic markers, poster board, Thermofax copy paper, thermal spirit masters, and some mounting forms become an arsenal of instructional technology when used with a proper focus.

The implication is quite clear: what the Southeast Arkansas Learning Resource Center does so ably for its users is a precise reflection of the kind of media based program that the building library media specialist should be presenting to special education and classroom teachers. As a blueprint for how-to-do-it, and a model of clear goals and obtainable objectives which relate support to improved instruction for handicapped learners, a better model could hardly exist.

Exemplary Program Elements
1. The close relationship maintained by the consultant in instructional media use with the classroom teacher.
2. The development of overall program goals to be achieved by clearly stated objectives which relate to teacher needs and expectations.
3. The use of simple equipment to produce teacher-made instructional materials for classroom use.
4. The preview and evaluation of instructional materials through classroom use.
5. The use of an outside agency to validate program achievement.

DELAWARE LEARNING RESOURCE SYSTEM
Dover, Delaware

Here, in the small seaboard state situated in the New York-Washington, D. C., corridor, is another regional network whose purpose is to supply special education teachers with support services and instructional materials. As with others we have queried, visited, and described in this book, this system is responding in its own admirable way to the rapidly intensifying demands for services to special learners and to those who teach them.

Because we have emphasized them to such an extent, we must state at this point that as important as we believe regional networking systems to be, even they are not the full, total, and complete answer to all of special education's problems and opportunities. The regional network is at once created by, and is the shaper of, the new technitronic world in which the word for progress is replaced by the word change. It cannot solve all problems, and like any system it is only as strong as its weakest link. Any information dissemination system must master its relationships with those it serves; the establishment of person to person relationships and the interplay of human associations and human values must precede the development of systems management and interfacing computers. Too much reliance upon the hardware of the system delivers, we find, little of value beyond a computer printout, which is usually irrelevant when we seek humane solutions to real human problems which require the full range of subtleties inherent in human cooperation.

The Delaware Resource System carries with it all the usual acronyms and computerized trappings of the thoroughly "with-it" system. It is effective because all of this is grafted onto a base of intelligent commonsense planning and simple, obtainable (not to be confused with easy and pointless) objectives. Part of a statewide network, the system was originated through the Special Education Instructional Media Centers of Delaware. The four resource centers comprising the network

can also access data through the National Center for Special Education Materials and this state network distributes services from the national network intrastate.

The first objective of the system and its component centers is to get print and nonprint resources to teachers of special learners as quickly as possible. A second objective concerns doing the necessary research to find and order the most pertinent and appropriate materials for teaching the special learner. Follow-through on these objectives provides a specific and direct program focus, some components of which include:

(1) distribution of the latest information and research data about services and resources available to or for special learners;

(2) demonstration of the use of special instructional materials;

(3) sponsoring or assisting school districts to present staff development workshops;

(4) providing information about commercially prepared instructional materials, and an assessment of their usefulness;

(5) providing a computer-generated catalog of all materials housed in each of the centers in the system.

The Delaware Learning Resource System is part of the Delaware State Department of Public Instruction, and serves 656 teachers of more than 24,000 special learners. Clearly, the unification of educational support services for special education into a strong state level system is a good idea, given the state's small geographic area, for the state agency provides an effective centralized focus, some equalization of the quality of learning opportunity for children across the state, and some impetus for getting things done at the local level.

Before the present system was established, several networking arrangements were tried. Most of these were tied to local school systems, or they had a college- or university-based research focus. In the early seventies, just before the explosive growth of special education emphasis and programs, a two-page dittoed catalog of Delaware's special education holdings seemed sufficient for everyone. Things were handled in such a casual manner that anyone who wanted

something from the two-page listing just drove over to Dover and got it. You could do that sort of thing in Delaware (and in many other places too) to satisfy the demands of the special learner as it was perceived in 1970.

Then came the great awakening and the anticipation of federal intervention to come. With bewildering speed, the catalog of special learner materials zoomed to 389 pages, and something had to be done to restore order and to permit access and quick availability—the two things, after all, that library media program users care most about. In 1975, the Delaware Learning Resource System was created and many bits and pieces of a system were assembled into a unified whole. Its organizational patterns and service objectives are clearly expressed in a handbook written by Shirley Botwines, entitled *The Special Education Instructional Materials Center.* Easy to read and functional, the handbook sets forth a well articulated philosophy and tells how to provide this specialized kind of service and why it must be provided. It would prove invaluable to anyone who is organizing such services.

Not surprisingly, the computer gives the system an enormously flexible capability to deliver the needed information to the right person at the right time. Two data bases are thus accessed: one identifies materials held throughout the state and their location; the second identifies users of these materials. A sharing arrangement among the State Department of Public Instruction, the University of Delaware, and the four centers apportions funding for the computer program. Abstract searching and updating of the data bases are done centrally and then disseminated to the centers. The university publishes a computer-generated catalog which contains all of the titles of materials held by the system. Annotations in this catalog include title, cost, copyright date, publisher (producer), author, and location. If the material is nonprint, the format is given (video tape, cassette, and so forth). Classification and use indicators for the materials are provided by subject categories designed for special education teachers at the University of Kentucky. Sample subjects are reading, phonetics, deaf and/or blind, games and aids, perceptual motor skills, and study training skills. Access through such

conventional subject headings as social studies, science, and English—grammar, is possible, too—and a title and series index is available also. Special searches within strictly limited areas are a useful service component. For example, a teacher can request and be provided with a printout of all materials published by a particular company, in a specific subject area. Available at all times, the service may be used by anyone who can sign into it and access.

The time saved in doing extensive bibliographic searches is but one aspect of the usefulness of this program. Just as important, if not more so, is the potential for locating specific materials for quick interlibrary loan; the cross-referencing of materials by subject and format to provide tailored bibliographies—we should perhaps say, mediagraphies—of the newest and most useful materials; and the capacity for matching particular media formats to specific special learner needs. Two thousand copies of the system's computer-generated catalog were printed and made available throughout the state. Every teacher of students requiring special education may receive one, and every school and program is provided with one. Thus has Delaware's program foreshadowed the future for many library media programs, for the statewide collection is literally put into the hands of every professional and access, that essential precursor of use, is guaranteed from the outset.

The data base which features indications of use for the system's materials is developed and updated as it is used. First-time borrowers are assigned a client number and a profile as to name, address, kind of classroom (regular or special), teaching level, and type of exceptional child being taught (autistic, emotionally disturbed, blind, etc.). From then on, every item borrowed is registered by client number so that there is correlation between who is checking out material and what is being checked out. This, too, gives an exciting glimpse into the future when indications of the suitability of an item may be shared, and a profile of teacher use of instructional materials may be of tremendous assistance in evaluating the collection and in purchasing materials.

Each of the centers in the Delaware system is supervised by

a local education agency, although center managers report to the State Supervisor of Exceptional Children Programs/ Special Schools at the state level within the Department of Public Instruction. This is a unique and effective concept of checks and balances to ensure that each of the four centers responds to, and reflects the needs of, its local users, while maintaining at the same time, state-wide standards of service and evaluation. It represents also a pattern of providing educational support services which looks to us very much like the wave of the future whose roll toward us will be greatly accelerated by the demands, and the responses to these demands, of special education programs. The managers research, collect, and maintain special education materials and facilitate their distribution within a region. The centers are the point of contact, the link, among the system and its materials and the local districts, the learners, the teachers, and their needs. Services to parents and teachers include providing requested information, duplicating materials, and helping plan and prepare teacher-made materials. The system's decentralized mode is underscored by the fact that each center does its own ordering and processing of materials.

The centers take their linking responsibilities seriously. Monthly reports are part of a management system and require a description of clients and details of the services requested and provided. All of these data are transferred into the computer data base so that trends may be quickly noted and responded to. It is this use of the most advanced forms of technology to respond precisely and quickly to people needs and expectations that gives the program one of its most exemplary dimensions. The computer is not used as a genius assigned moronic tasks of accumulating data for the sheer electronic thrill of it. Rather, the computer is used to sort and document, and thus to improve instruction by making use, evaluation, and locational assistance available.

In addition to the core services, there are other activities by the resource system which keep it constantly before the eyes of its public. They include participation in workshop and staff development activities; printouts of materials selected from among all of those held in the state and generated on

request for use with preschool or adolescent populations; and a trimester newsletter. This newsletter spotlights capsules of news about special education across the state and alerts parents and professionals about legislation, state and national development, and other useful information. Undergraduate students majoring in special education receive training at the University of Delaware center, and this is considered an integral part of their preparation program.

And so this statewide Delaware program provides a black and white photo of a grassroots oriented network for special education, a program with strict, although not rigid, standards which produce uniformly good service patterns and opportunities. Said an observer, "If there is a piece of information, a test just published, a book or an audiovisual item that a teacher has read or heard about, the system will try to locate that one piece of information or material and get it to the teacher who needs it." No more could be asked or said of any program.

Exemplary Program Elements
1. Establishing that networking systems, relying on advanced computer technology, can provide individual service to teachers and special learners.
2. Using computer technology to directly improve classroom instruction through quick access to information about appropriate instructional materials.
3. Establishing network systems, with local autonomy but statewide standards, for service.
4. Imaginative combining of services to varied groups, ranging from parents to college students, to improve special education programs.

METRO EAST CENTER
Georgia Learning Resources System
Scottdale, Georgia

Research done for this book, including extensive reading,
the site visitations, and conversations with many knowl-
edgeable people in the field of learning leads us to the conclu-
sion that the special education movement is going to effect
some revolutionary changes in American education; in fact, it
is already doing so. It is among other things a political move-
ment, and it is forcing change. Witness, for example, the
impact of the cooperative efforts being undertaken by hun-
dreds of localities, regions, and states to help those profes-
sionals who must cope with the extraordinary demands made
upon them by special education programs. They are changing
teaching styles, developing new uses for materials, obtaining
the right of equal opportunity to learn for a large disen-
franchized minority by means of individual educational pre-
scriptions, and more.

One such cooperative is Metro East, one of sixteen centers
in the Georgia Learning Resource System (GLRS), and part of
the national network of special education resource centers
that are leading the way toward change and shaping the
future of education. In truth, cooperative educational service
centers were pioneered much earlier in some states, long
before the traditions of local control of education began to
break down before massive infusions of federal monies and
mandates which regulated such matters as equalization of tax
effort to finance local education. But now, the need of educa-
tors to have access to a great deal of information about special
learners of all kinds, and the vast range of educational pro-
grams that must be made available to them, have made educa-
tional resource support centers an explosive growth
component in American education. The need for information,
assistance with methods, and special materials required to
mount successful programs has simply overwhelmed all but
the wealthiest and most far sighted school districts.

Networking, the most commonly used term to describe the process by which institutions or organizations such as schools or library media centers engage in an exchange of information, services, materials, or equipment has received a tremendous boost from the demands of special education. The purpose is for each participating institution in turn to receive a benefit it could not on its own provide, and to share its own store with others. Networks may consist of just two or as many as a hundred or even a thousand organizations or institutions. The end result should be, of course, to serve clients/users more effectively.

Special education programs are having a tremendous impact on the way schools, educators, and library media programs do their work. It is obvious that no single classroom or school building or library media center has the human or materials resources to afford a diversified, quality special education program. The programs are simply too expensive, too specialized for their demands to be met from limited resources.

Metro East, a unit of the Georgia system, typifies the other fifteen GLRS centers, yet it displays unique capabilities and activities that set it apart as exemplary. Anyone who works with special learners may use the centers' services. The range of those who use Metro East is extensive and includes teachers, college students, counselors, administrators, therapists, and others.

Serving that part of DeKalb County, Georgia, which is a part of the Atlanta metropolitan area, the Metro East program is headed by an educator with a master's degree in teaching children who are gifted and talented. His teaching experiences decidedly enhance his ability to relate well, with understanding and intelligence, to the large numbers of professionals who turn to the center for help. The professional is assisted by a full-time secretary, and both work a twelve-month year. Note, please, the similarity between this set up and that of school library media centers (except that most of the latter have no full-time secretary)—a low level of staffing, with high expectation by administration that services will be delivered to clients, matched by an intense motivation on the

part of staff to meet this expectation. An observer who visited the center described the director as "knowledgeable, energetic, and enthusiastic, with a personality that encourages many teachers to seek—and use—resources from the collection." Good descriptors for any able library media specialist, too, are they not?

Metro East presents a library media program which encourages users to preview materials, to borrow them, and to use them actively in staff development and teaching activities. Included in the collection are diagnostic and testing materials, professional materials, and instructional materials to be used directly with learners. Materials represent a healthy balance between theoretical and applied knowledge, and all have a multiple use potential greatly increasing their value. One important result is to help professionals to make well informed decisions about the selection and acquisition of instructional materials after they have been previewed and used with learners. The ability of the network to improve the selection and acquisition process at the building level is to be applauded as having a beneficial impact upon the quality of special education programs.

But selection through preview, even good preview, can still be a passive matter, and the center has taken upon itself an active staff development role. Through workshops, meetings, and conferences, it helps professionals to learn new or improved teaching techniques, highlights improved media use with special learners, and demonstrates use of innovative materials and how to work with equipment. Comparisons with the effective school library media program are again inescapable. The center director maintains a heavy schedule of outreach programs which take him before PTA groups, school faculties, service groups, and others who seek or should have information about the center's activities. Selling the program and recruiting new users are important aspects of this information program.

The center abounds in acronyms, almost to the point of irritation: project STRETCH (Strategies for Training Regular Educators to Teach Children with Handicaps) is but one example. This is, in fact, a staff development course which

fulfills a requirement of the Georgia State Department of Education which all teachers must now meet when renewing their teaching certificates: to have completed successfully a five-hour course in teaching the exceptional child. Obviously, the numbers of teachers who must fulfill this certification requirement severely tax the ability of the colleges and universities to meet their need, so STRETCH is most welcome by whatever acronym. A competency-based program which emphasizes the applications of knowledge over theory, it is a marvelous testimonial to what one competent person can do when imagination is married to energy and determination. The program is individualized through innovative uses of audiovisual materials and programmed learning, and meets a wide range of special education and teaching needs, including those of teachers who have been recruited into teaching special learners. It is a fine lesson in how less can be made to do the work of more, and it works here, although not generally recommended as the best kind of program planning.

An additional unique program dimension is provided by a video tape collection which records many of the excellent special education workshops that have been conducted throughout Georgia. This permanent record of workshops and programs on many aspects of teaching, learning, and the use of materials is an effective staff development tool, and provides the substance for many programs which allow excellence to be shared and reused. Additional resources are available through the national network. In dealing with the special learner, seeing the materials to be used is a necessity. All the world's words cannot help the teacher or library media specialist who must suddenly face up to teaching the emotionally disturbed or otherwise handicapped learner who has been mainstreamed into the classroom. The belief that to know more is to understand more is misleading in many cases, and it is downright dangerous in special education. The video tape library at the Metro East Center helps teachers to see and to do.

In fulfillment of its network function, the GLRS center also serves as an information exchange center. Programs, services, materials, and meetings—anything to do with improv-

ing the professional's ability to meet better the demands of special education—flow through and are interchanged and exchanged here. It is this educational cross-fertilization, something which comes only from an exchange and interchange of ideas, that makes this center, and others like it, truly revolutionary. The past has shown us that it is valid to expect that persons will change for the better to the extent that they have good models to follow and good information to use. But it is naive to expect that teachers will change of their own accord. The GLRS system, and Metro East, accept this fact of educational life, not in resignation, but as a challenge. Any exemplary library media program would see and accept this same challenge.

Structuring the introduction of professionals to innovative ideas, materials, and services to be used with special education students across the nation is, after all, a quantum leap ahead of the casual exchange of ideas over coffee, during lunch, or even during a more formal planning time. Access to the Educational Research Information Center (ERIC), Computer Based Resource Units (CBRU), and Master Analysis and Retrieval Systems (MARS) are the tools of tomorrow already here, and the GLRS system, of which Metro East serves as a leading example of excellence, accelerates this move toward a future which assures that a strong and progressive networking system will carry innovation for all teaching and learning, not just for special education.

Exemplary Program Elements
1. The use of a national access network to deliver materials and services to classroom teachers and library media specialists.
2. The use of an educational support center to provide staff development programs to improve educators' abilities to teach special learners.

3. The development of an effective preview program to improve the teacher's ability to evaluate and select instructional materials.
4. The close relationship of the Metro East center to the other regional centers which strengthens the statewide support system.
5. The excellent use of limited staff to provide extensive instructional services.

CHICAGO REGIONAL PROGRAM
Title I
Chicago, Illinois

Title I of PL 89-313 provides funding for supplementary educational services to learners with limitations so severe and complex that they cannot be mainstreamed into a regular educational environment. Profoundly mentally retarded, deaf, deaf-blind, multihandicapped, orthopedically impaired, and emotionally disturbed persons are the primary recipients of this program's assistance.

It is not especially to the Chicago Regional Program's library media component that we look for innovation or exemplary activities. We have observed that many library media programs are at their best where they are dealing with special learners in a regular or nearly normal learning environment, and special problems are being met and dealt with as a matter of degree in a program of individualizing the learning of all the learners in the school. Rather, it is through the applied curriculum development and its direct teacher support that the Chicago Title I program best establishes its identity as outstanding, and achieves its highest purpose.

Indeed it would be quite extraordinary for a building library media specialist to come into contact with many of the kinds of services and programs which such a highly specialized program provides. Why then report it? Because a purpose of this book even more basic than describing good library media programs for special learners is to relate the quality of library media programs for special learners very directly to the teaching of these children. A major theme, perhaps even the major theme, is that the library media specialist who expects to play a major role in the special education program must sharpen teaching abilities to an extent rarely achieved previously by our professionals. Dramatic improvement of this capability is our overriding interest. By reporting here a teaching program that is focused with great intensity upon a single area of the whole special educa-

tion spectrum, we hope to encourage library media specialists to emulate the principles of careful planning and goal setting in the teaching process which it demonstrates.

The library media program itself is charged in this program, we regret to say, with such trifling duties as "locating overdue materials and calling them in"; "keeping files of lost, stolen, and incomplete items"; and "checking materials in and out for loan." Clearly some consciousness-raising is needed here, for such definition of the role of the library media program bespeaks a program mired in the unlamented past.

The point is that examination of the instructional process established here to meet the needs of severely handicapped learners with highly specialized needs will yield several significant lessons which deserve consideration by school library media specialists who want to become more effective teachers. Also, such matters as developing a proper needs assessment, creating the IEP, and other tasks inherent in the development of excellent learning programs and teaching techniques for special learners have applicability to many kinds of library media programs, if they are viewed from that perspective. There is a good deal to be gained, too, from examining programs that are not just adaptations with a shift in emphasis in the direction of special education, but are instead programs built around the severely handicapped learner from the ground up. The contrast is great and can furnish some important understandings.

Too often from our observations on site visits and from conversations with persons using the services, we found that regional programs base their planning upon high hopes and hyperbole, but that when it comes time to deliver, services come dribbling through in sometimes muddled fashion. Promises of support and help are made, but not kept.

The path of the regional educational support program is always a thorny one, and there are bound to be critics aplenty, sometimes with reason, sometimes not. The notion that educational change and innovation are best initiated at the building level clings like cockleburs to the fabric of American education. This notion is a deeply entrenched article of faith. Certainly change and innovation must be accepted and re-

fined at the building level until they take hold in the individual classroom, but research and experience does not bear out that they are usually initiated there. It is obvious, especially in the area of special education, that the single building is most often lacking in resources—knowledgeable persons, effective leadership, appropriate materials, and a strong commitment to change—which lead to innovative methods and programs. Just the effort to get educators to admit that this might be true has forced many regional educational support programs into strident proclamations of their worth, and into claims and promises beyond their ability to deliver. Yet, some chutzpah and plenty of communication are necessary to establish an identity and to let potential users know what help is available to them. Striking a happy balance is essential, in this as in so many other things.

A brochure describing the Chicago Regional Program points out that it offers the advantage of:

(1) establishing a communications system among buildings and district programs;

(2) providing improved coordination among personnel;

(3) building accountability into programs;

(4) establishing clear, measurable objectives; and,

(5) creating a common evaluation system for programs.

We can only say that if library media specialists working within the school's instructional program could cite their objectives and their value in such a concise way, then the chances of their success would multiply dramatically. Let us quickly demur, though, that this advice cannot be taken too literally, for the ebb and flow, the rhythm with which the library media program supports the school's instructional program cannot always be so neatly put in service contract form as this. But it is through the process of orderly planning and a willingness to complete the commitment through the evaluation stage that we are able to project our purposes.

In the matter of curriculum development, the Chicago Regional Program blazes a trail that library media specialists can follow. Although library media program leaders have vigorously encouraged specialists to assist teachers in development of curriculum, most have fallen far short of actu-

ally doing it. Usually this happens because the task is too broadly stated to get a firm grasp on it. Better to attack one piece of it at a time. Instead of working on a new science curriculum at one time, identify specific curriculum-related instructional objectives, and then develop appropriate methodologies and material toward achieving them. This narrowing of scope does not, by the way, limit the contribution of the library media program to the instructional program, but provides for more immediate feedback and a greater chance of success and visibility for the library media program as a curriculum associated service. This straitening focuses and maximizes the library media specialist's contribution instead of diffusing it over a wide area.

Some of the curricula prepared by Title I personnel associated with CRP are worthy models. Examples include:

a developmental art curriculum for severely retarded children
a decision-making unit related to job awareness
an IEP in-service materials manual
a speech improvement unit

There are more than 180 such special curriculum units developed especially to meet identified needs. The development process adapts techniques associated with learning activity packages, or the Title III and Title IV-C *Educational Programs That Work*. All of these are intended for replication, and don't have to be reinvented.

We recommend that more library media specialists adopt this single-purpose instructionally based unit approach to curriculum design as a model, and try it out. By isolating specific curriculum areas in which instructional media support is essential, some quick successes may materialize, and a high degree of visibility for the library media program, plus intense teacher satisfaction and appreciation, may develop. These are all key elements in forging a successful relationship with teachers and the instructional process, and what better place to start than in the area of special education, where so much help is needed and will be welcomed by teachers.

This concept of curriculum building, based upon one instructional objective at a time, will help teachers plan and carry out. Replication from classroom to classroom is a primary purpose, for as curriculum-based units are developed they can be shared with other teachers once their worth is established. These ready-to-use units can be slotted in wherever and whenever they fit. What a service! Of course maintenance and updating are important, for just as no curriculum can remain static, neither can the material which supports it.

Other major activities of the Chicago Regional Program should be considered in establishing how the library media program relates effectively to the instructional program for special learners. These include staff development to improve the capability of teachers to utilize CRP's services effectively, and development of new materials.

Using an educational support program such as CRP to define some important priorities for library media program planning is an example of the kind of looking around we should be doing in connection with establishing a new dimension of service for special learners. While it is not the library media services of the Chicago Regional Program that have much to offer that is exemplary, the program itself, with its disciplined and focused approach to tailored learning offers important suggestions about organizing more effective library media programs for special learners.

Exemplary Program Elements
1. The development of original curricula to meet specific teaching needs.
2. The use of needs assessment to establish measurable objectives and establish goals.
3. The identification of staff development programs that will lead to improved use of programs and services.

SOUTH METROPOLITAN ASSOCIATION
Regional Inservice, Media and Information Service
Harvey, Illinois

In a book devoted in some part to providing a survey and overview of the ways in which a number of networks or cooperative associations has been formed to bring improved services to special learners and special education teachers, it seems useful to cite and describe excellent programs that can serve as models. Yet, reporting only successful programs is a little like having only partial vision: you see only a skewed picture of what is really going on. We thought it was important to take a look at some programs that were just getting under way, often powered by little more than an active sense of need, hope, and expectation. Many such programs come to unhappy endings after promising beginnings, but others with rather unpromising beginnings can have spectacularly successful fruitions.

Many of the newer regional educational support centers were established because something had to be done. Their goals and services are rooted in pragmatism. They reflect a belief that they are working with people, not with systems. Often the initial struggles of such programs show a passionate commitment which somehow overcomes many an uncertainty and lack. So we have included one or two sites whose aspirations still outrun their product, whose accomplishments remain to be validated, but whose intentions and plans look excellent.

Such a program is that of the Regional Inservice Media and Information Service (RIMIS) of Illinois. RIMIS is part of a legal entity encompassing by joint agreement 55 school districts serving low incidence handicapped, and 4 joint-agreement cooperatives for high incidence handicaps. As we have said, the provision of special services to learners is an extremely expensive matter, so for reasons of economy as well as efficiency the regional support service center has by now found favor in most states and is the most frequently used

method of providing these services. The growing preoccupation with finding the means to provide special education programs of acceptable quality to growing numbers of special learners will probably make these regionalized support centers the main growth sector in the field of education for the foreseeable future.

The primary users of RIMIS are special education teachers, district administrators, and support personnel. One of its major components is a comprehensive library media program designed to meet their needs. As is true with most educational support networks, RIMIS does not provide resources or services directly to students except by special arrangement. It is there to serve the professionals and reinforce their efforts.

The Southern Metropolitan Association (SMA) includes in its service program screening and diagnostic services (hearing, speech, language, neurological and psychiatric evaluation); programs for low incidence handicapped students which include deaf, hearing impaired, visually impaired, autistic, orthopedically impaired, emotionally disturbed, severely behaviorally disordered, and other multiple handicapped; staff development programs; an extensive collection of print and audiovisual resources for use by teachers; and a professional staff which sponsors and stimulates teacher use of materials. These are core services the regional centers must deliver if they are going to make a difference.

Here, as with many such ventures, facility counts for little as long as there are minimal areas for offices, a library, a production unit, storage, and conference and preview spaces. Also it is not the budget to which one looks to predict success in the enterprise, although at the $235,000 level in 1979 it was impressive enough. About one-third of the sum comes from ESEA Title I, but the bulk of it comes from professional development monies made available through PL 94-142. While program scope, facilities, and budget are certainly descriptors of this or any other such program, they alone cannot help us surely to predict effectiveness or failure.

The key word in doing this is *attitude*. From a review of the first two years of the RIMIS program it is clear that the prevalent attitude predicts success because the chief focus is

listening to what its users want and need, and upon creating a dialogue and planning involvement opportunities with those the center serves.

For example, careful attention is given to communication in writing. A newsletter starts off the year with the pledge that the central program priority will be to help teachers and administrators to cope with the mandates of PL 94-142 as they are put into effect. Front-line school personnel know that there is a place to turn to for assistance. Then, RIMIS also attends to such things as "the development of public aware-ness materials for SMA programs, such as brochures, news-letters, videotapes, and slide films." The staff "develops student diagnostic tests as well as teacher training media." RIMIS's communications with those it serves are frequent and intensive. Readers will have noted the similarity of these efforts to those of an excellent library media program.

Great hope for this program's successful mission lies also in the excellence of its long term and short term planning, and the care with which its needs assessment is performed, to determine what needs are to be met and setting priorities before trying to meet them all. RIMIS approaches needs with candor and a clear conviction that it can do something useful about:

(1) the need to develop a coordinated, regional program of staff development;

(2) the need to inform a much vaster audience of the ser-vices and programs available to them;

(3) the need to provide appropriate audiovisual equipment for staff development programs; and,

(4) the need to create more extensive programs to develop materials for special learners and for teachers of special learners.

Again, the similarity between these concerns and those of most building library media programs is quite clear and reinforces the potential for a close and productive working collaboration between the teacher of special learners and the school library media specialist.

The Southern Metropolitan Association's program state-ment faces up directly to problems and challenges and pro-

poses definite ways in which to meet them head on. Specifically, in the area of staff development, RIMIS proposes to survey more than 1,000 educators in its service area to find out from them their five highest priorities concerning staff development needs, matters relating to PL 94-142, and the establishment of mainstreaming methods and programs. Having determined specifically what people feel they need help with, SMA/RIMIS commits itself to a series of staff development programs, using additional and appropriately trained staff developers who can structure workshops that provide the priority help needed. To be sure, funding level does have an impact there, as the ability of SMA/RIMIS to bring in outside experts to extend and reinforce staff development opportunities is not available in many cases, and usually not to the building level library media specialist. Sharing and resource pooling arrangements, however, could make it possible.

Another indicator of growing effectiveness for RIMIS also is its commitment to plan and deliver services which meet the expressed needs of users beyond just staff workshops. A directory of staff development resources that would be locally available to teachers is planned. Allied to this, the development of three training packages will also address high priority needs. These training packages deal with the provisions of PL 94-142 and Section 504 (Rehabilitation of the Handicapped Act), with mainstreaming, and with the identification of handicaps of various sorts. They are composed of locally and commercially produced materials including videotapes, filmstrips, motion pictures, and other audiovisual materials used in workshops and staff development programs.

To increase awareness of RIMIS among its constituents, an increasing number of press releases is sent out, and other public relations and public information programs have been established. Videotapes and slides of SMA programs which cover a wide variety of topics related to special learners are available, and their use has significantly increased the number of people who know what RIMIS is doing and use its services.

An interesting and exemplary program goal is to give some of the special education students enrolled in other SMA programs the opportunity to gain some media skills and work experience by working in the library media program. We don't know how this admittedly ambitious plan will work out, but given the way in which RIMIS has set out to achieve its other objectives, we believe that this and other plans will probably meet with success. Where the blueprint for action is comprehensive and reasonable, and where it is based upon conscientious efforts to determine the real needs of those to be served, there seems to us to be much promise.

Exemplary Program Elements
1. The careful use of a needs assessment to determine program priorities, both short term and long range.
2. Involving users directly in the needs assessment process, thus ensuring them a voice in assistance provided to them.
3. The determination to adapt program objectives to user needs and objectives.
4. Mounting a strong staff development component to help special education staff to improve their performance on the job.
5. Imaginative use of videotape and slides to create awareness as well as to train.

LAWRENCE LEARNING RESOURCE CENTER
Lawrence, Kansas

The phenomenon of library media programs for special learners being linked in some sort of regionalized educational support system has been reported extensively in this book. Already the regional support system targeted at special learner programs has become a permanent fixture although there is, to our knowledge, little to substantiate that there are no better alternatives. As Frances Fitzgerald has pointed out in her book, *America Revised* "most educational theories can be neither proved nor disproved." Fitzgerald notes further that the lack of proof to support most theories (and, by extension, experiments) almost guarantees that "almost any idea about education has a chance of being taken seriously if it is accompanied by enough noise."

The disastrous end to which too many of these educational vogues come is evident in the number of failed movements from the past decade. And there is need for special vigilance in special education programs because there is money and power at stake, and there is pressure. Too many programs have already in just a short time shown themselves to be long on promise and short on delivery. The success of a program in education should be measured in terms of goals accomplished, and not in terms of accomplishments claimed. It is not difficult to confuse the two, but they are vastly different.

We have been pleased to find and report that the successful regional educational support system does in fact incorporate many of the same exemplary elements one might identify in any excellent library media program we have reported. These include that a program was:

(1) established to meet a need previously identified;

(2) the result of extensive cooperative planning about what was going to happen and how it would happen between the regional center and the schools it serves;

(3) run by a competent staff who understood the program's goals and were able to translate these goals by word and deed into concrete programs for the participants;

(4) supported financially by its member agencies; and,

(5) used for consultative program leadership by the sponsoring agencies.

The professionals who run the Lawrence Learning Resource Center believe that satisfying these conditions has been the most important reason for the program's success. And we think they are right.

We have noted a common predisposition in many of the regional support systems to oversell what they can do and to be tempted to offer salvation from whatever educational affliction a school or school district is gripped by. This impulse is difficult to resist because so many schools are prone to look beyond their own resources for the solution to their problems. Their vulnerability to the promise of the "easy fix" is coupled with the regional support system's belief that whatever they do is bound to be right. Inevitably, the result is disappointment and loss of confidence by those being served. With the loss of confidence comes the inclination to ignore the regional center's services, and the center is cast adrift.

Fortunately, an analysis of some evaluative reports on the Lawrence Learning Resource Center, a review of services provided to its clientele, and the observations of a visitor to the program, combine to provide an instructive look at the "how-to's" of a successful program. While it may seem to be working backwards to review a final evaluation before describing the program, here it serves to set the stage: "Most school system programs are doomed to failure if their goals, and the services they provide, are not useful to or needed by their clients.... The soundest evaluation of the LLRC program comes from the fact that the teachers use it, and so support for it is continued and expanding."

Some aspects of the carefully coordinated programs include the following.

(1) The center's materials are inventoried and catalogued centrally, but are disbursed on a decentralized basis throughout the system. An efficient delivery system guarantees that no teacher's class is ever more than a few hours from necessary materials.

(2) Evaluation, previewing, selection, and purchase of ma-

terials are done centrally, but only upon teachers' request, reflecting a high degree of cooperation among teachers as well as marked economy and efficiency in purchasing.

(3) Teachers exhibit a high degree of willingness to share materials because they are confident of having access to what they need through the delivery system.

(4) Teachers use the consultative services of the LLRC for staff development programs to help them improve their ability to teach special learners, as well as to locate and use special materials. Staff development activities include demonstrations of materials and techniques in using the materials well, plus assistance in diagnostic testing and prescription of appropriate teaching methods.

(5) Teacher access to information about materials and services is insured through a computer-generated catalog. These catalogs are available in loose leaf form to every special education teacher, and others as well, and provide instant access to a wealth of material.

The staff of the LLRC consists of: a director, whose responsibility is administration as well as development of a range of special education programs from those for the visually impaired to those for the gifted; a Learning Resource Center coordinator, whose day-to-day responsibilities include coordination of program activities, developing needs assessments involving library media programs and materials, helping to plan and produce effective library media programs for handicapped learners, coordinating staff development programs, and operating the purchasing, cataloging and distribution of the center; a materials consultant who works directly with the classroom teachers as a staff developer, helping them to use media more effectively and to improve their teaching abilities with special learners; and a secretary.

We note here, not by way of criticism really but by way of reporting facts as they are, that the LLRC program, while in all ways an exemplary library media program, does not utilize the services of a professional library media specialist, and it is not the only one that came to our notice during the work on this book. We certainly deplore the absence of the professionally trained and certified library media specialist, especially

in many of the regional programs we evaluated. More than one program observer and evaluator noted this unfortunate phenomenon, and their collective observations may be expressed as, "they are operating an excellent library media program, but they don't have a library media specialist." Yet of what use is it to lament over this? We think we would do better to try to learn something from it. There is undeniably a momentum to many of these programs, momentum powered by success. We are fully aware that in cases, such as this one, where we have cited programs as exemplary in spite of the fact that they are not run by library media professionals, we shall be criticized by some for holding them in high regard. We have taken the risk because it is an issue we, all of us, would be foolish to avoid. We believe we would do better to study the success of such programs, why they are having such significant impact, and analyze why these library media outreach efforts (and that is what they are) *without* a library media specialist can do so well without us. Maybe the people who run them have some methodologies we could adapt; maybe they know something about teaching, leading, facilitating, and in general working with people, that we could learn how to do better.

Excellent media use by teachers and by learners pervades the LLRC's operation. The goals of the center and the objectives by which these goals are achieved are modest and tactful, and applied with certainty and clarity of purpose—a compelling combination. The center took as an initial goal demonstrating the positive effect of good library media use in the teaching of special learners. Closely allied to this was the goal of demonstrating that a library media program to support the special learner program could be made cost effective. This latter goal is, of course, of the highest order of importance to many library media programs whose financial resources are stretched dangerously thin.

Some important decisions were made relating to this matter of cost effectiveness. One was to keep the materials and equipment close to the classroom where they could be readily available to teachers and learners. Decentralization was therefore the course followed, an unusual choice in a time of

high centralization, but it was made possible by a highly developed management system which inventoried and cataloged all materials available within the system. As additional materials are purchased, they are added to the master inventory and disbursed to the schools. A computer solves the puzzle of how a highly centralized system can be maintained in a decentralized mode. But knowing the materials exist in the system is only half the story; one must be able to get at them quickly. A passenger van delivers both materials and handicapped learners to schools. The usual time lapse between request and delivery is two days, but since the van is on a daily run, same day service is possible. Herein lies the economic viability of the program, for costly duplicate school buying is unnecessary, and maximum use of existing materials is guaranteed as the items move about the schools. The whereabouts of items can be ascertained at all times through the center.

Computer-generated bibliographic searches are a major service to teachers as well. Computer-assisted searches allow teachers to be informed about available materials, encourage exchange of materials among teachers, eliminate the need for a cumbersome and inefficient card catalog, aid teachers in writing IEP's for their students, and assist teachers in locating materials by title or by publisher. This is impressive, and it shows clearly the potential of technology to help the classroom teacher become a better teacher. This is far different from the money-consuming generation of useless information at the whim of some research freak who is overdosed on floppy discs! Here we see technology really used to improve teaching and learning.

Sound program support through a combination of funding sources is another evidence of success, too. The largest segment of the money ($25,000) of the start-up budget of $90,000 came from a federal grant. However, the state of Kansas, the school district, and the University of Kansas all contributed directly to financing the program to get it started. All of them can be pleased with its effectiveness.

Exemplary Program Elements
1. The use of decentralized programs to house instructional media and equipment, while devising a system to move it efficiently to gain maximum use.
2. The use of excellent planning techniques to develop more cost effective library media programs.
3. The use of computer technology to improve the teacher's ability to use and locate instructional media.
4. Cooperative and imaginative use of federal, state and local funds, as well as university funds, to establish a program.
5. The excellent use of a review and examination system to ensure teacher participation in the selection of materials.

MISSOURI SPECIAL EDUCATION
Instructional Materials Center
Columbia, Missouri

The Missouri Special Education Instructional Materials Center (SEIMC) presents an organizational pattern similar to that of most other regional support programs. The regionalized support system which provides leadership and materials for special learners and special education teachers is very much in vogue and words like "linkage" and "resource sharing" are as much "in" words for special educators as they are for library media folk.

What then separates SEIMC from the hundreds of other regional support programs we examined and might have included in this book, but did not? It provides very much the same services and the usual opportunities for staff development as other systems, but there is about this program an aura of assurance that communicates to users that it has something of value and intends to be around for the long term. It does its job with a style and flair that sparks a strong commitment to the program and a desire to see it achieve its purposes. It is as far as can be imagined from the regional special education support program which springs into existence with no visible relationship to the past of the teachers or the schools with which it does business, and with few plans for the future save doing what turns up. The ability to tie in to the accomplishments of the past and to show in the present how its existence is making life better for the student, the teacher, the administrator goes a long way toward helping the regional program feel secure enough to make plans for its future. In observing the SEIMC operation, there is no feeling that there may be no tomorrow if funding dries up, or a dynamic coordinator or director moves on to a more secure haven; SEIMC brings an almost laser-like concentration to bear on achievement of its goals. Its contributions toward helping teachers, parents, and students to be more effective in their relationship with special learners are abundantly evident. A program so pallid and

timid that it hides its light and its program under a bushel and conveys nothing to anyone about what it is doing or supposed to be doing is just as bad as one that promises what it cannot hope to deliver. Creative outreach which promotes increased program use and guarantees continued growth is a valid part of any program's responsibility; SEIMC meets this responsibility all the way in a manner that attracts educators and others to it. SEIMC has, in short, projected a self-fulfilling prophecy of excellence.

The SEIMC pays attention to what is important to its clientele, eschewing trivia. Too many regional support systems, we have noted, mirror the individual school program in their preoccupation with finding solutions to matters which do not really matter very much; how to tally the milk money becomes at the regional resource level an empty-headed, single-minded commitment to discovering a better way to store transparency film. The SEIMC staff cannot be observed concentrating on the inconsequential, to the detriment of teaching, learning, and everyday sustaining assistance to teachers and other school personnel.

SEIMC's newsletter goes to every teacher of special learners in the state of Missouri, and exerts a significant influence toward excellence upon those to whom it reaches out. These teachers are, of course, teaching across the entire range of special learners from the mentally and physically limited to the behaviorally disordered as well as the gifted. Users of the center are able to review materials before their purchase; compare curriculum guides from other states or regions; locate names of specific instructional materials for use in prescriptive teaching; locate names, publishers, and prices of materials; locate supplemental but vital-to-them information about special learners of particular types; examine professional books, journals, and other materials about the education of special learners; locate details of titles, prices, and publishers of screening or diagnostic instruments, and examine them to see which are the most appropriate to their purposes; and examine materials which present new ideas and methods which can be used by special education teachers to improve teaching or diagnostic/prescriptive abilities.

These aids, being commitments from the center to its clientele, are thoroughly followed through.

A recent issue of the newsletter highlighted the center's resources and services for improving gifted and talented programs. A commitment to this area of special learning is as frequently overlooked at the regional level as it is within the individual school program. That portion of CITE-gifted that is carried out by the center with funds from the U.S. Department of Education is described, and its purpose stated: "To identify those areas of knowledge, skills, and abilities which help deliver effective instruction to gifted and talented learners in public school settings." The primary thrust of the program is to help colleges and universities prepare better teachers for the gifted and talented learner; a secondary one, to assist local school districts plan and deliver appropriate staff development activities.

While the SEIMC's program for the gifted is only a relatively small part of its work, it feels a serious responsibility in this area. One notes here, too, the influential role of the State Department of Education in these programs, providing a clear substantiation and illustration of what we have said elsewhere—several elsewheres, in fact—in this book: special education programs do portend the increasing power of the state to mandate, supervise, and evaluate. While this is a cause for high anxiety in many school districts, the wave of the future is interpreted sensibly and reasonably here, and the SEIMC program is instrumental in de-escalating confrontations before they occur. Its program has proved to be a rational and effective way to reassure educators that the power of the state to improve special education programs need not be seen as a threat.

The center's newsletter announces, in one issue, the availability of a brochure about gifted learners. It is offered in the hope that school districts will use it to assure community support and teacher understanding and acceptance of these programs. *Education for Gifted Students* is intended to stimulate interest in gifted and talented education and to encourage widespread participation in developing it. The fact that the state so unequivocally and openly supports this develop-

ment is a matter of great moment, for in most states such
support is either nonexistent or furtive and of little or no
value.

Another extraordinarily valuable contribution made by the
center is made through its close involvement with the profes-
sional preparation of those who will one day teach special
learners. Because the center is located on the University of
Missouri's campus, its association with the university is close
and a tremendous bonus. Students enrolled in the Department
of Special Education are scheduled to use the center whenever
appropriate. Researching, reviewing, evaluating, and using
these materials and keeping informed about new instruc-
tional developments help to confirm to the future teachers
that a rich world of outside resources must be returned to
constantly if an excellent job of teaching special learners is to
be done, and instill proper habits and expectations which the
new teachers will carry with them when they go to their
school systems.

Materials in the center are organized into three distinct
categories: reference, child-use, and staff development. The
reference section contains curriculum guides, directories,
samples of legislation, journals and books about special edu-
cation, and more than 200 screening and diagnostic instru-
ments. The child-use section contains instructional materials
in a wide variety of format and subject matter for the children
themselves. The staff development section contains packages
for staff development programs, primarily in-service in na-
ture, which are available for a five-day loan period to Mis-
souri special educators, or for parent teacher meetings,
individual use, or preview before purchase. A telephone ser-
vice helps users locate information, varieties of material
needed, prices, and other required information. It is even
possible for them to find out about recreational equipment for
physically handicapped learners, for example.

Altogether, the SEIMC proves beyond doubt that the stay-
ing power and eventual criterion of success for any program
lies in its ability to follow through and deliver on its promises.
It's called credibility, integrity, or just doing your job well.
Though this kind of excellence may not seem very exciting or

especially new, it can pay off in improved instruction for special learners as its influence ripples out across the state. And that, by any measure, is success.

Exemplary Program Elements
1. The close association with the university teaching programs which prepare future teachers of exceptional children.
2. The careful coordination of services and programs to ensure that they meet local district needs.
3. The high level of commitment at the state level for special education programs.
4. The excellent use of newsletter format to influence all special education teachers, and many parents and community groups.
5. The excellent interagency cooperation (state and university) to provide comprehensive program development.

THE MEDIA DEVELOPMENT PROJECT
for the Hearing Impaired
University of Nebraska, Lincoln

The Media Development Project for the Hearing Impaired is a huge and influential one which has established its simply stated overall goal—to improve teacher use of instructional media and technology—in direct response to specific needs. A university-based research and development program, heavily financed by the federal government, it also depends for its support on private resources (a bequest) and has the resources to move efficiently and effectively, to experiment with all the newest forms of technology, and to adapt them to the needs of the hearing impaired.

MDPHI does much of its work under contract with the Captioned Films and Telecommunications Branch of the Division of Media Services, which has been in the past a part of the Bureau of Education for the Handicapped in the U. S. Office of Education (HEW). This association stems from earlier programs in collaboration with the Specialized Office for the Deaf (1974-77), the Midwest Regional Media Center for the Deaf (1966-74), and a contract with the Bureau of Education for the Handicapped to produce super 8mm films. Its cumulative track record of good performance, of product delivered, not just promised, gives MDPHI enormous credibility as the reliable resource for instructional media it is.

For this book, we generally sought programs of smaller scale and more limited objectives than MDPHI, since such programs bear more relationship to the situations in which most library media specialists do their work. But in the discussion of network/regional resources we saw a need to search out and describe the "big" program that serves the entire nation, carries with it the weight of great authority, and as the result of its pioneering achieves the momentum to mold the future of technology applied to special learning situations, worldwide. The purpose of the MDPHI program and the work that goes on there is not intended to be replicated at other

sites. It is a one-of-a-kind national resource designed to feed into the field innovative programs and practices for teaching the deaf and hearing impaired learner.

MDPHI's objectives are direct and action oriented. There is a cautious tone to what the program claims to do or promises, but the objectives are implemented efficiently and simply and with vigor and sophistication. A review of the program's objectives demonstrates this.

(1) locating and identifying materials to meet the needs of the hearing impaired;

(2) adapting or modifying existing media to meet the needs of the hearing impaired;

(3) developing new materials for the hearing impaired when existing materials cannot be located or adapted;

(4) evaluating newly developed materials through field tests and evaluative resource files;

(5) marketing selected validated materials for the hearing impaired, and improving ways to bring such products into use;

(6) providing a yearly state of the art symposium about current research and use of media and technology in teaching the deaf or hearing impaired learner;

(7) providing liaison within a local, regional, and national network, so that knowledge and skills about teaching the hearing impaired may be made available to the widest possible group; and

(8) sponsoring a field council whose purpose is to incorporate the advice and suggestions of those working directly in the field of teaching the deaf and hearing impaired into national program planning.

Program activities are centered in the William E. Barkley Memorial Center at the University of Nebraska. Specially equipped to provide evaluative, rehabilitative, and consultative services for children and adults with hearing problems (as well as some other limitation), the center is supported by the funds from the bequest. It is staffed and equipped to provide training in methodologies and techniques for teachers of the hearing handicapped as well. Some $275,000 worth of staff carries out the work of the center, a fact which in itself underscores the program's uniqueness.

Description of the program by which MDPHI sets out to implement its objectives is best undertaken by expanding upon the objectives themselves. With objective number one, for example, MDPHI takes as its mission the searching out and locating of *all* potential sources of educational media which can fill the learning needs of the hearing impaired. This alone is an ambitious undertaking as any library media specialist (and most teachers) can attest, but it is a key first step to creating an effective learning program. While catalogs and word-of-mouth recommendations—traditional routes to discovery, evaluation, and use—are helpful, they are unreliable if one wants to determine surely the extent of the universe in a particular area. Determining that a needed product actually does exist, and more important, determining its suitability for a particular group of learners presents a time demand alone which may be impossible to meet for most professional educators, even the most skilled. MDPHI provides a real service, therefore, as it "searches within prescribed areas of curriculum, seeks effective teacher-made materials [a most significant commitment, for these enormously valuable materials are so often ignored in networks], and monitors project reports for information on federally funded products." The maintenance of publishers' files, comprehensive reference tools, and bibliographies central to the search process is an essential part of achieving this objective.

To expand upon the second objective: Adapting existing materials, particularly in teaching the hearing impaired, is a matter of the highest urgency to those working in this area of special education. It can mean, for example, captioning uncaptioned filmstrips, or superimposing important information onto an existing format, or assessing alternative uses of such new technology such as the video disc. The aim is "to adapt existing instructional materials which have been identified as meeting the needs of the hearing impaired learner. ..." The adaptation process naturally requires classroom testing for validating its usefulness. That this critically important service is badly needed for all media use goes without saying, and here is a model. The project's commitment to outreach is demonstrated by its follow-through program

which helps teachers modify instructional materials already in use in other kinds of instructional settings.

Clearly, in a field so specific to the requirements and limitations of clients as hearing impairment, meeting learner needs means not just adapting what exists by way of materials, but creating new ones where a need exists and no appropriate material is available. New products especially planned for these learners are essential. This part of the project underscores the point made in this book's introduction, that special education will require an enormous investment in research and development funds, and the kind of money needed is simply not available under present economic conditions. MDPHI pledges itself to "prepare design requirements for materials, to plan product development, and to work with commercial and non-commercial producers to carry out new product development."

Of course, closely tied to new product development is, or should be, evaluation of its usefulness and effectiveness. Here, in this phase of its mission, MDPHI shows particular strength, for it commits itself to extending the value of its work through field testing, and to the maintenance of a testing/evaluation network to provide feedback about newly development materials and technology. The project maintains an evaluation resource file, which includes field test reports and creates an infrastructure which stimulates new product development and monitors product use with students on a continuous basis.

Allied to this function is the project's determination to "develop improved methods of delivering instructional products to hearing impaired learners." Working closely with commercial and noncommercial producers and distributors of materials, MDPHI "informs professionals and parents about new products and establishes methods of selection and dissemination" as well. This objective helps to increase access to vital instructional materials, and recognizes that knowing where to go for what you need is nearly as important as knowing what your need is.

The programs which spring from the three final objectives of MDPHI can be described almost as one program, relating to

its symposium, its liaison and its field council. Although their purposes are somewhat different, their unifying concern is to provide a broadly based public information, dissemination, and feedback mechanism to tell what is happening with materials and technology for the hearing impaired, and to find out what is needed and how it should be accomplished. Too often we hear that the professions talk only to and among themselves, and often this is true. In this instance, three strands of a public outreach program practically guarantee that MDPHI will be influenced continuously by those who live or work on a daily basis with the hearing impaired. The yearly symposium is designed to present the newest in thought and theory, but its continuing education aspect is to improve the ability and practice of the professional who works on a daily basis with the deaf and hearing impaired. Symposium topics from the recent past included "Career Education and Educational Media for the Deaf Student," "Communicative Television for the Deaf Student," and "Systems Approach in Deaf Education."

The liaison program, second strand in the public information/continuing education effort, ties together a series of programs and institutions, ranging from the National Technical Institute for the Deaf to Gallaudet College, to create more efficient/effective coordination and communication among these mutual interest units and others, all pioneering in the use of new techniques and materials and technology. These coordination activities become even more focused through the work of the field council, which provides for direct "consumer" participation in the evaluation process. The field council's task is to monitor MDPHI, to help insure that the project is meeting the instructional technology needs of the hearing impaired, to assist it in establishing operational priorities, and to insure that it maintains contact and credibility with those who use its products and services.

We doubt that there is a program more deserving of the accolade implied in the word "excellence" than this one. As a unique resource, its goals are broad and clear, and its objectives direct and specific. Although it is not meant to be, nor could it be, replicated in terms of its special field, it can serve

as a model for other special interest projects, and in many kinds of ways. There is much to admire and to emulate: its skillful management of the mixture of large sums of public and private funds; its action and result orientation which lends so much credibility and authority to its program; its continuous commitment to the involvement of users directly into the process of product design and evaluation; and its devotion to the overall goal, that of enabling the teacher and the library media specialist to do a better job with hearing impaired learners. These are all precepts which should be the backbone of any library media program, and they are given new meaning by the example of this excellent program.

Exemplary Program Elements
1. The development of an effective network arrangement to create and evaluate materials and technology needed for hearing impaired learners.
2. The strong commitment to staff development activities to improve the individual practitioner's ability to teach the hearing impaired.
3. The establishment of intensive research and development programs to ensure that new and needed materials and technology come on to the market.
4. The ability to relate theoretical aspects of the program development to practical teaching application in classrooms and library media centers.
5. The recognition that physical limitations have little bearing on how much learners learn, providing they are given proper materials which are used properly by teachers or library media specialists.

ROSWELL INDEPENDENT SCHOOL DISTRICT
Roswell, New Mexico

The pursuit of programs for inclusion in this book included talks with many persons involved with teaching special learners as well as reading documentation provided by the programs themselves, and also included listening to the observations of the site visitors to the programs reported. It was an exhausting but exhilarating task. Early on it became obvious that determining the criteria by which to evaluate and describe excellent programs was going to be more difficult than it usually is with ordinary general purpose library media programs. There is so much that is new, so much that relates to high quality teaching and high program standards, that it is hard to focus on one, two, or three specific indicators of excellence. But no matter what the temptations to report on showy excitement, we kept in mind that we wanted to find models that others could and would be most likely to adapt and emulate. Bombastic claims and huckstering were avoided in favor of commonsense, solidly grounded library media programs that were meeting the needs of teachers and special learners efficiently with a sense of restraint and a taste for simplicity during a period of transition and economic pressures. We found such a program in Roswell, New Mexico.

What the Roswell district library media program has done for and with the special learner reflects many of the indicators of excellence traditionally associated with the outstanding library media program: splendid management; the ability to work within the instructional program as an effective teaching component; the capability for leadership, in influencing the professional staff and changing it for the better; a high degree of responsibility for selection of materials by the entire staff so that these resources relate surely to the instructional program; and a plan, sustained by a vision, for what can be in the future. The Roswell program practices such virtues daily.

This district shares, with just about every other in the country, a common problem which can be known as the "less-

more" syndrome. This means of course that there is less money and fewer materials and people to do infinitely more program work and supporting and developing of special education learners and their teachers. Clearly, reactions and responses by administrators and teachers to adversity and lack influences the quality of teaching and learning considerably. Fascinating and significant as they are in today's education, the myriad ways of dealing with it all would have to make another book. Suffice to say that in this New Mexico city a coalition of administrators, professional staff, and volunteers found some exciting ways to affect measurably and for the better, the teaching and learning of the special student. They did this entirely by using resources already available to them, resources to be found in most school districts in this country.

The original impetus, to be sure, involved the federal funds coming into the district from its ESEA Title IV-B entitlement. Intended by the Congress to strengthen school library media programs by providing supplementary funds to purchase instructional materials or equipment, Title IV-B is a key support component for many school library media programs. Both ESEA Title IV-B and PL 94-142 require that each state file a plan that sets forth how it will spend its funds. Both legislative acts encourage spending for appropriate instructional materials to meet the special learner's needs.

The Roswell district set its goals about what it wanted to *accomplish* with its ESEA Title IV-B funds before it decided how to spend the money—surely an example of excellence often being an outcome of plain commonsense and good practice. The first priority was the addition of supplemental and enriching instructional resources for the individual special learner. This should hardly be considered newsworthy, but what is news, and good news for the library media program there and everywhere, is that when this priority for the special learner was established this did not cut off the special relationship of the library media program with Title IV-B— but rather strengthened and reinforced it. Too often, the turf battles over who is to control and spend Title IV-B funds take valuable time and strength, but in Roswell good sense again

asserted itself. Who or what else, reasoned the planners, but the library media program with its well-established procedures for evaluating and selecting materials, should take the lead in the matter of selecting and acquiring materials for special learners. Title IV-B funds do remain under the control of the district instructional media center, even though a wider process of educational planning and decision making has determined how these funds will be spent to support special education teachers and learners.

There is an important lesson to be learned here—a lesson in good program management. It is possible, after all, to satisfy the needs of two or even more distinct instructional programs without losing anything, and even while gaining a good deal of respect and good will. Multipurpose use of materials is a basic tenet for all library media programs, isn't it? Underscored, too, is that the exemplary library media program must display necessary survival techniques, be alert and quick to realize when particular educational programs are in the ascendency, and adaptable enough to modify here and be flexible there so that the library media program remains an important instructional support necessity *wherever* the emphasis shifts. Spending the money is where the power lies. Rather than bringing on Armageddon, any possibility of a threat to the library media program's spending prerogatives and expertise with materials should be met with cool competence and cooperation, with which a well-managed library media program with a good reputation will usually prevail.

Having settled the question of use and control of the money with Solomon-like wisdom, the Roswell schools identified the purposes for which they intended the Title IV-B monies be used:

(1) Providing audiovisual materials and equipment to meet the needs of the special learner as indicated by individually diagnosed needs;

(2) helping teachers to match the correct instructional materials to the unique learning needs of the individual student;

(3) selecting instructional materials that provided maximum support for the curriculum used to teach the special learner;

(4) providing instructional materials for use by *all* students.

Two things seem to leap to attention from this list: first, that the four purposes closely resemble those which govern the operation of any school library media program; and second, that the materials are intended for use by every nonspecial learning student if needed and appropriate. Once again, the influence of the library media program upon good standards of selection and use of material by all learners, special or otherwise, is evident.

Of equal importance, after decisions are made about which materials are to be selected and what their intended use is, must be how to get these materials into use effectively. In Roswell, the district's Title IV-B project, called Special Resources for Exceptional Children, is located in a former school now used to house several learning support programs, of which special education is one. Recycling schools in this way is a common practice and accentuates the value of having the management and consultative levels in close proximity to those to be served and to each other.

The relationship between the district IMC and the schools is a key element in ensuring that the program meets its goals. At the district level, important considerations were to have adequate storage space and access to an efficient delivery system so that materials and equipment could be moved with ease among the schools and the IMC. The usual services available at adequate district IMC's, including production facilities, graphics assistance, and video, are available to all the teachers of the Roswell district.

Since the Roswell Title IV-B Special Education project was intended to have its maximum impact at the building level, a resource room and a resource teacher in each building are most critical components. In Roswell, a resource room is a classroom for special education students who require *part-time* special assistance. General practice is for the student to come to the resource room from the regular classroom to work on a particular skill for an hour or so, and then return to the classroom. The resource program is a remedial program for help in basic skills and a professional resource teacher is in charge.

Minor renovations were necessary in some buildings as the special resources program began. New wiring and the construction of "privacy" areas and carrels were the most common construction projects. These were necessary because most special education students have difficulty in concentrating and have generally limited attention spans.

The Roswell program confirms that a good program does not relate entirely to facilities or budget. The budget by which Special Resources for Exceptional Children is sustained is modest, never having exceeded $10,000. Every available resource is concentrated, with an important sense of educational reality, in the school building where the teaching and learning take place.

After an initial entitlement of approximately $10,000 to start the program in 1976, a second-phase grant of $7,000 continued it. Most of the money went preliminarily to purchase small equipment items such as cassettes and filmstrip projectors, with the rest going for materials. No additional staff was employed. Trying to break out exact costs is a frustrating matter unless one understands that, since the district IMC already served all the teachers and all programs in the district alike, tidy separations cannot be made. We see this as a strength, emphasizing as it does that the library media program is bound by multiple strands to many programs. The site visitor noted this blending of program and funds as a strength also. Materials purchased for resource room use by special education students are used in the regular classrooms as well, frequently on the recommendation of the resource teacher. It is a healthy sign that materials purchased for the library media program in general also move among the library media center, the resource room, and the classroom with happy regularity. Sharing of resources has always been a major mission of library media programs; if special education programs can help to reinforce this concept, are we not all the better for it?

It should be pointed out that all the major elements needed to deliver this program for special learners were in place before PL 94-142 forced the district's attention to the task. These included space, a delivery system, an evaluation sys-

tem, an acquisitions system, and a processing operation.
Managerial efficiency, combined with administration and
community support, simply extended the existing circums-
tances to meet the goals established in response to the new
mandates to meet the needs of special learners.

Naturally, some accommodation with existing procedures
has to be made. For instance, most of the materials purchased
for the resource rooms are cataloged by the Dewey system.
Many special education materials do not lend themselves to
the precise categories of a system designed for different times
and different needs. Also, special education materials must
often be separated from their original packaging so that they
may be combined for different instructional purposes by the
teacher. And, most important of all, in the special education
world most teachers prefer to categorize their materials in
accordance with the specific learning disability they are deal-
ing with—blind, emotionally disturbed, mentally retarded,
etc. In this program, a directory of materials has been com-
piled to help teachers to select appropriate resources, and it is
arranged by type of learning disability.

Once in use, the materials are evaluated in terms of their
circulation, teacher evaluation, and, to a degree, by the suc-
cessful return of students who have used them to their regular
classrooms. The range of material is extensive, everything
from simple preceptual skills printed exercises to the costly
Borg Warner Systems 80 program. Not to be overlooked is the
fact that the parents of the special learners also have a voice in
the evaluation of these materials, inasmuch as they must
reinforce the work of the resource room with an at-home
portion of the child's Individualized Education Program
(IEP).

The positive result, the great success in mainstreaming
students by way of the use of these materials, shows up
continuously. The availability of special education resource
materials and a team approach to fostering their use have
increased the extent to which they are utilized within the
regular classroom. Teachers have learned to use materials
intended to remediate a specific skill deficiency with other
students who are having similar learning problems but who

have not been identified as being severe enough to need the intensive care of the resource room and special teacher.

Efficiency, economy, and improved classroom teaching for all students through teacher familiarity with materials for the special learner are estimable goals for any school system, and in Roswell this is happening daily.

Exemplary Program Elements
1. The innovative use of ESEA Title IV-B entitlements to purchase instructional materials for special learners.
2. The involvement of the district IMC in the evaluation, selection, processing and utilization of special education materials at the building level.
3. The use of special education materials in regular classroom settings.
4. The rearrangement of existing staff and facility to provide innovative new programs.
5. The involvement of teachers, library media professionals, resource teachers, and parents in selecting appropriate instructional materials.

LEARNING RESOURCE LIBRARY
Washington County Educational Service District
Portland, Oregon

"There is nothing flashy or spectacular about this program. . . . The facilities are limited, the budget tight, but in those areas that really count—materials, personnel, and program—the warmth and enthusiasm of the services offered are to be commended." The above quote was part of the evaluation report of the site visitor to this program, and it is worth emphasizing that the conditions under which this Learning Resources Library of the Education Service District of Washington County works to achieve its "commendable" program approximate those found in most school districts. There is never enough—of money, of space, of people, of time, of materials—to redeem completely the promises of an exemplary program. The compelling power of belief in what they are doing, idealism if you will, laced with a heavy dose of practicality keeps the library media specialist going against the considerable odds: the daily crises, the continuous need to prove the worth of the library media program (often to the same people over and over again), the constant struggle to defend budget and continued existence, and the need to "sell" the right image and identity.

Practical idealism obviously infuses the Educational Service District and makes it a powerful motivating influence. As a regional media-based support program its day-to-day operations differ little from many others described in this book, but it has fashioned a creative and energetic role for itself in its own setting. It is unspectacular but not colorless, achieving its goals within constraints that might have killed, or at least neutralized a lesser program.

The fact that the ESD program has been in operation for over a decade now helps to give it credibility. The critical need of the special learner for specialized resources and services was recognized early by this administrative district, well before the nationwide frenzy to embrace special education

began. As with any successful library media program, there are sound goals and precise, though flexible, objectives to take them step-by-step toward achievement. Among the objectives of the Learning Resources Library for the year in which information was obtained were:

(1) to provide clients with educational materials promptly and efficiently;

(2) to provide an examination center for instructional materials within the library;

(3) to provide an up-to-date catalog of the library's holdings and give it wide distribution for use by teachers and administrators;

(4) to increase the review and examination function of the library;

(5) to maintain a collection of materials for professional improvement related to teaching and education.

There were others stated, but these are the primary ones for our purpose, for they provide a reliable forecast as to how the resource library will serve its users, and even more important they indicate some of the reasons why these objectives were chosen. The soundness of the reasons "why" is a primary source of excellence in any educational program.

The whys behind the formation of ESD's program objectives include:

(1) teachers need special assistance in matching suitable materials to grade level, needs or other common denominators for improved teaching of the special learner;

(2) teachers and administrators need help in actually constructing instructional units for use in teaching; and

(3) teachers need to examine materials that will help them meet the challenges posed by the needs of the special learner. The preciseness with which the objectives tie the library's resources to the special education program gives strength and support to the library's role.

A professional media specialist, an aide, and a part-time student reflect the modest and common staffing pattern found in many school building and district library media centers, making up in enthusiasm, determination, and commitment what they lack in numbers and resources. The professional serves several roles, another familiar theme.

One role is that of library media specialist to the ESD special education staff of 40 whose range of teaching responsibility runs the gamut from students with severe mental retardation to those that are gifted and talented. For these teachers the library media specialist searches out materials suitable for use with their particular students; assists them in the review, examination, evaluation, and selection of instructional materials; provides staff development programs; does research; and serves as the "network-linker" to obtain materials and services not available locally.

In the case of the ESD Learning Resources library media specialist this traditional role is fulfilled with a gusto that gives it a flair and style that makes it seem innovative to the special educators who use the resources library. A sense of a library media program that goes the extra distance and provides the motivation and the encouragement to use the material well, is echoed in the comments of satisfied customers like the speech/language pathologist who said that, "the library houses all the standard diagnostic tests and equipment used in speech, language and hearing, and is constantly up-dating its inventory. . . . There is usually a large selection of therapy materials available suitable for various levels. . . ."

A second role for the resource library's media specialist is that of consultant to other teachers and library media specialists who work within the ESD's region. One school library media specialist says, "they have done wonders for my reputation; they make possible things I could not get and that makes my teachers like me." As with any successful consultation job, the specialist goes out into the schools a good deal talking with teachers, administrators, community groups, and parents in an unceasing effort to raise the library's visibility and expectations of its program of service. A crucial success factor is that the library media specialist has had long years of excellent teaching experience, and this experience coupled with broad understanding of special education and the media allows her to talk with teachers and work with them effectively. They respect her, listen to her, and follow her lead, for she earned her position through the excellence of her own teaching. The presence of many teachers coming in

and out of the resource library testifies to the ease with which teachers feel they can use the program.

The space for all of this is jammed and cramped, establishing yet again the minimal impact of facilities upon the program. Not for a minute does this mean that facility is not important, but lack of it is no excuse for a poor program of service. In this case, more space for the ESD's library would allow expansion of the review and examination project, and the textbook operation. The previewing service, despite limited space, is especially popular and educationally beneficial. Many publishing companies and audiovisual producers send material to the resource library for review, examination, and evaluation. The fruits in terms of improved selection and use of instructional materials are borne almost at once, for the chance to try before you buy is an opportunity most fine teachers appreciate.

The resource library's collection, in addition to print and audiovisual materials, includes some toys and games which are cataloged, easily retrieved, and heavily used.

An advisory group composed of teachers, principals, and one lay person helps evaluate the resource library's program and alerts staff to new needs and new expectations. Meeting six times a year, this group suggests other program improvements and helps establish the goals and objectives of the program.

Reliability and sustained, consistent helpfulness is a large part of the exempliriness of this program. The fact is, that if you are a teacher in this part of Oregon, the Learning Resource Library is always there. Not in the irritating manner with which a jack-in-the-box intrudes into your life, but in the plain, effective sense of just always being there when needed. It can be counted on to help, to suggest, to instruct or to do whatever is necessary to help fellow professionals to become even better on the job.

Exemplary Program Elements

1. The use of well-developed goals and clear objectives to provide program structure and framework.
2. The strong teaching component of the program which allows the professional to work as a co-equal with other staff.
3. The preview and examination program which allows proper consideration of materials before they are selected.
4. The use of an advisory group of professionals and a lay person, to help evaluate the program and to plan new program goals.
5. The intensive effort to relate instructional materials to special education classroom teachers.

SCHOOL OF EDUCATION
Portland State University
Portland, Oregon

"Media and Mainstreaming" is a program that was planned to last for three years. It is a Library Research and Demonstration Project (Title II-B, HEA) funded by the former U. S. Office of Education, Office of Libraries and Learning Resources. A brochure describing the program asks rhetorically, "What Can You Do as a Media Specialist to Promote Mainstreaming?" The anticipation is that something of excellence is at hand, and we hope that this is the case. Media and Mainstreaming, or the plans for it, seemed to fit so perfectly into the subject of this book that we could not by-pass it, but as the project had only just begun as this book was being completed it was the only program described that was not visited for first-hand observation and assessment. It could not be evaluated as to its value or its contribution, but we have included it because of its plans and aspirations and the promise it holds for helping the library media specialist to become a more effective member of the special learner-teacher team. Perhaps, you will go along with us and Winston Churchill in saying "If the things said about it are not so, they ought to be," for this program needs to succeed and fulfill the potential of its contribution. In our experience, a well-planned and thoughtfully prepared program which is designed to respond to a specific need will have a predictably high degree of success.

The overall goal of the program is broad, yet comfortably within the possibility of achievement. It proposes to "assess the media—related needs of handicapped students and to develop comprehensive and practical models, guidelines and assessment tools that will help library media personnel in revising their media programs to meet those needs."

Media and Mainstreaming holds, as do we, that the advent of mainstreaming need not forecast an imminent plunge over the edge of the abyss, a fear too many library media special-

ists seem to have. "Mainstreaming need not be threatening," reminds the project, and it buttresses its reassurance with some accurate observations about how library media specialists are already committed to the ideals of mainstreaming. We concur, for the library media program is traditionally a haven for all learners. It meets the need, for individualized instruction which is responsive to the needs interests and abilities of the individual; for lifelong learning beyond the years of formal schooling; for variety in teaching and learning; and for the maintenance of human rights, dignity, and freedom to make choices—the inalienable right of all learners.

And, as the project's brochure continues, "what better place than the school library media center for launching the handicapped student in the mainstream of regular school program?" Here is a warm inviting atmosphere; a place where everyone is doing their own thing, different from what others are doing; a program that encourages student access and involvement; instructional materials which express varying points of view in various formats; a program aimed at helping the individual to function effectively; and a staff which sponsors cooperative planning among all members of the school community. There is little here that is dramatic or astounding. What comes through most clearly is close attention to the daily working world of the building library media specialist who seeks answers and useful examples of applications of knowledge rather than theoretical digressions into the philosophy of education.

The no-nonsense approach to program planning is reinforced by the relationships which the project has carefully established with those who will most likely need its services. The staff, consisting of a director, an assistant director, research assistant, and graduate assistant, will work with consultants from both the special education and the media fields in devising and evaluating the activities, programs, and materials to be created by the project. Nationally experienced consultants will be backed up by university staff people, State Department of Education personnel, and special education and library media people from local Oregon school districts. It is a thoughtfully prepared team which should be

useful in offsetting or correcting the propensity of project
personnel to think that they know everything about the needs
of special learners. Often wrong but never in doubt is the
characteristic of all too many consultant teams.

The project's planned development spreads sensibly over
three years, 1979 through 1981. The initial year of funding has
seen maximum use of staff and consultant time for creating
project materials and preparing instructional strategies to
help the library media specialist to meet the challenges of
mainstreaming. Year two has seen the project task force and
staff conducting extensive field testing of materials and ac-
tivities within the state of Oregon. The Project's third year
anticipates publication and dissemination of materials and
research findings on a nationwide basis. The interrelation-
ship between the three-years' tasks and the project's final
goals provides another reason for optimism that what is
intended will indeed be accomplished.

The proposal for funding for this project outlined the bene-
fits and results of the focused and interrelated planning
activities:

> . . . operational models and strategies for increasing the
> usability of the library media center in support of the
> handicapped learner will result; administrators, teachers
> and media personnel will be more knowledgeable regard-
> ing media methods, techniques, programs, services, and
> materials for the handicapped learner; handicapped chil-
> dren will have the opportunity to have more extensive
> media services as part of their educational program, the
> opportunity to be placed in the least restrictive educa-
> tional environment, and the opportunity to relate to peers
> who are not handicapped; teachers will be better in-
> formed about utilization of media program services, pro-
> grams, personnel, materials, equipment and other
> aspects of the school's media services.

Careful attention has been given, too, to the reporting and
recording aspects of the project. To say that the mainstream-
ing components of PL 94-142 have caught library media spe-

cialists (and indeed most educators) ill-prepared is to state
the obvious. To date, just beginning to do something, almost
regardless of how well, has been the main thing. Now such
targeted projects as Media and Mainstreaming will help li-
brary media specialists not only to perform but also to evalu-
ate the effectiveness of their performance in helping to
mainstream the limited learner into the regular school en-
vironment.

The project is expected to "conduct a comprehensive as-
sessment of media related needs of the handicapped" ranging
across the spectrum from learning disabled to multiple-hand-
icapped. It will also "conduct a comprehensive literature
search for important information concerning library media
programs and the special learner; develop field-tested models
and procedures for school districts to use in reviewing school
library media programs to meet the needs of the limited
learner; develop specifications for media program services to
limited learners in terms of programs, services and instruc-
tion, media collections, facilities and environment, equipment
and staffing; develop a field-tested assessment guide which a
district can use to determine whether its media centers are
meeting the needs of handicapped learners; prepare bibliogra-
phies, articles, and kits to be used by media personnel; dis-
seminate the products of the project, first on a state and
regional basis and finally, nationally."

The scope of the project is the most comprehensive we have
seen. Models upon which to pattern professional growth are
greatly needed. The Media and Mainstreaming Project is the
first truly national model for exemplary library media ser-
vices to limited learners, geared to influencing the teachers,
the instructional programs, and the students of not just one or
several school districts, but thousands of them. Its potential
usefulness is great, and our professional hopes and energies
must be bent toward making sure that it makes a needed and
vital contribution toward helping us get on with the process
of mainstreaming the limited learner via the library media
program.

Exemplary Program Elements
1. Developing a comprehensive planning model which relates all aspects of library media program service to the limited learner.
2. Developing operational models, procedures, and assessment guides for limited learners to be used by library media specialists in school programs.
3. Developing cooperative program and planning links among university, state education department, local school districts, and consultants.
4. The innovative use of federal grant monies to provide essential materials to school library media specialists working with the mainstreamed learner.
5. The intent to influence administrators, teachers, and learners through a national dissemination network about the usefulness of the library media program to special education programs.

SOUTH DAKOTA DEPARTMENT OF EDUCATION AND CULTURAL AFFAIRS
Division of Elementary Education
Library and Media Services
Pierre, South Dakota

"Training Library Media Specialists to Serve the Handicapped Student" was the title of a project funded by a modest grant of $28,000 made available to the South Dakota Division of Elementary and Secondary Education by the Library Research and Demonstration Program of Title II-B of the Higher Education Act. Of one year's duration, the project stemmed from its director's certainty that the school library media specialists in the state would need help, and plenty of it, in developing the sensitivity, the proper attitudes, and the teaching skills necessary to provide creditable library media programs for mainstreamed special learners.

The purpose of the grant was to create a staff development program that would be truly relevant to the needs of the elementary school library media specialists who must teach the mainstreamed handicapped learner and must also provide support and assistance for special education and classroom teachers who were doing this in a new context and setting. The genuine and imminent need of the library media specialists for this help gave it an intensity of focus at its beginning and moved it smartly along toward achievement of its purpose. There was nothing of "greed before need" grantsmanship in this modest training grant; need and tight planning were in place before the money was applied for.

The three objectives established for the training programs were:

(1) to provide the elementary school librarian with additional skills needed to serve the handicapped learner;

(2) to provide the elementary school library media specialist with the resources and skills needed to aid teachers, support personnel and administrators in serving the handicapped learner; and

(3) to develop and disseminate a guide for the continuing support and maintenance of the library media specialists who participated in the demonstration project, after the project's completion.

Although "modest" is indeed the appropriate word to describe this program, it began its existence with a self-assurance that remained to sustain it through its funded life cycle, and more important still, to give it a lively and colorful life after its one year of funding was over. From the first the project eschewed the trivial for the basic, and sought long-term benefit rather than the temporary illusion of progress. Emphasis was on the relationship between cause and effect, and to provide motivation for participants to plan in such a way that plans and activities were associated and related, leading to a unified and effective program.

The project proposed to train one consultant who would then work with ten building level library media specialists to help them hone their skills and abilities to meet the educational needs of the handicapped learners. The disseminated guide of the project's third objective is an impressive publication with the coy title, *Kangeroo Kapers,* which provides a great deal of information, advice about methods and techniques, and program suggestions for the library media specialist to use with handicapped learners. A newsletter makes an occasional gesture toward the gifted and talented learner, but its primary focus, like that of the original project, is on the handicapped learners, especially the learner with visual, hearing, or psychomotor limitations. This comment is not meant by way of criticism, but it is simply there, and reflects the widespread tendency to deal separately with physical impairment, mental limitation, and the gifted and talented. In most cases, the mentally retarded and the learning disabled population will get first and major attention, since it is they who present the greatest challenge in mainstreaming programs.

Kangeroo Kapers is the tangible, how-to-do-it end product of a year's work, and is intended to be a resource guide and handbook. Its 178 pages are eclectic, with topics ranging from parent advocacy and accessibility to facilities for the hand-

icapped to a bibliography of wordless books and storytelling tips for those who will tell stories to handicapped learners. There is even a section which describes, and gives particulars about, periodical articles relating to barrier-free environment. *Kangeroo Kapers* features material that is solid and basic. Obviously the work of caring and creative people, it provides a treasury of important and useful information to the school library media specialist who wants to do the best possible job for special learners.

We liked very much some of the material which directs the library media specialist to effective use of the handbook. A first responsibility, it states, is to develop an "awareness of handicapping conditions," since obviously an effective program is not possible without understanding first of the nature of the handicapping condition and its meaning to the bearer of the handicap. This is first-things-first commonsense, of the variety too often overlooked in the rush to put on the program.

This is followed by a section designed to acquaint and familiarize the library media specialist with terminologies used by the federal and state governments to designate particular disabilities, and to help assure that stereotyping terminolgy is not used in the library media program. Becoming knowledgeable about specific disabilities and alert to signs which indicate that a child might need more than some casual assistance is also dealt with in the handbook. Of course, evaluation of the materials collection and the facility are given high priority too, for the professional needs to know how to evaluate a collection with a special eye as to which materials can be adapted to the specific needs of individual handicapped learners.

Kangeroo Kapers points out that "parents, board members, administrators, special educators, classroom teachers and others will be involved in planning effective library media programs for special learners." This is not a new idea, nor is any of the material included startling or especially pioneering. Rather the handbook is notable for the resolute endorsement and affirmation it provides for the traditional assets of an excellent library media specialist with skills such as knowing the learner as an individual, being alert to ways in

which to teach to individual needs, knowing how to evaluate collections and facilities, and coordinating the work of many disparate groups to deliver an effective program.

Such affirmation is in keeping with the viewpoint of this book that planning and carrying out library media programs for handicapped learners is a natural extension of the traditional service roots of the library media center rather than a radical change in operations or a significant break with past history. The more fully the library media specialist can adopt this viewpoint, we believe, the more effective will be his or her role with the handicapped learner and the teachers and other staff who will be working with these children in a regular school setting.

The consultant, who was funded by the grant money, was the only paid staff in this enterprise and of course a crucial factor in its success. This consultant was responsible for all of the planning and presenting of workshops and staff development programs across the state, as well as planning the after funding spin-offs of the project. A year is a short time to do this. To get it all done required a very positive attitude and a belief that the style of the future will involve learning as you go, on the job. There is not very much about this that is new, either, but it is the reality that dominates the working life of most library media specialists.

The ten schools that participated in the project were selected from the 94 school districts in South Dakota which already had special education programs. The population served ranged from about 5,000 to 20,000 students. Program participants had to be sponsored for participation by a superintendent of schools, who in this way pledged his commitment to the project's goals.

The workshop mode was a traditional one, but participant evaluations indicated that in this case this format was supportive rather than stultifying, and allowed for an appropriate creative approach. Two training sessions, attended by all ten of the participants, helped to increase basic awareness of the needs of the handicapped learner, while alerting them to materials and such resources as associations, agencies, and individuals who could provide information. The second phase

of the project brought the consultant into the participants' schools and into a close working relationship with them as the more theoretical aspects of the workshop training were put into practice. The third and final phase was one in which participants had responsibility for collecting resource materials, information resources, activity suggestions, program strategies, and other useful and inventive ideas dealing with "doing it." These, when collected and edited, became the core of *Kangeroo Kapers*.

The philosophy which suffuses this project throughout is very much of the "Each one, teach one" variety. It was of course recognized from the start that it was impossible for a lone consultant, operating under severe limitation of time and money, to turn masses of elementary school library media specialists themselves into excellent teachers of special learners as well as staff developers. However, the art of the possible dictated that teaching ten professionals thoroughly how to present some excellent, focused programs for special learners and then turning them into resource people for their regions would have the effect of a pebble thrown into a still pond. And it did, with ripples both visible and influential. It is a system which works where resources are limited but the will is really there to make it work.

Participants learned how to work with some of the highly specialized equipment used in special education programs, and their training included a workshop to increase their ability to help classroom teachers produce their own materials of instruction. Just as important was the training that helped library media participants see the potential uses of modified materials, and showed them how to modify them. Establishing publisher files, finding useful professional materials, and trying new techniques extended greatly their professional capacity. Each of the participants added value and a special intensity in sharing skills with teachers.

One limitation of the *Kangeroo Kapers* handbook which should be mentioned is its general disregard of audiovisual materials as a rich resource for teaching special learners. The numbers of these items, however, is already so great that bibliographic listings become almost impossible. Most li-

brary media specialists already have in their regular collec-
tions large quantities of AV materials that can be adapted for
use with handicapped learners. It is a much better policy, in
our opinion, to invent new uses and ways of adapting these
materials than to invest in a great array of new materials to be
segregated for the exclusive use of special learners. The
materials and the way in which they are used should promote
mainstreaming rather than maintain the separateness of the
handicapped children.

Our program visitor observed that, "the potential impact of
such a project is enormous in that it places the library media
specialist in a key, pivotal position between the handicapped
learner and the certified and noncertified staff." This demon-
stration project established, as all demonstration projects
should, that this process can be used by others to show how
the library media specialist can contribute directly not only to
the special education program, but to the development of the
teaching staff overall.

Exemplary Program Elements
1. The use of a modest federal grant to establish an influential
 statewide staff development program.
2. The use of consultant time and staff development programs
 to upgrade the ability of the library media specialist to
 teach handicapped learners.
3. The use of consultant time and staff development programs
 to increase the effectiveness of the library media specialist
 as a resource person for other staff.
4. The development of a handbook/manual which provides
 bibliographies, program suggestions, activities, and a host
 of other library media program activities to assist the
 library media specialist to be a more effective teacher of
 handicapped learners.

DEPARTMENT OF SPECIAL EDUCATION
Greenville Independent School District
Greenville, Texas

Words can convey only partially the intensity of this special education program and the spirited impact it has upon the students and teaching staff of this Texas school district. Sometimes it takes all the fervor of a Salvation Army tambourine shaker to recruit people into believing in a program or into using its important services. To do so without coming across as a self-appointed saviour, as this program has been able to do, takes skill of an uncommon order.

We see the regionally based support program as a prime necessity for establishing viable media-based special education resources for the schools. One building program alone just isn't sufficient even if it has a large staff with zeal and energy and a wealth of materials. Support and enrichment beyond the level of the individual program just has to be available, which is why we searched for and have tried to describe those emphasizing an effective library media component. The hope is that these examples will help overcome a cherished mythology of American education: that building autonomy and self-containment must be absolute. As an educational philosophy this may have been appropriate to the early years of the century, when times were much less demanding in their expectations about what the schools must deliver to learners. Radically altered expectations about who is to be educated and how demand new attitudes and new structures if they are to be met successfully.

Most regional programs begin with great enthusiasm and little experience. Within a period of two or three years, a program's consequence and the impact it will make are generally clear. Final judgments about a program's worth, its product, its capability for moving and leading those it is supposed to move and lead comes quickly. The time for accomplishment is mercilessly short. Programs that emphasize style over substance are quickly found out, rejected, or ignored. Pro-

gram style is important for leadership, but style must be related to productivity and a demonstrably positive effect upon teaching and learning. If a program's style is eccentric or overbearing, there is trouble. This holds for the building library media center too, where panache must be balanced with a sense of comfort and reliability without which teachers will not be attracted to try the new or the relentlessly innovative.

Each of these considerations has exerted a clear influence upon the development of the Greenville program. Now entering its third year, it has established a dramatic increase in its usefulness mainly through the use of its Special Education Resource System (SERS). A review of the goals established for the program at its inception provides important understanding as to why it has made the excellent progress it has during its short life. SERS "is a system designed to provide the effective delivery of media materials and services to eligible users working with handicapped students." The program promised to "provide leadership, guidelines, and resources necessary to develop a (network) of services as part of comprehensive special education programs." The program pledged further to "assist administration, support and instructional personnel to become more knowledgeable and more competent regarding instructional media and materials available for the handicapped student." Finally, the program anticipated the integration of its services and programs into the Instructional Resources System, a statewide network for Texas. There were many promises to keep and much ground to cover; how well have the pledges been redeemed?

The Greenville District Center (SERS) is the capstone of an intensive, well organized and highly effective special education program in that district. The department staff consists of a director, four deaf-education teachers, two diagnosticians, twenty-eight certified teachers, and fifteen teacher aides, and is an impressive group with its roots directly in the school buildings and branches that reach upward to the district level. As deep roots provide health and strength to a tree, so do they to this program, for a review of every aspect of it confirms that its strength relies heavily on a strong building

level presence which makes its purpose and programs comprehensible to teachers, library media specialists, administrators, and others enlisted in its efforts. Services are provided to learners from age three to twenty-one who have physical, mental, emotional, or learning disabilities. Learners from birth through twenty-three years of age with serious visual or hearing handicaps also receive services. Services are even provided in the home when appropriate.

The district level, though, is where the specialness which illuminates this program and gives it such purpose and spirit shows up the most. The SERS Instructional Materials Center contains nearly 5,000 instructional items, including professional materials. A three-pronged commitment to provide materials marks it—for the exceptional learner, for the professional who works with him, and for his parents. It underscores the point that no successful media-based special education program can be mounted or maintained unless parents, professionals, and the learners themselves are involved in the evaluation, selection, and use of the instructional materials. This program's policy manual makes it clear that all special education and regular teachers are eligible to use its materials, and that parents are invited to use them too.

The SERS materials center receives its financial support from a combination of regular tax-raised funds, state and federal programs for special education, and "gifts, donations and contributions." The given is, it seems, that the search for funding never ceases, and that the program which manages to stay afloat is the one that is the most alert in finding funding resources and most imaginative about putting them together in usable combinations. Sitting back and waiting for someone to "leave the money on the stump and run" (a down-home Texas expression) doesn't get the job done. Worth underscoring, too, because of its great importance, is the fact that this materials center from its inception established close links with the regional Educational Service Center, the Texas Education Agency, with its State Learning Resource Center (SLRC), and ultimately with the National Center on Educational Media and Materials for the Handicapped (NCEEMMH). It seems that acronyms, and a mouthful of

initials, are part of the price we must pay for regional net-
working systems! Nevertheless, this vision that impels a
program to look constantly beyond its own resources to a new
frontier of materials and services is basic to successful pro-
gram development.

Equally important to this program, both from a public
relations and an educational point of view, was the early
formation of an advisory committee to "advise the Depart-
ment of Special Education and the SERS Instructional Mate-
rials Center on matters of policy." The advisory committee,
consisting of professionals, support staff, community repre-
sentatives, parents, and college and university faculty,
provides a ready-made source of effective support in periods
of trouble or crisis. Because members have been involved in
establishing policy, their advice and counsel in day-to-day
matters are invaluable also. Both types of input are badly
needed in educational ventures of this nature. The advisory
committee is charged also with conducting an annual needs
assessment to establish the strengths and weaknesses of the
program, while evaluating its effectiveness. Involving such a
combination of persons in the policy making, planning,
monitoring, and evaluation of such a program is but a distant
dream for most schools or school systems, but nothing could
be more consonant with both the spirit and intent of PL 94-142
than that a representative coalition of parents, professionals,
and others interested be so involved. The process involved
and the dimensions of vision and purpose so provided are
important exemplary aspects of this program.

An observer noted particularly, and liked, the commitment
to weeding the worn, outdated, and little used audiovisual
items from the collection. Many library media programs,
suffering as they do from a tradition of lack and scarcity,
show a neurotic need to hoard and hold on to all audiovisual
materials. The natural end result of all selection and acquisi-
tion must eventually be a professional decision as to "what
and when" materials have reached the end of their usefulness
and must be discarded. If the first responsibility, selection, is
often poorly carried out, the latter—deleting and discarding—
is nearly always scandalously neglected. A real danger in

establishing an audiovisual collection for special education programs is that everybody's cast-offs may be relegated to the program. Bad audiovisuals used with disturbed or limited learners would be not only frustrating but dangerously destructive. We especially liked the reasons given by the SERS program for its assiduous attention to weeding: "to maintain its reputation for reliability" and "to remove an *outward illusion* of a well-stocked collection which does not meet district or student needs"—a statement to be loudly cheered if ever there was one. Finally, the weeding policy pledges itself that "while there are no universal rules, the materials specialist will evaluate materials in terms of user needs, educational usefulness, and knowledge of materials." So this was another exemplary aspect, important for all library media programs but especially so for those serving special learners.

The materials available at the center are organized under eleven subject areas, using a coding system developed by the Texas Education Agency's Special Education Instructional Materials Center. All new acquisitions are previewed and evaluated by the professional staff and others before being purchased. Another great strength is that teacher-made materials are part of the collection. This lends more emphasis to a point made elsewhere in this book: that the highly specialized needs of the special learner should promote an increase in locally produced materials, designed especially by the teachers who will use them. Such materials will have a focus and relevance that no nationally distributed, commercially produced materials can hope to have.

To make possible a resource of locally produced materials, as well as to help teachers to use all materials and resources well, there is a comprehensive program of demonstrations, workshops, and exhibits undertaken by the center. Other staff development sessions are offered in response to teacher requests, or as the SERS staff sees a need for them. An innovative mix of styles and staff combines to make these sessions creative and useful. Local staff, regional center personnel, or Texas Education Agency personnel present programs dealing with topics which range from behavior modification to production of materials for instruction. These

programs are successful because they meet the needs express-
ed by teachers.

As exemplary as the SERS instructional materials policy is,
as outstanding as its staff development programs are, and as
worthy of emulation as its parent and community involve-
ment programs are, perhaps the greatest feature of this ex-
emplary program is its outstanding publications output.
Newsletters, a *Special Education Handbook,* and *Special Ed-
ucation Packet* for the mainstream teacher, and a *Parent
Communication Packet* are samples. The purpose of all this
communication is to assist, to instruct, and to enlist. An
outstanding program like this one must work consistently at
getting its message across and making its influence felt. A
typical newsletter issue is filled with factual data about
department services, and contains articles (brief) of the "how
I do it good" variety of the kind so eagerly sought by most
classroom teachers. It announces an "Idea Exchange Work-
shop," a monthly program of sharing ideas that work. Newly
purchased instructional materials are announced as availa-
ble, and parent communications are stressed. Other newslet-
ter issues give advice about how to handle mainstreamed
children in the classroom, and tell about forthcoming pro-
grams. All in all, it is a splendid job of getting a program
before its constituency and keeping it there in an adept and
credible way. The gentle sell is sustained by performance, the
performance of the Greenville Special Education Resource
System which has much to be admired and emulated.

Exemplary Program Elements
1. The network relationship to regional, state, and national
 networks to extend the resources of the program.
2. The use of professionals, parents, and other community
 members as advisory council members.
3. The continuous needs assessment process which identifies

new issues of concern, monitors programs, and evaluates ongoing programs.

4. The excellent publication program used to inform, educate, and persuade users.

5. The clearly stated selection policy, and the well-established relationship of weeding to excellent collection building.

UTAH LEARNING RESOURCE CENTER
Murray, Utah

None of the other educational support services programs we have visited and described has such direct ties as this one to a state department of education. Many regional or state-wide special education support programs serve the dual objectives of increasing network or cooperative resource sharing programs while at the same time providing support for special education programs, and end up slighting the latter objective. Not so with the Utah Learning Resource Center, for its educational support role has been developed with precision and care and it has set out to make specific contributions and to deliver programs of excellence in a manner which is at the same time vigorous and deliberately low key.

Such programs are especially important for they demonstrate the increased authority and leadership required of the state education agencies. Using mandated powers such as those of PL 94-142 to raise the learning expectations of special learners and to enforce their fulfillment is not a comfortable mode for many state agencies which have historically considered themselves "on call" or advisory only, and thus able to beat a hasty withdrawal or disclaim responsibility if problems arose. To be sure, the charge to ensure that the laws and regulations which protect a child's right to an appropriate education (of which PL 94-142 is but one guarantee) will not alone develop effective state department leadership, but the overall trend whereby state education agencies are assuming more control over local education programs is quite visible in other ways. The financing of public education, the growing role of the Federal government in making and enforcing all kinds of educational policy, and the propensity of advocacy groups to turn to government to ensure the rights of children may seem to be antithetical forces, but they lead unerringly to this same end. Some state education agencies, still prisoners of the past, are unable to meet successfully the demands and expectations of the present, but we searched for some whose

programs, in response to PL 94-142, were playing an effective role in helping a whole state to meet its obligations to special learners.

The Utah Learning Resource Center exists only for special education teachers, and the satisfaction of their needs dominates all its activities. The keystone of its program is staff development. The perception of those who operate the program is that it's not the space, nor the materials or equipment available that makes the greatest impact on the special education teachers (and through them upon the special learners) but the professional staff and its ability to guide, support, and reinforce the teachers in their daily work. Without any doubt, this is underlying principle number one for this media support program, as it must be for any excellent program.

The quantitative figures here are impressive: 6,000 square feet of space in the center house more than $2 million in inventory of materials including books, 16 mm films, manipulatives, games, periodicals, professional materials, and other instructional items—all of them related to the educational development of the special learner. This wealth is used by a staff whose professional experience and preparation give them particular strengths in carrying out ULRC's priority program concerns. This staff is comprised of a teacher who also serves as director of the parent program, a specialist in curriculum development for special learners, a specialist in instructional materials and media production, a program director, and a secretary and two aides.

The collection of instructional materials and the staff as resource persons and consultants are available to the forty school districts in Utah, other state and private educational agencies, parents, and when appropriate, to students themselves. A remarkable array of consultation and support programs are included in service to these disparate groups with the sole aim of improving educational opportunities for handicapped special learners wherever they are to be found in the state. Consultative or staff development activities include:

(1) the modification or adaptation of instructional materials for handicapped learners;

(2) helping teachers to correlate short and long term objectives to appropriate media use;

(3) matching the characteristics of a specific handicapping condition to the most beneficial media in order to minimize learning limitations;

(4) identifying and prescribing appropriate media after the individual diagnostic process has been completed;

(5) providing programs about methods for utilizing materials which will motivate and challenge learners and help to adjust their behaviors;

(6) acting as resource for and conduit for communications among media producers, media personnel, teachers, authors, and other creators in an effort to stimulate availability of useful materials for special education teachers and their students; and

(7) assisting local school districts to plan better use of media with handicapped learners to ensure improved individualized education programs (IEP).

The "lighthouse" capacity of this statewide program, its role as a model of excellence from which every district and every school building can adapt programs and services can hardly be overstated. The priority status of teacher ability to deliver quality instruction to special learners must be perceived as being beyond question in this state. It is our belief that state education agencies in every state must make such a visible commitment and provide the leadership to implement it if there is to be any real hope for excellence of program and benefit for special learners resulting from PL 94-142.

Although most of the center's materials circulate throughout the state, the center and its facilities are used extensively on site as well. Borrowing materials is made easy, and renewals of up to four weeks are possible. The center makes no charge for its services nor for overdue materials, but it does charge for replacement of lost or damaged items. Through its bulletins and policy manuals, brochures, pamphlets, and bibliographies it conveys its eagerness to give assistance to its potential clients. Typical of its suggestions for special programs is a brochure entitled *Instructional Material Utilization with the Handicapped Student in the Regular Setting.* Unpretentious and readable in style, its content is compelling and helpful, the kind of quick and easy offering

that library media specialists should prepare for other profes-
sionals to use. In its introduction, the pamphlet makes a
useful point about the IEP—that instructional materials can
be used "to achieve academic success and social adjustment
for the student in . . . the mainstream environment." It con-
tinues with the thought that good media use can "provide the
handicapped learner with a method to achieve success, and a
process to change behavior."

The center moves directly from such promises to proof,
from expectations raised to expectations satisfied. Respon-
sibility rests squarely upon and is accepted by the staff for
seeing to it that the conditions prevail to make this possible.
The conditions include:

(1) close correlation of the media used to the curriculum, so
that the skills introduced and reinforced by its use are rele-
vant to the needs of the particular handicapped learner;

(2) certainty that the material selected for use with hand-
icapped learners are capable of being used at his own pace by
the individual learner;

(3) assurance that the media used is capable of providing
not only initial information but may be used also for drill and
reinforcement in response to the needs of the individual
learner;

(4) knowing that the media used may well include manip-
ulative devices which will allow the handicapped learner a
better opportunity to keep pace with the rate at which others
are learning in the mainstreamed environment.

Several other suggestions are offered, each with tremen-
dous potential usefulness to the classroom teacher or the
library media specialist who is seeking, sometimes desper-
ately, for anything that will help accomplish a good job of
teaching for the handicapped learner.

Of great importance is the center's relationship with the
publishers and producers of all the media. An important
concern of this book and for the library media profession in
general is with the need for library media specialists to
improve their ability to evaluate all types of instructional
media before selecting it for use. The center has recognized
the essential relationship of the evaluation/selection process

to sustained excellence of instruction. Many materials are placed in the center by producers for the purpose of on-site testing and evaluation by teachers before widespread distribution. This sort of cooperation between professional and the producer is not to be feared—it is important for, and beneficial to, both producers and purchasers between whom there is and must be a symbiotic relationship. The producers get good advice about the worth of their products from those in the best position to know, the potential users, and this allows for modification of materials before they are mass produced. The professionals get an undreamed of opportunity to provide verification about what materials can or cannot do, while gaining advance knowledge of the arrival of new materials on the market which they themselves helped to shape. It is an alliance devoutly to be desired and long overdue, and if programs such as this one can hasten the day when it happens more frequently in more places, that alone would make it exemplary.

Throughout the Utah Learning Resource Center's program there runs the evidence of meticulous attention to detail and the commitment to positive leadership action which make the difference between the front runner and the also-ran every time. Its visionary goals are supported by practical and obtainable objectives. Increasing the teacher's knowledge about instructional materials and the use of equipment so that these resources may be used to improve behavior and understanding in handicapped learners is, after all, what every media program serving this group is after. In this case, results may be observed.

Exemplary Program Elements
1. The process of matching media to the curriculum and then to the specific characteristics of the handicapped learner.
2. Relating instructional media use to short- and long-term educational goals for the handicapped learner.

3. The use of staff development programs to foster innovative teaching methods for handicapped learners.
4. The close association of producers and publishers of materials and the center's program to provide a comprehensive review and evaluation of materials.
5. The use of media based components within the individualized education program (IEP.)

Chapter III
The Learning Disabled and Mentally Retarded

One of the many citizen advocacy groups which have sprung up to take part in the action surrounding the special education movement recently distributed a glossary of special education terminology. Intended to be a laymen's guide, the range of initials identified ranges from AH, for Auditorially Handicapped, to VI for Visually Impaired. In between come such as CP (Cerebral Palsy), DL (Developmental Lag), GE (Grade Equivalent), MH (Multiply Handicapped), and TMR (Trainable Mentally Retarded). The list is a long one.

It is indeed unfortunate that it is necessary to label and classify in this way, but in medicine, this is seen as a precursor to proper diagnosis and treatment. Thus describing and categorizing has spilled over into education, too, and is probably necessary if we are to prescribe the best teaching to fit the specific conditions of particular individuals. We hope, though, that such classifying will not become an overriding concern in special education programs, whose primary job is prescribing and carrying out the proper educational treatment so that successful learning can take place.

As a book concerned first and foremost with the contributions library media programs may make to special education

programs, it follows that our focus is upon prescription and treatment, especially for the student generally described as learning disabled. Our great interest as library media specialists is in *doing* something about situations, not just in describing them, but we must understand as much as possible about those children with whom we work who are characterized as learning disabled.

The definitions of the learning disabled (LD) child are, like most definitions, pretty one-dimensional, and give little meaning to the condition. Nearly all of these various definitions tell us that "the learning disabled child will achieve significantly less than other indicators (IQ tests, aptitude tests, observed behavior) indicate that he should achieve." The layman is perhaps more at home with the more commonly used descriptors of this condition such as "underachieving," "not working up to potential," and "not motivated." "I know you can do better if you just try harder," is the common plea of those who are trying to find out what is wrong and what can be done to "cure" the problem. The trouble is that while the LD child may show by this or that accomplishment that the potential for achievement is there, there exists in him a physical reason why progress cannot be made in a particular direction. Knowledge and understanding are necessary for developing a learning program for such a child.

It is essential, too, for teachers to understand the differences between the learning disabled and the mildly mentally handicapped child. Because their end result may be failure in both cases, learning disability and mild mental handicap are often confused or considered to be one and the same thing when in fact their roots lie in different causes. While the learning disabled child is hampered as the consequence of physiological impairment, the mentally handicapped child's lack of achievement is due to mental limitation or a lower-than-average intelligence. Both the disabled learner and the mildly mentally handicapped or retarded learner can learn if the appropriate program and learning environment are provided. The earlier the disabled learner or the mildly retarded learner is diagnosed, the more likely it is that either will achieve a measure of success in learning. Research and

practice are bringing rapid changes to the methods used to teach both kinds of children and in perceptions of how much can be done successfully to educate them, but we know for certain that the greater their own involvement in their learning, the greater their achievement will be.

The learning disabled may be hyperactive or passive and withdrawn. They may show a lack of motivation to participate or to try, or a lack of concentration with which to sustain their ability to persevere in trying to learn. The problem may show up in inattention, restless behavior, or in a seemingly odd reversal, as overattentiveness or rigidly conformist behavior. The latter conduct, widely practiced among the learning disabled, may be a camouflage technique designed to fool the teacher into thinking that learning is taking place and so win approval—and, not so incidentally, be left alone.

Not being able to see or hear well are two of the most common physical causes of learning disablement, and they are often linked to a lack of coordination or memory dysfunction. Thus described, these problems sound as if they would be easy to identify or to recognize, but they are not. If they were, there would not be so many parents and teachers saying—with what must seem to be unbelievable insensitivity—"just pay attention and try harder."

The characteristics of the mildly retarded learner are often similar to those of the disabled learner, accounting for the troubling tendency to see the two types of limitation as the same. The mildly retarded learner will probably show a low tolerance for frustrations, a short attention span, reduced physical or perceptual coordination, reduced ability to use words, a lack of ability to concentrate, and an interest in surroundings that is less than that of normal peers. Both conditions are present at birth, indeed may be caused by birth trauma, or begin in early childhood. Both conditions result in poor learning ability, inadequate social adjustment, and reduced achievement. But without understanding the different causes of such similar symptoms, we cannot respond properly to working to improve conditions.

We have focused upon these two categories first, because it is from these groups that a great many of the children are

being mainstreamed into the regular classrooms of our school districts across the country in response to PL 94-142. Physically handicapped who are and have been fully able to compete with normal peers in the nonindividualized lockstep, everyone-maintain-the-same pace classroom, have been there right along. Conditions for them have now vastly improved in terms of lowered drinking fountains and doors wide enough for them to get their wheel chairs through, but theirs has never been exclusion on the basis of mental disability. The profoundly retarded, many of them in the "trainable" rather than the educable category, will generally not be among those mainstreamed. It is the visually and hearing impaired, the developmentally and emotionally disabled, who will make up for the most part the legions of children in the new special education programs in the regular public school buildings.

As with any other matters pertaining to special learners, it must be underscored that there is a close relationship between the attitudes of the family and the conditions of the home with what happens to the child in school.

For many parents, the emotional reactions to confronting the fact that their child is retarded are painful and predictable: shock, shame, bitterness and guilt ("what did we do wrong?"). There may also be jealousy of others not so afflicted, and a rejection of the initial diagnosis—and subsequent ones. There is a need to overprotect the child. "My child is mentally fine—the tests are wrong," or "my child is just a little slow in learning," are responses to be expected, as parents face the frightening future with a mentally retarded child. Getting the parent to accept the condition of mental retardation is rarely the task of a teacher or the library media specialist, any more than is the task of prescribing treatment for the retardation. What well may be our job though, at least in part, is helping the parents and other family members to make the most of the learning ability the child does have, and believe that there is hope for him to improve and enlarge his capabilities. Sensitivity and understanding are what we need, coupled with genuine interest in the aspirations of the family, as well as their frustrations and disappointments, for all of these will have an effect on how the special learner

performs in school. For the retarded child, more even than for most children, the influence of home and family, the expectations and the support (or lack of them) that emanate from them, are critical factors in allowing or enabling the school to do the best work with the child of which it is capable.

Accordingly, just as the parents of a mentally retarded child are enjoined never to be defeatist about what their child may be able to learn and do, so this attitude must be shared, indeed perhaps initiated, by the child's teacher or teachers— including, of course, the library media specialist.

Parents with a retarded child are generally advised:

(1) not to allow feelings of shame or guilt to overwhelm them and shape their attitudes toward their child or toward those who will come into contact with him;

(2) not to neglect other normal children in the family because of a fixation with trying to "make it up" to the limited or afflicted child;

(3) not to envy others for the fact that their child is not so afflicted—and yearn, with ever-increasing guilt, of course, for an undamaged replacement;

(4) not to assume the child's emotional problems, except within the usual limits of good parenting;

(5) not to bleed the family dry, financially or emotionally in maintaining the child or in trying to prove that there is no problem. There is a special bond, a unique symbiosis between parent and retarded child that often transcends the usual parent-child relationship. It has to do with pain and fear and guilt transmuted into a devotion unequalled—unless of course, tragically, the feelings express themselves in utter rejection of the child.

All of this teachers and other school staff must be aware of, accepting the strong effects of family attitudes toward the retarded learner, and using them appropriately in planning the learning program for each child. For teachers and library media specialists, these issues are not matters for future consideration, they are for now.

We have touched in an earlier chapter on the historical attitudes toward handicapped and disabled people. What we must understand now is that even the relatively benign but

patronizing emotions of pity and sympathy for the handicap-
ped are no longer in order—if they ever were. The transition
from the dark-ages treatment of limited people will not be
complete until we can see between ten and twelve million
Americans as persons functioning at their own levels, pro-
pelled by degrees of energy, aspiration, and opportunity just
as everyone else is, and not "burdens" to themselves and to
others. Disablement creates a life style shared by millions—
between ten and twelve million, according to U. S. Govern-
ment statistics released in the late 1970s. These figures in-
clude adults and children: half a million using wheelchairs;
three million using crutches or canes, braces or walkers; eight
and a half million had visual impairment, and more than one
million were totally blind; eleven million had a hearing im-
pairment, and two and a half million were deaf; seven million
had some developmental disability brought on by retarda-
tion, emotional disturbance, brain damage, or social prob-
lems. Some two million of these persons are bound to their
homes because of one or more of these disorders.

Granted, there are overlapping and other uncertainties
about some of these specific figures, but the point is that this
is not a minority that could be ignored, even if we would do so.
We are talking about a group of people who, with families and
those close to them, constitute an important segment of our
population. Liberation from past attitudes implies and re-
quires the willingness to share, something essential to the
democratic process, something basic, too, to education. But it
is, all the same, an enormous leap from the traditional atti-
tudes to one that holds that the physically limited child is,
after all, just a normal child with a limitation in his locomo-
tion, or that the blind child is a normal child with the excep-
tion of a narrowed sensory range. Perhaps not all of us will
find it easy to assert that limitations are not necessarily
handicaps—a view held, for instance, by Itzaak Perlman,
magnificent and widely acclaimed violinist who, badly crip-
pled, so that he must be seated to play on the world's great
concert stages, refuses to think of himself as "handicapped"
because of it. Nevertheless, we cannot deny that there is a
large degree of normality present in every limited or disabled

child, and it is our exciting business to help that child develop and extend that normal range of capability to its fullest, to learn to compensate and downplay, perhaps even partially overcome, the disabling or limiting condition. This approach sees the limitation caused by physical or mental dysfunction as something to be overcome and not allowed to become a handicap.

We see from this that it is how people react to being different or exceptional that is the vital factor in how they will learn, and how far they will be able to succeed in shrinking the handicapping effect of their limitation on their lives, and eliminating, in so far as possible its personal, social, and economic consequences for them. Thus, obviously the psychological state resulting from being limited or exceptional is as important to its bearer as the limitation itself. Who am I? What do I want to be? The limited child must learn first of all to be able to respond "I am me, I am myself, and I am important not only to myself but to many others as well." Next, must come the affirmation "I will become all that I am capable of becoming." Accepting a limitation without succumbing to it, and learning how to overcome it, and having the self-confidence born of discipline, can power achievement beyond many physical and even mental disabilities.

Understanding even some of these dynamics of hope and will and self image can give the library media specialist a new insight into how the library media program can become a useful, even highly valuable and central asset in shaping the attitudes and meeting the needs of the disabled or mildly retarded or disturbed learner. To achieve some of these subtle and delicate objectives in the affective domain will require personal as well as professional characteristics and skills. It calls for instructional approaches that feature adaptability and flexibility in combining affective learning with cognitive skills and content; it calls for personal characteristics such as perseverance, patience, imagination, and ability to feel and respond *with*, rather than just *to*, another human being. Such an instructional approach is capable of being persuaded as well as persuading, and is not "stuck" on one particular pet way of doing or teaching anything.

These characteristics should sound perfectly familiar to school library media specialists as those of an excellent library media program for any student. If, in honing them to reach and teach the special learner, we give them a higher gloss, so much the better. As we have said, the philosophical roots which have shaped the library media programs over the past two decades especially are very close to, if not identical with, those which now shape and sustain the special learner instructional programs. If we believe, as we have often said that we do, that *every* child is a special learner and that the teacher's essential job is to find the key that unlocks his understanding and involvement in learning, then we understand our role with the mentally or physically limited and learning disabled. If we truly believe that education's purpose is to develop understanding *and* to develop at the same time the learner's ability to act upon his understanding—to make it truly his, part of his repertoire, then most library media specialists will see the direct relationship of this to the library media program. And if we believe that teaching is not a process of casting learners adrift in the hope that they will find their own course, or, at the other extreme, force-feeding with facts that have no meaning, then most library media specialists will recognize their area of work. And if we say that stereotyping the limited child, lumping him, as with race or sex, with others who are superficially "of his kind," deprives the individual of his precious self-identity and the freedom to become himself, then most library media specialists would concur, and would know that there is plenty they can do to prevent this from happening.

The library media specialist who already, before the onset of PL 94-142, has been functioning as a master teacher knows full well that most children have more natural ability than is ever realized. One of the least acceptable realities in education as a whole to library media specialists is that so many childrens' capacities go undiscovered, unawakened, and unused. To a greater extent with the limited learner than even with other children, the teacher monologue and the textbook are not acceptable sole resources. More so even than other learners, the special learner who is mentally retarded or

learning disabled must have books and audiovisual resources in very wide variety. For one thing, the individualized prescription for learning demands it.

The special learner, with mental limitation and learning disablement in particular, has greater need than even that of other children to sense acceptance in a teacher's attitude. This acceptance brings into play the determination to measure up, and the creativity to do so. The teacher or library media specialist must be alert to those materials and techniques that allow full rein to the creativity once it has been sparked, so that it can feed upon itself. Nothing succeeds like success, and this is as true for special learners as for anyone.

We have just mentioned alertness. It must be sharpened, too, to recognize problems, barriers, and stumbling blocks which can appear suddenly and unexpectedly for the special learner and throw him off course. Diagnosing the root causes of problems, though, should be left to the experts. Knowing what to do if something goes really wrong is quite beyond the expertise of teachers or library media specialists, and a smattering of knowledge can be used in destructive ways. Knowledge used to develop sensitivity in oneself, or to understand what teaching methods to use is one thing, but attempts to diagnose disability by oneself are quite another. It is very important to maintain the distinction between understanding used to improve teaching ability and trying to operate an outpatient clinic in the library media center. The latter is a double no-no, although the library media specialist should be able to make an important contribution to the diagnostic and prescriptive process by adding information gleaned by observation and contact with a child. In fact, the ability to observe well is a priceless one, and understanding of what causes the most common learning disorders—dyslexia, for example—will reinforce the value of one's observations.

If a library media specialist is the first to notice that something is wrong with a child's ability, the rule is "don't try to decide yourself *what* it is, just note the symptoms." The child's teacher should first of all be alerted, and then the school should help the parent to find suitable professional diagnostic help. Good professional diagnosis should include recommendations for treatment.

No matter how sophisticated become the tools for evaluating, diagnosing, and prescribing for children, there will always be large numbers of undetected learning disabled persons in the population, as well as, just as tragically, numbers of gifted children, whose potential is never developed. The children characterized popularly and sloppily as "slow learners," "underachievers," and "marginal" can well become worse if the condition causing the inability to learn goes undiagnosed. Sad to say, very little research or teacher emphasis has gone into improving the lot of the marginally exceptional or mildly disabled learner in the regular classroom. Estimates as high as 20 percent of all children have been advanced to represent the number of children who have trouble "keeping up." These children usually start to read later than others, and their pattern is to fall farther and farther behind until they finally stop trying. Their frustration and the anger it causes—for they do desperately want to keep up—frequently erupt into bad conduct and behavior that is distracting and confusing to themselves, their peers, their parents, and their teachers.

The learning disabled child may hide behind a facade which shows him simply as a discipline problem, a truant, an inattentive learner, or just plain lazy, undiagnosed and unreached. While the learning disabled child may well be somewhat below average in physical development or appearance, may have a higher incidence of illness and be perhaps lacking in coordination, there is absolutely no certainty that these signs will be present. None of these characteristics goes intrinsically with being learning disabled, and many children slip through simply unreached and unhelped, if the retardation of intellectual development is not too severe.

Many matters in which the library media specialist is usually not too well informed intrude here, but since these concerns now loom so large in the classroom teacher's world it is essential that the library media specialist understand them too. If nothing more, some knowledge of them builds a bridge between the library media program and the classroom.

In determining who fits where in the classroom, teachers and administrators rely ordinarily, and heavily, upon

cumulative data. Such data usually include: IQ (intelligence quotient) tests, achievement tests, aptitude tests, personal observation, and other objective and subjective criteria. Each of these instruments or techniques become part of the cumulative record for each child, and that cumulative record is used to place, track, and predict future success for a child. It is the basis of expectation about what he is capable of accomplishing and what he will accomplish. It would be shortsighted to maintain that such a cumulative record of past achievement and measured aptitude is not a highly useful tool and resource in helping the school and the teachers understand a particular child. But—and this but is a great part of the reason why tests and formal records have a bad name in so many quarters— these tests and the record of past achievement are not and can *not* be the whole story for any child, and they are too often burdened with this responsibility. A child's attitude can change, his health and physical equipment can change, his home and emotional outlook can change, even his intelligence quotient can change from one year to another, even from one interpretation to another. And all of these things can cause major changes in his aptitude and his potential for future achievement. The library media specialist, who rarely becomes involved in the formal records or record keeping, is more apt to go by the barometers of observation, discussion with the child, and intuition born of experience, in the evaluation of the child, and the library media specialist may be more aware, therefore, of the fact that there are major changes taking place. Although lack of involvement in the formal measurement and evaluation techniques may be in one sense a weakness that limits the library media specialist's more active participation in the process of evaluating and prescribing for the learning disabled, this weakness may be turned to advantage. The more subjective data which the library media specialist gathers in lieu of the test data may be just the information that is needed by the evaluation and prescription teams in forming conclusions about the needs and programs of students.

In its instructional role, the library media program has usually dealt with learners individually, but sometimes in

more or less heterogeneous groups. The library media special-
ist will need now to consider also the use of homogeneous
groups of learning disabled children if all are to be reached
effectively. It should be quickly stated that the purpose of
such grouping is not to segregate the special learners, but
rather to provide a sense of security and interaction as well as
to enable the library media specialist to spend more time with
them. Grouping learners in order to help them, and to help the
teacher to teach properly, is a process that takes patience and
thought. As with such decisions made for regular learners, the
why's and how's are critical questions. Here is a place where
the library media specialist has an important opportunity to
become involved with the teacher in decision making, either
through the formal process of designing the IEP, or the one to
which library media specialists are so accustomed—planning
and consultation with the classroom teacher on an informal
basis. But even in an informal mode, the library media spe-
cialist needs to know why and how grouping is done, how
cumulative records are used for diagnostic purposes, and
other matters germane to classroom planning.

Grouping placement may not be used as a method of disen-
franchisement or to "get the special learners out of the way."
Intensive and very effective media components for the in-
struction of special learner groupings are one good way to
insure that the legal requirements for "equal opportunity for
access to an appropriate education" are met.

The potential for further educational development, reason-
able personal growth, and social adaptability which the dis-
abled learner displays is, of course, shaped by the degree and
type of his disablement. The severity of a child's intellectual
retardation, the extent to which his or her cultural and social
experiences have been restricted, the degree of deficiency in
physical and motor skills he or she shows, will profoundly
influence what is to be taught and how it is to be taught. For
the mildly mentally retarded, the skills of reading and writ-
ing, of finding and using information, are tools to be used to
enrich what has already been learned and to make more
learning possible. The enlightened and capable library media
specialist works closely with the classroom teacher to devise

a skills teaching program for this mildly learning disabled child which will relate to and reinforce classroom teaching, and enable him to apply the knowledge he has gained in ways that are useful to him.

For the learning disabled child, too, the focus of teaching must be the association of skills with purpose. Developing an understanding of why something must be learned, presenting basic concepts, and providing opportunity to use them are good teaching practices for these children. As a teaching program, the library media program emphasizes learning through application of skills in ways that mean something to the learner.

Thus far our attention has been devoted largely to the needs of the mildly retarded and learning disabled, since these large groups of exceptional children comprise the majority of learners with whom the library media specialist will be called upon to work in the regular school building. We must not overlook, though, the more profoundly disturbed or damaged exceptional child. A dysfunction of the brain, or brain damage, can show itself in so many ways that it would require several books just to list causes, outline symptoms, and discuss the range of appropriate treatments. The descriptions we shall give here of various conditions obviously are not intended to prepare anyone to diagnose or label, but to make readers somewhat aware of the effects of some specific dysfunctions so that they may better provide learning services and programs for those afflicted by them.

Brain dysfunctions can cause disorders in various parts of the body. Learning disorders commonly seen in the schools include *dyslexia* (reading problems), *dysgraphia* (writing problems), and *dyscalculia* (computational problems). Activity disorders which show up as physical problems include poor coordination, too rapid or retarded growth, and too large or too small a body. Behavior disorders may express themselves as passive or hyperactive behavior and other behavior problems. Brain dysfunction can manifest itself as cerebral palsy, epilepsy, mental retardation, or even childhood psychosis. The effects may be profound and irreversible, or minimal and responsive to therapy.

While we now use such words as "limited," "handicapped," or "exceptional" in place of the brutal, pejorative words that were once used to describe various levels of mental retardation—words like "idiot," "imbecile," or "moron"—we are still a long way from knowing precisely all the causes or gradations of mental troubles. We know that mental retardation can be caused by an injury (at birth or any time thereafter; an inflamation of the brain (meningitis is a common form); or simply underdevelopment of the brain, a condition still very little understood. Cretinism, caused by a faulty thyroid gland—a gland controlled by the brain—is an example of brain underdevelopment.

The list of causes of mental retardation grows as scientists, physicians, and other researchers test, experiment, and discover. We know that certain reflexes are present at birth: sucking, swallowing, sneezing, grinning, and, as doctors call it, a grasp reflex. At one month, the normal child looks at objects; at two months, he recognizes his parents and coos; at six months, he sits up; at ten or eleven months he forms such words as "mommy" or "daddy", for those he sees around him. At about one year of age, the normal baby walks; at eighteen months, he can name simple objects; and at about twenty-four months of age, he can form simple sentences. By about the age of four, there is a rapid increase in vocabulary, and by five years of age the normal child can conduct coherent and fluent conversations.

Jean Piaget, the Swiss psychologist who was a major contributor to establishing these descriptions of the early stages of child development, has termed this stage of life, from birth to two years, the sensory-motor period during which the child's major learning is through the senses and the physical responses to what is sensed. For normal children this learning and responding unfolds very much according to the book, because everything is functioning properly.

Scientists, even those of us who have had biology courses, know a good deal about the brain, and yet we understand very little of how it works. We know what happens, but understand very little about the consequences. We remember that the cerebrum, or the forebrain, is the largest part of the brain;

that the cerebellum, or the back portion of the brain which is smaller than the cerebrum, controls equilibrium and balance; that the cortex, the brain's outer layer, is the most important part because it controls both our physical movements and mental processes; and that the medulla regulates breathing. We know that there are glands in the brain: the pituitary which regulates bone growth and water metabolisms, and the pineal organ which affects our vision and sexual development.

What we didn't learn then, and nobody knows even now, is whether or not there is a definite center of intelligence somewhere in the brain. Nor do we know why it is, when something happens to one hemisphere of the brain, such as a crippling blood clot, that the other hemisphere can assume and carry on life-support functions. With retardation, something gets in the way of the well-ordered sequence of events which so well describes the normal child's learning progress. Sometimes early, but generally later, because the wish not to see is so powerfully present, the parent realizes that the child does not fix with interest on crib playthings, does not show any wish to crawl, coo, or toddle. There is no particular evidence of growth, which in the very young is measured on a month-to-month basis. The signs are there, and they accumulate to the accompaniment of tension and mounting anxiety. Something seems different, something seems wrong, something is wrong—the child is retarded.

As we have indicated earlier, there is a good-sized list of the likely causes or possible contributors to mental retardation. They include heredity; the ill health of the mother during pregnancy; smoking, drinking, and other drug taking during pregnancy (now all definitely established as affecting the size of the brain); the mother's illness with German measles, which causes brain damage in the fetus; an Rh factor (incompatible blood of mother and father); the age of the parents; a brain hemorrhage; lead poisoning; the presence of syphilis or gonorrhea; nutritional deficiences; congenital defects; even the disturbed emotional state of the mother during pregnancy. Several of these conditions, such as malnutrition, emotional upset, lead poisoning, and blood diseases are related to social

and economic distresses, and so medical and sociological factors in retardation should be considered together.

The important role of the medical doctor in the life of the retarded or disabled learner should particularly be mentioned here. If only because the incidence of retardation usually increases the number of physical ailments to which a child is prone, the doctor becomes much more than just a once-a-year check-up resource. Indeed, for some retarded children, intimate and continuous association with a doctor, or a medical team, is a matter of life or death. Advances in applied medicine have increased the use of drug therapy in many forms of retardation. While the teacher or library media specialist may be a keen observer of the effects of such medication upon a child, and may carefully record and report such observations to the appropriate person, it goes without saying that no educator should ever confuse his or her role with that of the physician.

In a way, the growing knowledge of the causes of mental retardation and how to deal with it has led to improvement in the ability of families to cope with it as a family unit, and for schools and the community to react constructively to it. But just as every problem solved inevitably creates other problems, so it is with this greater awareness and knowledge of the causes and gradations of mental retardation or disablement. The ability to define and describe with greater accuracy greatly improves diagnosis and treatment, but it can cause befuddlement and confusion, too. We have reached the level of refinement that allows classification of the retarded as mentally impaired or disabled, mentally deficient, or mentally handicapped, with the result that even the medical profession begins to ask, what does it mean that a child has this or that level of retardation? Increased knowledge does not always mean increased understanding. While it is appropriate to say that "mentally retarded" includes all learners with any *significant* degree of mental retardation, again, what does this really mean? Can the existing level of retardation be altered, or are there conditions involved which cannot be altered and must just be accepted? The parent in the emotion-laden state of trying to decide how to cope with a fearful unknown,

always hopes, and who can say that such hope shows a blind disregard of reality? Modern medicine and science have more than once altered a situation previously considered permanent or hopeless.

A school staff, involved with retarded learners, will almost surely become embroiled in this emotional issue. The parental involvement mandated by PL 94-142 in the structuring of an appropriate IEP for the learner almost guarantees that the matter cannot be avoided. All the same, confronting the question, "is my child's education being planned for the condition he is in now, or looking forward to the improvement that will surely take place," may well be unpleasant and frustrating. In most cases, fortunately, the degree and depth and the prognosis for the learner's form of retardation will have been established long before very much contact with the learning program takes place.

We noted earlier that most schools have relied traditionally upon two measurement devices to determine a child's learning readiness and to aid in placing him in school: chronological age and the IQ test. Neither takes into account the behavior or maturity level which so pervasively influences the learner's *motivation* to learn, so most educators feel that their usefulness is limited, and most schools do not rely exclusively on these devices to predict learning success. Still the mystique of the IQ is very powerful and influential, even though professionals are too cagey by now to admit to much reliance on it. It is a particularly dangerous mystique when applied to retarded learners, and misdiagnosis can consign a child to a tragically dead-end future. It has happened. If the parent has been sufficiently alert, and medical attention has been sought, the level of retardation has been diagnosed long before entry into school, but if not, and especially with mild retardation, all the symptoms may not add up to a correct diagnosis and learning program.

Too much failure too soon dampens interest in learning. Nothing fails like failure. For the misdiagnosed "slow learner" it is not for want of remediation that progress is lacking. In the belief that more is better, reading labs and math labs, programmed instruction and tutors and other remedial programs

are heaped upon him—and to everybody's discouragement, nothing "takes." For the retarded learner remediation is at best wasteful, at worst, destructive. The mentally retarded learner does not "catch up" by having a lesson repeated over and over, or even by having it repeated in smaller and more concentrated doses. For the retarded learner, knowledge and understanding do not increase through remedial lab work. The remediation approach always presupposes that certain absolute standards of learning or conduct can be established and that through reinforcement these standards will be met at a certain age or grade level. This reassuring notion is most appealing because it gives answers that are always the same—like a parrot. Unfortunately, they just don't happen to be true, all the time or for every child. For the learning disabled, perhaps, repetition and enrichment may help, but for the mentally retarded, learning will come more slowly and with less depth, and no remedial program can alter this. The fact is, in terms of the regular classroom, the mentally retarded child in competition with the normal learner *cannot* keep up. The mentally retarded display limited powers of self-direction, and limited abilities to abstract, to generalize, to transfer, and to draw upon past experiences to meet new learning expectations. For even the most mildly retarded learner learning must be concrete, specific, and tied to known experiences. For even the most mildly retarded special education means a specially trained professional to teach, and a carefully designed curriculum to follow. Often special classrooms and support facilities are required as well, although current emphasis on mainstreaming has lessened their use.

Depending upon the severity of the brain dysfunction, a learner's education will proceed. Nearly all psychologists and medical personnel working in this field agree that the most important thing for the child's development is that which is learned through direct experience, and assimilated as understanding. They all agree, too, that one successful learning experience will encourage the retarded child to seek another, and when all goes well, one success builds upon another. It must be understood and believed that with these children the teacher has a profound effect by shaping learning so that they

promote success. We know, too, that the desire to attain the maturity that comes from successfully meeting a series of challenges can motivate the retarded as much as the normal learner. For the excellent teacher it is a matter of orchestrating these motivations, combining them so that the child is carried from one learning experience to another.

It is worth remarking at this point that there are as many different personality traits and character differences among the mentally retarded as there are among other children. In describing and analyzing levels of dysfunction and disability as we have been doing, one tends to lose sight of the fact that we are not coldly discussing "cases" but real children—more like other children in more ways than they are different.

This might be as good a place as any to call attention to the United Cerebral Palsy Association's *Bill of Rights for the Handicapped*. It sets out simply the goals toward which all the diagnosing, the treatment, the educational prescriptions, and the mighty efforts of learners and teachers are directed. The handicapped—in this case specifically the mentally retarded—have, it says, the inalienable right:

(1) to the early detection of abnormality;

(2) to adequate health services and medical care for protection and well being;

(3) to education to the fullest extent possible;

(4) to training for vocational and avocational skills;

(5) to work at an occupation for which one is qualified and prepared;

(6) to an income sufficient to maintain a decent life style;

(7) to live anywhere one chooses;

(8) to barrier-free public facilities;

(9) to function independently; and

(10) to petition social institutions and the courts to achieve these rights if they are otherwise denied.

One notes that many of these rights or objectives are going to take mastery of *skills*. What skills? The skills most needed by the retarded learner who falls into the educable range

include perception and motor skills; communication skills—listening as well as speaking abilities; social skills—especially those that reinforce the ability to get along with others; and citizenship, particularly taking responsibility for one's actions. Much attention must be paid to the acquisition of health and safety skills, for looking after one's self is a very important matter for the retarded. Arithmetic, science, and ability to express feelings and be creative in the fine arts are useful additional skills. Finally of course, if one is going to be independent and hold a job, one must have vocational skills in which all previously mentioned skills play a part. For many retarded learners, the ability to take the responsibility of holding a job is probably the most important single event in life, for it means independence and a life of one's own. Therefore, job-related skills are paramount to the learning of an educable retarded child or young person. This is not to say, of course, that job placement must be the end product of education programs for the mentally retarded, any more than the purpose of career guidance is to help children to select a career in elementary school. But more than a sheltered workshop job should be possible, and will be the goal of many of today's mentally retarded children, and their education should reflect this confidence in so far as possible.

These skills, like all skills, will become useful and used only with repeated successful application in personally meaningful experiences. Need, use, and then reward must follow in a logical sequence if success is to be the outcome. The effort is not to bring the learner and his skills up to some preordained level, but to help him to make the most of the natural abilities he has but does not understand how to use with the ease of the normal learner.

Retarded children are inclined to carry a poor self-concept around with them. Since the potential to learn and the will to strive depend greatly on the support of a good self-concept, it is very important for the teacher of the retarded to bring to the fore in a retarded learner those characteristics that will enhance a positive self-concept. To do this, an attitude which is firm in its expectation of correct conduct, but supportive of individual needs, is necessary. This attitude creates a learn-

ing environment that is consistent, structured, comprehensible, reasoned, and based upon clear expectations of what is to happen. Firmness, tempered by the support which implies caring, and patience, in accepting the small, often infinitesimal, steps of progress, are requirements.

Personal qualities in a teacher which encourage the retarded learner to relate well to that teacher are to be valued above all known methodologies or techniques. It is these qualities that suggest praise for small victories, and make a teacher avoid making judgments about what may seem to be failure. It is these qualities that spur the teacher—or library media specialist—to get acquainted personally with learners.

The library media specialist is equipped with some powerful assets which can bring much that is of value to the teaching of the mentally retarded. Whether we speak of specially designed library media programs, supplementary enrichment programs, or compensatory programs, the library media program has the capacity to bring essential resources to the job and greatly assist the school community in coming to grips with what can and what cannot be done for the retarded learners.

There are good reasons why so often the best users of audiovisual materials and equipment have been the teachers of the mentally retarded. Their purpose has not been simply to fill the hours with sight and sound in anesthetic procession, nor to distract rather than to involve. They have used these materials because they have recognized that the stimulus of sight and sound, carefully planned, is a provocative aid to stirring the imagination and motivation of retarded children. Effective use of filmstrips, audiotape, overhead projectors with acetate, and the like gives the library media specialist an excellent opportunity to observe reactions, follow leads, record, and evaluate responses. This is sound educational practice in any setting and with any children, but with the retarded it is vital, since every little scrap of information, put together with others, provides a clue to the child's potential for the future.

It can probably be assumed that most of the retarded children with whom the library media specialist will work

can be divided into two general groupings. The first, the mentally handicapped or less severely retarded, are considered to be educable and capable of learning all of the basic skills discussed earlier. The educable mentally retarded are perfectly able to lead useful lives as good citizens, with the potential even for personal and economic independence. The second group, the mentally deficient, are those more severely retarded, and are usually considered to be uneducable, at least in the narrow sense of learning academic skills, or assuming full adult responsibilities. However, it cannot be emphasized too strongly that the skills of group association, self-control, and a degree of independence can be assimilated in some degree even by the severely retarded. Some may consider such definitions too general, but our concern is not with the minutia of definition but with what the library media specialist can do to become better able to teach the retarded of all gradations. In order to do this properly one must learn to expect the unexpected, and deal with the unanticipated— hardly new experiences for the library media specialist in any school. While this is an unwritten job responsibility, it comes with the territory.

For the mentally retarded, library media programs are perhaps most useful when they help to reduce certain negative characteristics apparent in most retarded learners. Decreasing the impact of destructive personality traits and negative responses through the use of positive reinforcement is old hat to behaviorial psychologists, and while we do not fully share their beliefs about changing behavior rather than altering attitudes, this approach has its uses in teaching the mentally retarded. It is most important to reduce, if possible, the anxiety level and fear of failure that the retarded learner brings to learning, although even with these children some reasonable degree of anxiety may be a useful motivational spur to learning. As one observer has expressed it, "the retarded child is beseiged with anxiety." Self-doubts multiply, and fear of rejection is all pervasive at times even for some normal learners, but for retarded children this condition is often fairly continuous, and must be alleviated before much attention is given to the skills of learning and living.

Library media programs for retarded learners must be as failure-free as possible. The end product can not be the traditional pass or fail. Both physical and mental fatigue are ever present with the retarded learner, hence the need to present learning activities in short or small doses, and to be prepared for a good deal of "forge ahead and fall back." Frequent rest periods are necessary, and learning activities that increase in their challenge very gradually, so that degrees of success are provided all along the way. The preferred activities are those that encourage children to let go of preoccupation with self, and to transfer concern and care to other persons or objects. Interaction—with the group, with another person, or with some medium—becomes an important instructional goal in a library media program for the retarded child. Activities encouraging the retarded learner to help others and to think of their needs are essential learning experiences. Also, it is helpful if these activities that stress reaching out, caring, and being involved are associated with some physically therapeutic activities that help improve coordination and mobility. Games, puppet shows, and short films come quickly to mind as excellent library media activities which assume beneficial mental and physical instructional dimensions for retarded learners. To the extent that these program components incorporate humor, sharing, and good will in their format and presentation, greater helpful results can be expected.

Retarded learners are often restless and have difficulty in focusing intently on the work at hand—paying attention, as it is known in teacher talk. In the mentally retarded learner, the capacity for learning is circumscribed by the fact that his ability to hear, see, and think are undernourished. But with good judgment and a careful attention to attitude, the library media specialist can pace and adapt programs so that they tend to reduce the effects of retardation rather than to try to overcome them.

Psychology tells us that a first requirement in teaching the retarded effectively is to reduce the number of extraneous stimuli. These children cannot be bombarded with sights, sounds, happenings—they are too easily distracted and become confused. Since the use of extraneous but integrated

stimuli is an integral part of the library media program, this needs some interpretation and also some qualification. What this means is that the best library media program for the retarded learner will be one which allows him to concentrate on one media presentation at a time. The idea is not to proscribe the use of a variety of media with the retarded learner, but to use one format at a time and keep the period of use short and intensely focused. Multimedia—the high intensity four-screen sound and light show—would not be useful, for example, with the retarded learner, as it would be likely to disorient him. But the availability and use of many forms of media are as much a necessity for teaching the retarded as for other learners. Orderly arrangement and presentation is important, and structure, as we have said, is all-important. Visual presentations are excellent, and the short 16-mm film, the transparency, the opaque projection and the study print can be used with very positive results. Not too long, not too much, and not too often is the basic rule to follow, always remembering that the learner has great trouble in concentrating. Visual presentations are expecially good because they stimulate the learner's reactions and responses and help him overcome an often inhibiting reluctance to express feelings or ideas. Having the retarded learner listen to the sound of a bird, a car, or a train and then describe it is very useful since it helps hone the skills of listening and responding. The use of game formats is good, and activity that involves physical movement and group relationships is wonderfully rewarding to both learner and teacher. *Involvement* is a very key word in teaching the retarded learner.

One sign of the high achiever is a good sense of organizing both things and people to get desired results. In the mentally retarded, this organizational sense is strictly limited. Forgotten assignments, slowness in gathering things together to get started on a job to be done, even an actual physical slowness in moving around, are all typical of the retarded learner. It is these kinds of conditions that must be "worked around" in planning library media programs. The unified nucleus, the self, around which the normal learner organizes is not "together" in the retarded learner, and often the library media

specialist or some one else must help to provide it. A kind of balance at the core of physical and mental self must be present if the learner is to learn. Providing a "buddy" or a helper to aid the disorganized learner cope with the situation at hand is often a practical way of dealing with his need. Since the intent of mainstreaming is to provide the least restrictive educational environment, this concept is in harmony with the intent. To encourage the nonspecial child to look out for, to share with, and to have some responsibility for the retarded learner can be regarded as a healthy situation all around.

Coping fully with the disorganization which is part and parcel of the retarded learner's life requires close cooperation with other teachers and probably also with the home. Be reminded again that the purpose of teaching the mentally retarded is *not* remediation—for most of his characteristics will not be changed—but altering the effects through conditioning and experience. The purpose is to *reduce* to the lowest possible level the deleterious effects upon the child's life and his ability to function. Close cooperation between the classroom teacher and the library media specialist is essential for this purpose. Failing this collaboration, putting together the right combinations of materials and activities in order to motivate and structure the retarded learner's program is well nigh impossible. Even with two caring and committed professionals involved, the search is often no less difficult, but the results are apt to be more satisfying. If the parent is involved in this team effort, the probability for success should be even greater. In fact, the coming of special learners into the mainstream should greatly increase parent involvement in all types of library media programs—to the benefit of all.

The generally poor coordination usually present in the retarded child is another example of a fixed condition which usually cannot be remediated, but which can be made into a more manageable deficiency for many children. While library media programs have rarely been associated with activities that improve the learner's ability to overcome the effects of poor coordination, this must become a consideration in program planning for the retarded. Perceptual distortions and inability to command one's movement as one wishes can lead

to a feeling of intense anxiety and the expectation of failure. This erodes the limited stock of self-confidence the retarded learner may have managed to build up. Using the library media program to help means using existing materials or adapting activities in some innovative ways. This requires of the library media specialist mostly imagination and energy, rather than additional materials.

Library media programs can, with some thought, be made to incorporate some basic physical activity such as moving about and using in a coordinated way, different parts of the body. Even picking up and opening a book requires coordination, and what would be considered routine movements and not even thought about for the normal child becomes a physical coordination activity for the retarded learner. It does not take a great deal of colorful imagination to use a filmstrip about health or safety as an instructional mechanism which helps the retarded learner recognize the shapes and colors of safety or precaution signs. It becomes a matter of thinking and of sensitivity and of not taking *anything* for granted. Every activity should provide the retarded learner with connections and relationships—relationship with his own body, the images he sees, the meaning of these images, and how to link them to something else. Reducing the complexity of physiological processes involved in seeing, hearing and in thinking, should be constantly kept in mind. A chain of small, related, useful experiences is far more productive than a big, complex experience.

Abstract thinking—the ability to take symbols and ideas into our brains and assimilate them, make inferences and deductions from them, and then express them in new ways and in new contexts—is the ultimate purpose of learning. For the mentally retarded, in whom brain damage has occurred with the resulting limitation of this chain of abilities, learning cannot be a sequential process, with one thing, one step leading naturally to another. We expect in the process of normal learning to be able to shift gears from one aspect of an idea to another, and to be able to hold several ideas or concepts in the mind at one time. The normal brain holds a tremendous data base, and the ability to retrieve from it, to

sort through and program, is what gives us our ability to encompass abstract, creative thought. For the retarded learner it is all much more difficult, and he needs practice in going through a series of processes that the normal brain undertakes naturally. He needs conceptualization activities which help him form one idea out of a combination of several ideas or input activities that help him to move, blocked though he is by anxiety, from the known to the unknown. Such activities must help him transfer understanding from one situation to another. Ideas are presented one at a time, then reinforced through application in different combinations. Repetition need not mean boredom. The inhibitions of the retarded learner, very much like those of the normal learner, can be reduced by the teacher who motivates through the senses, captivates learners into trying for themselves, and personalizes the rewards of mastery. Again, it is not so much a matter of pioneering new methods as it is carefully fitting the right method and the right piece of material to the teachable moment for a particular child. And note how similar this is to what library media specialists do with every child on any given day.

There is little question but that behavioral problems associated with retardation are intrusive, never easy to understand, and hard to cope with. Apparently that part of the brain which leads, by way of the acquired socialization process, to expected behavior, does not function properly. The retarded learner will often be boisterous, loud, insistent, and repetitious. Sometimes a retarded learner is quite the opposite— passive, withdrawn, and disconnected from the surroundings. When actually experienced, the impact of either type of behavior can be overwhelming. Since disruptive behavior must be modified or contained before any meaningful learning can take place, the psychology which the professional uses to deal with retarded learners must be firmly in mind.

Especially useful here is a full measure of common sense, fairness, and a sense of purpose strong enough to be transferred even without words to the child in question. The library media specialist who wants to be an effective teacher of the retarded children in the school must be, in short, everything

that they are not—serene, calm, confident, cheerful, positive, and above all, *consistent*. Since one knows that discipline problems will be a given, the first order of business will be to firmly limit, put boundaries around disorder, so that it doesn't have a chance to snowball. One must have the good judgment to ignore the minor infraction in order to concentrate on and prevent a major confrontation. Consistency in everything—tone of voice, action, words, movements, and judgments—is of prime importance. It is again important to recall here that one is bent on limiting bad effects, not permanently changing the conditions which bring them about. Punishment or force is contraindicated. The overall goal remains that of helping the learner to develop a good self-concept. Like everyone else, the more confident retarded learners are about their ability to handle a situation, the less likely they are to react aggressively and with hostility. Dime-store psychology, perhaps, but pretty good common sense, too often ignored by teachers.

In one way or another, each of the limiting conditions retarded learners bring into the library media program relates ultimately to social maturity, the child's ability to accept responsibility for decisions made and actions taken. Creating some sense of this social maturity underlies every effort to reduce the mentally retarded learner's limitations and their effects. The emotional deficits associated with retardation mean that the library media program must provide, above all else, experiences of sharing and telling which undergird the development of improved social skills, experiences of trying, doing, and seeing positive results. Improving the retarded individual's self-concept and self-confidence relates remarkably well to most of the activities already in common practice in the library media program. Having children tell about their feelings after seeing a short film, making up a story about a picture—strategies like these are used in nearly every library media program.

A sense of time and timing is critically important in programs for retarded learners. The library media center activity should begin promptly, end within an appropriate span of time—never too long, and build toward a high interest point

so that the retarded learner will be sustained until next time. This relates to the importance of continuity, too—helping the retarded learner to look ahead, to anticipate, and to look backward to the past provides important learning experiences. Involving limited learners in planning for "next time" is a good way to give this time sense, the sense of continuity and motivation.

Evaluation of what has happened compared to what was expected is as essential in teaching the retarded as it is in teaching other children. Evaluation based on wish fulfillment is no good. Keeping accurate records about what is happening, including the unanticipated, helps not only in evaluating a learner's progress but in one's self-evaluation as a teacher, and thus is the beginning of a useful feedback loop. To many library media specialists, record keeping means circulation figures and costs, but to be fully effective in teaching retarded learners, the library media specialist must begin to keep records that deal with particular learners. The purpose is not to tot up pluses and minuses for a grade, but to develop a cumulative record of what learning activities were used, how the learner responded to each, what growth or deficiences were noted, and what changes should be made in methods or goals. This record keeping for individual students is a teaching discipline most library media specialists have never undertaken, but keeping such records will help in becoming a better teacher.

Becoming a responsible citizen in a democratic society is a goal so broad as to be almost meaningless. Since the worst of educational goals often combine irrelevance and incomprehensibility, it is hard to phrase the goal of good citizenship for the retarded learner without being one or both. But there are some specific objectives that can make citizenship goals both relevant and understandable. Wherever instruction occurs, whether in classroom or library media center, every lesson presented to the retarded learner must aim at helping him become a responsible person. Among these objectives are that the learner develop a reasonable understanding of the nature of a community, a respect for the law, open-mindedness toward the opinions of others, receptivity

to new ideas, appreciation for doing what is right, and under-
standing the obligations of citizenship. While citizenship edu-
cation for retarded learners must incorporate these major
elements included for all students, it is vital that certain ones
be highlighted, such as acquiring good work habits—being on
time, following directions, finishing the job.

While most normal learners have a social awareness which
includes a sense of their responsibility to others, ability to
deal with personal problems, as well as involvement with
community problems, things start off more concretely for the
retarded learners and more narrowed in focus. For the re-
tarded learner, being a good citizen is expressed primarily in
such ways as getting and holding a job, being law abiding, and
in acceptance of responsibility for personal behavior. The
requisite belief now for both the retarded learner and those
who prepare him for his citizenship role is that he can partici-
pate productively in a form of society which rests upon full
participation by *all* its citizens, not just those who are phys-
ically and mentally complete. The law instructs us now that
we must prepare the mildly retarded child to play a broader
citizenship role in making decisions and choices. To fully
achieve this, some fundamental prejudices that have molded
our thinking in the past must be discarded, chief among them
the belief that when they reach adulthood, the retarded will
play no role in democracy's decision-making process and the
shaping of public policy. Development of a good self-concept,
with accompanying confidence in one's own judgment, should
increase the retarded learner's interest and involvement in
public affairs. For the retarded, education's purpose can be
said to be to reduce the effect of the limitations imposed by the
handicapping condition to the level at which the person living
with the limitation understands it and is able to compensate
for it.

We hope now that the handicapism prevalent in education,
in employment, in government, in the mass media, in architec-
ture, and in transportation is being brought to a level of
understanding in our consciousnesses just as racism, sexism,
and age have been. As one assertive group of handicapped
political activists put it, "our bodies or our minds make us

disabled, but society makes us handicapped." For the severely retarded it remains true that survival skills are the goal, and these are not to be assisted in any great measure by the finest library media program. But the library media program can make a *real* difference for the vast majority of the retarded—the learning disabled, the mildly retarded, and the educably retarded learners. It is this learner that the library media program must mainstream successfully, as a requirement of law, but more importantly even, as a matter of conscience and because an excellent library media specialist cannot bear to see one spark of potential go to waste.

Exemplary Programs

The eight following programs are representative of those we selected and visited relating to the mentally and physically limited or disabled. In several of the programs learners have been mainstreamed into a regular school, and thus their library media components deal primarily with mildly mentally retarded or disabled learners, but a number of other programs have been developed in separate facilities and are devoted to more severely retarded or disturbed children. We have placed them here in alphabetical order by state.

Jefferson High School, Lafayette, Indiana
The Mark Twain School, Montgomery County, Maryland
Variety School for Special Education, Las Vegas, Nevada
Mill Neck Manor School for the Deaf, Mill Neck, New York
The Public Library of Cincinnati and Hamilton County, Exceptional Children's Division, Cincinnati, Ohio
Amelia Street School, Richmond Public Schools, Richmond, Virginia
Whitten Village, Clinton, South Carolina
Lapham Elementary School, Madison, Wisconsin

JEFFERSON HIGH SCHOOL,
Lafayette, Indiana

Jerome Bruner, the educational philosopher whose thinking and writing has profoundly affected American education, maintains that a learner, at almost any stage of development, can be taught just about any subject in an appropriate manner. He calls this process "Mastery Learning." The concept is much in vogue, latched on to by school districts and staff development programs in their efforts to find solutions, or more properly, ripostes to the newest round of complaints that Johnny cannot read, spell, write, or think. Nevertheless, we believe that much of what Bruner says about learners and learning is true; this book, after all, is built on the notion that most learners *can* learn some things that are of value for them to know in a regular school environment. This means, of course, that each learner must be carefully diagnosed as to his own learning needs and then prescribed for, and guided toward, learning mastery in an atmosphere oriented to success, in which expectations are high but realistic and the environment humane and compassionate. All but the most "do-it-my-way" educators can find something to endorse about Mastery Learning which demands strict discipline in learning but also places great emphasis upon accommodating the learner's personal learning styles and abilities.

We looked for building level library media programs that would incorporate the best of the prevailing educational theory of the Bruners, the Ilychs, the Kozols, and the others—those whose words in praise or condemnation of what is or is not happening in the schools are delivered with the authority that attracts both followers and critics. We hoped that these building level programs would demonstrate in practice some of the most provocative and challenging of their theories without taking themselves or the theories too seriously.

The school we found which most successfully adapted high-powered and advanced beliefs to its own low-key style and relaxed attitudes about what can be done for special

learners through the library media program is the Jefferson
High School in Lafayette, Indiana. A site visitor to the pro-
gram saw this at once and sized up the situation by saying,
"The media program for those students designated as special
learners is innovative because there is no difference between
what they are offered and what is offered to other students....
Special students are treated as any other students are,
whether they come with their class, in a small group, or as
individuals." That the special learner here is considered "just
another learner"—not in an offhand sort of way but with a
sense of intense commitment and with lively support—goes
straight to the heart of Bruner's thinking, at least as we
understand it. We add that last phrase not so much to cover a
possible misinterpretation of Bruner (who is used to it) but in
recognition of an observation by Frances Fitzgerald to the
effect that many educational theories can be neither proved
nor disproved.

While so many schools, especially high schools, seem to be
in the business of providing unneeded or unwanted knowl-
edge to uninterested consumers, this high school gives sub-
stance to the belief that the library media program can give
both reason and meaning to learning for the diverse range of
students it serves. The program builds strength on a base of
tone and manner that projects the belief that all learners *can*
learn and *will* learn when the proper combination of human
and material resources are mixed skillfully by a library media
specialist working in consort with other professional and
support staff. It must be considered central to this confidence
and to our understanding that the Jefferson High School
library media program was already a top quality program of
established excellence long before it was challenged with
incorporating the special learner into its operations. Main-
streaming here became a logical course of events, for the focus
is innovation by accommodation, an educational practice
little understood in schools. The philosophy and the goals
that flow from it are internalized in this program and put into
practice on a daily, or one can almost say, on a minute-by-
minute basis. This motivates and sustains the kind of library
media program which deserves the accolade, "excellent."

The success of this special education program seems to be the natural result of a philosophy based on educating everyone in the school, and a tradition of getting on quickly and effectively with what is to be done. During the 1967-68 school year, the initial plans for a program for mildly mentally handicapped learners were laid for the region which contains the Lafayette schools. As the program took shape it was christened with the obligatory acronym, in this case GLASS, for Greater Lafayette Area Special Services. The psychological and consultative services provided by GLASS are so similar to those found in other agencies and so well detailed in other parts of this book that we mention them here only in passing. One early and extraordinarily good program aspect, however, was the active involvement of parents and professional staff in planning new or altering existing programs for special learners. That this was being done half a decade before PL 94-142 mandated that it be done gives the region's schools a psychological boost toward good programs, and underscores an attitude that was readily transmitted to individual buildings and staffs, that these programs were appropriate, necessary and possible. The self-assured ease that comes, as the song says, of "doing what comes naturally" is apparent in the Jefferson High School library media program.

The special students using this program, forty out of an enrolled two thousand students, could easily be lost in the shuffle in a program run without regard for the individual differences of *all* students. Consideration of their special learning needs is offered in ways that strengthen their individual intellectual and character traits so that they are able to compete in a world which, despite their limitations, will still require of them some ability to compete.

The special learners group receives a five-day orientation at the start of the school year. One session we observed dealt with using books from the library media center. Taught in one of the library media center classrooms, the session encouraged students to ask questions and seek direction. Using a book of photographs, the library media specialist involved students in the wonders of looking at and enjoying photographs, and led to examination of other books as well. In

addition to stimulating browsers' interests, these books could be checked out and used at home or elsewhere to share and appreciate. Book talks involving carefully selected, high interest books, topped off the session. The staff noted that with mentally limited learners, it is best to finish the story rather than ask students to read the book and find out the ending for themselves.

Using the library media center's production facilities encourages a number of positive behaviors, too. Responsibility is reinforced, but so too is creativity, skills for associating the familiar with the abstract and the sense of relationships, and physical and manipulative skills as well. An excellent example is the slide/tape show about the topic, *The Family,* produced by the special learners. With an instamatic camera checked out of the library media center, a special student had photographed family groups and living situations throughout the city. An extra benefit, in terms of public information and interest, is that this production was used to stimulate community interest in the program for special learners, and to convey a new awareness of their capabilities and enthusiasm for learning. The use of equipment and activities which tie into hobbies or interests is not only good teaching for all students but essential for special learners because it reinforces the image of self and the ability to use that self in positive ways to create a more satisfying life.

Facilities, which may or may not be very important in many special education programs, are important here. The twelve to fifteen students who comprise a special education class do have a library media center classroom in which to work, production areas, and preview areas. Maintaining an acceptable noise level is sometimes difficult with special education classes, but this library media center is better equipped to deal with some high pitched enthusiasm than many other areas, and having toilet facilities and a drinking fountain close by helps too.

Finding unique uses for traditional materials is an essential ingredient of the library media program which successfully serves the special learner. For example, at Jefferson High School merchandise catalogs, the picture file, and audio tapes

of books are incorporated into the program in unique and interesting combinations. What is necessary, as demonstrated here, is that the staff have the imagination, the energy, and the inventiveness to make of the media, all of the media, just what they really are: exciting conveyors of meaning and information. The Jefferson High School program underscores the point that the school library media program that has been doing a fine, tailored, instructional job with other learners and has its roots firmly planted in excellent teaching, and is always ready to range further afield to find new things to be done and new ways to do them, will have little trouble extending itself to teaching the special learner. It will find the challenge renewing rather than traumatic and threatening.

Exemplary Program Elements
1. Relating the special learner library media program to the regular library media program, and using one to reinforce the other.
2. The use of a media production component to reinforce creativity and responsibility for special learners.
3. The use of traditional (print and nonprint resources) and nontraditional (comic books, catalogs) in combination to reinforce special learner programs.
4. The use of library media specialists as teachers in cooperation with regular teachers, for special learners.

THE MARK TWAIN SCHOOL
Montgomery County, Maryland

For many years before PL 94-142, the Mark Twain School has been providing individualized education programs (IEP's) for special learners and exemplary services for emotionally disturbed learners, always related to an excellent library media program. The result, not surprisingly, is a school that educates special learners with sureness and success. Sometimes good programs such as this one get overlooked as we seek out the newest examples of innovation, assuming that newer means better, and that traditional means not as good—and that anything done well for a decade in these days of rapid change is tradition.

A brochure describing the programs at Mark Twain states boldly that "To Learn Is to Change," and that, further, "Education is a process that changes the learner." Mighty truths, these, expressed in a few pithy words, and it is obvious that they motivate and sustain the professional staff of the Mark Twain school whose attitudes, sense of purpose, and can-do style of teaching match the words to perfection.

Too often it seems that special education programs are built around the belief that theory derived from the behavioral psychologist's laboratory can be transferred directly to teaching children. The learner is above all a person—not a dog or a rabbit. Direct application of educational psychological theories is often accompanied by intense determination to prove these theories right, and this can result in some mighty eccentric, not to say inhumane, teaching. The alternative, on the other hand, need not be programs so homogenized that they show no spark of individuality or experimentation.

The Mark Twain School demonstrates that a special education program can be both unique and anchored firmly to solid learning. Its energetic instructional program gives an air of exuberance to the school's atmosphere rather than the pall of gloom so often found in schools serving the emotionally disturbed learner.

Since the Mark Twain school serves only the emotionally impaired learner, it cannot be called in the usual sense a mainstreaming program example. The school's library media program does have, however, a special mainstreaming responsibility, and what it has developed because of this is worth sharing with others. A public school, Mark Twain is designed and staffed to "serve youngsters of average intelligence who, because of learning or behavioral difficulties, are unable to function effectively in their local school." Casting aside the educator's euphemisms, these kids are the tough, the disruptive, and the unruly; they are the hard-core discipline problems whose ways have made keeping them in a regular classroom impossible.

But not all the students at Mark Twain are bad actors. Also there are the students with "a general pervasive mood of unhappiness or depression," and those with "a tendency to develop physical symptoms or fears associated with personal or school problems." A series of negative occurrences or problems must be manifested before children are accepted here. These can range from attendance problems (truancy), to trouble with peer relationships, or evident inability to cope with frustrations or to accept authority. Entrants must have an IQ reading of at least 90 and be reading at a fourth-grade level; students diagnosed as primarily learning disabled are not admitted.

Mark Twain functions as three schools within a school for the 275 students it accommodates: there is a lower school with 110 students (grades 5-7); a middle school of 110 (grades 7-9); and an upper school with 55 students (grades 9-12). It is understood upon entry that all Mark Twain students must leave the school after two years; their destination then either a return to their regular school, placement in another Montgomery County special education program, or placement in a private institution. In some instances, a third year in a satellite program is prescribed. As many as 75 students are lodged in a junior and senior high school satellite which serves as a transitional "half way house" for those who may have difficulty in returning directly to a regular school program. The fact is, obviously, that the "cure rate" is not 100

percent, despite the maximal attempt made during the two-year period to do the job.

At Mark Twain the individualized education program (IEP) is the educational program. The school's clear statement of objectives places the IEP at the top of the list, committing the staff to the development of an appropriate IEP for learners whose main problems include not getting along well with others, not being able to organize their personal or academic lives to achieve much that is satisfying to them personally, and severe problems with academic achievement. Given all of these difficult conditions and others still, the school's goal, to which it pledges itself, is to return as many students as possible to a regular school environment. The entire program relies heavily upon the skill and responsibility of the teacher advisor, each of whom is assigned eight to ten students, and the role of becoming their "advocate, counselor, and friend."

Other strands of the program are woven in to reinforce the whole fabric of this undertaking. The school functions as a staff development center, a place where educators and others may come to learn new methods for improving their skills. Of great importance is the strong commitment to establishing a working partnership between school and parents, and eliciting the cooperation, and the understanding, of the community. Another significant dimension is the continuing evaluation of the program, which provides new insights, techniques, and research findings and shares them with others.

As a learner moves into the IEP process, the library media program becomes a major factor in instruction. Since the IEP is based upon an assessment of the individual's learning and behavior weaknesses *and* strengths (the latter weighed as heavily as the former), the prescribed learning program is tailored precisely to the student's needs. A task-oriented curriculum stresses mastery learning and is taught in small classes by an interdisciplinary instructional team, members of which maintain close personal relationships with their students. The end product of this intensive care and concern, reinforced by discipline and high but realistic expectations, is a return rate of about 80 percent to regular school programs.

The services provided by the library media program have a comfortable familiarity because they are what they should be in any school served by a well run center. This fact nicely reinforces the central theme and purpose of this book, which is to convince library media specialists that generally speaking their existing programs, *providing* they are offering individualized services and instructional leadership, will see them through with flying colors as they move into increased work with special learners and their teachers. An observer of this program has stated that "the media center program is the only form of mainstreaming at Mark Twain. It offers students a less restrictive environment in which they may test their ability to meet the school's goal of having them assume responsibility for their own actions."

Included among the responsibilities of the library media program are planning, with the *principal* and staff, for a skills program integrated into the regular instructional program; encouraging faculty and student participation in the evaluation and selection of materials and equipment; conducting staff development activities; and choosing, designing, and producing materials or learning activities appropriate for specific individuals or groups. Just reading through this list may not convey a sense of excitement and verve, but there is one at Mark Twain. By following through on such projected activities, a fine library media program, well used by teachers, becomes an inevitable consequence.

Reading, listening, and viewing guidance is a top priority for students. Others include instruction in media skills and media production, introducing students to community libraries, and assisting students with projects. Again, the priorities for a library media program in any regular school and those in many special education programs are seen to be remarkably similar, and it is in their modification and alteration that they are made "special." The library media specialist's program of instruction here is activity oriented with emphasis on acquiring visual and listening skills. Instruction is built around a single concept, is of short duration (ten minutes), and reinforced often because skills are integrated into subject content.

There are other critical elements contributing to the excellence of the Mark Twain library media program. Its director is a gifted teacher and generous in sharing good teaching qualities with others. Regarded actually as a co-teacher and co-leader within the school, the specialist works actively in curriculum development and implementation. Completely at home in the classroom, the library media specialist is called, in fact, a curriculum specialist, serves on the principal's advisory committee, and acts as liaison to other specialists in the County Department of Curriculum and Instruction. To a substantial degree, she helps to shape and mold what is happening in the school and carries responsibility for the successful teamwork that makes it happen. Most skills instruction is initiated by the library media specialist-classroom teacher team in the classroom and reinforced in the library media center. The policy of the center is completely open use; teachers request student use or specific services through a plan book. Assignment to the library media center is used as a reward to students for behavior improvement. This business of go-to-the-library-as-a-reward is a firmly rooted tradition in many schools; library media people dislike it intensely, believing that it is wrong to treat the library media center as either a candy shop or a holding pen, as many teachers do. Of course, at Mark Twain behavior modification is at the heart of the entire program, really its chief purpose, and the student body (which is 90 percent male) can gain additional time in the library media center through positive behavior modification, so perhaps in this case there is some justification for such a reward system. Since change in attitude, resulting from improved behavior rewarded until it becomes habitual is the primary purpose of the school and its instructional focus, the library media center cannot very well isolate itself from the effort, but must play a significant part in it. As with most educational theory, the validity of this operation cannot be proved or disproved with certainty, but certainly the Mark Twain library media program is providing permanent benefits to the lives of a good many emotionally disturbed young people.

Exemplary Program Elements
1. The relationship of entire school program (including the library media program) to establishing the IEP.
2. The strong home-community relationship program which reinforces the teaching and learning goals of school.
3. The use of library media specialist as teacher and curriculum resource person.
4. The involvement of students and staff in evaluation and selection of instructional materials and equipment.
5. The involvement of the library media program in establishing instructional goals for the entire school.

VARIETY SCHOOL FOR SPECIAL EDUCATION
Las Vegas, Nevada

Much of this book's attention is directed toward main-streaming, the process of educating special learners in as nearly normal an atmosphere as possible. But there are students whose ability to learn is limited by conditions so profoundly handicapping that no reasonable educational or individual purpose would be served by putting them into a regular school. Their needs demand a unique learning environment that is protective yet challenging. This kind of sustaining and stimulating environment is provided by a school called Variety Tent Number Thirty-nine.

Yes, that is really its name! Setting is the reason, for it is in Las Vegas, and as the program's visitor pointed out, "Las Vegas is a show-biz town." In a sense it is a show-biz school as well, for show business personalities have traditionally been associated with support for the physically or mentally limited child, and the Variety School is itself supported in large part by annual donations from the entertainment world. It is from Las Vegas that Jerry Lewis mounts his annual telethon for muscular dystrophy. There is associated with the school's atmosphere a kind of crap-game momentum, a sense of contagious optimism, and a self-deprecating zaniness. It's not recklessness that pervades the school, though, just a sense that here the odds are with you, even though as a profoundly handicapped person they may never have seemed to be before. There's an underlying seriousness of purpose to go with the school's letterhead which displays a pugnacious bulldog across whose scowling face are superimposed two crossed crutches! With it all, there are activities of important educational and personal consequence going on here.

The Variety School opened in 1953, a special project of the Variety Club Tent Number 39, an international charitable club made up of people in the entertainment world. In 1955, the Clark County School District assumed responsibility for the school's operation, although the Variety Club makes an-

nual donations to help defray the operating costs, which are staggering for this kind of school. For example, in 1979, a new swimming pool complex was added, made possible by a $150,000 donation by the Variety Club and $70,000 worth of school district tax bonds. Variety's clown insignia is imprinted upon the school's front door, an appropriately warm and jolly greeting to a wide range of physically and mentally handicapped learners—some 300 of them—who enter to find a hospitable and supportive environment for learning. All students are bussed into the school.

The school's programs are offered to the physically limited, the physically/mentally limited, the multiple handicapped— all from age 3 to 18; the homebound and hospitalized, grades K-12; and the hearing impaired, blind, and autistic. An extensive staff includes speech, physical and occupational therapists, nurses, a psychologist, and a social worker; vocational and other parent-student counseling is offered, and other special purpose programs aim at counteracting the effects of the limiting condition upon its bearer.

Consistently we have found that library media programs that serve the special learner expertly have adopted from the start the attitude that their major purpose is to provide the instructional services, materials, and equipment to teachers and students that make for an excellent teaching-learning program. These programs have then joined attitude to practice. This program at Variety School is a splendid example. All the elements are here including a library media specialist who sees her role as instructional, and welcomes being part of the teaching team; a library media program which focuses its efforts not only upon providing suitable materials and equipment to teachers but also accepting responsibility for helping teachers to use them well; a program that is quick to capitalize upon an effective public relations and outreach program, telling of its services within the school and to the wider community of parents in unobtrusive but compelling ways. Perhaps most important, this is a program which makes no promises that cannot be delivered. It is hard to be patient with other library media programs that are doing less when you see what has been done here so well.

The role of the library media specialist in this very special school is in many ways like that of most other professionals: acting as a resource person, helping staff to locate and use instructional materials and equipment; selecting and purchasing books, audiovisual and other materials; assessing materials and programs as to their effectiveness; and lest it be forgotten, cataloging all instructional materials used schoolwide. But the secret ingredient does not come with the job description, it comes with the person or persons who give it life, the library media specialist and staff. It comes in the shape of sensitivity to needs, tact, alertness, competence and imagination, and energetic pursuit of objectives.

Two library media programs in particular illustrate the point. Channel 6 is the local television access station for the school, and its use adds a dimension not generally associated with video in most schools. Using a video tape recorder and camera, available through the library media center, specially planned and targeted lessons are prepared, tailored to students for whom many mass media educational TV shows, such as "Sesame Street," are too fast paced. Video tapes on vocations and the responsibilities of work are examples of well used tapes. Video tapes made of the children in school help parents and teachers monitor the learning progress being made by their children. This use of technology in video format is an opportunity realized and made much of here.

The library media specialist takes seriously the responsibility of being a resource person for the entire staff. An observer of the program watched a girl who was severely limited by muscular dystrophy relearning the alphabet by using a Phonic-Mirror-Handvoice, an invention developed in Sweden which uses number combinations and push buttons to provide a voice which can direct a learner's activity and channel it into meaningful ends. The library media specialist was the first person to see this device and pushed hard to have it added to the school's special equipment.

Perhaps the most innovative aspect of the service provided by the library media program relates to its use of the computer to assist the staff in locating appropriate instructional materials to use with the special learners in their care. All of the

sites reported in this book take seriously their responsibility to help teachers and students gain access to the materials, equipment, and services they need; it is this that makes these library media programs exemplary and gives them reliable instructional impact. But the Variety School must assign top priority to this accessing role, because the highly sophisticated and specialized materials and equipment required for them to carry out their program are simply not available within the school. The Variety School, therefore, making a virtue of necessity, has pioneered in computer technology to show how the services of the building level library media program may be dramatically enhanced for special learners.

The University of Nevada at Las Vegas has access to the Lockheed Dialogue Program. This is one of the earliest data bases established as a commercial enterprise and is widely used nationally. A teacher wishing to search for special materials to use with a Variety School learner can utilize the Lockheed System, thanks to arrangements made to that end by the school's library media specialist.

The teacher is required first to do a careful analysis of what is needed, requesting the search only after the characteristics of the learner, the area of curriculum for which material is needed, and the type of format desired have been established. For the primary age educable mentally retarded child, a teacher might, for instance, request some materials in the field of reading or language development, specifying that a kit or a sound filmstrip was the desired format. In this way, the teacher does not have to think too exhaustively about matching the right materials to the proper child for the appropriate purpose. This same methodical approach, which encourages planning, is in evidence with each step, and this carefully structured attention to what materials will help the learner to learn best gets results.

The cost of the searches is recorded along with the requestors name. The printouts of searches are mailed to the library media center, so that the library media specialist and the teacher can continue to plan together how to locate or to use materials identified in the search. The school's use of the Lockheed Dialogue Program is charged through a budget

process established by the Clark County Schools and the University of Nevada Library. The drawing account which supports the computer searches can be used only with the authorization of the library media specialist. The teacher who uses the search process is asked to evaluate the system as to such matters as whether or not the materials located were what was wanted; whether the suggestions led to the discovery of appropriate materials in the library media center; the length of time it took to get the information; and the only really important question, "Did the materials, once they were secured, satisfy your student's needs?" The federal grant which funds the service requires this evaluation, but it is an excellent opportunity to monitor the program's effectiveness.

We do not, incidentally, recommend the Lockheed System above other computer-based information systems. An obvious first step for any school or school district that is thinking of instituting such a service is to establish very clearly what exactly it wants from such a program and what needs it would satisfy, before going shopping. Entry costs for all computer systems are very high, and getting out of the wrong choice is an expensive and difficult process. Here again, the value of a network relationship asserts itself; at the very least, risks and expenses are shared.

The visitor to the Variety School posed the rhetorical question, "What can one learn from this library media program?" The first thing, a reconfirmation of what has been learned from other programs, is that the benefits resulting from the full integration of the library media program into the school's instructional program are many and significant. The second is that the aptness and sensitivity with which the library media specialist reacts to the specific needs of teachers and students depend on the specialist's sure knowledge of what teachers are teaching and how students learn. The third thing to be marked, learned, and digested is how effectively the library media program can harness the most sophisticated computer technology and communications technology to its own well defined uses, to help deliver excellent learning opportunities to the most severely limited learners at the building level.

Exemplary Program Elements
1. The use of advanced technology (computer, video) to provide direct building level instructional support through the library media program.
2. An excellent public relations program which leads to funding from private donors and public funds.
3. The close instructional links between the library media program and the teaching program.
4. The relationship the library media program has established to meet the learning needs of profoundly handicapped children.
5. The establishment of a communication network with other schools and libraries for purposes of aiding staff development programs.

MILL NECK MANOR
School for the Deaf
Mill Neck, New York

"In order to get where you do not know, you must go by way of not knowing." The truth of that statement comes to the surface again and again whenever one looks deeply into those qualities that make for excellent library media programs for limited learners. We have savored T. S. Eliot's words often, waiting only for a place to use them that would do them justice. The place is here, the time is now. For Mike Harrison, who daily on the job reaffirms the essential pioneering instinct that must be present in every library media specialist, and must *absolutely* be present in library media programs for special learners, has a quality that gives new meaning to the words.

Mike Harrison is the only professional identified by name in this book in association with a particular program. Since this book describes programs rather than individuals, we thought, one would need only to have places or sites to which to tie program descriptions, but Mike Harrison is the exception that proves the rule. He is proof positive that it is the talent, the energy, the imagination, and the commitment of the top-flight professional which are the essential ingredients for moving a library media program to accomplishment of feats dreamed of but very seldom achieved or even tried.

Some words and phrases come instantly to mind if you spend more than ten minutes in the engagingly contagious presence of a person like Mike. Candor and spontaneity are two of them, commitment is another. In some persons, such intensity is wearing; just as three acts never helped a talky play, two minutes is too long for such a focused personality, and yet this contact served to affirm for us that, like it or not, sometimes the person who runs it *is* the program, and all else follows from this reality.

Mike Harrison's involvement in mounting excellent library media programs for the deaf and hearing impaired is moti-

vated by more than just a professional commitment, for he himself is a hearing impaired person whose life is devoted to substantiating that the impaired are handicapped more by circumstances than by their condition.

It takes only a short while in talking to Mike Harrison to discover that what is being affirmed by this program for special learners is the workability for them of all the best principles on which an exemplary library media program is based. These include an enormous amount of professional integrity and a sense of what can be accomplished by a job done right; a precise understanding of the nature and needs of the user to be served; sure knowledge that attitudes about what the learner can or cannot do will largely shape what the results are; and a willingness to tinker and try out, to experiment and adapt anything and everything in the effort to provide programs of consequence and benefit to learners. Almost everything else we associate with the term "outstanding"—be it the library media specialist or the program as a whole—is secondary in importance to the matters of attitude, sensitivity, and effective consistent follow through.

Attitude assumes a transcendent importance in providing the best possible library media program for the hearing impaired or deaf child. First of all, before worrying about what materials to buy or how to use them, some false assumptions must be banished: for instance the assumption that the deaf learner is also mute. The faulty speech patterns of the deaf person result from not being able to hear sounds; not being able to listen to voices (including their own voices); and not being able to discriminate concerning loudness, pitch, tone, word formation, and other things heard, around which normal hearers pattern their speech. Few deaf persons have any trouble with the parts of their brain or body in general which produce sounds, but speech, perhaps beyond all other skills, is directly related to the behavior that has been modeled by others. What the child hears is what he says, and the way he hears it is the way he says it (e.g. accent and tone). Without the ability to listen and hear, there is no pattern to copy. The fact that the deaf person's voice may be too loud and unpleasing and the words scrambled and garbled is not owing to

faulty intelligence, as is often assumed, but rather to not being able to hear the sounds one is making. The range and causes of hearing loss are large and many. Deafness can be mild or profound and can involve one or both ears. And there are many kinds and varieties of deafness. Knowing and understanding the nature of each individual's impairment or limitation are extremely important where hearing is concerned.

It should not be assumed that all deaf children can read lips with total accuracy, or that deaf children will necessarily, in compensation, read better. In fact, most deaf children do not read as well as their normal peers, for if one has not heard language it is more difficult to interpret the symbols of print. As we know, the skills of viewing and hearing are exceedingly important to reading, as all of the language arts are interrelated.

It must be remembered that for the hearing impaired or deaf learner books are just full of printed talk. The process of sifting through and sorting out the words to give meaning to them in a particular context is much more difficult for the child who cannot hear, or hears poorly. Thoughts are disconnected, and idioms present real trouble. Think, for example of the phrase "red tape." For the learner who has heard it used in context, it connotes bureaucratic fumbling and processes to get through; for the hearing impaired or deaf child, it means sticky stuff colored red. To read "there is too much red tape in Washington" is a nonsense phrase to the deaf child. Consider how much of our speech and reading is cast in idiomatic form. The deaf learner must depend upon what is seen to create thoughts, and since one must hear others speak to understand how thoughts are put together and associated into coherent conversation, the deaf child often literally does not know how to communicate what could be some very intelligent thoughts racing around in a highly active mind.

For the hearing impaired child, as with many limited learners, social adjustment may well be the most important factor in school success. Acceptance by peers, and most important, by the teacher, is still the prime motivation for all young learners. Not being able to hear what is to be done, or what will happen, can lead to great insecurity. Nobody wants to

always be the one to ask, "What did you say?" for the worst
label of all is to be labeled, "stupid."

While Mike Harrison was at the Mill Neck School he served
as librarian for the entire school, an ungraded institution with
180 students, ages three to twenty. Another professional
handled the audiovisual program. There is a tendency to
assume that within the private school setting, the library
media program is always well loved and well nourished. Not
so. The question here was, how to get enough of a budget to
operate an effective program? How to convince administra-
tors of the value of what you are doing? How to involve the
other teachers in planning programs that would lead to im-
proved student use? And ever and always, how to assert the
importance of the library media program without sounding
self-serving and without nagging? Stay put in the library and
stamp the books is, astonishingly, the response even yet of
some administrators when they are asked what should the
librarian do?

When he began at the school, Mike Harrison was expected
to be the custodian of the books—nothing more. Yet even that
limited mandate brought frustration, because most of the
books there were not very useful. A determination for excel-
lence and pride moved this professional to achieve over odds.
Rather than just sit, Mike began to develop a collection of
idiom-free books for deaf learners. High interest, low vo-
cabulary books were not always the answer, since they too
were often written with idiomatic references, as a crutch for
the child with poor vocabulary, not poor hearing. What of the
bridging affect of audiovisual material on the child who does
not read well because of hearing defect? The relationship is
there, and the associative stimulation from nonprint to print
does have some validity. Mike Harrison points out something
that is frequently noted by librarians working in secondary
school: that the learner's interest level in all reading drops
precipitously from the middle grades on up.

Selling the product to the students is as vital for the hearing
impaired learner as for any other. The use of color to heighten
the feeling of warmth and welcome in the library media
center, and associating reading with other activity, such as

talking or acting out a story, is successful. There are many frustrations for the hearing impaired child, and the library media specialist must build extra time for explaining and understanding into the schedule.

Meeting and planning with teachers is as important in a hearing impaired library media program as in any other—if not more so. The individualized education program (IEP) assures that each learner is dealt with individually. The process of developing a team relationship, however, is the same as that for any school: "What can we do together?" The small classes at Mill Neck School—usually just 8 or 9 pupils to a class—ensure intensive individual involvement. The library media program is involved with assisting with the socialization of learners as well as with promoting intellectual achievement.

In schools and library media programs for the deaf, heavy use is made of captioned filmstrips. A captioned 16-mm film library is also available and used. Appropriately, the most intensive use of these materials is within the classrooms, the teacher being the chief diagnostician in the matter of what the student needs and how the particular piece of material fits into the program. However, the library media specialist reinforces and follows up with activities and materials in the library media center. Finding suitable materials, created so that hearing impaired learners can make sense of them, is a prime concern and remains a constant problem for the library media specialist.

The ability to "sign" a story being read is a necessary skill for any library media specialist who works with the hearing impaired. Knowing where to get materials is essential. The regional resource centers and the federal and state governments have a great deal of material, as do special associations and foundations, but one must know where to find it, go after it, and request it.

The use of captioned slides is successful in this program. Mike Harrison found, too, that comic books could be used for photographing selected frames on the Visualmaker, and placing them in sequence to produce a story. Appropriate dialogue can be inserted in place of existing printed captions. This

activity was particularly effective in getting learners inter-
ested in a story, talking about it, and then into reading. One
comic book in particular, about dinosaurs, provided provoca-
tive pictures against which the childrens' own story could be
created. The use of football trading cards proved to be equally
successful with many of the students whose interest in sports
and sports stars was at its height, and interpreting the coding
on the cards became a link with reading comprehension. *Star
Wars*, the fad film of the decade, was used to get students
involved in learning library skills and preparing book re-
ports. Using the Visualmaker to create brief pictorial bio-
graphical reports, with captions done in large bold type, was
another inventive program which hooked its learners. With
the video tape recorder, students prepared a story for produc-
tion, acted it out, and then critiqued their efforts.

Says Mike Harrison, "I took advantage of every opportun-
ity!" and we don't know of a better cry from the heart for any
library media specialist.

Exemplary Program Elements
1. The production of media (slides and video), to promote
 student interest in reading and how to read.
2. The intensive effort to locate, identify, and evaluate new
 materials which could be adopted for use with learning
 impaired or deaf.
3. The careful attention to the proper use of audiovisual
 materials to stimulate interest in reading.
4. The clear enunciation of the "language limitations" which
 traditional materials (books and audiovisuals) have in
 working with the hearing impaired or deaf child.

THE PUBLIC LIBRARY OF CINCINNATI
AND HAMILTON COUNTY
Exceptional Children's Division
Cincinnati, Ohio

When this book was planned we expected that every library media program for special learners included would be found in a school setting or a school-related environment. We supposed—and this was generally confirmed by what we found—that most public libraries are not heavily involved with educational programs for special learners. We heard about some splendid exceptions, however, and learned that there is some extraordinarily fine work being done with certain special learner groups in a few public libraries, including this one in Cincinnati.

The tradition of media and library services to the blind and physically handicapped, which for so long has provided for the needs of local users through an outstanding and pioneering state and national network program emanating from the Library of Congress and associated with public library systems, has demonstrated the values of networking. Not to be overlooked, either, is the long history of services provided to other groups of special users, adults for the most part, through state libraries. These well-established services and advocacy of the rights of the handicapped and institutionalized to have access to library/media/information services and materials have had a profound influence in shaping the present surge of laws intended to secure the rights of handicapped persons of all ages to receive library services of good quality. We salute the public libraries and librarians who have been so involved and greatly respect the impact they have had.

The Division of Library Services to Exceptional Children of the Public Library of Cincinnati and Hamilton County provides a model which many school districts, as well as public libraries, would do well to emulate in terms of commitment, purpose, and achievement. A philosophy and the total

resources of staff have been joined to create a program that achieves an intense focus on library service for the special learner. As with most performances with "star" quality, the results didn't happen overnight.

The Exceptional Children's Program demonstrates the absolutely essential basic of good organization and planning, clear goals, and a tradition of solid accomplishment. The program's sturdy roots go back more than twenty years, to 1959, when a professional librarian was appointed by the library system to be a specialist for exceptional children—to our knowledge, a first for the nation. In 1964, the ALA's Committee on Library Services to Exceptional Children proposed that this program be encouraged to "develop a program which would demonstrate the regular library services could be provided to exceptional children." This demonstration or "lighthouse" project—important concepts in the early 1960s—was to show how regular or existing children's public library programs could be tailored to the special needs and expectations of exceptional children. There was some federal funding for the program in those halcyon days, through the Library Services and Construction Act.

The fact that the Exceptional Children's Division not only survived but continues to thrive is in itself a cause for celebration. Most federally funded programs intended to beacon us to a bright new day of better services for all were shipwrecked on the shoals of the 1970s. Time has altered the program as it must alter all programs that are to grow along with changed expectations and needs, but its passage has not worn but refined and rejuvenated this effort. By 1980, when much of the country was discovering for the first time that limited learners expected and required special programs, the Cincinnati/ Hamilton County program was well established, generating its own energy and exerting a powerful influence for excellence in this field.

The objectives set by the original demonstration project were selected to substantiate the fact that the world of the physically or mentally limited learner could be encompassed within the library traditions of services to all children, but with intensive focus on special needs. Making a varied collec-

tion of books and other materials available, cultivating reading tastes and enjoyment, and helping children to choose books were objectives, standard enough for any children's librarian. But they had here a unique dimension, for they were designed to show that these most basic library services for children could be made viable for special learners as well as other children. This was accomplished without officious quibbling or the fears sparked by today's nervous sense that "they're coming"! The fundamental attitude expressed by the program was casual acceptance and understanding that being physically or mentally limited or emotionally or socially underdeveloped does not after all mean that one is totally and in all ways different in terms of needs, responses, or satisfactions from other persons. The library was well ahead of its time as a public agency in grasping the concept that normal is not an absolute, and the sensitivity of the planners strongly motivated the program from its beginning, and sustains to the present, a program as intelligent as it is benevolent.

A key element in assuring the success of the Exceptional Children's Division was that it was rooted in an already outstandingly strong children's services program. The new initiative was created without causing the resentment so often engendered when money and staff are diverted for a new program at the expense of others. The program for an expanded clientele was regarded as a natural outgrowth of an area of service already recognized for its excellence and innovation. Stability and coherence were built in and with them acceptance of accountability for producing results.

Exceptional Children's Division activities, designed to carry out its objectives, included locating deposits of books at three general hospitals and a child guidance home, a residential treatment center for emotionally disturbed children, and at a hospital for emotionally disturbed children. Fifteen years after establishing this first round of service outlets, the program is able to state in a pamphlet describing its services that, "any child not in a regular classroom situation is eligible for services from the Exceptional Children's Division. . . ." The program never rests on the plateau of a success—another visible mark here of a dynamically successful program. By

1980, the Division's program had expanded to include the trainable mentally retarded as well as the educable retarded and the physically handicapped. The learning disabled, the homebound, and the juvenile delinquent were included, as well as the blind and partially sighted and the deaf and hard of hearing. This is a comprehensive library-media service to a broad range of special learners unmatched in most school systems. A staff of two professionals, one support staff, and a part-time clerical assistant are the nucleus of the entire program, proving once again that the right few can form a multitude.

Having collections of books and other materials in place is only the beginning for such a program as Cincinnati's; they must be programmed for use and move out to meet potential readers, listeners, and viewers. When the program was observed during the site visit for this book, some marvelous programming was in evidence both at some school sites and a hospital. The librarian arrived, carrying five bags of books, to meet a class at an elementary school. (Yes, stamina *does* count!) It's clear, too, that personality counts for a lot. This is true with most endeavors in life, but for programs for the limited learner it is essential or you might as well forget the program. Here, the class of mentally retarded learners was exposed to a wide range of activities; the pace was fast without being frenetic or confusing. A story was read, a song was sung, and the flannel board was used to stimulate some responses from the class to the story. The children radiated a sense of anticipation, and their active participation was stimulated through good, evocative questions. In sum, good teaching was taking place which involved the learner in a purposeful, satisfying manner.

Using a library activity to reinforce an important social self-care skill is a key concept to be followed by all library media programs for the mentally retarded. Here the lesson was care for public property and following the rules which govern the use of such property: the librarian began the period by calling the name of a student, whose turn it then was to return to the book bag the book that had been loaned to the student for the past month. Important coping and survival

skills are incorporated within each library lesson; the staff never loses sight of this important core, because enjoying a book or a book talk, important as it is in developing personality, self identity, and communication skills, is not the sole purpose for these children. During the choosing and distribution of new titles which followed, a child who had requested a specific title and received it, was requested to share a little bit about the book with the class. The class gave him its rapt attention, every child in it supporting and participating in a momentous achievement for a retarded learner. Other titles were distributed, most of them in response to interests expressed at an earlier session by the children. A dialogue which motivated interest and stimulated individual involvement was maintained with the greatest skill by the librarian.

At another school, a most unusual class was observed, which contained sixteen three- to five-year olds, many with Down's Syndrome and other severely limiting conditions. Here, two teachers and four student teachers sat on the floor with the children, holding many of them close while two stories were read and the flannel board was used to illustrate. Try as we may have, throughout this book, to avoid mixing emotional responses with learning and confusing compassion with teacher strategies, it cannot be denied that some emotional factors are at work in contacts with special learners. Love of the pure and undemanding variety, known to the Greeks as *agape,* is almost certainly present, and must be, as reinforcement and reassurance that facilitates learning for these children. The library staff members leave the books and something of themselves to share and treasure until they come again in a month. This allows for reinforcement of coping skills of responsibility, and permits teachers to undertake follow up activities on a sustained but short-term basis.

In addition to book talks—truly a pedestrian term for all the caring and sharing and glowing and showing that goes on— the Exceptional Children's Division includes in its activities story hours, book discussions, films, and puppet shows. Varied presentations are kept in careful balance while maintaining a constant theme. Every activity is definitely if unobtrusively related to helping limited learners to develop

their fullest potential as good citizens. Carefully prepared bibliographies, very much in the tradition of fine public library children's services, provide an excellent resource for the parent, the teacher, other professionals who deal with exceptional children, and the concerned citizen. Special collections can be and are developed for teachers for use in outreach programs upon request.

The Cincinnati/Hamilton County Exceptional Children's Division proves, with distinction, that there is life after federal funding, and after the demonstration program which having demonstrated settles down for the long run. This alone would commend it to the attention and study of any professional library media person, because knowing how to weather your successes and how to move from them into permanence and sustained service is as important as attaining success in the first place.

Exemplary Program Elements

1. The initiative taken for going out to seek users and stimulate their use of library media resources.
2. The relationship of traditional library programs, such as storytelling and book talks, to the development of survival skills in mentally retarded learners.
3. The development of excellent resource bibliographies to improve teacher and parent understanding of the special learner and promote their involvement in the program.
4. The creative use of federal funding for program start up, and obtaining local funding support to maintain the program.
5. Demonstrating that special learners can love and respond to stories and books with the enthusiasm and involvement of other children.

AMELIA STREET SCHOOL
Richmond Public Schools
Richmond, Virginia

Planning a return visit to a school several years after the first is a little like attending a class reunion. You go with some sense of dread, fearing that there may be changes for the worse; what a delight it is then to find that people (or situations) are just as good or better than you remembered them as being.

A return to the Amelia Street School is like this. The first time around (in 1975) we visited their program with a focus upon media use and reported our observations in *School and Public Library Media Programs for Children and Young Adults* (1977); now, four years later we wanted to see what differences time and the passage of PL 94-142 might have wrought in this excellent program for trainable mentally retarded and physically handicapped children. We can report with pleasure that the intervening years have reinforced and added to the merit of this program.

Unlike the approach that most school districts have taken to the provision of special learner programs—that of taking action to fulfill the mandates of PL 94-142 only when they become inescapable—the Richmond Public Schools began its program in 1973 in implementation of a broad commitment to help all limited learners to become all that they are capable of becoming. Two goal statements from an annual budget report set forth the job to be done:

(1) The Richmond Public Schools seek to aid each pupil, consistent with his/her ability and educational needs, to participate as a responsible citizen;

(2) The Richmond Public Schools seek to aid each pupil, consistent with his/her abilities and educational needs to develop ethical standards of behavior and a positive and realistic self-image.

In applying these goals to its own particular student population the Amelia Street School displays its seasoned skill and experience by asserting that the media program in its entirety is an energetic and creative component of the total instructional program. This should by now sound familiar as rule number one for all library media programs.

Although a major purpose of this book is to describe methods, activities, and programs whereby mainstreaming of special learners into the regular school's program may be greatly aided or even made possible by the library media program, we recognize that there are circumstances which render mainstreaming an unrealistic prospect, and have reported several programs which operate under these circumstances. The Amelia Street School deals with children as students who score in the 30-50 range on the Stanford Binet IQ scale. While we are, and have always been, quick to agree that IQ scores have over the years been sometimes dangerously misused by educators and parents to force learners into predetermined molds and judge potential unfairly, we realize fully that within this IQ range competition as a spur to achievement is just not a reasonable approach to teaching.

The passage of PL 94-142 in 1978 really required school systems to think through the question about which children could take or could even benefit from mainstreaming, and which could not learn at all in competitive settings such as regular classrooms. When Amelia Street School began, it served both the trainable mentally retarded and the orthopedically handicapped; under the rethinking and the mandate of the new law, the latter group was moved to other public schools where they could be mainstreamed and their learning needs met. Remaining at the Amelia Street School were 162 trainable mentally retarded learners between the ages of ten and twenty-one. The sole purpose of the school's instructional program is to help these learners fulfill themselves to the limit of their capabilities.

The linking of the physically handicapped with the mentally limited has a long history in American education, even though it has been fully established that the two conditions have no relationship to each other unless the individual is

multi-handicapped. The severely retarded learner needs to acquire socialization skills, ability to care for individual needs to the greatest extent possible and to cooperate with others in the most harmonious fashion, and the ability to play the most personally and socially responsible role possible. Self-help skills, linked to the ability to survive and to cope, are literally life or death skills for the mentally trainable learner.

The Amelia Street School never loses sight of these primary goals, and the library media program knows its priorities in helping learners to achieve them. For example, citizenship responsibilities are reinforced mainly through a broadly based audiovisual component that exposes learners to a wider social environment and sparks discussion about what citizenship and social responsibilities are, as well as providing positive role models of such community workers as policemen, firemen, postal workers, and others. The library media program also takes as its special focus objectives concerning self-confidence and self-image. Using various methods, the staff hones in on the effective elements that help the learner develop a positive self-concept that will in turn develop his confidence for trying to do as much as possible for himself. Use of the audiovisual media is important since it allows learners to *see* and *hear* a portrayal of what appropriate social behaviors are, visualize what is expected, and emulate correct models to incorporate what is seen and heard into their life patterns.

In order for the trainable mentally retarded learner to learn, the environment must be carefully structured and reasonable learning expectations must be expressed. Yet, this fact should not be thought of as contravening the philosophy which must pervade all teaching: *that all learners, whatever their level of intelligence, are capable of learning.* Believing so, and acting upon the belief, means that no person is ever consigned to a slag heap of hopelessness. At the Amelia Street School, each student is treated with dignity and with courtesy; learning to behave with restraint and with due respect for the rights and comfort of others is encouraged and modeled with care and concern. The environment created is perhaps the true mea-

sure of the school's worth. The total effort, never lost sight of for even a moment, is to help each learner with limited abilities to develop as much of existing potential as possible. In this setting learning skills of any kind is inextricably tied in with personality and attitude development. For these learners, good manners, good health, and safety habits must be developed along with ability to listen, follow directions, and establish functional literacy. Mastering all of this within a framework of responsibility and respect for self may enable trainable retarded persons to make their own way, earn money, and care for themselves to a large extent.

For too many students exposure to the world of audiovisual media means an hour in the dark, learning in limbo things with seemingly little purpose or connection with anything else. Most regular learners adapt to this misuse of their time and just put up with it, as captives must. The retarded learner, though, lacking either the intellectual sophistication or the patience to play such games, demands excellent teaching use of audiovisuals. And so at the Amelia Street School, while 16-mm films and filmstrips are used frequently because they are the best format for displaying concrete experience rather than abstract expectations, they are stopped often in use, and discussion about what has happened or is going to happen is encouraged and stimulated. The teacher, the audiovisual, and the student combine their efforts to teach the lesson, for the teacher does not abdicate, in favor of mindless viewing of sixty-five filmstrip frames in succession. Viewing, discussion, and reinforcement combine to make good teaching, good viewing, and exemplary use of the media. Every theme reinforced by the material is related carefully to an expected and designated learning outcome. Audiovisuals used to sedate or merely to stimulate without followup have been mercifully banished from this environment. Books and pamphlets have a role to play, too, although they must be picture books, and then the experience will be useful for the retarded learner only if the learner can identify with the pictures and relate them to his own life experience and expectations. Since many picture books for children contain some very sophisticated illustrations with imagery obscure even for adult users, selection is

extremely important and critical review as to usefulness with the retarded special learner is imperative.

As with most programs for the retarded, classes are small and range between six and twelve participants each. Each class is scheduled for an hour in the library media center once each week. Each class is accompanied by a teacher and an aide. This is especially important because attention spans are limited, and a high ratio of adults to children is a requisite in all special education programs for retarded learners which often demand a one-on-one relationship. It is important to maintain a calm atmosphere and a strong teaching presence to lend an air of certainty and security, and to create an environment in which interruptions are kept to a minimum. Although the library media specialist serves the school only three days a week, the aide and the classroom teachers are quite capable of maintaining a program on the other two days. This falls short of course of the full-time professional staff ideal, but here it is not really necessary, probably because the teachers have become so much a part of the library media program, and its materials and services so much a part of their instruction.

The Amelia Street Program substantiates, too, that the resources of one building, even when those resources are concentrated only in the area of special education, are just not enough to do an adequate job. The Curriculum Materials Center of the Richmond City Schools provides additional print and audio-visual materials. Equally as important, a staff development program consisting of workshops provides essential library media program support. A workshop at the time we visited dealt with the preparation of intermediate-age trainably mentally retarded students for vocations. Going still further afield for resources, the library media specialist also uses the Virginia Department of Education's Educational Media Examination Center, the local telephone company, and other government and business sources to bring useful materials and services into the program. Networking is perhaps too fancy a word to use in describing these activities, but it in fact serves the same purpose, being a "network of necessity" that sustains and enriches the special learner's library media opportunities in ways that would be impossible otherwise.

The Amelia Street library media program is a good old friend. It has worn well and grows stronger now that it is able to focus all its resources on a group that must have a sheltered, unique program.

Exemplary Program Elements
1. The individualized attention given to the trainable mentally retarded learner.
2. The relationship of the library media program to the intruction of basic survival skills, i.e., home and school safety and self-responsibility.
3. The involvement of the faculty in the evaluation and selection of appropriate instructional materials.
4. The excellent use of audiovisual materials as effective teaching tools for mentally retarded learners.

WHITTEN VILLAGE
Clinton, South Carolina

The range of possible physical and mental limitations or handicaps is so broad that one book cannot deal extensively with special learning programs designed for any one group along the spectrum, especially those at the severely limited extreme for whom highly specialized programs must be provided. This book's purpose is to give information and advice primarily about how library media programs support learning for those learners who *can* be "mainstreamed," given some special provisions, into regular schools—those who fall into the range generally known as mildly retarded. But it would not do, when describing library media learning programs for children in all special categories, to ignore the services that can be provided for the profoundly limited who cannot usually be mainstreamed.

As with the gifted and talented, coming to grips with this other extreme of the learning ability spectrum raises anxieties and calls motivations into question; what is to be done is an emotional as well as an intellectual issue, requiring a great sensitivity. But while society and its educators, yes, even its library media people, ponder what they can do, the learning needs of the severely retarded pile up like newspapers accumulating during a vacation absence, even though models like Whitten Village have proved the worth of library media programs of excellence for children so severely retarded that they cannot be accommodated within the regular school environment.

Whitten Village is a residential facility operated by the South Carolina Department of Mental Retardation. Its 2,300 residents range in age from young children to adults, and represent all forms of mental retardation, with physical capacities ranging from semiindependent to bedridden. A visit to Whitten Village pleasantly confirms that a library media program tailored to such specialized needs demonstrates the same indicators of excellence which mark any exemplary

library media program: flexibility, creativity, warmth and hospitality, respect for the individual and his choices and interests, intense involvement with the instructional program; a direct participation in teaching; assistance to teachers in improving their professional abilities and skills; provision of strong support services; and energetic leadership and commitment to purpose. The *principles,* then, which govern the operation of any good library media program do not vanish in the night because of setting or because its clients have a wide range of incapacities but take on new meaning as the program is adjusted to meet their needs.

Every library media program we saw that was attempting to meet the needs of the mentally limited placed a high priority on the very extensive use of audiovisual materials. Interestingly, however, at Whitten Village, the audiovisual and print holdings are very nearly in balance, there being 9,000 books and 10,000 audiovisual items. Picture books and high interest limited vocabulary books are most evident in the book collection. Notable too, is the fact that high priority is given to the professional library—over 3,000 books and professional journals are available for the staff. This is important especially in the field of special education, particularly education for the mentally retarded, because of rapid changes and new information in the field. Because teachers and library media specialists and other staff must try harder to reach the retarded learner and help him to learn, there must be great emphasis on keeping up with what is new and constantly updating one's knowledge. The professional collection here is a refreshing change from the dismal collection found in most schools, its very excellence sounds a warning to library media specialists that as they get deeper and more fully into work with special education and special education teachers, they will encounter new demands, not only for information on teaching strategies, but for greatly enhanced professional resources overall. This demand creates its own web of implications, of which budget, selection, access, and evaluation are only among the most obvious.

Yet even with this unusual interest in the professional resources, the Whitten Village library media program dis-

plays a balance which reflects a healthy tie to more traditional programs and their values. In some instances tradition tends to smother; here it seems to provide the program with a calm normality upon which innovation and experimentation can be built. The three major service components of the Whitten Village library media program involve the residents, the staff, and the parent community. This latter client group has not traditionally been given much prominence by most school library media programs, but the forces involving special education, as well as community education, and cooperative school and public library programs are shaping these new service components even as this is being written. In this regard, PL 94-142, with its intensive emphasis on parent involvement, simply accelerates a trend that has already been exerting itself.

The Individualized Education Program (IEP) so tentatively being now developed for other learners in many regular schools is a long-accepted way of doing business at Whitten Village. The library media program's prime responsibility here is to relate to each resident's educational program, so rather than being concerned with learning Mr. Dewey's numbers or playing card catalog lottery, this library media program gets down to the business of improving communication skills and the socialization and self-help skills that will permit some measure of independent living. Herein lie the important learning objectives of mentally limited, and often physically limited, learners. For retarded learners, such objectives are often best achieved through a program that reinforces the learning of skills through their constant use, and with rewards.

The scheduled library period, anathema to library media specialists in most other settings, is here the life line to involvement. Residents enrolled in the three schools which comprise the service community of the library media center come to the center on a scheduled basis each week. The time there is used for storytelling, for puppet shows, instruction with audiovisuals, or reading from books or magazines. The groups are small, and maximum attention is paid to the individual; the end result is learning, reinforcement, and

reward. Participation, participation, and still more participation by the learner and the library media specialist are what makes the difference. Activities must be geared to the short periods of concentration characteristic of retarded learners. Plenty of time must be built in for all activities: to work with puzzles, to play with toys, to browse through books.

Outreach, that marvelous public library word, now being given a lively new meaning through many special education programs, is present here with vigor. Since many of the Whitten Village residents are multihandicapped, they cannot get to the main library media center, so the center and its program comes to them. Branches are established, a staff member goes out to work with individuals, and collections of materials are kept in satellite centers. Even the bed-bound patients get service.

Media therapy is becoming a concern of convention programs as the realities of special education programs and teachers move to the foreground. Just as bibliotherapy, the use of books as an adjunct to other therapy, has its devoted advocates (as well as its detractors), so undoubtedly will the use of the whole range of media as an ameliorative and restorative therapy add another dimension to library media programs, especially in special learner settings. Substantial research has already established the uses of music in this manner. Also, the use of puppets to provoke reaction and stimulate interaction from patient-learners is based on the fact that many limited learners will respond to puppets and marionettes when they will not respond to human beings. They are used and play an effective instructional role here. In fact, media therapy, quite possibly an important idea whose time has come, is already exerting some significant influences here at Whitten Village.

As with any excellent library media program we have ever seen or know anything about, every effort goes into demonstrating that the user comes first. The card catalog, the bane of many a user's life in the regular school setting, is here modified to the simplest subject level, so that those who can use it, do, and take pride in their sense of accomplishment. A regular card catalog serves the professional staff.

One of our visitors summed it up beautifully by remarking that "whether the individual's interest be music, drawing, or learning to arrange library books, the end result is an individual capable not only of functioning, but achieving as well!" What more could any educational program hope to provide or be expected to accomplish in any setting?

Exemplary Program Elements
1. The use of reinforcement and reward techniques to involve mentally limited learners in learning skills.
2. The development of individual media programs to reinforce or create an appropriate IEP.
3. The use of media therapy to serve as an adjunct to other therapy programs.
4. The use of extensive outreach program to bring library media programs to patients unable to use the library media center.

LAPHAM ELEMENTARY SCHOOL
Madison, Wisconsin

When we went looking for library media programs that were providing for special learners in exemplary ways, we hoped to find a certain number of modestly staffed and funded programs that were, nonetheless, exerting a powerful influence upon their users. Since modestly staffed and funded programs are indeed the norm, we needed examples to show what can be done to make the most of a little through the use of determination, imagination, and a spirit of "yes, we can." To say that we found all of this at the Lapham School is to praise only faintly, but clearly Lapham represents a measure of progress to which many building programs could aspire with success.

Serving 325 students, one-third of whom are physically or mentally limited or emotionally disturbed, are a library media specialist, a part-time aide, five adult, and forty student volunteers. In describing how they do their jobs so well, a visitor to Lapham said, "The program is exemplary not because of its size, the sophistication of its equipment, or the depth of its collection. . . . Its excellence and success may be traced to human factors, a philosophy based on a dedication to discovering and meeting the needs of each student, and a method of carrying out that philosophy that empasizes cooperation among the entire staff."

At Lapham, that determination to cooperate creates an energetic and sparkling program that, through sheer presence, leads the way to innovative programs for special learners. The program elements that spell success for any library media program are remarkably constant, and they are here, though the needs and expectations of their users vary widely and differ greatly from those of other schools.

The Lapham library media program recognizes that its first responsibility is to provide an environment that guarantees an equal opportunity for every learner to explore and discover. Those who have planned and who run the program

understand that from the process of learning and growing will come the confidence and ability to learn still more. It is difficult to describe what makes a breakthrough program so good, but again, it would probably have to come under the heading of "attitude." There is a feeling here that even though limited in a physical, mental, or emotional way, a learner may still respond to encouragement to browse through, select, and use books, pictures, magazines, and audiovisual materials. The Lapham program confirms the fact that the limited learner can learn to find, to use, and to share information as part of a finely tuned, individualized learning program, and that limited learners can have their curiosity piqued and their interests aroused as fully as can any other student.

Above all else, the Lapham library media program is a first-rate teaching program. It reflects the reality that when the library media program is an excellent teaching program it earns the respect and support of the rest of the professional staff. Emphasis on staff development is here, expressed not as anyone telling anyone else how to do this or that, but as a way of getting people to work things out together and to plan processes and outcomes at the same time. This cooperative planning emphasis pervades the program and is the single factor most responsible for its success. Competence and good will are unbeatable as a combination in any setting, and Lapham displays a wealth of these attributes.

The Lapham program substantiates—and for this we are more than grateful to it—that the library media program has a contribution of great value to make to planning and good working order of the IEP, mandated for the special learner. The library media program does not play just the role of supplier of materials or equipment, either, because the library media specialist is regarded as a skillful teacher participant while the IEP is being devised for each student. She is not only present at the creation, but maintains an active role—a teaching role—during the entire time. Also, of the highest import, she is part of the evaluation process as well. The open schedule under which the library media center operates assures that teachers can come into the center and plan with the library media specialist as they find the time, and they do—in

droves! This helps make the IEP a truly individualized and prescribed and monitored learning plan rather than an image with no substance, transmitted to paper in a meaningless shuffle of plans and students.

How to select the right materials for "them" is another negative preoccupation of many a library media specialist who is facing, for the first time, the onslaught of special learners. Here at Lapham, selection is considered to be very important and is based not upon a narrow concept of what students with a particular disability can use but upon what can become a valuable resource for someone who, properly motivated, wants to learn. At Lapham, the library media specialist and the professional staff are deeply involved together with the selection process, believing that any material, when used in combination with the proper activity and experiences, can be interesting and useful. It is this liberating notion that deserves wide emulation—that selection need not be limited to those materials thought to be useful to a special learner with this or that limitation. Part of this concept of the relationship between instruction and instructional materials is that the professional believes that from among the array and range of services and materials that are found in almost any adequate library media program an appropriate learning experience for any student can be put together. Further, there is the feeling that if one approach or combination of methods proves ineffective, another can be put together and tried. Matching the right medium to the right teacher who applies both to the learner according to his needs is a conscious goal of the Lapham library media program, not just an idea that looks well on paper.

In small groups, or in especially scheduled larger groups, the flow into and out of the Lapham library media center is unceasing. Even those students with more limiting disablements who must remain in the care of a special teacher or aide are mainstreamed in the library media center. Perhaps one of the most notable things about the Lapham program is the degree to which it adheres to the *raison d'etre* of mainstreaming; the regularization, the normalization of the learning environment, the comfortable mixing of the regular students

with the special, the resulting relaxation of the fears and anxieties that are the natural consequence and being and feeling different. The informal contact among the children has been reinforced by more formal contacts established by the pairing of certain classes. This system, initiated by the teachers themselves, encourages the members of the professional staff to pair with compatible partners, so that they can plan and share many activities. This pairing lessens the lone teacher's feelings of apprehension at being left alone with resources and skills which may not be good enough to do the job. The library media specialist is an active member of these teams, helping to plan their activities, and serving as a consultant and in a teaching role once they are in operation.

An example from among many one could choose illustrates the excellence and explains the optimism one feels about this program. A class of trainable mentally retarded children and a regular kindergarten class participated in an extended folk tale unit. On a weekly basis, these children came together in the library media center for storytelling, puppet plays, film programs, creative dramatics, and other activities designed to involve the paired classes in sharing experiences. Between visits to the library media center, other activities were undertaken in the classrooms, underscoring the follow-up and the movement back and forth between media center and classroom. This easy flow between library media center and classroom makes it possible for each class to extend particular elements of the joint experience on its own, and the whole activity alters the relationships among the children so that there is less emphasis on the disabilities of some of the learners.

We have tried to reiterate at every opportunity the certainty that the parent of the special learner has a significant part to play in teaching him, especially in connection with the library media program. Quite aside from the legal mandate of federal and state laws that parents be involved in planning and monitoring the IEP for their child, we are considering now the importance of the motivational role that parents can undertake and carry out. The sensitivity to the needs of parents demonstrated by the Lapham program shows itself in many

ways. Parents are involved as volunteers, but more than that, the library media center has made itself into a kind of information agency with a network spreading out among parents to inform them about services of various organizations, and to keep them in touch with advocacy groups which are so much of a lifeline to the parents of special learners. And just imagine a library media program that provides all parents with a mid-year report which states the library media program goals, and the objectives toward those goals that have been set for their child. The response to this report, as one might suspect it would be, is enthusiastic, and the material is well used for reinforcement by the home. The entire communications process is open and in good working order. One parent of a child who rarely speaks pins notes to her child's wheelchair, interpreting some needs the child has, and suggesting activities and materials for him. A great difficulty for many parents of special learners is that the children are so often shifted from school to school as provision for them is changed from year to year, but more than other parents these parents need to feel a part of a community, feel the need to share information and garner the support that comes from knowing one another. Through its advocacy/information role, the library media center has assumed an important role and one that pays big dividends in good will, appreciation, and support of the library media program.

Volunteers, a powerful force for excellence in so many elementary school library media programs, are highly visible in the Lapham program. They do their jobs eagerly, knowing that in doing so they are freeing the library media specialist to work intensively with a student or teacher. They have been brought to understand how what they are doing relates to the overall purpose and objectives of the library media program, and indeed the entire special learning program of the school. It is of course, just good program management to explain to people—whether they are working for money or for love— what you want to have done, and why it is so important for them to help you do it. But how many of us forget to do this, often taking it for granted that the people who are working with us know these things.

Finally, and most unusual, is the student aide program at Lapham. Using fifth grade students—the highest grade at Lapham—the library media program accepts the help of any student who wants to volunteer to help, *including the emotionally and physically limited*. The teachers in the school were advocates of extending the aide program to include older trainably mentally retarded children as well. The teachers supported this because they understand the great benefits that come to the child who assumes the responsibility of working and helping somebody else. This is one of the finest examples we found of how the library media program itself becomes a prime agent of mainstreaming. Tasks to be accomplished are assigned beforehand; there is a variety in them; and the students work together to reinforce and train each other to do particular jobs. Success as an aide relates directly to an improved sense of confidence in one's self and in one's own ability. Sorting date-due cards into groups by color is an important bit of learning for the trainably mentally retarded learner, and as valid in terms of teaching him to organize and sort out as any activity could be.

The more one studies or thinks about the qualities which separate the truly excellent from the pedestrian and the also-ran, the less certain one is about what the catalyst is that causes the various elements to come together and create a synergistic, beneficial force. Trying to isolate reasons—the selection policy, the facility, the numbers of staff, the type of equipment—we only confuse ourselves with elements that can be quantified, weighed, or measured. We still don't know why "excellence" is "excellence" or what the mix is that makes it so. And yet we know that the catalyst, whatever the other elements, or the shaper of excellence is one person or a small group of very few individuals who exert an irresistible force. Where that person is, there is excellence; remove him or her and erosion sets in.

Clearly this phenomenon is at work in the Lapham program. An observer spoke of "relentless communication from the library media program to the staff," and while that word—relentless—may make it sound more driven, more compulsive than necessary, we choose to use it here because, in fact,

relentlessness, tempered with a clear sense of purpose, a willingness to share the burden so that it becomes a task of love, and sensitivity to the needs of other people is what makes for success. This sense of purpose and purposefulness is the key to the estimable value of the Lapham program. Although it is a library media program for the mentally, emotionally, or physically limited learner, its conduct, and especially its recognition that teaching the special learner is remarkably similar to teaching any learner, reinforces every library media program everywhere. *Note:* Shortly after being visited for inclusion in this book the program at Lapham underwent considerable alteration. The library media specialist took a leave to pursue a doctorate in library science with emphasis on services to special learners, and a number of the special education students were transferred to other schools. Now, truly comes the test: can effectiveness and philosophy of the media program be maintained and can it remain a model for others?

Exemplary Program Elements
1. The intense and full involvement of the library media specialist in planning, presenting, and evaluating the IEP's.
2. The use of the library media center as a mainstream learning environment for limited learners.
3. The excellent parent awareness and parent involvement program.
4. The intensive planning relationships established between the library media specialist and the classroom teacher.
5. The use of instructional materials as adapted to special learner needs.

Chapter IV
The Gifted and Talented

American education has shown a strong tendency, particularly over the past twenty-five years or so, to redress past wrongs and correct inadequacies by mounting drives for this or that reform. Sometimes the reform movements were led by a crusading U. S. Commissioner of Education—witness James Allen's "Right to Read" emphasis—or the initiatives of Sidney Marland for the enshrinement of career education within the curriculum. There was the "new math" impetus which came largely from the schools of education and foundations; there was the "open classroom" largely borrowed from England.

Citizen advocacy has joined the educational establishment, or perhaps more correctly, has pushed the educational establishment into other reforms that involve more than a single program or subject field—especially those related to the civil rights movement. Busing to achieve racial balance, and now the special education reforms, have been achieved by legal mandates from the legislatures and the courts. Certainly in the past decade we have seen these reform movements associated with some form of massive and sustained government intervention and support. We should remember that one of these reforms, engendered by funds from the federal government, was the widespread development of school library

media programs. This has been on the whole a very successful reform—because, we like to think, it really *did* effect widespread improvements in the learning and teaching habits of students, and also—let us be permitted the satisfaction—we school library media specialists have worked hard to graft it permanently into the instructional program, and have gained a great many allies in doing so among administrators, teachers, and parents.

Reform is an alluring enterprise which often summons forth our best instincts and sharpens the communal sense of pulling together to accomplish a useful purpose. Working together to accomplish a community goal has a long tradition from frontier days onward, but too often when applied to education the reformers' zeal becomes flawed with pride and a touch of arrogance; wrong but never in doubt for a minute, the leaders of more than one educational reform that might have proved beneficial had they but listened better, have ended up in some inpenetrable swamp.

Some serious errors in judgment have been made, but if it is difficult for individuals to admit errors or misuses of power, it is almost impossible for any institution or the government to do so. Therefore, public policy, once determined on a course, follows that course to its conclusion, even if the consequences are less than envisioned or even downright bad. This has led to the condition we have now, of a society that distrusts its own institutions and the bureaucracy that runs them, and an atmosphere of bitter suspicion that any program reform, promise, or intention is invalid or, that if it is, it will ever be carried out.

Sometimes educational reformers have been simplistic and naive. They have underestimated the will of their constituents, or even ignored the perverse ways of human nature. Government intervention to secure the right to full economic and social and educational participation by racial and ethnic minorities has not yet been universally successful, because there have been too many social, economic, and human factors and complexities involved that are beyond the control of educators.

Over the past decade, we have been exhorted constantly to

face urgent changes before it is too late. The energy crisis has been perhaps the most pervasive example of this. In education, the issue has been how to fund equitably and adequately, and without sole reliance on property taxes.

Against this background, front and center stage, now comes one of the recently reborn concerns of education: doing something real and significant for the gifted and talented learner. This concern matches, indeed was brought to visibility, by the determination to improve educational opportunity for the mentally and physically handicapped and the emotionally disturbed. It has come to the forefront in connection with other special learner programs, and it has come about as the result of massive government intervention and citizen advocacy for the rights of the limited. The child of superior mental capacity, or outstanding ability to develop or apply talent, has been caught up in the contagion of the times: redress of years of societal neglect and educational indifference of the exceptional child, the one who is "different." At the least, even if the pursuit of superior learning programs for the gifted and talented is still erratic and sluggish, the indifference with which the matter has been traditionally addressed by the schools has been transformed into an attitude of interest and even commitment.

The steady growth of interest in, and attention to, learning opportunities for the gifted and talented owes as much to political, as it does to educational, leadership. To be sure, years of effort by some educators, many parents, and other advocates to ensure that gifted and talented children had some attention paid to their special needs have had a cumulative effect, and their insistence that the public schools make some moves in that direction has had some impact. But it is also true that the recent rapid growth in mandated programs for gifted and talented children and the funding to support them were as much an outgrowth of the civil rights movement as of the educational establishment. Gifted learners, a small minority, but not as small as many have assumed, may be at the opposite end of the pole from the limited, but they have unique learning needs that require attention also.

Joseph Renzulli, one of the leading experts in this field and

long an advocate of providing appropriate stimulation and
opportunity to the gifted and talented child, points out that
"2200 years before the birth of Christ, the Chinese had already
developed an elaborate system of competitive examinations
to select outstanding persons for government positions of
leadership." To a degree not understood in a democracy that
values its tax-supported comprehensive public education
system as the point of entry into the adult world of economic
and social success, the lycees of France, the English public
schools, and the elite preparatory schools of other nations
serve to winnow out the less able, and provide springboards
into leadership roles for the able. Only the brightest and the
best survive the screening to take, by virtue of intellectual
superiority, endurance, and good social adaptation, the posi-
tions of leadership in government, business, and politics that
they have won by right of safe passage through the system.
Although we have our prestige preparatory schools and elite
universities, we do not maintain an education system whose
single most important purpose is to weed out and discard the
less capable so that only the most able are equipped to lead.
Such elitism, used to create an intellectual, social, and eco-
nomic aristocracy, is totally at odds with the traditional
prevailing belief in this country that the public schools do and
should guarantee that everyone has at least an equal oppor-
tunity to get the education that leads onward and upward to
entrepreneurship and social mobility. All this is a basic credo
and part and parcel of the American Way.

This whole package of belief about the purpose of the public
schools has come under serious question by a wide range of
critics all the way from far right reactionaries to leftist nihil-
ists. There are those who would have American education
emulate other systems, throwing off the less motivated and
less able. There are those who maintain that universal free
and equal education, which supposedly provided everyone
with the opportunity to move up the ladder of success, was
exposed as the fraud it had always been at the exact moment
when it was finally forced to accept the concept that large
numbers of black, hispanic, and other minority group chil-
dren had the right to genuinely equal educational opportun-

ity. As far as both contenders are concerned, education has drained the cup of public confidence to its very bottom. Especially are the lines of battle drawn when the elitists and the convinced democrats address the question of the needs of the gifted and talented. Here, anger and hostility are far more evident than when dealing with the needs of the physically or mentally limited. Probably, reasons are not too hard to find, or at least to guess at. For one thing there is the pity factor where the disabled are concerned; who is going to stand foursquare, at least overtly and publicly, against a better break for the limited child? There is a bit of arrogance implied too, in the assumption that most of the gifted or potentially gifted are to be found among the privileged; and a racist assumption, too, that more of the disabled are to be found among the minorities—probably with some basis in fact because of the connection of some disablements with social and economic causes.

Renzulli points out that even defining what "giftedness" is presents a problem. Many hold with the narrow definition: that the term "gifted" should be restricted to those whose scores fall in the top one percent of general intellectual ability as measured by the Stanford-Binet IQ test. The restricted definition is challenged by others who maintain that giftedness must be defined primarily as potential. The concept of the "remarkable performance" as being the best indicator of giftedness places a high value on recognition of excellence as reflected in performance in the arts, in writing, or in leadership. Heavily influenced by this broader definition, proponents of the performance criteria for establishing giftedness look to multiple measures of aptitude, ability, and performance to define what it is to be gifted, and how the gifted should be identified.

The United States Office of Education (predecessor of the present Department of Education) has long maintained an interest in the education of the gifted. Its definition of gifted and talented concludes that "gifted and talented children are those who by virtue of outstanding abilities are capable of high performance. . . . These children . . . require different educational programs and/or services beyond those normally

provided by the regular school program, in order to realize their potential contribution to self and society. . . . Children capable of high performance include those who have demonstrated any of the following abilities or aptitudes, singly or in combination: (1) general intellectual ability; (2) specific academic aptitude; (3) creative or productive thinking; (4) leadership ability; (5) visual and performing arts aptitude; (6) psychomotor ability."

This description, clearly bureaucratic, demonstrates nevertheless that the U. S. Government comes down squarely on the side of broad definition, a broad and inclusive umbrella to determine who is gifted or talented, and a liberal view of the ways in which these gifts may show themselves. We would go with the broader set of standards, if for no other reason than that more can be done to develop giftedness under them, and that they therefore provide more enticing opportunities for the library media program.

And of course, it almost goes without saying that library media programs have traditionally shown an affinity for the gifted and talented learner. One need not look far to understand the reasons, either. Here is a child who is by intellect and nature a searcher, a listener, a looker, a reader, a thinker. Many kinds of programs have been created for the gifted by the library media staff, and sometimes they are the only special nutrients these children have had to keep them going. Many such enrichment opportunities have been created informally, spontaneously because of the enormous reservoirs of motivation and interest in a child or group of children and the library media specialist sparked by so much response. Some of these programs have been wonderfully creative, and many times their very presence has been contagious and the benefits have spilled over to the less able children.

While spontaneity is important as an energizer and may have creative results, the times require justification, accountability, and objectives, and these are not incompatible with good programs for the gifted and talented. The loosely planned and unfocused program is hard to evaluate, difficult to follow up, and almost impossible to replicate. It is possible to carefully structure gifted and talented programs without sti-

fling them. It is essential too, to find effective ways to be certain that more than the casual drop-ins, and those who happen to have an effervescent personality or a shimmering brightness of intellect, get in on the programs. This is a complex challenge, this business of finding and developing gifts, and too important to be left to chance.

If we use the Department of Education statistics, there are approximately two million gifted children in the United States, or between two and four percent of all the pupils in our elementary and secondary schools. Sidney Marland, mentioned earlier as a former U. S. Commissioner of Education and later with the Educational Testing Service in Princeton, has called these children "our most neglected students." It is possible that less than five percent of the total number identified as gifted or talented get the enriched and special instructional programs they should have to develop their potential to its fullest.

The gifted or talented learner usually has a longer than ordinary attention span; a greater tolerance for abstraction; a faster rate of learning; a keener sensitivity; a desire to explore in depth; and above all, an ability to extrapolate and to relate ideas and concepts. Like the man who climbs the mountain, he wants to know because the knowledge is there to be known, and he is often powered by a drive for perfection. Unfortunately, these are personal and intellectual characteristics which the average person deals with ineffectively. The classroom teacher, equipped, as most of us are, with normal intellect, and average motivation to succeed, is easily baffled and often annoyed by the gifted learner. It is an all too easy transition from annoyance to hostility, especially when a teacher is faced with the precocious child who does not suffer fools gladly, especially if that fool is his teacher. The threat implied by the teacher's inability to respond to the satisfaction of a demanding inquirer can easily end in confrontation. The confrontation can spill out beyond the walls of the classroom, involving the administration and the parents, and the resulting pressure on the teacher can ensure all sorts of negative possibilities. A climate is created which is entirely opposite from the environment that is conducive to creative learning.

Just as the library media center has often served as a dumping ground for the slow learner, so too has it been the exile place of the gifted learner in many cases. The classroom teacher can easily justify an hour away to the library media center to work on a project, pick out some books, or look at a filmstrip; the gifted child, likely as not is happy, and so is the teacher. Meanwhile the insistent questioner is being enriched and stimulated, and the teacher can get on with the work with the other children who really have more need of instruction. The scenario is an old and familiar one. Such casting away is almost always given a cloak of respectability, known to many library media specialists who have been left to cope with the lonely gifted voyager who is to do "independent research" that is very vague in scope. For years, in fact, independent study, individual research, and self-directed study have served as definitions for illusory and largely nonexistent programs whose great purpose was to "get this kid out of my room and out of my hair." Library media specialists have endured these bypasses usually with stoicism and a determined effort to help the gifted child make the best of it, and with only an occasional flare-up of anger against a particularly chronic offender. Clearly a more effective and appropriate course needs to be charted to help teachers to become adept at meeting the demands and needs of the gifted and talented learner.

The signs and signals transmitted by the gifted and talented that they are unusual really begin early in life. Almost from birth, the gifted and talented child exhibits some or all of these characteristics:

(1) They are naturally more curious, and show a great and intense interest in their surroundings;

(2) they will begin to form words and to put sentences together earlier than other children;

(3) they are physically alert and active, crawling and walking sooner than other children;

(4) they are interested in creative kinds of toys and games which provoke response and stimulate imagination;

(5) their attention span and powers of concentration are longer and greater than those of their peers, and they show an inclination for solving problems very early;

(6) they retain information, and learn new things easily and quickly;

(7) they want to know what makes things happen around them, and learn very early by inference how to manipulate their surroundings to their satisfaction;

(8) cause and its relationship to effect is an early preoccupation with these children;

(9) they are usually early readers, often learning how to read before formal schooling begins.

These traits combine and reinforce each other, and usually result in putting a child ahead of his peers from the start of schooling. If all goes well, he maintains and probably increases this gap as time passes.

The curiosity, imagination, and energy which reflected superior intelligence in a child's infancy continue to assert themselves in new and more sophisticated ways as the gifted learner grows older, as for example in

(1) the ability to bring more ingenuity and creativity to the solutions of problems;

(2) the ability to concentrate for longer periods of time and at a more intense level on the solution of a problem;

(3) the ability to reason quickly and logically and to draw correct inferences from assumed relationships;

(4) the ability to apply curiosity and concentration to a field of special interest—science, art, or mathematics, for instance;

(5) the ability to focus a great deal of energy and creativity on the solution of problems that are of particular interest;

(6) the ability to sustain a high interest in abstract matters, and a bent toward innovation.

Psychologists and scientists who have worked with gifted and talented learners also identify some social traits that are likely to be evident in the gifted learner:

(1) An early disposition toward leadership;

(2) a strong personality around which peers cluster with an inclination to follow;

(3) a quick sense of humor and ready wit;

(4) a rather highly developed sense of justice which translates into an early developed concern with what is right and what is wrong.

It is worth noting that these social characteristics, which make the gifted learner quite often a strong leader with an ability to influence peers, are traits which might easily upset the equilibrium of certain teachers and library media specialists who bring to their work the idea that conformity is part of divine order, and that if they say so it is right! Gifted learners sometimes demand to know *why* this or that is considered so important, why the world is run the way it is, and what they can do to change it. Above all, the gifted and talented child values freedom, to inquire, and to find truth and meaning in his own way. This need can conflict head on with a passion for order, and for "getting it right." So, although the forecast is favorable for the learner to enjoy a lifetime of accelerated learning and leadership, there is no guarantee that it will work out this way. In fact, the institutionalized teaching program geared to the needs, the pace, and the talents of the average learner may work against the unfolding of intellect and talent within the gifted learner. Sparking a learner's inventiveness, independence, and individuality has not been heretofore the goal of many teachers, who must, understandably, maintain an even environment.

As with the mentally and physically handicapped, school library media programs can play an important leadership role in fulfilling the promise of enriched programs for the gifted learner. While it is essential, and often necessary for the library media specialist to be able to teach a class of twenty-five or thirty students, rarely is this the most effective way for the library media program to make its optimal contribution to the school's teaching program. Focusing carefully tailored teaching effort upon individuals or small groups of learners should always be the preferred option for the library media specialist. Gifted and talented students, who need individualized attention and lots of options and choices as to material and substance, are an ideal group around whom to plan and offer innovative services and programs. The library media center, with its resources for stimulating the mind and promoting inquiry, exploration, and creation is usually a totally comfortable habitat for the gifted and talented learner.

The gifted learner's exceptional intellectual ability gener-

ally displays itself in a cluster of skills, no single one of which seems to be the cause of why the gifted learner learns so well. It is how the skills are put together and used together that matters. Reasoning skill, language, and numerical skills are usually prominent, although some children who show brilliance in language and reasoning seem to have little aptitude for numbers. But whatever the skills that are demonstrated, and however strong the motivation to learn, gifted children like other children need guidance and the concerted interest of teacher and library media specialist as they become involved in the learning process. Common sense should have told us long ago that the gifted child cannot be left to his own devices to muddle through and learn by himself just because of his abundant energy and motivation. In addition, however, we now have an accumulated body of research-generated data which confirms the fact that gifted learners, like normal-average learners or mentally and physically limited learners, need some special kinds of teaching and attention if they are to reach for and attain the highest level of their capabilities.

Although they share some basic characteristics, described earlier, gifted children show their giftedness in some quite diverse and unique ways. Above all, the gifted learner is an individual, subject to the same conditioning by heredity, environment, and circumstance that affects other mortals. Thus a high level of language skill, often characteristic of the gifted, does not necessarily result in quick comprehension of written or spoken words, or a heightened ability to speak or write fluently. It is possible for the gifted learner to be totally inarticulate. We have indicated already that while the gifted learner usually shows a high degree of facility in the manipulation of numbers, and is quick to see the relationship among them, this does not necessarily mean facility with higher math. Advanced reasoning power based on a heightened sense of cause and effect, and of conceptual relationships, does not necessarily mean that to be gifted is to ensure logical thinking or rational thought processes.

It is clear that there are as many myths, generalizations, and assumptions about gifted and talented learners as there are about other varieties of special learners. Understanding

what being gifted and talented *does* mean, and realizing that the gifted learner has special first steps to take as well as other children is essential. Accepting that giftedness is a many faceted phenomenon which displays itself in aggravating as well as rewarding ways, is an important base for program planning by classroom teachers and library media specialists. Being an effective teacher of gifted and talented learners includes knowing that these children develop best when they are allowed to set their own pace; that there will be as many different learning styles for the gifted as for other learners; and that overindulgence in one style or activity can kill creativity in the gifted as well as in any other learner. Developing self-reliance, maturity, and discipline is important for the gifted child, for no matter how well endowed with mentality a youngster is, physical and mental maturity are required to unlock his full potential.

The climate of elitism and exclusiveness or arrogance attached to many gifted and talented programs should be strictly controlled. Resistance to establishing these programs or to expanding those already in place arises, in many school districts, from fear of fostering too much separateness, as well as a fear of hostility and reprisal from those parents whose children don't make it into the program. A school needs the stimulation, the pacing, of top-flight students, but they, like the disabled, should be conscious of being part of, not above, the mainstream. The fact that the library media program does not evaluate, pass or fail the gifted student, or judge his ability, but simply offers opportunity available to him, makes involvement by the library media program especially appealing. The absence of regular grading does not mean that standards of excellence are not set or met. It does mean that the gifted learner's objectives can be set especially for him, and that unlike other areas of school program where he excels at the expense of others, in his work in the library media center he is competing only with himself and the standards set for his performance. The gifted learner shares with all others the expectation of being rewarded for a job well done, although he may not rely as much as others on the external motivation to participate.

For the gifted and talented learner, as with most other learners, self-concept will be the single most important factor in motivating the desire to achieve. Belief in self and confidence in one's ability to perform is not to be mistaken for arrogance, just as determination to succeed is not to be equated with "my way or not at all" or the desire to follow through with bullheadedness. All are necessary for achievement. Liberating these factors and directing them with a light but steady hand is to move the gifted learner along the road to the achievement of which he is capable. The library media specialist, using the resources of the program and personal expertise, is by training and instinct wonderfully adept at helping learners develop proper attitudes and habits. The library media program, as a learning laboratory operated by a person who is interested in the exchange of ideas, welcomes creative thinking and provides a climate in which it is easy to develop a good feeling about one's self and one's capabilities. What other learner can benefit more fully from the intellectual stimulation for which the library media program stands?

As a referral center where a searcher for information can be put in touch with that information and helped to use it fruitfully, the library media center has much to offer the gifted learner. Providing materials and resources needed by highly motivated and demanding gifted students often stretches a school building's resources to the breaking point. Working effectively with the gifted and talented learners and their teachers frequently becomes a matter of tapping resources beyond those of a single library media program. And this is certainly not to be construed as failure by the library media program: it is a triumphant fulfillment of a vital teaching responsibility when gifted and talented learners, their teachers, and even their parents can be brought into contact with some of the great information resources of the region.

A by-product of well-practiced referral and a well-planned referral system is inevitably an immensely improved library media program for all learners, who have the gifted and talented minority and an alert library media staff to thank for it. As we have noted elsewhere, meeting the needs of gifted and talented learners has promoted some of the better work-

ing examples of networking, resource sharing, and coopera-
tive programming to be found. It is impossible to overestimate
the value of these cooperative activities.

As one writer has observed perceptively, "It is important to
see the gifted as thinkers, not as learners." The library media
specialist who is serious about becoming a fine teacher of the
gifted would do well to remember that all learning requires a
framework only excellent teaching can provide. A framework
for thinking is what it truly is, and the most intellectually
gifted and creatively talented need this framework, not as a
restraint, but as a secure mooring from which they can ven-
ture forth on their own. Putting such a framework in place so
that it provides shelter without confinement is a very impor-
tant matter in teaching the gifted. Providing a secure learning
environment means creating an environment wherein the
gifted and talented learner can take time to digest and ponder
and learn the notes so that he is free to improvise. The library
media specialist who is fully at ease in the teacher's role, but
can at the same time freewheel into and away from the
demands of any one curriculum, is perhaps in a better position
that anyone else in the school building to provide the frame-
work, the guidance, and the stimulation that the gifted learner
needs to make him bloom.

Unlike the classroom, even in its most open form, the
library media center must operate without the hour-to-hour
structure which allows a teacher to get to know students
through close and continuing association. This is a problem,
for the open admissions policy can lead to poor instructional
supervision and articulation between classroom and library
media center. In a busy media center the single student can be
easily overwhelmed or overlooked. The fact is that if the
instructional program emanating from the library media cen-
ter is to earn its credentials as a true laboratory of guided self-
development for the gifted learner, the teacher in charge—the
library media specialist—must be in enough control of the
environment there to accomplish what any good teacher does
with students: observe them, talk with them, listen to them,
and work with them. The library media specialist must know
and come to understand attitudes, abilities, objectives, and

idiosyncrasies on an individual basis. This is accomplished usually in infinitely small flashes and bits and pieces, but when all is fitted together it forms a picture. It is wasteful when the child who comes to borrow a book from the library media center gets something inappropriate because no one had time to help owing to the demands of other children already there. It is frustrating to the learner who gets the wrong audiovisual item because of carelessness. Yet these things are daily happenings in most library media centers, which harm credibility with students and with teachers. Sometimes the damage done is minimal, but when it happens too often, the user shops somewhere else for information and help in using it effectively.

Teaching gifted or talented learners must be something more than a game of instructional roulette. Gifted and talented learners require special handling, not because they are fragile cargo but, quite the opposite, because they are often impatient and are quick to see through pretense. The instant these children see that the library media specialist is inadequate, doesn't know what he or she is talking about, and doesn't really care whether one gets the help needed or not—watch out! These particular customers, if not satisfied, are likely to be quite articulate and specific in their criticism, and devastating in their accuracy. Their built-in sensitivity and sham detectors quickly separate the pompous from the producers, and quickly consign the dull, the deadly, and the pretentious to the slag heap. While this criticism can be mean, malicious, and even downright malevolent, it is all too often plain good judgment by people who think for themselves. Teaching the gifted and talented is not a program filler; it can be exciting and rewarding, but it is also very hard work.

Modesty, consideration of others, and generosity of spirit are constant themes to be reinforced when teaching the gifted and talented. That these are only decent and basic human characteristics which are always in short supply is obvious, but it is important that the gifted and talented child be impressed with the fact that because he will be followed, because he will be expected to lead, he has a special responsibility—call it *noblesse oblige,* if you will. If he has been

endowed with ability—through no virtue of his own—he can expect to have more expected of him.

Closely related to this is the need to establish an effective system of personal values. Of course, every child needs to develop this, but it is especially important that the gifted and talented learner come early to some kind of personal commitment about what principles are to be followed, and about the rights and needs of others. We have noted that gifted children often display a high degree of concern about personal justice and a keen interest in right and wrong. Because they are articulate and assertive, they are apt to speak up on such matters even as young people. But positive personal commitment is not guaranteed by giftedness and talent, and the fact that many gifted learners are long on the skills of manipulation and persuasion can take a sinister meaning. The phrase "evil genius" comes to mind, and we are told that some of the worst criminals in history have had IQ's bordering on genius. This need not concern us overmuch, but the fact remains that for personal as well as public benefit, a good value system and good traits of character are an important need of gifted and talented children.

Another cluster of needs associates itself with the intellect. The teacher of the gifted student must teach in ways that foster intellectual exercise, helping the learner to sift through, sort out, and classify major strands of knowledge and apply them in new ways. These intellectual needs require more sure reliance upon teaching techniques than do those of the social or affective domain. They require discipline and structure, and this means striking a reasonable balance between plodding and taking off on flights of fancy. Intellectual fireworks can be fun, but they can't be counted on for nourishment in the long haul. Learning how to think, with some product at the end, requires some drudgery. Gifted learners must be taught to look for conclusions and results and for applications that move the human agenda forward.

For the average student, learning or thinking about relationships and meanings often comes to a halt when an assignment is done. Once the term paper is completed, the book read, the report given, he will wait for another closed-end assign-

ment to do to satisfy the powers that be, to get the grade, and then to run. If he has been nurtured properly, the gifted and talented learner's quest for learning should be motivated quite differently. These students are often intrigued by results achieved when old variables are combined in new combinations, and they enjoy manipulating present understandings in ways that make possible new interpretations or meanings. No sooner is a problem solved or a solution provided than the gifted learner is off again in pursuit of a new truth. This is what makes work with gifted students so challenging and interesting. For these learners, everything is open-ended. They are so motivated by an urge to see what lies beyond the next bend in the road, so unaccepting of the obvious, and so challenging of the accepted. Learning is motivated by a heady mix of curiosity flavored with skepticism and fantasy. Mixing these elements is a very volatile business, which probably explains why so few people care to try it. Developing the inquiry method of teaching to help students develop their own learning styles takes a highly personalized gift for orchestrating, and it is the mark of the excellent teacher, and one who will be recognized and appreciated by gifted and talented students. The library media specialist who works with the gifted must above all be able to share with these learners the enormous joy, illumination, and satisfaction there can be in learning and in making contact with the great minds of the past and present.

Earlier we made reference to the need for the library media specialist to be a keen observer in the never-ending effort to discover the gifted student's needs and special potentials. The insight and understanding that comes from a well developed ability to look and see, to listen and hear, is a gift found in only the very finest teachers. The nuances of reaction and emotion—both expressed and suppressed—are as telling and as helpful to the observant teacher as any number of test scores. As with the uniqueness of a finger print, a person's reactions to ideas, personalities, and knowledge are totally original with, and unique to, that person. The teacher who senses this uniqueness, so highly developed in most gifted learners, is already halfway toward learning how to meet the learner's

need for personal, social, and intellectual development. The laboratory scientist's approach as well as the humanist's and the artist's must be used in combination by the teacher of the gifted. Teaching the gifted is a two-way street: the teacher must be confident enough, and humble enough at the same time, *to learn* as well as *to teach.*

Improving the ways in which the gifted learner can get at and use a variety of materials and helping him to use them are of course prime responsibilities of the library media specialist. The most inspired teacher and the most overflowing library media center in the country could not contain, should not be able to contain, the gifted and talented learner. With gifted students the library media specialist must anticipate the most far ranging need for information and resources and be sure that the referral system and whatever network is available are in good working order.

The importance of scheduling adequate time for access to the library media center for gifted and talented students is often overlooked with highly negative consequences. This learner cannot and should not be turned out of the library media center with a crisp "time's up." Inspired program planning and attention to the needs of the gifted learner simply cannot be restricted to the fifty-minute hour.

Yet it is precisely such a mundane matter as scheduling that can cause friction among the gifted child, the average child, and their teachers. Time, expressed in schools in the form of daily schedules of compressed periods which move along to an appointed end, is often the refuge of mediocrity. It is often at odds with the learning of the gifted student, because his mind is not intent on the end of the period or when the bell is going to ring. Of course, the gifted learner must learn, among many other things, that most of the world runs on schedules, but it is horrible to throttle learning because it is time for another activity and the summons must be rigidly observed. Scheduling that allows the gifted learner enough time to finish what he is doing need not be so difficult; one just does it. It is a matter of attitude, and of flexibility on the part of some teachers who demand that every student be seated in front of them so learning can take place. If the library media center is

acknowledged as a respected and respectable classroom, with a special place for gifted learners, this can help immensely. For many years team teaching has immeasurably enriched and improved teaching and learning in many schools. If the library media specialist is part of the teaching team for gifted learners, then use of time and space and resources, monitored by both the classroom teacher and the library media specialist, can be much freer and more flexible for the gifted student. Cooperative teaching and joint use of instructional resources between classroom teacher and library media specialist needs to be much more fully developed for all learners, and the program for gifted learners is a good place to start. The dream of the library media specialist is to become part of the teaching team, and it becomes a reality more quickly in many gifted programs because there is not enough time, money, or talent and resources within the classroom to tempt the teacher into trying to shoulder the responsibility alone. The library media program's long history of sponsoring inquiry learning activities which get learners involved in their learning, tied to nonthreatening assertiveness by the library media specialist who demonstrates daily that tests of good teaching can be met and passed, is enough to admit the library media specialist into a full working partnership with other teachers of the gifted and talented.

Of course, such teaching involvement takes additional staff planning time. The school administration must play a central role in making this time available. When staff see that administrators place the highest value on cooperative planning and teaching between the library media specialist and the teacher, it gets done! Evaluation and sharing of teaching responsibility and use of instructional resources must be the "how to" focus of the staff development program. At the level of salaries of today's teachers, the outlay of funds for staff development and planning is too large to waste. Failure of staff development programs to deliver improved teaching and more effective learning has caused public cynicism about such programs, and has raised the charge that many professionals do not have the integrity or intellectual credentials to indulge in long-range planning or innovation, or that when

they do so, the results are so experimental or so expensive that few children benefit. These doubts have cast a long shadow over much educational planning, but the alternative, to do nothing, is not acceptable to most professionals who are concerned about good teaching and sincerely committed to exploring new ways to improve their teaching abilities.

Planning enlightened and thoughtful programs for the gifted and talented requires the participation of enlightened and thoughtful persons. Planning results should be reflected in program options and learning choices. No one seriously disputes the fact that a wide variety of alternative teaching methods must be available to the gifted and talented child. In the late 1970s when many of the most cherished beliefs about open education fell by the wayside under heavy and sustained criticism, a large part of the educational establishment buckled and threw out innovations it had hardly begun to understand and to use properly. Many districts beat a hasty and disordered flight back to the basics. Certainly misapplications and misuses of open education's methods had occurred, but practiced properly, open education provides a great deal of structure, learning focus, and intellectual substance to learners, something that has been largely overlooked by critics.

This is especially unfortunate for the gifted and talented learners, for educating them effectively depends upon the provision of an open-learning environment, flexibility of methodology, and the teacher's ability to act as a learning guide and stimulator of learning. Overcoming public distrust and the battle cries of the "back to basics" right wing, while at the same time helping teachers to become at ease with this most difficult, creative, and satisfying of teaching styles is, to put it euphemistically, a challenge! But the needs of the gifted and talented can help us. The multiple choices for learning built in to the open learning philosophy must be maintained if gifted and talented programs are to be anything more than one dimensional experiences.

Another essential outcome of staff development activities focused on planning for the gifted and talented is a carefully prepared evaluation plan for both the program and its partici-

pants. The joy of learning does not refer to fun and games, but to the hard work of encountering and of overcoming obstacles through perseverance. There can be no justification for letting learners roam at will through knowledge until something turns them on, nor of course do we advocate the opposite course. Avoiding the extremes is assured only by setting objectives by which success can be evaluated.

Evaluating the results of learning programs for the gifted and talented must consist of more than groping in the right direction. Realistically one cannot measure the totality of learning and thinking which has taken place, and measuring the gifted intellect or its growth is not as simple as administering tests and interpreting scores. Despite significant breakthroughs in devising tests and measurements, we still lack a single measure for genius or even extreme giftedness. But this does not mean that being gifted or talented automatically places a child into a category in which the consequences of choices or the results of effort are not evaluated. A lack of evaluative procedures and expectations about results are as bad as an overly regulated and too rigid evaluation system, for both lead the learner to conclude that it doesn't matter if he does or doesn't.

The library media specialist may be tempted to hold back from involvement in evaluating participants in the gifted program. Not much of anything about evaluating is taught in library schools, except in regard to materials, and most library media specialists are hesitant about evaluating, but we believe they should not be. The most important qualifications to be brought to the job are good judgement, common sense, a knowledge of sound principles of both teaching and learning, an ability to listen and to find consensus, and the ability to apply theoretical concepts to actual teaching. John Dewey told us early in this century that we learn best what we discover for ourselves, and this is still as true of our own learning as for that of the students.

It is to our advantage that evaluative systems attached to library media programs have rarely aimed at establishing absolute standards of achievement or productivity. Much of the learning that takes place in the library media program is

open-ended. We would like students to learn through their work in the library media program that no assignment is ever *really* finished because there is always more to know and more directions to take in a project. If this sense of the on-goingness of learning can be built into the evaluative criteria for the gifted program, then something very beneficial has happened. For the gifted and talented child, all achievements should be interim achievements, the best he can do right now with what he knows right now.

Closely related to the contention that the library media specialist should be an active participant in planning, opera-tion, and evaluation of gifted and talented programs, is the matter of articulation among grade levels, school levels, or the school and any other agencies or organizations involved in teaching the gifted child. Good management skills and quality control of the product throughout all the steps of production should not be the province only of corporations and profit-making enterprises. For years many of us have realized that one of the giant flaws in education as a whole and in the school library media program in particular has been the *extremes* of excellence and inadequacy and the unevenness in matters of program, services, materials, and staff to which children may be subjected during their school years. In one building may be found a library media program of established instructional excellence, well managed by an energetic and creative profes-sional who is well supported by administrators, teachers, students, and the community for sustained contribution to learning for all students. Within two miles there may be a school library media program, unworthy of the title, which has earned the contempt in which it is held by everybody. How is it possible? Why is there so little articulation often in the same school district? Why does one program make a negative impact only, while the other powers the instruction for the entire building?

Such questions don't often get answered, but we believe they should at least be asked occasionally. Obviously, prod-uctivity and effectiveness are tied to personalities—those of the library media specialist and the administrators es-pecially—to intellect, to energy, to management competence,

and to a host of other things. Yet, each professional is subject, within a normal range, to the same influences which shape and effect every library media program. What then, must be done to regularize such extremes of good and bad program development so that reasonably effective patterns of programs and services are established as the norm? Certainly, with a few notable exceptions, the chronic lack of effective state leadership and district-wide coordination for library media programs has harmed uniform program development. It is at these state and district levels, rather than in some national model, that excellence in program standards, the development of innovative programs, and exemplary teaching activities should be highly visible and influential. The absence of such leadership leaves such issues by default up to each building, and this is not satisfactory.

In developing the links necessary to tie together buildings, districts, regions, and states throughout the nation to ensure excellent library media opportunities for the gifted and talented, the American tradition of going it alone, as expressed in the passionate belief in local control of education, has proved to be a deterrent. However, PL 94-142 and other federal legislation, affirming a more likely intervention by state and national governments to ensure quality and equality of program for special learners, will move some degree of control beyond local constraints and prejudices. Consider also the issue of tax reform to assure equalized funding of education, and the trend away from local control appears no longer a trend, but an established fact.

Whatever the structural weaknesses resulting from inadequate coordination and penurious budgets, library media specialists have often looked outside their own buildings for support and direction in maintaining programs. This has not been so much an enlightened action as it has been making a virtue of necessity, but the end result has been the same. And if requests for help often went unanswered, or the help received wasn't much good, we have never lost faith in the process. Now reborn under the name of "networking" and benefiting from strong national interest and support, the school library media specialist's interest in cooperation with

other kinds of libraries and with other public and private agencies is undergoing a sparkling renaissance. Programs for gifted learners will greatly accelerate this kind of activity.

It is possible that the term "networking" speaks to a more highly sophisticated process or arrangement than we need. The planning and sharing begin within the school building, and it is here that needs are established and decisions made about how best to meet them. From here it is a question of people talking together and agreeing on some cooperative measures. Putting out lines to others is generally considered to be the principal's responsibility, but in many schools it is done on a hit-or-miss basis. When such a vacuum exists, many library media specialists have shown themselves capable of stimulating, focusing, or even managing this planning for obtaining and sharing outside resources. In this, as in developing programs for the special learner, it is better to take the tide at its flood rather than at its ebb, and the library media specialist should play an activist role, getting in on the formative stages, rather than being dragged in later. Gifted and talented programs are very special programs, and they can become totally controlled in a very short time by either those with a mission, or by the persons attracted by funding and the hope of power, or by both together. Bureaucracies have a life of their own and control of them is not easily wrested away from those who have seized it, and so library media specialists must move quickly to take initiatives. The inevitable result of sitting on the sidelines is always to be too late, and then to see one's professional life become a matter of nibbling away from the outside while looking in.

Developing gifted and talented learning programs presents schools and communities with an extraordinary opportunity to put some of education's best traditions to work. Citizen participation, consensus decision making, and use of the government's power to make a better life are, after all, at the heart of a democracy. If, in establishing these programs these democratic processes can be strengthened, something of additional value has happened. Understanding is established among participants in the process of setting goals and objectives through the involvement of professional educators, par-

ents, interested community members, and the students them-
selves. This understanding, the sense of embarking together
on an enterprise, will give the program big momentum and
help carry it along. Conversely, the less these people know
about what is going to happen and why, the farther they feel
removed and not responsible for it. And so the chances of
failure and dissatisfaction are increased.

From the joint planning relationships established flows all
else that makes a gifted and talented program work, includ-
ing:

(1) establishing a flexible teaching program, one which
offers variety in learning programs and encourages gifted and
talented learners to find the one, or several, which suit them
best;

(2) careful selection of the professionals, the paid support,
and the volunteers who will operate the program and see to it
that it keeps its promises;

(3) linking the community's resources (both human and
material) for incorporation into the program;

(4) identifying the program's participants in terms of apti-
tude and performance;

(5) assuring that the gifted and talented program does not
exist in splendid isolation from the school's general education
program, but is looked upon as a school-wide, community-
wide enrichment resource; and

(6) developing and using thoughtful evaluative devices to
measure the program's worth and its effectiveness with par-
ticipants.

Even achieving all of these does not guarantee success,
which, as always, rests firmly upon the abilities of the per-
sons who carry out the program, but failure to achieve them
anticipates little chance of a decent program.

Throughout this chapter we have linked the gifted and
talented learner together as though they were one and the
same for the purpose of establishing program needs and goals.
It should be clear, though, that being intellectually gifted and
being creatively talented *are* different. It is fully possible,
indeed it is likely, that one could be intellectually gifted and
have little or no creative or performing talent. However, what

about the child who shows outstanding skill in mechanics or turns out to have the makings of a highly skilled carpenter? What we are saying is that we may need to think about enlarging the traditional definition of giftedness or talent to include other than ability to achieve in an academic or intellectual sense and ability to perform in other than an artistic sense. The capability for outstanding achievement comes in more and more directions and modes, and we need to be aware of a wider variety of potentials than we have ever been. Common characteristics of high achievers are:

(1) a strong determination and persistence to achieve

(2) an ability to use several skills to get results

(3) the attitude that what one has decided to achieve one can achieve

(4) a strong streak of self confidence

Any political leader, a good courtroom lawyer, a successful athlete, or an excellent plumber needs these traits. Achievement does not always depend upon intellect, although they are often found together.

The underachieving but gifted learner is a source of bafflement and concern to both educators and parents, for failure to achieve is often seen as a rejection of values important to an individual and to society as a whole. Stimulating latent ability in a gifted or talented learner is a matter of high priority.

Joseph Renzulli points out that to be truly gifted an interaction among three basic clusters of human characteristics must take place. He tells us that it is, in fact, this interaction that ignites and sustains giftedness or talent. One needs (1) the force of an above average general learning ability; (2) a high degree of commitment to get things done; and (3) a high level of creativity. Renzulli observes that, "gifted and talented children are those who possess or are capable of developing this composite set of traits, and applying them to any potentially valuable area of human performance." But—and here is where the interaction comes in—just having these characteristics doesn't guarantee giftedness or talent, for they must be fueled and given thrust. To assure that these traits *energize*

each other requires not just a brain and the urge to use it but "A wide variety of educational opportunities and services that are not ordinarily found in the regular instructional program."

Sidney Hook, an important political observer and writer, has written that "the cult of conformity can make the pursuit of excellence seem educationally subversive." This is not just a philosophical comment; many a gifted and talented child has been and will be in the future a victim of hostility aroused when the schools try to provide special programs for him. This is and should be a matter of great educational, parental, personal, and social concern.

Education for the gifted or talented learner is too important a matter to be left to a haphazard state of sporadic disconnected efforts and proposals which are too often the sum and substance of our good intentions in educational planning. Library media specialists will be able to use to the full, in connection with gifted and talented programs, their considerable gifts for persuasion and for mediation in addition to their other personal and professional talents. Interpreting the rights and the needs of gifted and talented students among them, their need for freedom to hold their ideas and express them, their need for open-endedness, and harmonizing these needs with those of an institutional stability will take diplomatic ability of the highest order. Who can better serve as double advocate—for the students on the one hand and the institution on the other—than an effective library media specialist? Tensions will exist, but tension can be creative or divisive, and the library media program has enormous potential for making it the former rather than the latter.

The gifted and talented are a reservoir of leadership and discovery and performance from which society will draw. Library media specialists can do much, more perhaps than any other teacher they will ever have, not only to sharpen their intellects and find the right channels for their talents, but to help them live comfortably in a world of work and play, of stress and joy, and of achievement and failure. Historically, the library media specialist has seen this kind of character development role as a valid and vital part of the library media

program, and never will it come into its own with more
reward and consequence than with gifted and talented learn-
ers.

Exemplary Programs

The five following sites are representative of those we se-
lected and visited relating to programs for the gifted and
talented. We have presented them here in alphabetical order
by state.

Frederick County Public Schools, Maryland
Grand Rapids Public Schools, Grand Rapids, Michigan
Lewis Research Center, National Aeronautics and
Space Administration, Cleveland, Ohio
Taft Elementary School, Lakewood, Ohio
Students Participating in an Active and Creative En-
vironment (SPACE), Richland School District, Columbia,
South Carolina

FREDERICK COUNTY PUBLIC SCHOOLS
Maryland

It is not unusual to hear the description, "gifted," coupled with the description, "impetuous," reflecting an attitude in which it is assumed that being gifted means that erratic or irrational behavior will be present as a concomitant of giftedness. It is all too apparent that a certain number of programs for the gifted and talented have been put together by dreamers who seem to have some doubts about the fact that programs for the gifted and talented require structure and the elements that make for solid learning, and that freedom does not equate with license. There are gifted and talented programs that prove that it is possible for them to be glamorous as well as sensible and innovative as well as basic. We found such a program in Frederick County, Maryland.

In this situation, several conditions asserted themselves early in the game and had the effect of channeling the program into a productive cycle. Initially, there was a firm commitment from the Board of Education. As part of a statement the board said it was "committed to a program that recognized the unique value, needs and interests and talents of each student. . . ." and established specifically its belief that "gifted and talented students are an integral part of that commitment, and that gifted and talented students have special and essential contributions to make to their own fulfillment and to society."

From this commitment to the gifted at the policy-making level, which any program must have if it is to have any expectation of success, flowed objectives which implied the need for innovation and experimentation. In turn there must come refinement and action by those with the resources at the building level, where policy must be transmuted into a teaching and learning program.

In Frederick County, this sequence of events, and the reinforcement it provides all down the line, is evident. The goals, stemming from the board's policy, were as follows:

(1) To identify gifted and talented learners through a process of observation and evaluation;

(2) to provide an appropriate educational program, *within the school building if possible,* for gifted and talented learners;

(3) to evaluate continuously the effectiveness of gifted and talented programs for individual participants; and,

(4) to plan and implement training programs and activities for administrators, teachers, parents, and other community leaders to permit the development and continued improvement of talented and gifted programs.

These thoughtful statements show a recognition that the gifted and talented program will be most acceptable (and accepted) if it can establish its own in-school base and attract a maximum number of teachers, administrators, and parents into planning and establishing it. Providing for continuous monitoring and evaluation of the program and incorporating a broad base of resources (material and human) into the planning stages also give it strength.

A delightfully unpretentious manual entitled, *Gifted and Talented Students of Frederick County,* describes much of the planning process, and there is a section aptly titled, "Successful Beginnings." Emphasis is on the action plan which emerged from the involvement of parents and of professionals with scope and purpose, and it makes it all sound easy. Just as there is nothing as hard to see as the imagination of a genius, so there is nothing as difficult to do, in reality, as to follow these planning steps successfully. Too often something goes wrong and individuals and groups who should be working together wind up working against each other.

There is another element here which is found routinely in any exemplary library media program, and that is that the search for funds to support the program must range far and wide. For example, in Frederick County, the Comprehensive Employment and Training Act (CETA), a federal program aimed at reducing hard-core unemployment and providing on-the-job training and practice in marketable skills for its participants, was used in an imaginative way to help the gifted and talented program achieve its goals. CETA Title VI, which is devoted to public service employment, was used to add twenty-four aides to support staff of various school

library media centers. The CETA program, criticized in some quarters as a boondoggle, has had a turbulent history. In addition, the danger of using "soft money" or funding whose future is of uncertain duration should be kept in mind before going in this direction for staff positions, since, when funding dries up for a project, there is no guarantee that the local school district will be able to assume the position salaries. But the alternative, to try for no outside funding and perhaps end up with no staff at all, is not a good one either. Nothing is accomplished without some risk. If a program made possible through use of personnel funded from out of district sources proves to be of value, its chance of being continued with district funds is certainly greater than if it had never been demonstrated at all.

Support staff in this case attend to the duties usually associated with aide positions, such as processing materials; scheduling the use of equipment, materials, and space; helping students locate materials; and helping the library media specialist assemble materials for the use of the staff. While these are a few specifics, it is clear that the major contribution of the support staff is in allowing the library media specialist to be "the catalyst, leader, and coordinator of gifted and talented programs in the school." And there it is! A clear commitment by the Board of Education places the library media program and the library media specialist at the creative center of the gifted and talented program.

This means, of course, that the focus for the entire program must be established in the library media program, and it is. The coordinator of the library media program for the county conducts staff development workshops, with the aid of the state consultants, for educators. Teams composed of a library media specialist, a classroom teacher, and an administrator are trained to be the leaders in establishing the gifted and talented programs. Later, other workshops for elementary and secondary school library media specialists help them plan programs of value for the gifted and talented learners in their schools. Program responsibility and accountability for results is clearly established, yet district support has been provided and staff development programs helped ensure that

no one was left exposed with an assigned mission and no resources to bring to it.

The result of all of this careful preparation and planning is, not at all surprisingly, a cornucopia of programs for the gifted and talented, each one involving an impressive number of young learners and teachers. The programs are coordinated with finesse and excellence through the library media program. Consider, for example, fifth and sixth graders doing a unit on communications. The use of various communications formats from prehistoric times to the present were analyzed and evaluated. Trips to a radio station broadcast, the telephone system, an East Coast relay station, and other facilities bring resources from outside the school to the learner, an essential ingredient in any gifted learner program. Or, take the "World of Literature" project in which such genres as fantasy, mystery, science fiction, and historical fiction are introduced and used at various grade levels. Tying research to production, students wrote some fantasy stories which were made into books. Dioramas illustrating books were designed, as were mobiles featuring mystery characters. The intermediate grades used other formats and made slide/tape presentations, super 8-mm films, and realia to express their delight with the topic.

An advanced mathematics group (grades four to six) made field trips to a nearby computer center in a community college, and the students operated the computers, even doing simple programming such as switching from the hexidecimal system to the binary system. And a trip to a hospital made it possible for these eager and curious learners to observe a complicated heart-monitoring system. Developing a perspective on the history of mathematics and creating a time line of significant historical events added immediacy to the program.

An astronomy group, at about the same grade level, turned to an outside expert to guide their explorations. County and regional resources were used to demonstrate the use of the spectroscope and other sophisticated equipment. And what could surpass a visit to the Goddard Space Center and the Albert Einstein Spacearium at the National Air and Space Museum in Washington for making a topic glitter.

And so all kinds of special resources both inside and outside the building were brought together with the burning interests of gifted and talented students. The ability to organize such resources, to coordinate them, and to serve as a link with the classroom, requires an activist philosophy of curriculum planning and instructional development, of the kind that must lie at the heart of any successful library media program. The use of media to sharpen the learner's ability to reason and to make good decisions is also an aim of this program, and the use of the library media center as the center out of which all of this emanates gives new lustre to the hopes and aspirations of the library media profession.

Exemplary Program Elements
1. The use of the library media program as the key delivery element of the gifted and talented program; and the designation of the library media specialist as chief program planner.
2. The commitment to make the gifted and talented programs a grass roots program, with careful involvement of regular teachers in its planning and operation.
3. The use of staff development programs to insure maximum staff commitment to meeting program goals.
4. The use of a wide array of resources to provide the enriched learning environment required by the gifted and talented learners.
5. The imaginative use of a federally funded program, CETA, to provide support, allowing library media specialist to assume an instructional leadership role within the building.

GRAND RAPIDS PUBLIC SCHOOLS
Grand Rapids, Michigan

Compared to the apathy, even dullness, that engulfs so many classrooms, programs filled with gifted and talented learners may sometimes seem a little zany. There is an aura of improvisation, of creative energy that cast shadows of doubt as to the "serious learning" that is going on. The Grand Rapids program, with the name of "Spectrum," has accommodated to brightness and cleverness that is not smart-alecky, flexibility that is not just change for its own sake, and combined these with a broad-based professional and community support to accomplish some distinctive results in a brief but productive life.

The Spectrum program is based upon models prepared by Dr. Joseph Renzulli, a professor at the University of Connecticut and an eminent authority in the field of educating the gifted or talented learner. A brochure describing the program depicts it as one of a cluster of programs sheltered under a huge umbrella.

A "spectrum," as the dictionary defines it, is a range of varied but related ideas or objects that have a sequential relationship to each other. Built around interest areas, this particular spectrum of learning opportunities offers an array of topics which vary each semester, based upon student interest. Course examples include archeology, futuristics, computer mathematics, budding botanist, interior design, time machine (history of prehistoric man and ancient Egypt), and creative writing. The teaching aims to stimulate and encourage students to explore, research, and then prepare as an end product an independent study to be shared with others.

These courses are available to intermediate grade pupils (fourth to sixth) district wide, and some 320 of them are bussed in once a week to a special Spectrum Center School where the program operates four days a week. About eighty students are involved in the program on each of the four days

on which it operates. By the way, just *where* to locate a gifted and talented program is a question guaranteed to provoke controversy, especially when principlas and staff are resolutely opposed to bussing the gifted and talented out of their school for any part of the school week. The argument is that this can produce elitist tendencies in the children who are thus separated from their peers, and "skim the cream" of a particular school's population. The elitist charge is best dispelled when the teachers and others who are associated with the gifted program work hard to show that what they do while separated from the classroom can still enrich its life and the learning of the other children. It seems doubtful that having some of its children away from their regular classrooms one day a week could be detrimental to the life of the "sending" school.

Programs for gifted or talented learners are not, after all, established to *reward* or promote the children selected to take part in them; they are an effort, quite simply, to provide appropriate individualized learning for abler children, just as, it is to be hoped, the school has attempted to provide what is prescribed and needed for average or below average learners. Such programs can hardly be established without some sense of specialness about them. There is, of course, a world of difference between ability and pride in meeting demands and arrogance. The well-run and sensitive program for the gifted and talented recognizes this; it works hard to reinforce the former attitude among participants, and equally hard at damping down the latter.

Understanding something of the process by which students are selected for the Spectrum program is helpful in understanding the way in which the program functions. The Grand Rapids Schools recognized that, "Gifted and talented youngsters exist at all age levels and in all ethnic and socioeconomic groups. They are students whose abilities, talents and . . . potential for accomplishment are outstanding. These students perform at a high level, supported by their motivation, perserverance and interests." The definition examines these potentials in terms of academic talent, creative thinking and talent in the visual and performing arts. Academically gifted

children manifest "superior aptitudes to the extent that they will benefit from programs beyond the regular school program." The creative thinker is identified as someone "who consistently engages in divergent thinking that results in unconventional activities and will benefit from a special environment in the area of the visual and performing arts." Outstanding creativity or production in graphics, in representational art, sculpture, music, or dance also establishes the need for another kind of special atmosphere and opportunity.

The underlying purpose here is as far as can be from learning to conform to the group and from the mediocrity of homogenized sameness; it is for each child to develop those special attributes of intellect or creativity that makes him or her special. An observer notes the budding botanists busy with their microscopes, the creative writers working with a poet in residence, the math students working with a computer, and other examples of high intensity learning, housed in an informal setting with peers totally engaged, and wishes that all learning could be as absorbing and as rewarding.

There is always, of course, the problem that has been around since schools began: many more parents believe that they have gifted children than actually do have gifted or talented children. Yet, no gifted or talented program can possibly be successful without consistent and intensive parental involvement. In fact it is parent expectations and appropriate early training that help set most gifted and talented children on the road to fulfillment of their potentials. But how to insulate children from parental *pressure,* without isolating them from appropriate support and motivation? In Grand Rapids this is done by means of a needs assessment made for all children who request enrollment in the program. A Survey of Student's Educational Talents and Skills (ASSETS), developed by the district's Office of Curriculum, Planning and Evaluation, is administered to each potential participant. Parents, teacher, and student all provide inventories which become part of a profile used together with achievement scores in the selection process. This is a variant of the IEP which assumes a highly useful form here.

Once a child has been identified and recommended by a

selection committee at each school, a letter is sent to the parents. The letter tells how the child was selected and outlines the expectations of each child enrolled in the program: production of quality work, consistently good attendance, independent study, and a sense of responsibility for self-learning and to the program. The decision as to whether or not to enter the program is a shared one; the letter urges parents and child to discuss the invitation as a family matter, a family responsibility, and together to arrive at a decision. This process is time-consuming, but it is well worth the time it takes to avoid the possibility of parental pressure or disinterest.

In the letter of invitation that goes to the home, inviting participation, learners are promised a "specialist in resources and media to work with students." This promise is handsomely redeemed; the media specialist works four days a week as the resource consultant for the Spectrum classroom program, and then on the fifth day is responsible for coordinating the Junior Great Books Program which operates in twenty schools and is another part of the Spectrum umbrella for gifted and talented learners. The Junior Great Books Program remains one of the most easily organized beginning projects a library media specialist can undertake in the gifted and talented area. The program requires a small number of able and motivated readers, a second adult to assist, and confident teaching ability—especially including the ability to stimulate inferential and open-ended discussion, as opposed to finding right answers.

The question of adequate staff for the library media program comes up again and again in evaluating the relationship of this program to programs for special education. One thing is certain, and that is that neither the AASL Standards of 1969 nor the AASL/AECT Guidelines of 1975 anticipated the unique demands that special education would impose upon the library media program. We do not evade the question when we fail to provide absolute staffing figures as the musts for any special education programs; it's just not possible to do it! The notion of one professional and two aides to serve 250 students as per the Guidelines were never more than a stab at

quantification. Standards and guidelines never cope well with factors such as the individual's motivation, intelligence, perception, managerial ability, and determination to succeed. These factors have been shown, again and again, to be the pivotal elements in establishing effective library media based programs for special learners.

The Grand Rapids elementary schools do not have professional library media specialists in the buildings, and volunteers who staff the media centers are supervised by a District Elementary Media Consultant. The system does not offer a model of an excellently staffed school library media program, but in this case it works well. It works because for this particular gifted and talented program the services of a superbly trained and highly qualified part-time professional mesh beautifully with, and enrich the contributions of, the four regular teachers who staff the program. The result is the school library media specialist as synergist: "an agent which increases the effectiveness of another agent when combined with it"—the ideal, born of excellence.

The part-time professional trying to provide full-time service learns, if nothing else, to plan and execute with precision—the only alternative being to sink without a trace. The Spectrum library media resource person does an extraordinary job of both planning and producing. The objectives of the program are clearly stated and embody such a personal and professional commitment to carry them forward as to make it seem that the program is multistaffed instead of partially staffed. The objectives include

(1) helping students to locate media resources;

(2) helping student to utilize the media;

(3) helping students to appreciate the media;

(4) helping to encourage creativity in students as they work toward realizing the first three goals; and

(5) helping students to produce their own media

These objectives are backed by a teaching program planned in terms of specific expectations for individual learning outcomes. For instance, the manner in which the skill of locating the media is taught is a minor masterpiece stressing the associated library skills of researching, retrieving, and eval-

uating the information resources which are available on a topic and requiring that they be thoroughly learned and well used. Pretests are used to determine entry level skills, and these skills are developed as part of the instructional process. There is nothing elaborate in this; it simply works well because the teachers have agreed to work with the library media specialist as a fellow teacher, part of the professional teaching team. The Spectrum students must use their developing skills to fulfill their commitments, and they are motivated to use them.

The library media specialist recognizes that the resources of the one school are not adequate to support Spectrum's highly motivated learners, and a commitment to have students use the resources of a nearby middle school, high school, and public library are included in the library skills/location unit. For the gifted learner, access to special reference resources will be a necessity. The link to applied skills use is the library media specialist, who recognizes that library media skills are in fact *study* skills, and who helps students, as any classroom teacher should, to use these skills in meaningful ways. Making outlines, taking notes, presenting information to others, using community resources, developing listening skills, and following directions are regarded by too many library media specialists as skills to be taught by the classroom teacher. The Spectrum program fosters application of skills through the library media program as opposed to learning them in a vacuum. Skills teaching is cumulative in effect, and it is the rightful territory of every teacher, including most of all the library media specialist. In one instance, the library media specialist may introduce the skill, and the classroom teacher reinforce it; in the next, a classroom teacher may be the introducer, and the library media specialist the reinforcer.

In the Grand Rapids program for gifted and talented, many of the activities associated with any good library media program are carried out—the performing arts activities, the annotations of favorite books recorded on cassettes to "sell" them to other students, the author visits, the video productions, and the film and filmstrip making. Somehow, though,

they are carried out to a higher power here with these gifted children. The library media program has such vitality and focus that it succeeds in meeting a commitment to an intensive and demanding program under less than perfect circumstances.

Exemplary Program Elements
1. The encouragement of students to investigate subjects of special interest to them, and to produce projects which use a variety of media.
2. The intensive reference skills program that encourages a teacher/library media specialist combination stressing utilization of skills to learners.
3. The focus on district resource sharing through schools at different levels and the public library.
4. The total involvement of the library media specialist in both planning and teaching the instructional program.

LEWIS RESEARCH CENTER
National Aeronautics and Space Administration
Cleveland, Ohio

We have a fantasy about the perfect library media specialist and the perfect library media program. The library media specialist is skilled, indeed inspired, in directing a media based instructional program which exerts a forceful influence on every teacher and student. Because of this, the library media specialist is greatly respected as a person who makes a sustained contribution to the school's learning environment and to every learner, a person who is looked to for leadership when new ideas are in the air and change is in the offing. The library media program is well regarded and appreciated, too, in the wider community of parents and citizens who recognize that the instructional and service programs it originates are highly effective and delivered efficiently. The library media program is so integrally entwined with the educational quality and destiny of the school, that to be without it would be unthinkable.

Oh, that the fantasy were real in all schools. The realities of daily life in a school building make it seem sometimes impossible for any library media program to achieve this dream, and the amazing thing is that there are some that do. On Friday afternoon, in the midst of teacher burnout (or meltdown) it seems unlikely, but one of the great things to know is that we are more and more approaching a time when library media programs will not be as static and site-oriented as they all once were, and most still are. As time goes by, and especially with the need for outside resources for gifted and talented learner programs leading us on, more and more library media programs are going to be functioning in part in resource centers outside the school building. One such center, the library media annex of the future, is the NASA Lewis Research Center which any library media specialist should be thrilled to count as part of his program.

The Lewis Research Center would not meet the criteria set

forth in the national *Guidelines* or *Standards,* for it doesn't have the recommended number of staff or amount of space or materials. It does have, however, some important elements such as professional program accountability, evaluation of results, and staff development, matters which are now looked upon as being as central to the effectiveness of the library media program as those others.

It is possible to believe that perhaps the Lewis Research Center represents the next generation of library media programs. This is especially so if one subscribes to the view expressed so succinctly by Alvin Toffler that "the future is now." Toffler's corollary that for some, indeed for many, the future has come too soon, could be relevant here, too. The center, in any case, should be viewed as a creature of the future. Many professionals might even question whether it is a media program, but we think it is.

Its program is presented here because it emphasizes the fact that providing library media programs of real scope to gifted and talented learners requires ranging far afield; and also because it underscores that institutions other than schools can provide library media programs of extraordinary depth and value, and that school library media programs should associate themselves with these wherever possible, using the association to strengthen themselves and to compensate for their own limitations. Perhaps the most critical task of the school library media specialist of the future will be to find resources that can be shared, ferreting them out wherever they can be found, and bringing them together to improve the learning program of the school. The relationship of various schools and school library programs to the Lewis Center is a source of satisfaction and optimism.

Many library media programs go about the business of alerting their users to their services and programs in a desultory manner at best. Or, when the information is available about what these programs can do for a teacher or learner, it is often so ambiguous as to be nearly worthless. Little wonder that teacher/learner contact with the library media center is often tentative and vague in the extreme: "where can I find something. . . .", or "I need something on this list. . . ."

The Lewis Research Center mounts the kind of forceful teacher outreach program that should be integrated into every library media program in every school. They tell teachers what they have, invite, urge that they use the materials, and show them how to use what may be unfamiliar in various ways. It may be that they go out to recruit users, not having any client group that is supposed to be "captive" just across the hall. We live in a time when advertising and public relations are used in every area of life to catch peoples' attention, and Lewis certainly does a good job of this. There is a teacher resource room exclusively for the use of school people, with material oriented to such science related topics as space science, astronomy, each resources, energy, and weather. This room is part of the visitor information center, an area which incorporates 10,000 square feet of display space and a hundred and fifty seat auditorium. There is an extensive collection of 35-mm slides which may be copied; an audio cassette library, also available for copying; sample lesson plans and suggested teaching activities on many topics, from aeronautics to space colonization, and suitable for grades K to 12; a large collection of NASA and other publications which may be used in the teacher resource room with help from the staff in getting one's own copies if wanted; slide cassette programs available for viewing and borrowing; a copying service for ¾-inch video cassette and ½-inch reel to reel format; and a film library consisting of 4½-minute 16-mm films and clips ranging across a wide range of science topics, available for two weeks' borrowing. The resource room also offers teachers the opportunity to be placed on a mailing list to receive NASA information.

Obviously, this is a fabulous one-stop service-oriented media program for teachers, with elements of staff development, too, which any library media center should be happy to emulate. Of course, the center is backed by the considerable financial resources of NASA and, interestingly enough, is bound by law to pursue its public information program which requires that NASA, "provide for the widest practical and appropriate dissemination of information" about its activities and the results thereof.

We are not saying that every school library media program should try to do just what NASA does, but rather that there is an *attitude* here to be emulated, a spirit of *selling* the programs, materials, and services of the library media program. Many library media programs provide many of the same things, they just don't package it as well and move it off the shelves into the consumers' hands. The purpose here is not to create, as some of the less attractive elements of advertising do, a need that doesn't exist. For teachers do need, most especially in the area of science, and most especially with the young gifted scientist, all the help they can get.

The Lewis Research Center serves the states of Ohio, Indiana, Illinois, Michigan, Wisconsin, and Minnesota. Naturally, its teacher/student programs are just one portion of a public outreach program that brings to it an average of 10,000 visitors a month to see its exhibits and to use its resources. This reaffirms that it is quite possible to manage public information programs side-by-side with more specifically targeted educational programs for teachers and students. This public agency does it, and so have many public libraries for many years, encompassing a wide variety of programs to serve a varied constituency.

The task force created by the National Commission on Library and Information Science to study the role of the school library media program in networking saw this as a realistic and thoroughly sensible goal, stating in its final report that, "millions of students, their parents, teachers and others involved in their education should find their school library media centers to be effective points of access to a total information resource."

The use of the Lewis Research Center to customize teaching is another important program element which school library media programs would do well to consider emulating. Educators who use the center are asked to preplan their use with a staff person. This preplanning includes an explanation of what is available for educational use at the center, and the educator and staff person discuss in an informal but thorough way what the teacher's goals and objectives are and how the center's resources may be used to achieve them. Not so desira-

ble is the fact that because of heavy scheduling, this preplan-
ning must occur at least two weeks in advance, creating a lack
of spontaneity as a motivational factor. But this is imposed by
separateness and distance rather than program. The point
being made is that the better the preplanning and the target-
ing of goals and objectives, the more successful will be the use
of the resources. It is not surprising to learn that, according to
the Center staff, the most unsatisfactory experiences occur
when teachers bring their students to the center with little or
no preparation and the attitude that they are out for a frolic.
But they never give up in their effort to teach teachers how to
make better use of the resources.

For the the gifted and talented student particularly, the
Center offers richness and new paths to discovery. Special
arrangements can be made to provide in-depth programs for
individuals or small groups. The Taft Elementary School in
Lakewood, Ohio (a Cleveland suburb), uses the program in
this way, and a description with greater detail follows this
one.

An obligation of the professional, we believe, is always to
look ahead, as well as to live as creatively as possible in the
present. We believe that the Lewis Research Center is a
sample of what lies ahead for school library media programs
in networking, in resource sharing, and staff development,
and it is a vision of the future that gives us hope.

Exemplary Program Elements
1. The use of networking and resource sharing to enrich indi-
 vidual building library media programs.
2. The use of exemplary public awareness programs to alert
 educators about program services and how to use them in
 their teaching.
3. The use of a teacher research room to give teachers access
 to a wide array of instructional media which may be used to
 improve their teaching.

4. Access to the program by gifted and talented learners to extend and enrich their learning.
5. The use of a federally funded agency to help individual educators improve in their teaching abilities.

TAFT ELEMENTARY SCHOOL
Lakewood, Ohio

Some years back there was a product hyped into the consumer consciousness with the phrase, "This one does it all!" The Taft Elementary School's gifted and talented learner program not only does it all, but it does it best! If we were to select one program which best illustrates what one would hope to find in an exemplary library media program for such learners, it would be this program.

Why? And in what way does this Taft program put into daily practice the principles identified as central to successful programs for this group of special learners? Consider these cardinal points: the commitment of a principal to the gifted and talented program to the extent that he helped to plan it and takes an active teaching role in it; a library media specialist who is a skilled and creative teacher as well as a highly efficient program administrator and is capable of motivating teachers and students alike to use the program's resources; a program that is so well balanced that its gifted and talented children move easily back and forth from its enriched atmosphere to the regular classroom. This is a program that uses the human and material resources of the school building to the fullest extent, and then goes beyond it to locate additional resources to reinforce an already outstanding program. This is a program with a single, simple overriding goal: "to help each child develop to his or her fullest potential"; it is a goal to be arrived at with a series of apt, low-keyed, measurable objectives. This is a program that proves by inference that the worst teaching is that which aims to obtain as much control as possible over children, and that the best teaching has as its ultimate purpose the liberation of the learner's mind to challenge, to discover, and to decide on its own that knowledge is worth having. These are only some of the reasons why the Taft program is such a fine one.

It is evident in surveying many gifted and talented programs that the mandates of excellent teaching and creative

learning have in all too many cases been ignored. Often this
has led to luxurious programs which display a kind of elegant
vulgarity and elitist tendencies about which many warnings
have been sounded. Common sense and good judgment have
been sacrificed by those rushing to embrace still another
promise of educational salvation, and their product has been
programs which, in the guise of being for gifted and talented
children, do little more than practice a higher level of manip-
ulation and control. Such programs have drawn ill-will both
from the inside and from those parents and children on the
outside looking in—those, by definition considered to be not
so gifted or talented.

Nevertheless, these programs, properly planned and car-
ried out, have enormous and important potential. The mind of
the gifted learner is a priceless asset to himself and to the
entire society; the insights, imagination, and energy which
the talented performer is prepared to bring to the educational
process must not be wasted. The constructive program must
provide enough structure so that the learning that results is
satisfactory to the learner and the teacher, yet steers clear of
being compulsively methodical or rigid. It relies on the seren-
dipity produced by the right combination of personalities and
circumstances to a degree that makes it difficult to evaluate.
Like an icicle held in the bare hand, it defies our holding it
quite long enough to know what distinguishes it from other
objects of its class, but we certainly know what it is while we
are holding it.

It is both discouraging and encouraging to acknowledge the
extent to which *persons* are responsible for a program's suc-
cess or failure. The response and the reaction of people to the
goals of a program will determine to a large extent its success
or failure. At the Taft school this fact shows up with the
happiest of results. An observer of the program described the
library media specialist as being "knowledgeable, enthusias-
tic, innovative, and professional in her approach." The fact
that an excellent library media program, known for its ability
to foster a good self concept in *every* child in the school, is at
the heart of the gifted and talented program gives it strength
and wide acceptance and enthusiastic support throughout the

school. Everybody in that school is aware that the library media center strives to "respect and enhance the uniqueness of each child . . . reinforcing (for all children) their sense of worth and strengthening their ability to function in their own best interest." It seems natural that this be done with gifted and talented learners just as it is with everyone else.

The gifted and talented program began because of the principal's concern that the gifted and talented children in his school be challenged beyond the demands of their regular curriculum. The initial approach was simple, and, of prime importance, nonthreatening to teachers. Fourth- and fifth-grade teachers were asked to identify students who had shown signs of heightened intelligence, creativity, interest, and achievement. Involving teachers early and respecting their opinions gave the program built-in credibility from the start. The first ten students selected for the program (from a total school population of 320) spent only half a day a week away from their regular classrooms. There are now sixteen enrolled. Students were given a choice as to whether they wished to participate or not, but once having made the commitment they were expected to stick with it. A useful method for preventing inflated egos is the requirement that participants share their experiences with their classmates so that they too may benefit from the enrichment activities the program offers.

The program itself is a marvel of simplicity and effectiveness. Divided into five-week sequences, its areas of concentration have been science, math, communications/language arts, political science, and philosophy. Students have been able to concentrate in one area long enough to see a high interest topic through, and then move on to another area of interest. The objectives of the program remain constant whatever the area of concentration:

(1) Developing critical thinking and decision making skills;
(2) fostering creativity;
(3) learning advanced research methods;
(4) improving writing skills;
(5) producing instructional media; and
(6) involving resource persons from the community.

A high level of expectation is maintained, stimulating learners to produce at their maximum capability without the high intensity concentration on excelling that mars many programs of this kind.

Such phrases as networking, resource sharing, and community school take on clearer meaning when seen at this school. In the math program, guided by a fifth-grade teacher and a district coordinator, the focus is on computer programming. Individual computer programs were devised, and a visit to the Baldwin-Wallace College Computer Center allowed students the opportunity to run their programs through the computer and see the printout of the results. The principal, who was formerly a teacher of science, guided that program which was structured upon the eternal scientific triangle of hypothesis, proof, and conclusions. Access to the chemistry lab at Lakewood High School, and a big brother or sister relationship with students there, gave dimension to that program. The resources of the NASA Lewis Space Research Center provided another actively creative facet to the program.

The political science segment was a study of city government which actively involved the mayor, the city council president and a member of the Board of Education.

The library media specialist and the language arts coordinator team taught the communications portion of the program. The culminating activity was a slide-tape presentation. These presentations were excellent examples of skills applied to, and through, the use of media, not mere fun and games media exercises. Organization of content, research techniques, rewriting, proof reading, extended word fluency, and photographic skills were interrelated with sustained effort and final achievement. A wide range of interests was encouraged, as evidenced by topics as diverse as "Angel Fish," "Solar Energy," and "Jim Brown." Every aspect of this gifted and talented program is influenced by the excellence of the library media program. The director of the program meets weekly with every teacher involved in the gifted program to discuss activities, schedules, and materials that will be needed.

Also under the direction of the library media specialist is an enrichment program aimed at students who are not in the gifted and talented program. This gives other children who

want to undertake it special opportunity to research, direct, and create their own productions. Fifth graders, for example, produced a video tape on "Pioneer Life: Clothing, Chores, Games and Craft"; fourth graders produced a slide tape presentation on the history of money. Relating research technique to production skills is a central concern of any learning activity which is incorporated into the library media program.

One reliable measure of success is that others decide to emulate your work and adapt it to fit their needs. The curriculum advisory council of the Lakewood schools, in direct recognition of the excellent results achieved by this Taft School program, recommended that "Increased programming opportunities should be provided for gifted and talented students . . . and that, further, the library media center should be the organizational and program base for accommodating the academically gifted student." Now that's success, to be recognized within one's own district and to have that recognition translated into formal policy commitment. More than that, Taft School's excellent library media center based gifted and talented program is success for library media centers, and a model for schools, nationwide.

Exemplary Program Elements
1. Developing a gifted and talented program which provides special learning programs for these learners but incorporates their activities into the regular school program.
2. Skillfully combining school, community, and other resources to provide an enriched learning program for gifted learners.
3. The intense involvement of the library media specialist in planning and implementing a gifted and talented program.
4. Establishing clear program goals and objectives to achieve these goals that provide excellent learning structure while maximizing individual creativity for the gifted learner.
5. The degree of teaching excellence exhibited by the library media specialist in all instructional programs.

SPACE
(Students Participating in an
Active and Creative Environment)
Richland School District
Columbia, South Carolina

You may have noticed, as we did, the preoccupation of
many gifted and talented programs with a name that forms a
catchy acronym with a meaning related to the intent of the
program. SPACE is obviously such a one. A mid-seventies
publication of the American Association of School Librarians
(AASL), called *What's in a Name?* was intended mainly to
reassure doubters that whether we called ourselves li-
brarians or media specialists, our growing professional re-
sponsibilities would be much the same. By the same token, an
acronym is only as good as the idea behind it and the SPACE
program we visited has more than enough excellence and
credibility to survive the acronym game with dignity. We
wonder—to pursue the name phenomenon a few sentences
further—if the tendency to obscure the existence of these
gifted and talented programs behind a sometimes fanciful
acronym is not indicative of the desire of many school sys-
tems to hide them out of sight. We have noticed that many
school districts display an almost furtive attitude about them,
and we can only assume that this is because the very exis-
tence of gifted and talented students in a school—let alone a
special program designed to enhance their special aptitudes—
can spell trouble of many various kinds. Contrary to what
would seem to be a logical reaction—a school bursting with
pride over its gifted and talented students and the program it
provides to develop them—many schools still practice, albeit
unconsciously, the traditional response: to extinguish, or at
least modify or ignore, the learner who burns too brightly. He
must be socialized; he will be happier among his peers if he
learns to conform to the mode of the average, "well-adjusted"
child.

Gifted and talented learners are often troublesome. Imag-

inative and bored, they can create behavioral pandemonium in a classroom. They are the posers of difficult, sometimes unanswerable, questions. They make some teachers nervous with their insistence on answers and their intensity of inter-est—often in things the teacher knows little about. If the gifted and talented children themselves are trouble, their parents are often worse, nagging for increased services and programs for what is, admittedly, a small minority of the population in any school. Like any minority, this one tends to irritate and upset the majority which usually likes the status quo just fine and doesn't want to be disturbed on its perch. Add to this the cries of "elitism" that any small efforts to meet the needs of gifted and talented children bring forth from the school's community, and it is plain to see why programs for the gifted and talented are anathema to many school admin-istrators and teachers and boards of education, and why many prefer to file and forget them under an acronym. There is a happy medium between too visible and invisible, but, nevertheless, low-keyed programs seem to have the greatest chance of success on all counts.

The SPACE program, which is only one component of a gifted and talented program spanning grades four through twelve, has pizzazz aplenty, but without arrogance. The SPACE portion of the gifted and talented program continuum is that part available to grades nine and ten. The district's decision to make gifted and talented programs a full sequence of advanced options, available at different grade levels, has an important bearing on its success and its acceptance. For example, gifted students in grades ten through twelve focus through seminar and independent study programs on re-search topics of special interest to them, while sharpening research and study skills in the process. Then there is an Exterior Intern Program which allows selected students to spend a semester working within fields such as government, cultural agencies, foundations, or business. These are part of a national network plan to help satisfy the desire of highly motivated students to become involved in management or in services to the community.

Within this context, how about the SPACE program compo-

nent itself and its relationship to the library media program? SPACE is organized instructionally in a mini-course approach to teaching. Each mini-course has a unifying theme to "encourage the development of critical thinking, creativity, research skills and better human relationships." Within such a commitment nearly anything is possible and, subject to the availability of resource personnel, course offerings have included archeology, oceanography, law, creative writing, parapsychology, media production, and many more. The availability of resource personnel means, of course, someone to teach the course, not necessarily someone who is already a teacher in the system. This is something to be kept constantly in mind about gifted and talented programs: that it is not possible to mount a creditable program of this kind without using resources—people as well as materials—found outside of the school, or even the school system. The range and often the depth of the gifted and talented learner's interest are too great, and his expectation of satisfaction generally too high to be satisfied within one school building or district, even one with rich resources.

The first step in putting together any successful gifted and talented program is to survey and assess the total resources available (people and materials) and to plan how these can be coordinated into the program. The idea is to look not just at what is readily at hand but at what is needed, and go from there. The field trip, so often a pointless time killer or end-of-year-reward (or worse, tradition-without-a-cause), becomes a lively, intellectually vibrant teaching laboratory for the students in the SPACE program. Laboratory teaching-learning sites have included Boston, to study "a culture of a large metropolitan area which skillfully combines the old with the new," and Washington, D. C., for a first-hand exploration of different aspects of the federal government. SPACE students have participated in laboratory teaching at its best. There have been seminar programs held at the Parapsychology Institute in Durham, North Carolina, and the Bell Baruch Marine Biology Institute at Georgetown, South Carolina. Such experiences, structured, but with plenty of leeway for individual learning paces and styles, extend the horizons of

the gifted and talented learner and give him still more to wonder and think about. They provide the stimulation of travel and seeing new things, and buttress this with the discipline of scholarship and the expectation of intellectual achievement.

Yet, with all its rich variety of inputs, the SPACE program's media component consistently draws the highest level of participation by these students, and is rated a stand-out success by them and by their teachers. A description of the media mini-course component, prepared for a presentation to an Association for the Educational Communications and Technology (AECT) South Carolina meeting avers that,

> "Because effective media production depends upon the student's ability both as artist and technician, there is an outstanding opportunity for excellence to develop in a variety of ways. . . . The learner must be creative as well as exacting, learning to plan ahead and organize well. . . . But learners must develop, too, aesthetic sensitivity, an ability to be flexible, to take advantage of unusual opportunities, and begin to see the world around them imaginatively . . . (at the same time) they must recognize their limitations, and the technical limitations of equipment.

That about says it all; these statements, we believe, almost provide a framework of scope and sequence for gifted learners to follow, react to, and learn from, while associating critical learning skills, attitudes, and values with a media course. This linkage signifies something of the greatest importance for gifted and talented learners, for their teachers, and for the media program.

Course offerings providing exceptionally well for the media relationship to these important human and technical aspects are photography, film-making (one section focussing on animation, the other on live action documentaries); and multi-media production. The photography course offers work with the 35-mm SLR camera, and relates the techniques of photography to a broader concern with visual literacy and photography as communication and art form. Composition skills

are emphasized, as well as the use of light and other effects to achieve sensitive forms of expression. But discipline is always present, as is preciseness of techniques, including darkroom and printing, to see the creative process through to production. In the animated film-making course, students end up making a film, but a great deal of preparation for this includes study of the history of film-making, the techniques of film criticism, a special effects and sounds workshop, and the critiquing of professional and student-made films. The second film-making course in live-action films involves students in comedy, drama, or the documentary. Both courses use a super 8-mm format. A third media program component of Space, a media production course, combines equipment and technique to produce slide-sound shows. Special visual or audio effects, composition, graphic representation, design, and script writing are separate activities, but represent closely associated disciplines which must be interwoven for a quality product. Having fun learning need not mean "fun and games."

The SPACE program substantiates the fact that while gifted and talented children must have programs that help them establish their particular gifts, neither the gifts nor the programs need separate them from their classmates. It is evident that the close and cooperative relationship between the SPACE program instructors and the library media program have had a measurably beneficial effect in helping to mainstream this gifted and talented program successfully into the total school environment.

Exemplary Program Elements
1. The use of filmmaking and other media production courses to reinforce writing, viewing, and listening skills.
2. Relating media production courses to specific learning outcomes and objectives.

3. Relating goals for the gifted and talented program to traditional learning goals.
4. The involvement of the library media specialist in planning and presenting media courses within the gifted and talented program.
5. The use of outside resources and field visits to enrich program offerings.

Appendix I.

Associations and Organizations Providing Services and Information for Special Learners

The following list is intended to serve only as a beginning. Owing to the vast number of organizations and groups concerned about the special learner, we were forced to be selective, thus having to exclude many important sources of information. For greater detail, consult the *Directory of National Information Sources on Handicapping Conditions and Related Services* which is a comprehensive source of organizations and associations providing information about all handicapping conditions. It is available from the Clearinghouse on the Handicapped, Office for Handicapped Individuals, Department of Health, Education, and Welfare; Washington, D.C. 20201.

Accent on Information, Gillum Road and High Drive P.O. Box 700 Bloomington, IL 61701

The Alexander Graham Bell Association for the Deaf, Inc., 3417 Volta Place, N.W. Washington, DC 20007

American Academy for Cerebral Palsy, 1255 New Hampshire Avenue, N.W. Washington, DC 20036

American Academy on Mental Retardation, 916 64th Avenue East, Tacoma, WA 98424

American Alliance for Health, Physical Education & Recreation Physical Education & Recreation for the Handicapped: Information & Research Utilization Center, 1201 16th Street, N.W. Washington, DC 20036

American Association for the Education of the Severely/ Profoundly Handicapped, 1600 West Armory Way Seattle, WA 98119

American Association for Gifted Children, 15 Gramercy Park, New York, N.Y. 10003

American Association of Special Educators, 107-20 125th Street Richmond Hill, NY 11419

American Association on Mental Deficiency, 5101 Wisconsin Avenue, N.W. Washington, DC 20016

American Council of the Blind, 1211 Connecticut Avenue, N.W Suite 506 Washington, DC 20036

American Foundation for the Blind, Inc., 15 West 16th Street New York, NY 10011

American Occupational Therapy Association, 6000 Executive Boulevard Rockville, MD 20852

American Printing House for the Blind, 1839 Frankfort Avenue Louisville, KY 40206

American Speech & Hearing Association, 10801 Rockville Pike Rockville, MD 20852

Association for Children with Learning Disabilities, 5225 Grace Street Pittsburgh, PA 15236

Association for the Education of the Visually Handicapped, 919 Walnut Street 4th Floor Philadelphia, PA 19107

Office of Special Education U.S. Department of Education Donohoe Building, 400 6th Street, S.W. Washington, DC 20024

Center for Innovation in Teaching the Handicapped University of Indiana, 2805 East 10th Street Bloomington, IN 47401

Closer Look Information Center (National Information Center for the Handicapped) 1201 16th St. N.W., Washington, DC 20013

Council for Exceptional Children (ERIC Clearinghouse on Handicapped and Gifted Children), 1920 Association Drive Reston, VA 22091

Deafness Research Foundation, 366 Madison Avenue New York, NY 10017

Epilepsy Foundation of America, 1828 L Street, N.W. Suite 406 Washington, DC 20036

Federation of the Handicapped, Inc., 211 West 14th Street New York, NY 10011

Foundation for Child Development, 345 East 46th Street New York, NY 10017

Gifted Child Society, 59 Glen Gray Road, Oakland, NJ 07436

Handicapped Learner Materials Distribution Center, Indiana University Audio-Visual Center Bloomington, IN 47405

Helen Keller National Center for Deaf-Blind Youths and Adults, 111 Middle Neck Road Sands Point, NY 11050

Joseph P. Kennedy, Jr. Foundation, 1701 K Street, N.W. Suite 205 Washington, DC 20006

Junior National Association of the Deaf, Gallaudet College Washington, DC 20002

Library of Congress National Library Service for the Blind and Physically Handicapped, Taylor Street Annex 1291 Taylor Street, N.W. Washington, DC 20542

Mental Health Materials Center, 419 Park Avenue South, New York, NY 10016

Muscular Dystrophy Association, Inc., 810 7th Avenue New York, NY 10019

National Association for Gifted Children, 217 Gregory Drive Hot Springs, AR 71901

National Association for Mental Health, Inc., 1800 North Kent Street Arlington, VA 22209

National Association for Visually Handicapped, 3201 Balboa Street San Francisco, CA 94121

National Association of Coordinators of State Programs for the Mentally Retarded, Inc., 2001 Jefferson Davis Highway Suite 1010 Arlington, VA 22202

National Association of State Directors of Special Education, 1201 16th Street, N.W. Washington, DC 20036

National Association of Hearing & Speech Agencies, 814 Thayer Avenue Silver Springs, MD 20910

National Association of Private Schools for Exceptional Children, 130 East Orange Avenue, Lake Wales, FL 33853

National Association of the Deaf, 814 Thayer Avenue Silver Spring, MD 20910

National Association of the Physically Handicapped, 6473 Grandville Avenue Detroit, MI 48228

National Center for a Barrier Free Environment, 8401 Connecticut Avenue, #402 Washington, DC 20015

National Center for Law and the Handicapped, 1235 North Eddy Street South Bend, IN 46617

National Center on Educational Media & Materials for the Handicapped, The Ohio State University, 356 Arps Hall 1945 North High Street Columbus, OH 43210

National Clearinghouse for Mental Health Information National Institute of Mental Health Public Health Service, Department of Health, Education & Welfare Rockwall Room 505 5600 Fishers Lane Rockville, MD 20852

National Easter Seal Society for Crippled Children and Adults, Inc., 2023 West Ogden Avenue Chicago, IL 60612

National Epilepsy League, 6 North Michigan Avenue Chicago, IL 60693

National Foundation/March of Dimes, 1275 Mamaroneck Avenue White Plains, NY 10605

National Information Center for Special Education Materials (NICSEM), University of Southern California University, Park 2nd Floor Los Angeles, CA 90007

National Multiple Sclerosis Society, 205 East 42nd Street New York, NY 10017

National Public Radio Print Handicapped Services, 2025 M Street, N.W. Washington, DC 20036

National Society for the Prevention of Blindness, Inc., 79 Madison Avenue New York, NY 10016

National Therapeutic Recreation Society, National Recreation & Park Association, 1601 North Kent Street Arlington, VA 22209

Orton Society, 8415 Bellona Lane Towson, MD 21204

Research to Prevent Blindness, 598 Madison Avenue New York, NY 10022

Sex Information & Education Council of the U.S. (SIECUS), 137-155 North Franklin Street Hempstead, NY 11550

United Cerebral Palsy Associations, Inc., 66 East 34th Street New York, NY 10016

Appendix II.

Selected Special Education/Learning Disabilities Programs

The following are educational programs which may be adapted and/or replicated. While time may alter situations and bring personnel changes, the programs as described here are representative of exemplary educational programs for special learners.

This information is taken from *Educational Programs That Work*, a resource of exemplary educational programs developed by local school systems and approved by the Joint Dissemination Review Panel in the Education Division of the former Department of Health, Education, and Welfare. The descriptive information was compiled by the Far West Laboratory for Educational Research and Development in San Francisco, California.

Should you desire additional information about any of the programs, contact either the person listed or your State Facilitator at your State Department of Education.

PROJECT:　　**ACTIVE (All Children Totally InVolved Exercising)**

TARGET AUDIENCE

Handicapped students and students of all abilities, pre-K through 12—a comprehensive individualized physical education program; and physical educators, special educators, recreation teachers, teacher aides, parents, and others working with the handicapped—a teacher-training program.

DESCRIPTION

A diagnostic/prescriptive physical education program that provides teachers with the skills, strategies, and attitudes necessary to initiate a physical-activity program for handicapped individuals.

. . . developed to serve handicapped individuals, but is equally applicable to slow learners and normal and gifted children. ACTIVE offers: (1) a training program to provide teachers with those skills/strategies necessary to implement an adapted physical education program; (2) diagnostic/prescriptive curriculum manuals and materials addressed to the entire gamut of handicapped conditions; and (3) consultant

services to assist implementers during the installation phase. Program strengths include: (1) extreme flexibility for adoption/adaptation; (2) a total curriculum package that can be implemented immediately at minimal cost; (3) compliance with the federal mandate requiring "written education programs for the handicapped population;" (4) the provision of unlimited support services (at no cost) to enhance successful implementation; and (5) accountability features to enhance administrator/community support. Student instruction is based on instruction format (i.e., the program is structured to ensure that the trainees acquire the skills, knowledges, and attitudes stressed), with emphasis on trainee exposure to handicapped individuals in a field setting. Participants are trained to diagnose and assess pupil strengths and deficiencies, and to prescribe motor, perceptual-motor, physical fitness, posture, nutrition, and diaphragmatic breathing tasks accordingly.

CONTACT

Thomas M. Vodola, Director, Project ACTIVE, Township of Ocean School District, Ocean Township Elementary School, Dow Avenue; Oakhurst, NJ 07755.

PROJECT: **CHILD STUDY CENTER (CSC) (A Validated Pupil Personnel Services Demonstration Project)**

TARGET AUDIENCE

Children from kindergarten through middle school who exhibit multiple symptoms associated with learning and/or social behavior problems.

DESCRIPTION

A pupil services delivery system to assist children with learning problems to achieve gains in intellectual performance, basic skill acquisition, and personal/social functioning.

Because of the multi-causation factor present for many children with learning problems, the CSC concept was developed on the premise that the solution to such problems lies

in an interdisciplinary team approach which focuses on the whole child in a single referral setting. These troubled children need to receive comprehensive, in-depth diagnostic and remedial services so that they can become more effective and efficient learners. CSC embraces the disciplines of education, psychology, social work, and speech pathology with consultation from medical and other community professions. The purpose is to provide the diagnostic, prescriptive, and consultative intervention necessary for these children to experience success. The diagnostic study encompasses intellectual, physical, social, familial, emotional, and communication factors affecting learning. The key ingredients for implementing this program are the exchange of information and the active cooperation among Center, school, home, and community resources.

Major activities of the Center include conducting an in-depth study of each child and developing composite diagnoses and prescriptions for remediation. The interdisciplinary Child Study Team has served as a model for staffing teams who develop Individualized Education Programs (IEPs) for students with special needs.

CONTACT

Ralph E. Bailey, Director, Pupil Personnel Services demonstration Project, All Children's Hospital, 801 6th Street South; St. Petersburg, FL 33701.

PROJECT: **DIVERSIFIED EDUCATIONAL EXPERIENCES PROGRAM (DEEP)**

TARGET AUDIENCE

Grades 7-12. The original target group included the apathetic learner, the "discipline problem," the poor attender, and the potential dropout. The model also works well with the gifted, the talented, and the creative learner. In fact, most students function well in the DEEP management system.

DESCRIPTION

A new method of organizing and managing an academic classroom.

The major goal . . . is to develop an instructional process for secondary school classrooms that allows an instructor to create an academic environment emphasizing success for every learner while decreasing learner hostility to institutions.

DEEP offers students and instructors a method of organizing and managing an academic classroom that differs from the usual classroom model. Students in the DEEP classroom identify needs, formulate objectives, develop tasks based upon these objectives, present group and individual projects based upon fulfillment of objectives, receive teacher debriefing following presentation of the projects, and participate in their own evaluations. DEEP offers learners in academic subjects alternative ways to create, gather, develop, and display information. Extensive use is made of electronic and nonelectronic media. The role of the teacher is that of advisor, consultant, and learning systems manager. The classroom environment is casual, open, trusting, and task-oriented. A workshop atmosphere exists. Community resources are utilized.

The DEEP classroom is highly structured, but the structure is not the same as in the typical academic classroom. Teachers who demonstrate the ability and desire to change their methods of instruction are trained in the use of these new management techniques. They must be willing to teach one or more DEEP classes along with their regular classes. The teachers are trained as learning facilitators, and the conflict-management process is based on human relations and peer-group interaction as well as teacher-student interaction. Once the training has been accomplished, students can be enrolled in the program as part of the normal scheduling procedure. The project provides management charts and materials along with evaluation procedures.

CONTACT

Jane Connett, Director, Project DEEP, Wichita Public Schools, 640 N. Emporia, Wichita, KS 67214.

PROJECT: **ENGINEERED CLASSROOM FOR STUDENTS WHO ARE BOTH EDUCABLY MENTALLY HANDICAPPED AND BEHAVIORALLY MALADJUSTED**

TARGET AUDIENCE

Mildly handicapped students, grades 1-6. Primary target group: educably mentally handicapped, learning-disabled, emotionally disturbed. (Centers are being established at secondary level with same basic design.)

DESCRIPTION

A diagnostic teaching program that provides individualized instruction and engineering of time and behavior for handicapped students.

The Learning Center instructor, through daily prescriptions or lesson plans, provides each student with a highly structured program in the cognitive and affective domain. Behavioral management skills are emphasized as well as academic growth. The design of the program requires a basic commitment to a least-restrictive alternative program for handicapped students. The design provides direct service to both student and teacher; it is flexible and adaptable, enabling a staffing team to plan a program to meet each student's educational needs.

Project results demonstrate marked improvement, and teacher, student, and parent attitudes are positive. As a result of the project, the degree of integration of the special education students into the regular classroom is so high that it is difficult to tell the handicapped from the non-special education students.

One of the concepts that make the program unique is the degree of input the regular classroom teacher has in the program. The teacher is involved in every phase of referral and staffing. This teacher will remain as the youngster's homeroom teacher, even though the youngster will spend time in the Learning Center. For each child in the program there is a two-way responsibility; Learning Center teachers and regular classroom teachers must communicate. Regular teachers are responsible for meeting each student's educational needs,

and if the student is staffed in the Learning Center, this teacher has a responsibility to monitor the student's total program. Parental communication is mandated by at least four home contacts during the year. Due to their role in the program, the regular classroom teachers have become more knowledgeable about handicapping characteristics and more competent in working with handicapped students.

CONTACT

Robert H. Ostdiek, Federal Programs Coordinator, Papillion-LaVista Public Schools, 420 S. Washington Street, Papillion, NB 68046.

PROJECT: EXPERIENCE-BASED CAREER EDUCATION (EBCE) FAR WEST LABORATORY (FWL)

TARGET AUDIENCE

Designed for a cross-section of high school students; adaptable to special target groups, e.g., "gifted" students, potential dropouts, adults, college students.

DESCRIPTION

An alternative program of secondary education that uses the entire community as a school.

Through direct experience in a wide variety of real-life settings, EBCE helps students to acquire the skills and knowledge necessary for them to choose, enter, advance in, and find satisfaction in adult roles. Individually planned learning programs utilize large and small businesses, governmental agencies, community organizations, and individual professionals and entrepreneurs. Learning is accomplished through individualized projects that blend growth in academic subjects, career awareness, and basic and interpersonal skills. While learning programs are planned and monitored with the assistance of EBCE staff located at a school center, students spend much of their time in the community, working with volunteer resource persons and organizations. Seminars and other group sessions support and expand upon students' experiences and assure them broad exposure to major fields of study

and work. *Project Planning Packages* (in Commerce, Communications and Media, Life Science, Physical Science, and Social Science) contain goals and guidelines for planning individualized projects in career/subject fields, as well as criteria for assigning credit.

Community experience enables students to discover the utility of basic skills and to expand their skills through practice in real-life settings. Students with skills deficiencies, as well as those desiring advanced study, use individualized materials (assisted by tutors); or they may enroll in regular high school or community college courses. Learning coordinators work with 25-30 students each, helping them to develop long-range goals, shorter-range objectives, and project plans. They also monitor progress, provide feedback, and help evaluate performance. A resource analyst develops and maintains the external resources; a skills specialist diagnoses student needs (e.g., in reading skills) and coordinates supplementary learning activities (such as tutorials or workshops in basic skills). Program emphasis is on helping students to acquire skills needed for lifelong learning. Using an inquiry process, students design their own projects under staff supervision. Program handbooks and materials offer guidelines within which students and staff make decisions, and tools for documenting student plans and progress.

CONTACT

Karen Chatham, Director, EBCE Developer/Demonstrator Project, Far West Laboratory for Educational Research and Development, 1855 Folsom Street, San Francisco, CA 94103.

PROJECT: THE FAIL SAVE CONTINUUM OF SERVICES FOR LEARNING DISABLED STUDENTS

TARGET AUDIENCE

Originally validated for students with specific learning disabilities, grades 1-8, but may be adapted for children having other handicapping conditions. The model has been successfully field tested in both rural and urban areas of New Mexico.

DESCRIPTION

A continuum of special education services for learning-disabled students.

The program is designed to provide a model educational program for children with specific learning disabilities. The "Fail" refers to a district's failure to appropriately meet the needs of these students. The "Save" represents the adaptation of the educational setting to meet the students' individual needs.

There are five phases in the Fail Save Continuum, only two of which (for the mildly and moderately handicapped) have been operationalized in New Mexico's Child Demonstration Centers. Since the main objective of the program is to emphasize the educational strategies that will allow the child to function adequately in (or as near as possible to) the regular classroom situation, only the first two phases have been implemented to demonstrate that an identified learning-disabled child can effectively function in the least restrictive educational setting.

Measurement of student progress in the basic academic skill areas is an integral part of every phase of the model. At any time, in any phase, a decision can be made to move the child along the continuum toward the goal of full-time regular class programming without special intervention. However, before a child can be moved to a more intensive program phase or re-cycled in the same phase, he or she must remain in that phase for a pre-determined period of time.

CONTACT

Daphne Rowden, Albuquerque Public Schools, North Area Office, 120 Woodland N.W., Albuquerque, NM 87107.

PROJECT: FAST (Functional Analysis Systems Training)

TARGET AUDIENCE

Students of all abilities, grades K-6, with emphasis on prescriptive programming for students with learning problems in regular classrooms.

DESCRIPTION

A developmental diagnostic/prescriptive teaching system for mainstreaming handicapped students.

... a comprehensive delivery system that uses the combined energies of teachers, parents, consultants, and school administration to target in on the child's developmental and learning processes. Teacher development, support personnel, parent involvement, classroom organization, utilization of learning materials, and sequencing of instructional modules all converge on the same objective: to accommodate most pupils as they progress toward optimal functioning in the regular classroom in an ongoing diagnostic, prescriptive, and evaluative process.

Teachers are trained in the nine teaching tools: (1) Classroom Organization, (2) Behavior Management, (3) Classroom Observation, (4) Deciphering Developmental Levels, (5) Prescribing Educational Programs, (6) Task Analysis, (7) Support Assistance, (8) Sharing Educational Strategies, (9) Teamwork With Parents.

Project FAST provides an efficient delivery of support services to the mainstream teacher to assist teachers in diagnosing problems and implementing educational prescriptions to meet the needs of students.

Parents are involved in the implementation of educational prescriptions and in making games and materials for the classroom teacher.

CONTACT

Sonja K. Tweedie, Dissemination or Herbert H. Escott, Project Director, Essexville-Hamptom Public Schools, 303 Pine Street, Essexville, MI 48732.

PROJECT: **LEARNCYCLE Responsive Teaching**

TARGET AUDIENCE

Teachers of K-9 special education or mainstreamed students. Teacher trainers or consultants.

DESCRIPTION

An intensive teacher training program developing flexible, effective skills for managing and teaching mainstreamed or "high risk" students.

The program includes two levels of training.

(1) *Responsive Teaching for Mainstreaming and Accountability:* "Responsive Teaching" comprises a variety of reinforcement-based teaching techniques including precision teaching, contingency management, and token economies. Through lecture, demonstration, roleplaying, data collection, and task groups, participants learn to generate their own unique behavioral programs. The course also shows teachers how to monitor, evaluate, and revise their programs in accordance with changing student needs and in line with recent accountability mandates. Short pre- and posttests let participants assess their mastery of the teaching skills. Classroom applications can include any of the following: a change in schedule of activities (to motivate difficult tasks by following them with more enjoyable ones); a re-direction of teacher attention; use of readily available reinforcers (recess, privileges, special activities) in simple token exchange systems; precise systems of monitoring and reinforcing students' behavioral change with tokens and concrete reinforcers. What implementation is chosen depends on the students' needs and teacher preference. A unique feature is training of teachers in proven ways to enlist a whole class's support for program success with one or two "high risk" students. Further, teachers are trained in an overall *problem-solving method* that allows them to continuously adapt the program to new situations.

(2) *Training to Train:* Districts that would like an ongoing training capacity can have graduate(s) of the above course trained to train others. They learn how to tailor courses to the individual needs of their trainees, as well as how to deal with system-wide implications of program implementation.

CONTACT

Hilde Weisert, Project Instructional Director, EIC-NW, c/o Vernon High School, Vernon, NJ 07462.

PROJECT: **MODIFICATION OF CHILDREN'S ORAL LANGUAGE**

TARGET AUDIENCE

Language-handicapped students, preschool to adult.

DESCRIPTION

A special program for training staff to work with students having language disabilities.

This project is based on materials and instructional methods of the Monterey Language Program. These language-teaching programs combine modern linguistic theory with advanced behavioral technology applied to teaching. The programs are universal: designed for any individual with a language problem, regardless of the reason for that language-learning disability. The curriculum and individual program design include a screening procedure, individual placement, automatic branching, and continuous data collection for evaluation. With the Monterey Language Program, it is possible to obtain accurate pre- and posttest measures of a student's progress in syntactical and overall expression. The program also helps language-deficient children acquire language skills in a short period of time. It is completely individualized and performance-based instruction. In addition to providing teachers with materials, an objective of the project is to provide teachers with an instructional strategy, and to assist them in becoming proficient in techniques for using the materials. Implementation of the program includes training, on-site supervision, refresher conferences, and data monitoring. Language remediation services may be expanded without increasing staff by using aides, parents, or other volunteers.

The language program is effective with children and adults defined as language-delayed, hard-of-hearing, mentally retarded, or physically handicapped, and with the non-English-speaking or English-as-second-language individual. It is particularly valuable in early childhood education centers, classes for the educable and trainable mentally retarded, and speech-correction centers.

CONTACT

Betty H. Igel, Monterey Learning Systems, 900 Welch Road, Palo Alto, CA 94304.

PROJECT: NORTHWEST SPECIAL EDUCATION (NWSE)

TARGET AUDIENCE

Originally validated as a 1-8 program for students with specific learning disabilities (SLD), this project now operates for K-9. Program implemented by all classroom teachers with specialized support from learning disability personnel using the project training kit.

DESCRIPTION

A systematic way of training classroom teachers to focus on specific learning disability (SLD) students.

. . . designed to offer classroom teachers a way to focus on individual students who have specific learning disabilities. Teachers are provided with new ways of observing children, interacting with students, parents, specialists, and each other. This project is effective for use as inservice for classroom teachers in efforts toward compliance with the "Bill of Rights for the Handicapped," PL 94-142. The central emphasis of the experience is on team planning in order to develop individualized educational programs. Specialized specific learning disabilities personnel are required to serve as team coordinators and in consultative and resource capacities for this special service. Regular staffings and monitoring of the teacher during the initiation of this clinical teaching approach is crucial for student and teacher growth.

Project NWSE provides a framework that describes a process for personalizing instruction. The critical elements of the process are assessment, programming, and evaluation. The skills learned by the teacher are informal individualized testing, observation, planning objectives, developing curriculum, reporting, evaluating, and teaming. A training kit is available that provides the manual and forms needed for implementing the NWSE process.

Adoption of the NWSE project becomes a "course in a child" as the teacher approaches the child in a systematic way in order to determine how to teach him or her effectively. The requirement of specificity in planning, reporting, and evaluating enables the teacher to be trained while providing services to the student. The teaching effort culminates in the

development of a unique instructional material and method which is named for the student. An SLD student's success or failure in school is a function of the interaction between the student's strengths, weaknesses, and limitations, and the specific classroom situational factors the student encounters. The project format enables the learning specialist to help the teacher to begin developing the ability to conceptualize a child's problem.

CONTACT

Joan Bonsness, Project Director, Northwest Special Education, Box 585, Lignite, ND 58752.

PROJECT: OKLAHOMA CHILD SERVICE DEMONSTRATION CENTER FOR SECONDARY LD STUDENTS

TARGET AUDIENCE

Learning-disabled students, secondary school, grades 7-12.

DESCRIPTION

An individualized diagnostic/prescriptive teaching intervention system that has proved highly successful with learning-disabled adolescents.

The major goal of this project is to provide each identified learning-disabled student of secondary school age within the target population with a specific prescriptive learning program that will enable that student to develop skills and knowledge at a rate commensurate with his/her ability level. The model is basically a diagnostic/prescriptive intervention system. Components include: (1) a professional-staffed learning lab; (2) a prescriptive diagnostician who has particular ability in developing educational intervention programs for individual students; and (3) a media library for use by the learning disabilities teacher to implement intervention strategies.

Students placed are those who, in a psychoeducational evaluation, were noted to have a specific learning disability of a perceptual, conceptual, or integrative nature.

The curriculum provided within this diagnostic/prescriptive project follows, where possible, the curriculum offered in the regular classroom. A student with a reading disability might spend two periods daily in the learning lab during English and social studies periods. Another student with a math disability might spend only one period each day in the learning lab during regular math class time. At other times, LD students are integrated into the regular curriculum. This arrangement, the least restrictive alternative, does not necessitate that curriculum content be similar in the regular and learning lab classrooms. The content for the learning lab is determined by a prescription from the prescriptive teacher aimed at helping the student either remediate or compensate for his/her learning disability.

CONTACT

Jim D. Mason, Developer/Demonstrator Director, Oklahoma Child Service Demonstration Center, Hillside School, Route 3, Cushing, OK 74023.

PROJECT: **PA PROJECT ADVOCATE—Northwestern Illinois Association**

TARGET AUDIENCE

Students from preschool to tenth grade (ages 4-16) with severe emotional or behavioral disorders.

DESCRIPTION

A consistent, data-based, intensive learning environment for students.

. . . a short-term (three- to four-semester), self-contained, regional special education program for severely behavior-disordered students. Referrals prevent extrusion into hospitals or residential facilities. Students are referred because they: are non-compliant, swear, talk back, pester, disrupt classroom environment, destroy property, steal, or are physically abusive. Most have difficulty with authority figures and have "control" issues; however, they are not hard-core delinquents, psychotic, or autistic. The student body is multiracial.

340 LIBRARY MEDIA PROGRAMS

Through structure and the reinforcement of positive inter-actions, students are assisted in making adaptive decisions. PA uses positive reinforcement and a token economy. Students are on a behavioral-level system. Each level has more privileges. Quiet-training procedures are utilized for disruptive behavior: chair in corner, mat, or time-out room.

The four major aspects of the program are: (1) academics; (2) social behaviors; (3) affective curriculum: decision making, values, relaxation training via group process; and (4) parent groups (teaching child-management skills) and family therapy. Behavioral objectives are reviewed three times per year and revised as necessary. The techniques and procedures are derived from experimental analysis of behavior, broad spectrum behavior therapy, and humanistic education.

PA support staff integrate students into LEA programs in the home community and provide follow-up consultation.

CONTACT

Mark L. Becker, Project Advocate, 210 South Sixth Street, Geneva, IL 60134.

PROJECT: **PEECH (Precise Early Education for Children with Handicaps)**

TARGET AUDIENCE

Handicapped children ages 3-6 and their families.

DESCRIPTION

An individualized educational program designed to enhance the development of pre-school handicapped children while involving family members in the educational process.

... serves handicapped children 3-6 years of age, functioning in a wide intellectual range with a multiplicity of cognitive, language, speech, social, emotional, and/or motor problems. The majority of children are identified through community-based round-ups designed to screen all young children. Children identified as high-risk receive an in-depth psychoeducational assessment to determine eligibility. Also integrated into the program are children who have no special

educational needs. These children serve as models for language, cognitive, motor, and social skills.

Children are enrolled in a classroom program for a half-day five days a week. Educational needs are determined by systematic observations of each child. This procedure provides information on each child's level of functioning in the fine motor, gross motor, language, math, social, and self-help areas. Program features include a low student/teacher ratio, a positive approach to behavior management, extensive training and involvement of paraprofessionals as teachers, a carefully structured learning environment, and precise planning and evaluation of daily individualized teaching sessions.

Families are involved through an extensive individualized program. Parents have input into the educational program. Parent conferences, home visits, group meetings, classroom observation, and other activities are employed to help family members. A resource room serves as a lending library for parents interested in books and tapes for themselves, as well as in books, records, and toys for their children.

One staff member should be assigned the responsibility (and time) for (1) coordinating screening, child assessment, classroom programming, staff training, and evaluation; and (2) acting as liaison with the PEECH demonstration site. Optimal staffing would include one head teacher and one paraprofessional, with ancillary service from a speech and language therapist, psychologist, social worker, and occupational therapist; but a basic program can be implemented by a trained teacher and paraprofessional alone.

CONTACT

Merle B. Karnes, Director, PEECH, Institute for Child Behavior and Development, University of Illinois, Colonel Wolfe School, 403 East Healey, Champaign, IL 61820.

PROJECT: **PROJECT ERIN (Early Recognition Intervention Network)**

TARGET AUDIENCE

Children 2-7 with mild to severe handicaps in either main-

stream or special settings. Competency-based training programs for regular and special teachers, program coordinator, and parents are utilized to establish the program for children and parents.

DESCRIPTION

Coordinated training programs and service delivery systems aimed at harnessing the learning environment/materials/ adult intervention to teach young children with a range of special needs.

. . . used for children 2-7 years old (and parents) in specialized preschool classroom/home programs for children with moderate to severe special needs; and in regular early childhood (nursery, Head Start, day care) and primary (K-1) programs serving mild to moderate special-needs children integrated with their peers. The ERIN Training Program for Adults (special or regular teachers, coordinators, parents) provides the equivalent of three to six college credits through a week-long Institute plus on-site consultation by ERIN staff. Each adult implements a year-long program in his or her learning environment for two or more children with special needs in his/her care. Using competency-based training/implementation materials, each observes the children and the learning environment using structured activities and checklists, then plans to match child-in-environment by general and specific adaptations, and implements these plans through weekly contacts which are monitored by local supervisors pairing with ERIN staff. The Child's Individual Education Program is implemented through large and small groups as well as individually. The teaching adult organizes his/her own learning environment to facilitate Participation (social-emotional-affective), Body Awareness and Control, Visual-Perceptual-Motor, and Language Skills—all organized into Self-Help, Developmental Concept, and Academic Readiness content areas, depending on the age of the child. The curriculum approach focuses initially on general classroom/home modifications of the physical space and daily time units, learning materials and their organization into learning sequences, the grouping of children, and teacher cueing/ monitoring. This is followed by the teaching of specific skills

to each child by teacher, parent, volunteer, etc. (in much greater intensity in specialized than in mainstream programs). ERIN Materials available in several publications include: classroom observation activities and criterion-referenced checklists, modification strategies and teaching sequences in each learning skill area, parent workshop materials, and program coordination organizers.

CONTACT

Peter Hainsworth, Director of ERIN, 55 Chapel Street, Newton, MA 02160.

PROJECT: **PROJECT SHARE (Sharing High Yield Accountability with Resource Educators)**

TARGET AUDIENCE

Administrators, teachers, and tutors responsible for education of students with specific or multiple learning disabilities. Emphasis is on preschool through grade 8.

DESCRIPTION

An instructional process for remediation of basic skills in learning-disabled students in mainstream education.

Project SHARE is a process. Its special-education systems design meets needs for individualized instruction, mainstreaming, and accountability. The basic format for serving students in reading, spelling, and math is behavioral. Diagnosis, prescription, monitoring, and evaluation employ precision teaching techniques. Project-designed task ladder guides pinpoint a student's instructional starting point. A student's best learning mode and his most handicapping learning modes are quickly identified. Skill efficiency and accuracy are determined—a key Project SHARE difference.

Field-determined minimum basic skill rates have been established. Daily performance measures by the teacher or student provide an ongoing diagnostic/prescriptive process. The SHARE process speeds remediation of basic skill learning and produces cost-effectiveness data. Computerized evaluation is available.

CONTACT

Marvin Hammarback, Director or Fay Hammarback, Coordinator; Project SHARE; R. R. 1; Hendrum, MN 56550.

PROJECT: **PROJECT SUCCESS—Handicapped**

TARGET AUDIENCE

Children with reading, math, handwriting, and self-management difficulties, grades K-6.

DESCRIPTION

Low-cost academic and self-management programs for handicapped elementary school students.

... provides instructional service to handicapped students within a fully integrated educational program. A learning specialist works as a staff member in each of the home district's four elementary schools, assisting regular program staff in identifying and serving handicapped students. Assistance is provided to students identified through continuous (weekly) progress checks in basic academic, social, and self-management skill areas. Handicapped students are then given instructional and/or motivational assistance by teachers, peers, high school tutors, aides, or parents using instructional packets designed for this purpose. Upon successfully mastering the skill, students are tracked to assure continued success.

The intensive use of nonprofessional personnel for assessment and service delivery required a systematic approach to training. Each volunteer participant demonstrated competency in assessment techniques and use of assistance program training packets. Direct instruction training procedures included modeling for these personnel during training and direct observation in the classroom.

CONTACT

Ronald Smith, Director of Special Services; North Kitsap School District No. 400; 150 High School Road South; Poulsbo, WA 98370.

PROJECT: **PROJECT SUCCESS FOR THE SLD CHILD**

TARGET AUDIENCE

K-9 pupils with specific language disabilities.

DESCRIPTION

A prescriptive program and classroom delivery system for K-9 pupils with specific language disabilities.

... provides a prescriptive program and classroom delivery system operating in three areas: (1) a structural linguistic language program with a multisensory approach, integrating all aspects of language—reading, writing, speaking, and listening; (2) motor perception training and adaptive physical education, emphasizing the relation of movement to learning in areas of muscular strength, dynamic balance, body awareness, spatial awareness, and temporal awareness to develop the capacity to make efficient and effective use of the body; and (3) technique modification in other curriculum areas to allow SLD students to capitalize on strong modalities. This individualized learning program will keep the child functioning in an adequate manner within the educational mainstream.

CONTACT

Richard Metteer, Director, Project Success, Wayne Middle School, 312 Douglas, Wayne, NE 68787.

PROJECT: **RE-ED SCHOOL OF KENTUCKY**

TARGET AUDIENCE

Pupils in grades 1-6, of average or above-average academic/ intellectual potential, exhibiting characteristics of emotionally disturbed/behaviorally disordered children as defined by federal and state guidelines, particularly age-inappropriate behavior.

DESCRIPTION

A short-term plan for the re-education of emotionally disturbed/behaviorally disordered children.

RE-ED School is a . . . program intended to provide short-term treatment classes for emotionally disturbed/be-

haviorally disordered children unable to function in regular classrooms. Its objective is to help such children to achieve enough reorganization to allow them a higher probability of success than of failure in a regular classroom. The emphasis is on unlearning negative behavior patterns and learning positive ones. Meetings with parents are designed to encourage positive parental behaviors and management.

Individualized academic and behavior-change programs, based on problem identification and education pretesting, are employed. Goal-oriented records are kept for each child by a team composed of liaison teacher/counselor, day teacher, children's program specialist, educational specialist, and others.

RE-ED is the only facility in the nation that has taken a mental health concept into an educational setting, and has successfully enjoined the State Department of Mental Health and state and local departments of education to unite for the good of emotionally disturbed/behaviorally disordered children. Children are referred through the local schools, with parental permission. The program includes an individual educational plan. These plans begin and end with parental participation, group dynamics, and gross motor activities. Monthly written reports are sent to the referring teacher regarding the child's behavioral and academic achievement. Parents are involved in child-management programs. Visits to RE-ED by the referring school's counselor, principal, and teachers are geared to keep parents and school secure in the belief that the child belongs to them, and that RE-ED is the least restrictive placement.

CONTACT

Donald Alwes, Director or Pallen Nubia Starks, Dissemination Coordinator, Project RE-ED, 1804 Bluegrass Avenue, Louisville, KY 40215.

PROJECT: **REMEDIATION OF LEARNING DEFICITS THROUGH PRECISION TEACHING—THE SACAJAWEA PLAN**

TARGET AUDIENCE

Students of all abilities. Originally approved by the Joint

Dissemination Review Panel as a K-3 program, the program now operates as a K-8 program.

DESCRIPTION

A precision teaching model designed to remediate and build basic tool skills through use of these components: (1) screening, (2) identification, (3) remediation, (4) continuous measurement, and (5) data-based decisions.

The overall intent . . . has been to develop a model for the delivery of educational services to elementary students who have been identified as experiencing learning deficits. Precision teaching procedures have been used not only to identify these students, but also as remediation tactics. ("Precision teaching" is a set of measurement procedures that is based on direct and daily assessment.) A resource room was provided for students with more severe learning deficits, while the regular classroom dealt with basic skills and minimal problems. One-minute practice sheets were used extensively as a means of building basic tool skills to a level where the student could compete within the regular classroom. Direct and daily measurement procedures were employed, using both the manager and the student for recording and charting. Curricular decisions were based on available data.

Resource teachers as well as regular classroom teachers use precision teaching procedures, which include curriculum materials developed within the project. Instructional methods include one-minute practice sheets from the Precision Teaching materials bank and data-based decisions made from the standard behavior chart.

CONTACT

Ray Beck, Project Director, Precision Teaching Project, Special Education Center, 801 2nd Avenue North, Great Falls, MT 59401.

PROJECT: **THE RUTLAND CENTER—DEVELOPMENTAL THERAPY MODEL FOR TREATING EMOTIONALLY DISTURBED CHILDREN**

TARGET AUDIENCE

Originally validated for severely emotionally disturbed or

autistic children from birth to 14 years of age, their families, and teachers, the program is now applicable for children up to age 16.

DESCRIPTION

A community-based psychoeducational facility that offers a developmental curriculum to severely emotionally disturbed or autistic children from birth to 16 years, their parents, and teachers.

The Rutland Center Developmental Therapy Model is the result of eight years of intensive effort by the Rutland Center staff. Developmental Therapy is a therapeutic curriculum for social and emotional growth. It is used in a classroom setting with five to eight individuals in a group and is based on the assumption that young disturbed or autistic children go through the same stages of development that normal youngsters do, but at a different pace. The curriculum guides treatment and measures progress by focusing on the normal developmental milestones that all children must master. By doing so, Developmental Therapy has established itself as a "growth model" rather than a "deficit model." The model is composed of four curriculum areas (behavior, communication, socialization, and pre-academics) arranged in five developmental stages, each requiring different emphases and techniques. Special services to parents are an integral part of the approach. Developmental Therapy also emphasizes concurrent placement with non-handicapped children. This "school follow through" aspect of the model requires that regular school experiences mesh smoothly with intensive Developmental Therapy experiences.

In response to P.L. 94-142, two resources are available which emphasize how to plan, implement, and evaluate an Individualized Education Program (IEP) using the developmental approach. (1) The National Technical Assistance Office offers four types of technical assistance to the Rutland Center Developmental Therapy model to treat severely emotionally disturbed *preschool* children. This assistance, including information dissemination, program planning and design, training, and program evaluation, is provided through site visits and exchanges of audiovisual materials. (2) The

Developmental Therapy Institute uses the Rutland Center Developmental Therapy Model to provide on-site, year-long training assistance to individuals, schools, and agencies concerned with personnel training for *school-age* severely emotionally disturbed and autistic children. The institute staff provides assessment of training needs, designs an inservice instructional sequence suited to agency and trainee needs, and implements the training program at the agency site with periodic visits.

CONTACT

Mary M. Wood *or* Anthony G. Beardsley, Division for Exceptional Children, University of Georgia, Athens, GA 30602.

PROJECT: **TALENTS UNLIMITED**

TARGET AUDIENCE

Originally validated by the Joint Dissemination Review Panel for grades 1-6, the program has been adopted at the kindergarten, middle school, and high school levels. Suitable for any age or ability groups.

DESCRIPTION

A structured attempt to apply a multiple talent theory approach to the classroom situation.

... designed to help teachers recognize and nurture multiple talents in all children, including talents in the areas of productive thinking, communication, forecasting, decision making, and planning—as well as in academic areas. The program is a structured attempt to implement and evaluate primarily at the elementary classroom level the multiple-talent theory as defined by Dr. Calvin Taylor, and is based on sound educational and psychological research in learning. Replicable models for teacher training instruction and evaluation have been developed. The program can operate within any organizational pattern.

CONTACT

Sara Waldrop, Talents Unlimited, 1107 Arlington Street, Mobile, AL 36606.

PROJECT: **THE TEACHING RESEARCH INFANT AND CHILD CENTER CLASSROOM FOR MODERATELY AND SEVERELY HANDICAPPED CHILDREN**

TARGET AUDIENCE

Moderately to severely handicapped children, ages 1-18, including mentally retarded, cerebral palsied, autistic, emotionally disturbed, and deaf/blind.

DESCRIPTION

An individualized skills instruction program for moderately to severely handicapped children.

Program children are pretested on skills selected from the *Teaching Research Curriculum for Moderately and Severely Handicapped.* Pretest results are used to determine which skills will be taught. The deficit skills are prioritized by the parent and educational staff. After the priorities are established, the child is placed in one or more of the four curricular areas—self-help, motor, language, and cognitive.

Individual instructional programs are prepared for each child. A program prescribes the skill to be taught, the way in which the materials are to be presented, and the feedback to be given to the child. Trained volunteers play an important role in this model. They are taught the proper way to deliver cues and feedback, and to record the child's appropriate and inappropriate responses to instruction. Maintenance of these skills is objectively monitored by the teacher. Volunteers implement the instructional programs with each child and record child performance data in a specified manner. If the volunteer indicates, either through recorded data or verbally during classroom instruction, that the child is having difficulty learning a particular program, the teacher provides instruction for the child. The teacher uses the daily data to determine the appropriate individual programs for the following day and to ascertain whether alterations are needed in sequencing, cue presentation, or feedback.

When group instruction occurs, the teacher interacts with each child according to the individual instructional program of that child. In this model, group instruction is provided only

by the teacher or aide. Some instructional programs are chosen by the parent and teacher to be taught in the home, and are coordinated with programs in the school. Teaching periods in the home vary from 10 to 30 minutes. Approximately 85 percent of the parents of project children participate in home instruction. All parents participate in the program planning conferences for their child.

CONTACT

H. D. Bud Fredericks, Teaching Research, Oregon College of Education, Monmouth, OR 97361.

Appendix III.

Clarification of PL-94-142 For the Classroom Teacher

Public Law 94-142: Its Background and Purpose

Public Law 94-142 is a federal law passed by the 94th Congress as its 142nd piece of legislation. Signed into law on November 29, 1975, it is also known as the Education for All Handicapped Children Act of 1975. This law amends the Education for the Handicapped Act (EHA), Part B, a section regarding State grants in the education of the handicapped. Essentially, P.L. 94-142 is a "funding bill" designed to assist the States and, as such, may be implemented differently in each State. P.L. 94-142 is based on a number of Congressional findings, or understandings:

- There are more than eight million handicapped children in the U.S. today;
- More than half of the handicapped children in the U.S. do not receive appropriate educational services;
- One million of the handicapped children in the U.S. are excluded entirely from the public shcool system and will not go through the education process with their peers;
- There are many handicapped children participating in regular school programs whose handicaps are undetected;
- Because of the lack of adequate services within the public school system, families are often forced to find services outside the public school system, often at great distance from their residence and at their own expense;
- Developments in the training of teachers and in diagnostic and instructional procedures have advanced to the point that, given appropriate funding, State and local educational agencies can and will provide effective special education;
- State and local education agencies have a responsibility to provide education for all handicapped children, but present financial resources are inadequate; and
- It is in the national interest that the federal government assist State and local efforts to provide programs to meet the education needs of handicapped children in order to assure equal protection under law.

Public Law 94-142 addresses itself specifically to these concerns and defines handicapped children as: mentally re-

tarded, hard of hearing, deaf, speech impaired, visually hand-
icapped, seriously emotionally disturbed, orthopedically im-
paired, other health impaired, deaf-blind, multi-handicapped,
or having specific learning disabilities. The purpose of P.L.
94-142 is:

- to assure that all handicapped children have available to
 them free appropriate public education,
- to assure that the rights of handicapped children and
 their parents are protected,
- to provide financial assistance to States and localities for
 the education of all handicapped children, and
- to assess and assure the effectiveness of efforts to edu-
 cate handicapped children.

P.L. 94-142 is complemented by Section 504 of the Re-
habilitation Act of 1973. Just as P.L. 94-142 addresses itself to
the educational needs of handicapped individuals, Section
504 deals with the physical accessibility of buildings and
public programs to the handicapped. Section 504 requires
institutions to effect architectural changes that would afford
handicapped individuals the same accessibility to public pro-
grams as non-handicapped individuals. Both Section 504 and
the subsequent enactment of P.L. 94-142 work toward effec-
tively integrating handicapped individuals into the main-
stream of American life.

However, these laws are by no means a magic wand. Even
though both are presently being implemented and progress is
being made, the majority of handicapped individuals are still
excluded from many facets of American society.

(Reprinted by permission of Line Services, Inc.) Copyright
1978 by Line Services, Inc. Reprinted from *Clarification* of *PL
94-142 for the The Classroom Teacher published by Research
for Better Schools, Phila. PA. 19123*

*The Regulations for Implementing P.L. 94-142: Major Provi-
sions*

Realizing that P.L. 94-142 would have a powerful impact on
the education of handicapped youth nationwide, the U.S.
Office of Education (USOE) took steps to insure that the

regulations for implementing the law would be the result of public input. After more than a year of extensive public participation, the regulations were completed and publicized in the Federal Register, August 23, 1977, pages 42464-42518 (45 CFR Part 121a). Additional regulations related to the evaluation of learning disabilities were published in the Federal Register, December 29, 1977, pages 65082-65085.

These regulations specify the methods that States and local education agencies (School Districts*) must use in implementing the law if they are to receive federal funds under P.L. 94-142. The scope of the regulations encompasses all areas of the law, and although all areas are of some importance to the classroom teacher, there are seven provisions which are crucial to a teacher's understanding of the law. These provisions are:

1. Free Appropriate Public Education (FAPE)
2. Least Restrictive Environment (LRE)
3. Evaluation/Placement
4. Individualized Education Program (IEP)
5. Personnel Development
6. Procedural Safeguards (Due Process)
7. Funding

A summary of each of these provisions and its implications is given below.

Free Appropriate Public Education (FAPE). Simply stated, P.L. 94-142 makes provision for free appropriate education at all levels of schooling for all handicapped children who are in need of special education and related services. The law specifies a September 1, 1978, deadline for providing this service to handicapped children 3-18 years of age, and a September 1, 1980,deadline for handicapped children 3-21—provided these stipulations are not "inconsistent" with current State laws or court orders. Free is defined as at public expense, under public supervision and direction, and without charge to parents. The appropriateness of a program for a given child is one

*Hereafter, the term School District will be used in place of "local education agency" for they are, in most cases, synonymous.

that meets the requirements of that child's Individualized Education Program and is carried out in the Least Restrictive Environment.

By "related services" the law means transportation and those developmental, corrective, and other supportive services as are required to assist a handicapped child to benefit from special education. These services include speech pathology and audiology, psychological services, physical and occupational therapy, recreation, early identification and assessment of disabilities in children, counseling services, and medical services for diagnostic or evaluation purposes. Also included are school health services, social work services in schools, and parent counseling and training.

Least Restrictive Environment (LRE). The law states that each handicapped child must be educated with non-handicapped children to the maximum extent appropriate to that child.

The appropriateness of a learning environment for a handicapped child would be determined by the severity and effects of the handicapping condition as well as by the nature and quality of the learning environment. For example, placement of a hearing-impaired child might be dependent upon degree of hearing loss, language development (e.g., vocabulary, lip-reading ability, speech ability, and reading level), and by factors of personal and social development as well as the availability of supplementary media, special teachers, or other environmental factors which might be necessary in order to provide the special education and related services stipulated in the child's Individualized Education Program.

The law goes on to say that special classes, separate schooling, or the removal of handicapped children from the regular educational environment may occur only when the nature or severity of the particular handicap is such that education within a regular classroom "with the use of supplementary aids and services cannot be achieved satisfactorily." Placement in the school which the handicapped child would attend if not handicapped is preferred, but consideration is given to any harmful effect this placement would have on the handicapped child and the quality of services received.

In addition, the School District shall insure that a continuum of alternative placements is available, i.e., instruction in regular classes, special classes, special schools, home instruction, and instruction in hospitals and institutions, as well as supplementary services, such as resource room or itinerant instruction to supplement regular class placement.

Needless to say, there will be some tension between the concept of LRE and determination of appropriateness, for there are those who believe "mainstream" placements in the regular classroom and school are appropriate for even severely handicapped children. A clearer definition of "appropriate" will occur in time.

Evaluation/Placement. Before any evaluation is begun, written parental permission must be obtained after the parent has been fully informed of all information relevant to the evaluation activity.

A full and individual evaluation of the handicapped child's educational needs must be made before the child is placed in a special education program. This evaluation must be made in all areas related to the sususpected disability, including, where appropriate, health, vision, hearing, social and emotional status, and motor abilities. This evaluation, which must not be racially or culturally discriminatory, provides the basis for determining eligibility and developing an educational program for that child.

The evaluation is performed by a multi-disciplinary team of professionals designated by the School District after parental permission has been granted. Though the examinations and procedures employed in this assessment are designated and regulated by each State and School District, the School District is responsible for the following conditions concerning examinations and evaluations:

- all tests and evaluations must be provided and administered in the native language of the child unless it is clearly not feasible to do so;
- tests and evaluations must be validated for the specific purpose for which they are used;
- tests must be administered by a trained professional in

conformance with the instructions given by the producer of the test; and
- all tests must be selected and administered so as not to be racially or culturally discriminatory.

Also, no single procedure is to be used as the sole criterion for determining an appropriate education program.

Once this assessment information has been gathered and analyzed, the child's placement is determined by the IEP team.

Individualized Education Program (IEP). The IEP is one provision of the law which directly affects classroom instruction. It represents the most appropriate educational program for each exceptional child.

The law requires specific items to be included in all IEPs. The implementation methods and the detail with which these items are spelled out will vary from state to state; however, the following information must be included:
- present educational performance level of the child;
- the annual goals set for the child, including a statement on short term instructional objectives;
- a statement of the specific special education and related services to be provided to the child and the extent to which the child will be able to participate in a regular educational program;
- the projected initiation date and anticipated duration of special education services; and
- an evaluation schema (appropriate objective criteria, evaluation procedures and schedules for determining, at least on an annual basis, the achievement of short term instructional objectives).

The IEP, based on the child's evaluation, must be developed, reviewed, and revised by a team which includes a representative of the public agency, such as the school principal, the child's teacher, one or both of the child's parents, and the child, where appropriate. If the handicapped child has been evaluated for the first time, the IEP team must also include a member of the evaluation team or some other person, possibly the child's teacher or the principal, who is

familiar with the evaluation procedures used and the interpretation of their results.

The law requires the scheduling of planning meetings at times mutually agreeable to both parent and teacher. Furthermore, the School District must insure that parents understand the proceedings of the meeting. (Such arrangements might include the use of an interpreter for deaf or non-English speaking parents.) These meetings may be scheduled at any time prior to the beginning of the school year (in most instances they will be scheduled in the spring) for children continuing in a special education program.

A notice indicating who will be in attendance and the purpose, time, and location of the meeting must be sent to the parents in sufficient time to provide them the opportunity to attend. If the child's parents cannot be identified or if the child is a ward of the State, then the School District has the responsibility of selecting and assigning a surrogate parent to the child. This individual assumes parental responsibility for all matters relating to the identification, evaluation and educational placement of the child, and the provision of a free appropriate public education.

October 1, 1977, was the first deadline for the development of IEPs for each child. The beginning of every school year thereafter marks the due date for their revision. The development of IEPs for students new to the District or newly identified as eligible for special education programs must be completed within thirty days of their enrollment. The law stipulates that IEPs must be in effect before special education and related services are provided to a child.

Personnel Development. Each State is required by law to establish procedures for needs assessment to determine the number of qualified personnel available in the State, to provide professional and support personnel with inservice training in special education based on the findings of the needs assessment, and to acquire and disseminate significant information to teachers and administrators of programs for the handicapped.(A-39)

Procedural Safeguards. Also referred to as the right to due

process, this provision outlines the procedure to be followed when a parental or School District grievance exists. In the event of such a grievance regarding the appropriateness of the child's education, identifying information, evaluations, or educational placement, the law provides for an impartial due process hearing involving the parent and the School District to be conducted by someone not employed by or affiliated with the School District. A written notice must be given to the parents of a handicapped child a reasonable time before the School Dstrict either proposes or refuses to effect changes in any of the aforementioned areas. Either party involved in the hearing has a right to: be accompanied and advised by legal counsel and others; present evidence, confront, cross examine and compel attendance; and prohibit, under certain circumstances, the introduction of evidence. In addition, both parties are entitled to a written or recorded verbatim record of the hearing and to written findings of fact and decisions. In some states this impartial hearing is taken directly to the State level.

A parent or School District dissatisfied with the results of this hearing may make an appeal to the State educational agency, who will then conduct an impartial review and make a decision. If this second appeal is not satisfactory to all involved, any party has the right to bring a civil action in a State or U.S. district court. If a lawsuit is initiated by a parent, it would probably be brought against the School District and not the classroom teacher. However, this does not preclude the parent from bringing a personal lawsuit.

Funding. Under P.L. 94-142, both States and School Districts are entitled to federal funds based on a formula which multiplies the number of children between the ages of 3 and 21, who actually receive special education and related services, times an annually increasing percentage of the average funds spent, per pupil, in U.S. public elementary and secondary schools.

The annual increasing percentage is:
 1978 — 5 percent
 1979 — 10 percent

1980 — 20 percent
1981 — 20 percent
1982 — thereafter — 40 percent

During fiscal year 1978 the State and School Districts will both be entitled to 50 percent of funds distributed by the formula. In fiscal year 1979 and thereafter, 25 percent of the funds will be allocated to States and 75 percent to School Districts. School Districts can use these funds only to pay the "extra costs" of special education (i.e., costs above a computed minimum amount to be spent by the districts in providing special education and related services to handicapped children). It should be noted, however, that although the law provides a formula for the amount of funds to be allotted and the distribution of funds available, this does not necessarily mean that all needed funds will be forthcoming.

The following restrictions have been imposed for federal allocation purposes only:

- no more than 12 percent of the number of all children ages 5-17 in the State may be counted as handicapped;
- the handicapped children who are counted and already funded under Section 121 of the Elementary and Secondary Act of 1965 (also referred to as Title I, funding for compensatory education) can be counted for allocation of funds.

In no way do these restrictions place a limitation on the number of children identified as handicapped by the State or School District for their own purposes, or on the federal mandate to provide all handicapped children with a free appropriate education.

To qualify for assistance in any fiscal year an active "child find" program must be instituted. Such a program must involve: the identification, location, and evaluation of all handicapped children, regardless of the severity of their handicap; and the determination of which children are or are not currently receiving needed special education and related services. The classroom teacher should be a key person in this process. It should be noted this program is not limited to young children, but seeks all handicapped individuals eligible for services under the law.

Other Topics Covered by the Regulations

In addition to the seven provisions discussed, additional areas covered by the regulations include:

- the establishment of a full educational opportunity goal for all handicapped children ages birth through 21
- the annual count of handicapped children ages 3-21 who are receiving special education and related service for allocation purposes (due by April 1 of each year)
- priorities in the use of funds under P.L. 94-142
- the proper use of funds under P.L. 94-142
- methods to guarantee public participation in the review of the State annual program plans, and on the State advisory panel
- children placed or referred to private schools
- policies and procedures to protect the confidentiality of personally identifiable information and data

Appendix IV.

Site Observers
Sites
Site Visitations—What To Look For
Response Form

SITE OBSERVERS

Georgie Goodwin
 Box 214
 Almyra, Arkansas
Jane Love
 Centreville, Maryland
Donald Adcock
 Glen Ellyn Public Schools
 Glen Ellyn, Illinois
Joanne Lincoln
 Atlanta Public Schools
 Atlanta, Georgia
Phyllis Land
 Indiana Department of Public Instruction
 Indianapolis, Indiana
Mona Alexander
 Kansas State Department of Education
 Topeka, Kansas
Elsie Lawson
 Maryland State Department of Education
 Baltimore, Maryland
Rosa Presberry
 Maryland State Department of Education
 Baltimore, Maryland
Judith Steepleton
 Portage Public Schools
 Portage, Michigan
Jo S. Albers
 Missouri State Department of Education
 Jefferson City, Missouri
Clara T. Rottmann
 Lincoln Public Schools
 Lincoln, Nebraska
Wilma S. Rogers
 Las Vegas, Nevada

George E. Morey
 Las Cruces Public Schools
 Las Cruces, New Mexico
Carolyn Conrad
 Indian Hill Junior High School
 Cincinnati, Ohio
Annette Shockey
 Cuyahoga County Public Library
 Cleveland, Ohio
Mary Rawlings
 Rocky River, Ohio
Joan Griffis
 Portland Public Schools
 Portland, Oregon
Wanna Ernst
Peggy Hanna
 Charleston County School District
 Charleston, South Carolina
Carol Quissell-Nelson
 Sioux Falls School District 49-5
 Sioux Falls, South Dakota
Lotsee Smith
 Texas Woman's University
 Denton, Texas
LeRoy R. Lindman
 Utah State Board of Education
 Salt Lake City, Utah
Genevieve W. Smith
 Commonwealth of Virginia
 Department of Education
 Richmond, Virginia
Richard Sorenson
 State of Wisconsin
 Department of Public Instruction
 Bureau of School Library Media Programs
 Madison, Wisconsin

SITES

ARKANSAS Southeast Arkansas Learning Center
 615 West 6th Avenue
 Pine Bluff 71601
 Nina Moore, Materials Consultant

DELAWARE Delaware Learning Resource System
 Department of Public Instruction
 Townsend Building
 Dover 19901
 Steven Godowsky, State Specialist
 Diagnostician

GEORGIA METRO EAST - Georgia Learning Re-
 sources System
 385 Glendale Road
 Scottdale 30079
 Judy Harvey, Director

ILLINOIS South Metropolitan Association
 250 West Sibley Boulevard
 Dolton, P.O.
 Harvey 60426
 Tom Asher, Director of Media and In-
 formation Services

 Chicago Regional Program - Title I
 33 West Grand Avenue
 Chicago, Illinois
 Genie Lyons, Curriculum Specialist

INDIANA Jefferson High School
 1801 South 18th Street
 Lafayette 47905
 Peggy L. Pfeiffer, Director, Instruc-
 tional Materials Center

KANSAS Lawrence Learning Resource Center
 Unified School District #497
 2017 Louisiana, Lawrence 66044
 Donald W. Herbel, Director Special
 Services

MARYLAND Mark Twain School
 14501 Avery Road
 Rockville 20853
 Roberta J. Chase, Media Specialist

 Frederick County Schools
 Route 10 Box 45
 Frederick 21701
 Charlotte S. Holter, Supervisor of Li-
 brary Media Services

MISSOURI Department of Education and The
 University of Missouri
 UMC - 515 South 6th Street
 Columbia 65201
 Judy McElmurry, Director-Missouri
 Special Education Instructional Mate-
 rials Center

MICHIGAN Grand Rapids Public Schools
 143 Bostwick, N.E.
 Grand Rapids 49503
 Ruth Graham, Supervisor, Instruc-
 tional Media

NEBRASKA University of Nebraska at Lincoln
 Media Development Project for the
 Hearing Impaired
 318 Barkley Memorial Center
 Lincoln 68583
 George Propp, Associate Director

NEVADA Variety School for Special Education
 2601 East Sunrise Avenue
 Las Vegas 89101
 Jacqueline Pozar, Media Director

NEW MEXICO Roswell Independent School District
 300 North Kentucky
 Roswell 88201
 Flo Starkey, Coordinator of Media

NEW YORK Michael Harrison (Formerly Librarian)
 Mill Neck Manor School for the Deaf
 Frost Mill Road
 Mill Neck 11765

OHIO Public Library of Cincinnati and
 Hamilton County
 800 Vine Street
 Cincinnati 45202
 Coy K. Hunsucker, Head Librarian Exceptional Children's Division

 Taft Elementary School
 13701 Lake Avenue
 Lakewood 44107
 Gloria Lloyd, Media Specialist
 Fiore Tassone, Principal

 National Aeronautics and Space Administration Lewis Research Center
 Cleveland 44135
 Walter T. Olson, Director Technology
 Utilization and Public Affairs

OREGON Education Service District of Washington County
 Learning Resource Library
 14150 N.W. Science Park Drive
 Portland 97229
 Mary Parker, Coordinator

 Portland State University
 Media and Mainstreaming Project
 School of Education
 Box 751
 Portland 97207
 Joyce Petrie - Director
 Linda Whitmore, Assistant Director

SOUTH CAROLINA Dent Junior High School
Talented and Gifted Program (SPACE)
2719 Decker Boulevard
Columbia 29206
Lynn Washington and Idris McElveen,
Coordinators and Instructors

Whitten Village
South Carolina Department of Mental
Retardation
Box 239
Clinton 29325
H.Y. Keng, Librarian

SOUTH DAKOTA Department of Education and Cultural
Affairs
Division of Elementary and Secondary
Education
Kneip Building Church Street
Pierre 57501
Ardis L. Ruark, Director of Library and
Media

TEXAS Greenville Independent School District
Box 1022
Greenville 75401
Mike Cardwell, Director of Special Ed-
ucation

UTAH Utah Learning Resource Center
4984 South 300 West
Murray 84107
Joanne Gilles, Specialist

VIRGINIA Amelia Street School
1821 Amelia Street
Richmond 23230
Freeda N. Eaken, Librarian

WISCONSIN Lapham Elementary School
1045 East Dayton Street
Madison 53703
Eliza T. Dresang, Media Specialist

SITE VISITATIONS—WHAT TO LOOK FOR

PROGRAM
1. In what ways is the program innovative or exemplary? What is unusual or excellent about it?
2. Does the program have an impact beyond the institution or its target audience?
3. Can you find out community or other attitudes about the program? Are other community agencies involved with this program?
4. Is the program making a significant contribution to learning? Improved teaching? Helping parents to take part in their children's learning? Helping children in other ways?
5. Is there any spin-off or multiplier effect visible? Has the impact of the program multiplied itself beyond the original target audience?
6. Technology—Computers; dial access; ties into local state or regional networks, other?
7. In what ways could this program be adopted or adapted by other institutions?

STAFF
1. What are the characteristics of the staff in the following areas:
 —Education
 —Experience
 —Training
2. Attitudes (toward other staff, students). Enthusiasm for the program and commitment to its goals.
3. Responsibilities of professional staff. Is adequate staff available and how is it used?
4. Support staff - How many? How are they used? Is there adequate support staff?
5. Are other institutions or service groups cooperating with or involved in the program?
6. Are there volunteers in the program? If so, how are they used?

7. Names of persons interviewed and their titles.

FACILITY
> (For some programs this section may be of minor importance, for others, most important).

1. Is the facility important to the program or not relevant?
2. General atmosphere, attractive, decorated with imagination, maintained well?
3. Cost of facility and any special design information. Has the building been written up? If so, where? Provide samples of writeups or pictures if you can.
4. Was there any renovation involved in implementing the program?
5. Are there production facilities e.g. video studio, dark rooms, soundproof rooms, graphic areas used in the program?
6. Were modifications for handicapped users necessary?

BUDGET
1. Are funds adequate to support the program?
2. Are there combinations of funds used—e.g. foundation, federal, local, or other? Look especially for federal funds or state support.
3. Has budget increased in recent past? Or, is it decreasing?
4. Has any other program of the institution been "sacrificed" to keep this program going? Is this a priority program?
5. Is there any program analysis or budget cost accounting being used to develop future budgets?

RESOURCES/MATERIALS
1. How are the resources/materials organized? Are they immediately available for use?
2. How are the resources/materials being used on a daily basis?
3. Is there balance of print and audiovisual resources available?

4. Is there any evaluation of the results of the use of materials?
5. Are any unique resources necessary to support the program?
6. How are materials selected?
7. Is any unique or unusual equipment used in the program?

RECOGNITION
1. Has there been recognition? Local, state, professional, community, national, other?
2. Is there an on-going PR program for the program or is it self generating?
3. Can you locate any newspaper or journal articles about the program? Photographs or other write-ups should be included as well. Please provide exact citations, dates, pages, name of journal for any write-ups available.

ADDITIONAL SITE VISITATION QUESTIONS
1. Are there any specific documents or statements that relate to either long or short range goals for the program? Secure if possible.
2. Is the staff (paid, professional and support and volunteers) involved in the evaluation and reassessment of program goals and objectives?
3. Is it possible to identify two or three specific program activities that are truly innovative?
4. Have the numbers using the services of the program increased or decreased in recent years?
5. What is the major impact of the program?
6. What failures has the program experienced?
7. In retrospect, what would they do differently, if they were starting again?

RESPONSE FORM
LIBRARY MEDIA PROGRAMS AND
THE SPECIAL LEARNER

FOR INFORMATION ABOUT LIBRARY MEDIA PRO-
GRAMS WORKING WELL WITH SPECIAL EDUCATION
OR LEARNING PROGRAMS I SUGGEST THE FOLLOW-
ING (please print)

1. SCHOOL OR DISTRICT _____
Address _____

(zip)
Phone number _____ Contact Person
(area)

SPECIAL PROGRAM EMPHASIS _____

2. SCHOOL OR DISTRICT _____
Address _____

(zip)
Phone number _____ Contact Person _____

SPECIAL PROGRAM EMPHASIS _____

3. SCHOOL OR DISTRICT _____
Address _____

(zip)
Phone number _____ Contact Person _____
(area)

SPECIAL PROGRAM EMPHASIS _____

Additional comments:

Name of person completing this form _____
Address _____

Phone _____
(zip)

RESPONSE FORM
LIBRARY MEDIA PROGRAMS AND
THE SPECIAL LEARNER

Mr.

Name of person completing
this form Ms. _____
 Miss
 Mrs.

Title _____ Address _____

Phone _____
(area code) (zip)
School or district (name) __ Address _____

 Mr. (zip)

Name of person in charge of
program Ms. _____
 Miss
 Mrs.

Title _____ Address _____

Phone _____ (zip)
(area code)

Description of students served by the program (check all
appropriate)

_____ Physically handicap-
ped _____ Emotionally disturbed

_____ Mentally retarded _____ Visually handicapped

_____ Hard of hearing _____ Gifted and Talented

_____ Deaf _____ Other (Please clarify)

_____ Speech impaired _____

Number of students served
by program _____ Grade or age level _____

LIBRARY MEDIA PROGRAMS

Source of funding (check PRIMARY source of funding)
_____ Local budget _____ Foundation
_____ Federal _____ Other (Please clarify)
_____ State _____
Please describe briefly the unique or exemplary aspects of
this program, especially how it relates to or uses media or the
library media program. PLEASE USE THE REVERSE SIDE
OF THIS FORM TO COMPLETE YOUR DESCRIPTION IF
NECESSARY

Index